I DEDICATE THIS BOOK TO
IVANA ABRAMOVIĆ

First published in Great Britain
in 2023 by Laurence King, an imprint
of The Orion Publishing Group Ltd
Carmelite House, 50 Victoria
Embankment, London EC4Y 0DZ

An Hachette UK Company

10 9 8 7 6 5 4 3 2 1

A CIP catalogue record for this book
is available from the British Library.

ISBN 978-0-8578-2946-7

Senior Editor: Laura Paton
Design and Art Direction: Hingston Studio
Art Director for Laurence King: Liam Relph
Production Manager: Simon Walsh

Typefaces: Mason Neue Mono and Unica77 LL
Text paper: Magno Volume 150gsm
Vol.1.08 FSC
Endpapers: Tauro Offset 140gsm
Vol.1.20 FSC
Case: Skivertex Serie 3 Ubonga FSC and
Gardamatt – Art 150gsm Vol.0.87 FSC

Origination by DL Imaging, UK
Printed in Italy by Printer Trento S.R.L.

Cover: *Art Must Be Beautiful, Artist
Must Be Beautiful*, 1975, Denmark
© Marina Abramović. Courtesy of the
Marina Abramović Archives

www.laurenceking.com
www.orionbooks.co.uk

MARINA ABRAMOVIĆ

WITH KATYA TYLEVICH

A VISUAL BIOGRAPHY

CONDITIONS:
THE ARTIST, MARINA ABRAMOVIĆ,
GRANTS THE WRITER, KATYA TYLEVICH,
FULL ACCESS TO HER ARCHIVES AND
FAMILY PHOTOGRAPHS WITHOUT PRIOR
REVIEW. THE ARTIST WILL ANSWER
ALL QUESTIONS THE WRITER ASKS, BASED
ON SELECTED MATERIALS. IN THIS WAY,
THE WRITER COMPOSES A VERSION OF THE
ARTIST'S LIFE AND WORK UP TO MAY 2023.

PURPOSE:
THE ARTIST WISHES TO SEE
HER LIFE AND WORK THROUGH
SOMEBODY ELSE'S EYES.
THIS CONDITION IS BASED ON TRUST.

DURATION:
17 MONTHS

NUMBER OF IMAGES VIEWED:
23,000+

PERCENTAGE OF SELECTED
IMAGES CUT FOR SPACE:
60%

NUMBER OF IMAGES IN BOOK:
602

01

MY GRANDMOTHER'S KITCHEN

YUGOSLAVIA
1946–1965

WAR, VIOLENCE, RITUAL

‘THE HEART NOT ONLY BEATS, IT ALSO TAKES BEATINGS...’

Marina Tsvetayeva, in a letter to Rainer Maria Rilke, June 1926. From the collection
Letters: Summer 1926, given as a gift to the artist by her mother at age 17.

Oh God, this is such a sad story for me [laughs]…

How do you remember your childhood?
With shame.

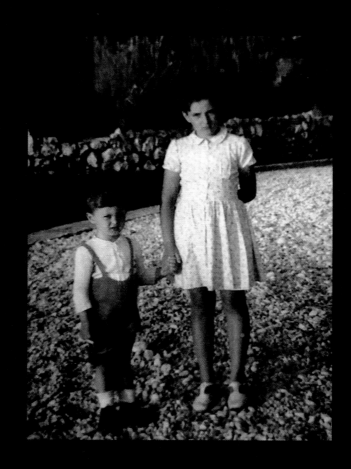

I was so shy I couldn't walk down the street
if someone was behind me. I was tall, skinny,
bad haircut. Everybody called me giraffe.
I wore orthopaedic shoes that my mother fitted
with metal, like a horseshoe. I tried sitting
in the back of class to hide and got bad marks
in school.

You were a bad student?
I was a good student! I just couldn't see.
I needed thick glasses, which I tried to break
in every possible way. I closed windows on them
and threw them across rooms.

eat love of art. She was an art
nist and historian under Tito.
Museum of Art and the Revolution
. We always had tickets to the
e opera, to classical concerts.
ch literature and philosophy.
the possibility to make my work,
om for a studio, made sure I had
y for oil paint. So, that was
and.

hand?

freedom. She was obsessed
ere was nothing I could do
ever touched me, she never
e she let me touch her was
er's and didn't know who I
saw my mother naked? Look
e she is wearing her suit
never relax.

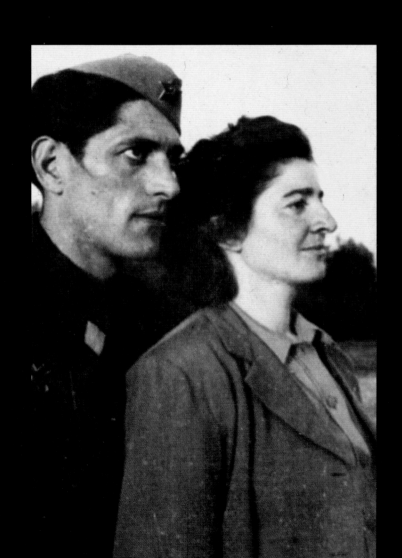

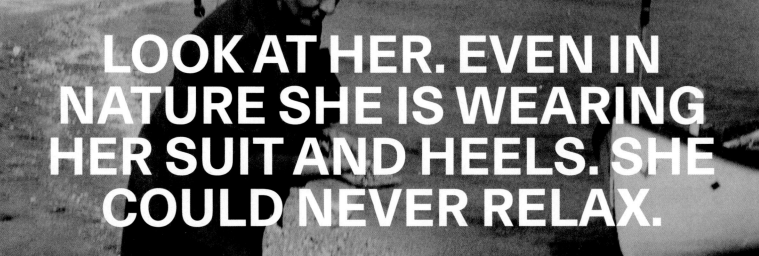

LOOK AT HER. EVEN IN NATURE SHE IS WEARING HER SUIT AND HEELS. SHE COULD NEVER RELAX.

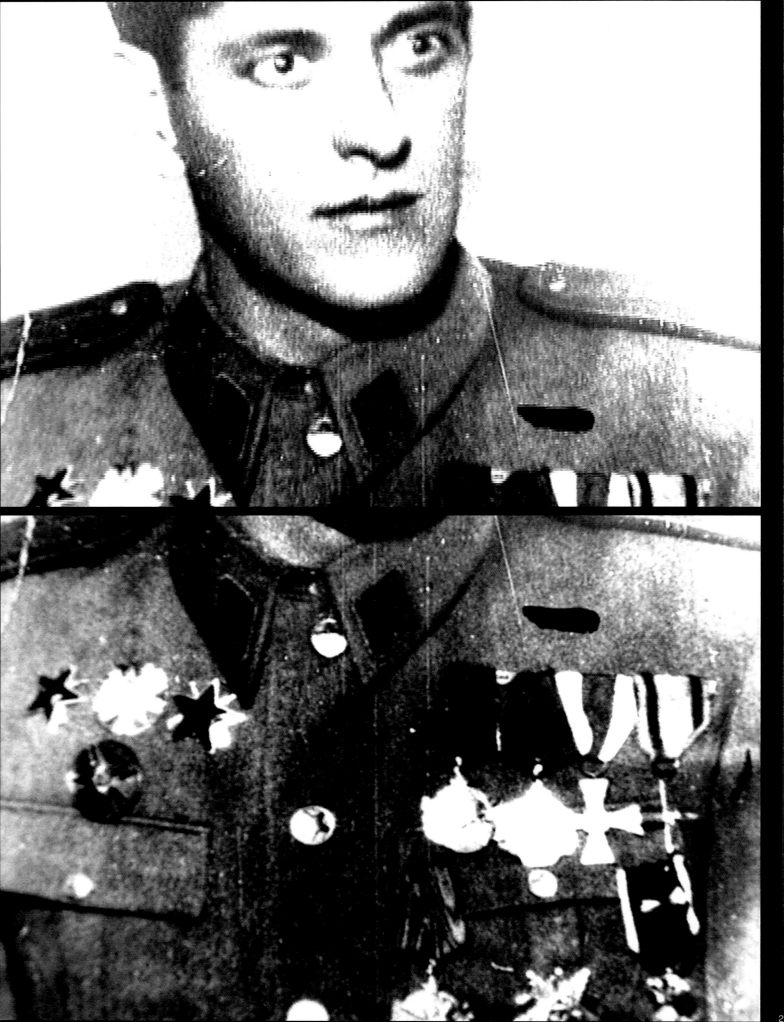

He had none. My fathe
bought me paint if my
didn't go to exhibiti
in art. He was interes
of action and revolut

I idolized my father, even though he was here
and there. Not really part of my daily life.

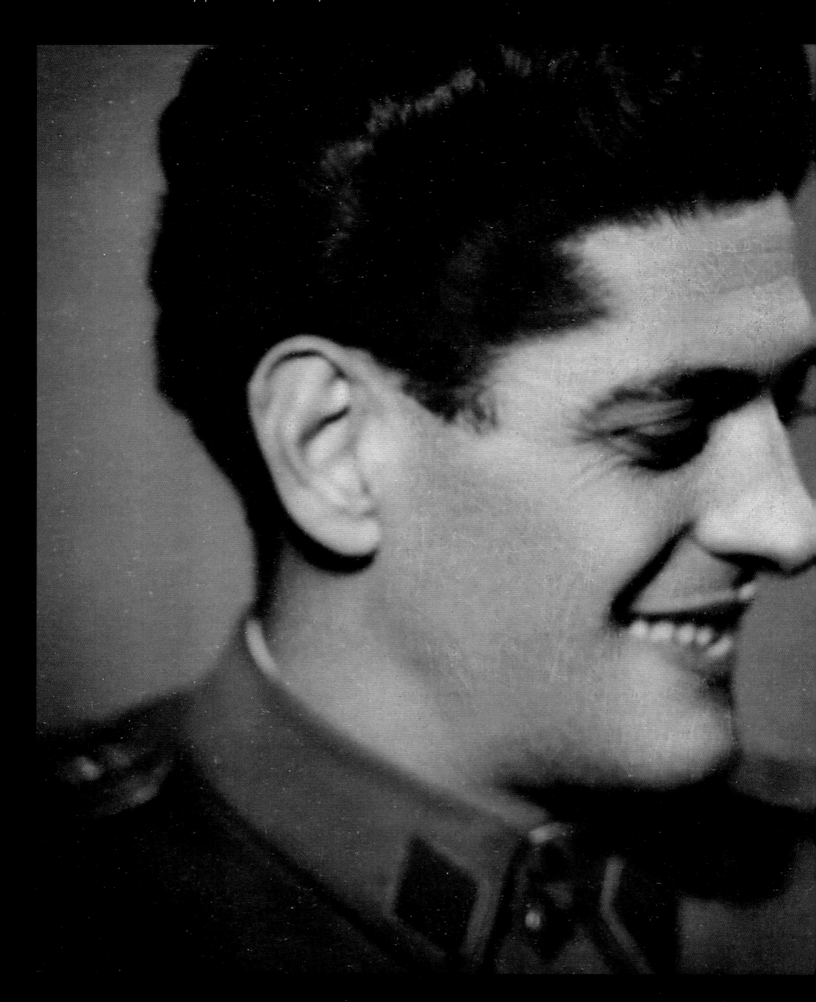

He finally left the house when I was 17. He was
fucking everybody. I didn't understand how hurt
my mother was. Only after she died.

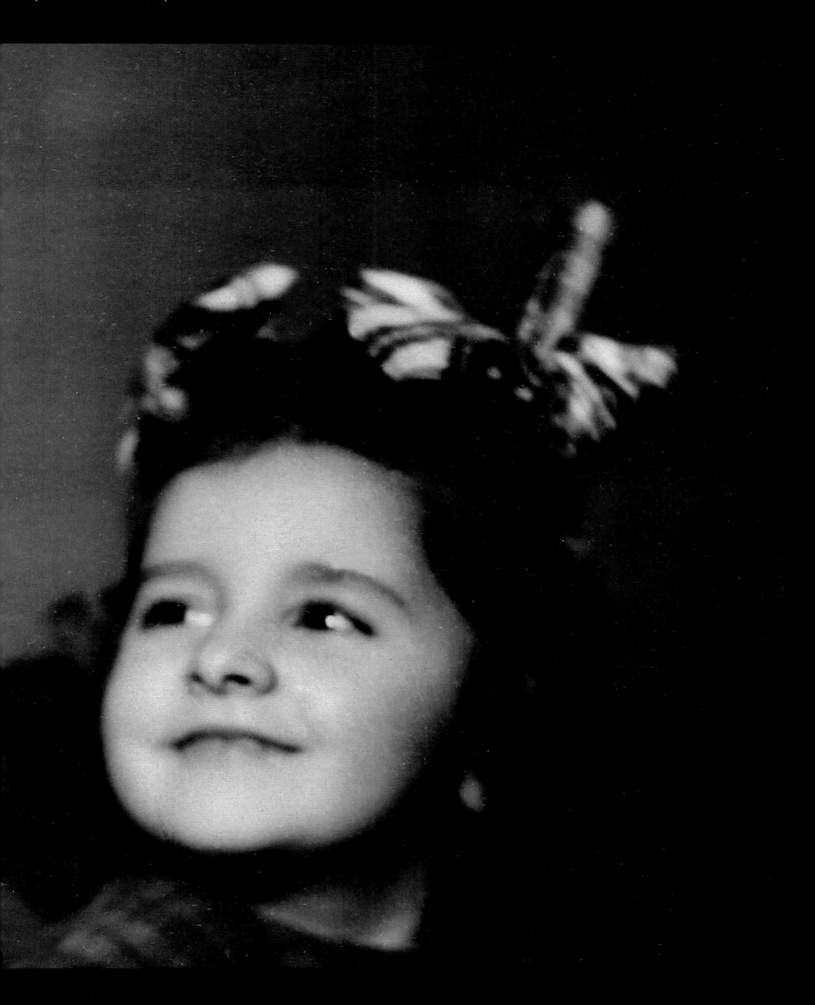

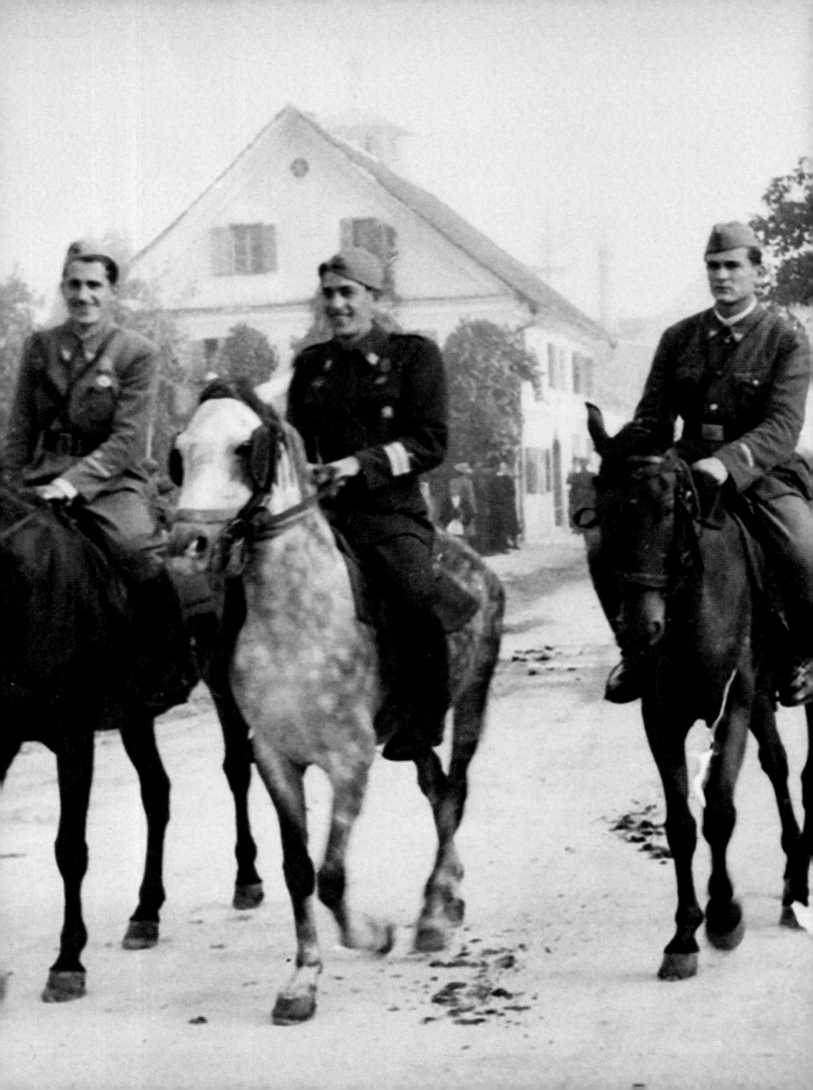

ds like a myth.

her never lied. He always told the
mother? Everything was a lie.

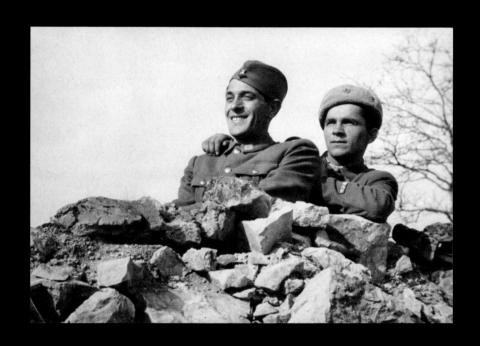

NO. MY FATHER NEVER LIED. HE ALWAYS TOLD THE TRUTH. MY MOTHER? EVERYTHING WAS A LIE

Death was a lie. Unhappiness was a lie.

Our terrible, shitty family was a lie. To the outside world, she had to be perfect. My mother and I could be screaming at each other, crying, then the telephone would ring, and she could pick up as if everything is fine.

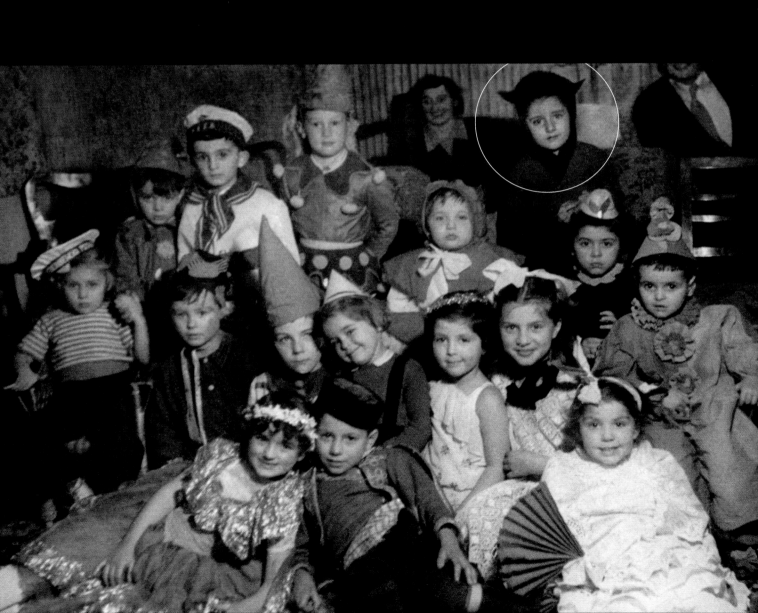

She said I was born on 29 November, the day
of Yugoslavia's establishment as a republic.
All the kids born that day got sweets from Tito.
I remember thinking: 'Why am I not getting
sweets?' She told me it was because I was a bad
girl. It was because I was actually born on
30 November.

And, later on, when I came home with Ulay, she lied and told everyone he was Dutch. He was German. His father had fought in Stalingrad. Ulay was just a baby then, but she was so ashamed!

<u>How did your father feel about Ulay?</u>
He loved him. They bonded. He gave Ulay a pair of binoculars from the war – they'd probably belonged to a German he had killed [laughs]. Ulay was super-happy.

 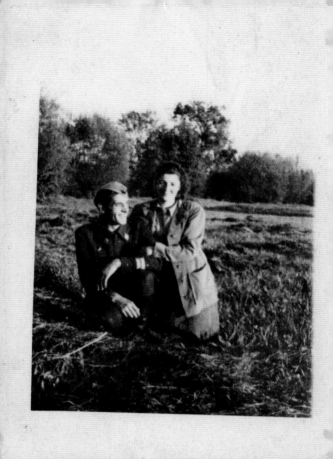

IT'S FUNNY THE WAY SHE'S HOLDING ONTO HIM IN ALL OF THESE PHOTOS

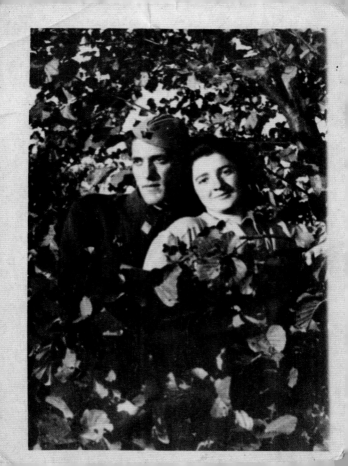

ed coat. She had

hough Easter

country.

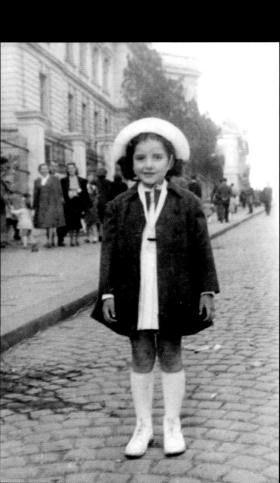

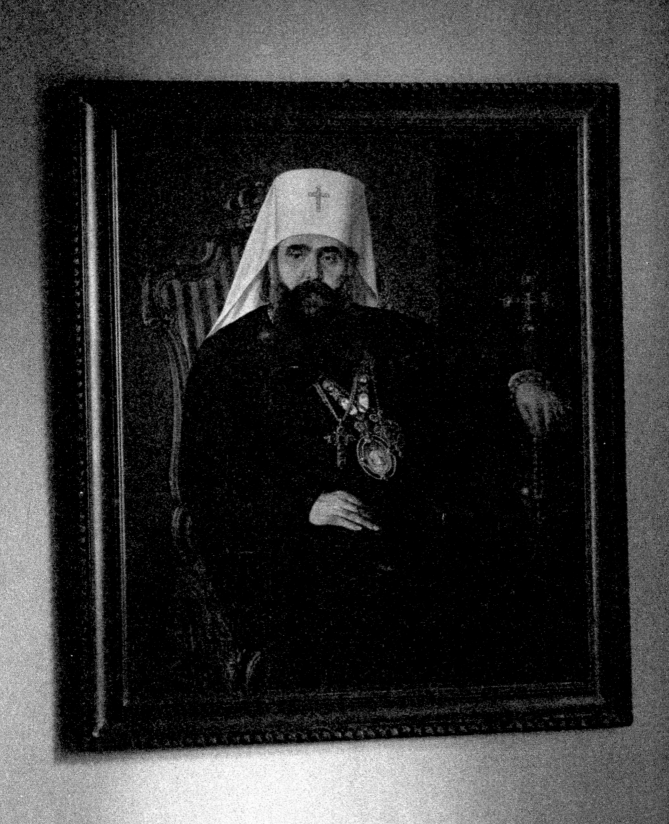

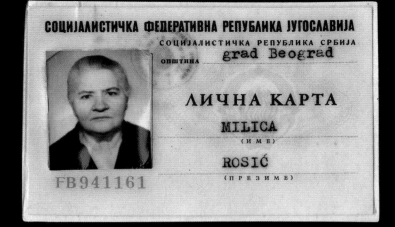

GOD, MY GRANDMOTHER
HATED COMMUNISM.

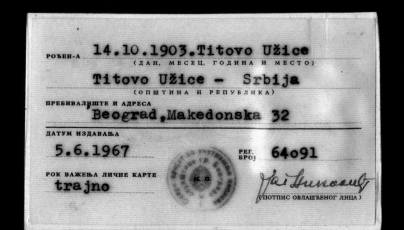

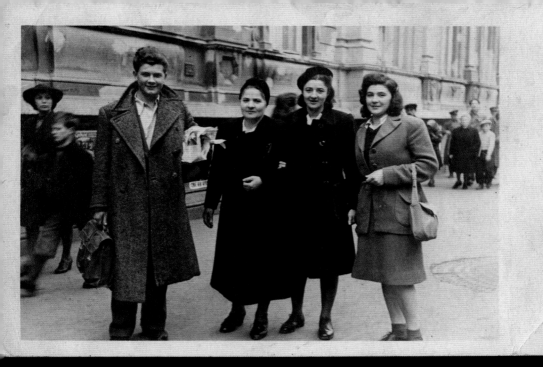

Душко, моја мама и Жене
1946 г.
или 1947 године
у Београду

God, my grandmother hated Communism. My grandmother was Serbian Orthodox. She went to church every day. She baptized me, which was totally against the rules of Communism. My mother and father were criticized at Party meetings, but they had no idea she did it. The church was full of Communist spies. My grandmother celebrated all religious festivals with the blinds down so nobody could see.

Grandmother's courtyard.

MY GRANDMOTHER CELEBRATED ALL RELIGIOUS FESTIVALS WITH THE BLINDS DOWN SO NOBODY COULD SEE.

uality and ritual.
and taught me mysticism.
childhood are sitting
r. She was the centre of

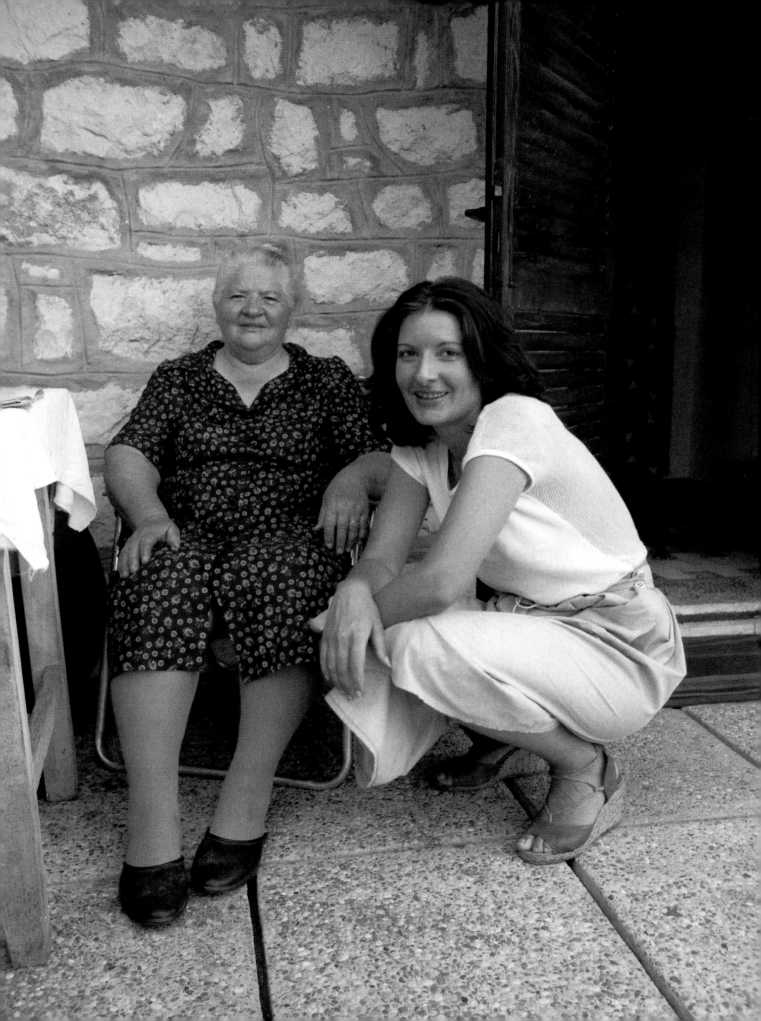

Do you know the story of how they killed
her husband?

We're talking about your maternal grandfather?
Yes, my grandfather. He had two brothers: one,
a merchant like him, importing silk and spice
from the Middle East; the other, a patriarch
of the Serbian Orthodox Church – one of the
most important people in Yugoslavia. When the
king wanted to unite the Serbian and Catholic
Churches, the patriarch refused. So the king
invited him and his two brothers for lunch.
The king's personal doctor served them food
with crushed diamonds. Within a month and
a half, all three brothers died from internal
bleeding. My grandfather died as they buried
the patriarch. My mother found out her father
died at her uncle's funeral. Later, he was
proclaimed a saint. He is embalmed in a church
in Belgrade.

Yes, this saint in my background. Really, my grandmother's whole side is a world apart from Communism. And she herself was

superstitious and very private. In Communism, your private life is not important. You are supposed to sacrifice your private life for the bigger ideal.

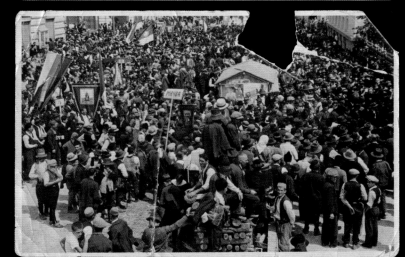

I SPOKE TO MY MOTHER ABOUT SEX!

versation?

d sex is dirty and
if you want a child.

vić, my first kiss
ound 16. He introduced

me to Zen Buddhism, her ma
We exchanged books. I rem
The Brothers Karamazov a
home until I finished the
want to live the reality
to live the reality of bo
behind the wall of my poe

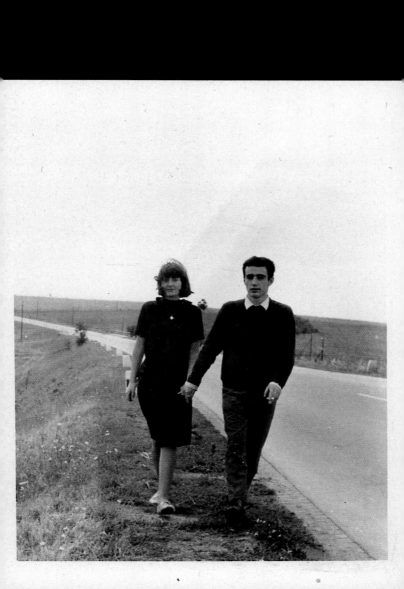

For my lesson, he asked me to cut several pieces of canvas. He then put them on the floor in my little home studio, glued plaster to them and added red, yellow and black pigment. Then he covered it all in turpentine, lit a match and threw it on the canvas. We watched everything explode. 'This is a sunset,' he said and left. It was a more important lesson than I could have ever wished for.

When I first started painting, I would go out with a camera looking for accidents. I went through a period of being fascinated with huge Communist trucks and thinking about what would happen if the driver fell asleep, or if two trucks collided.

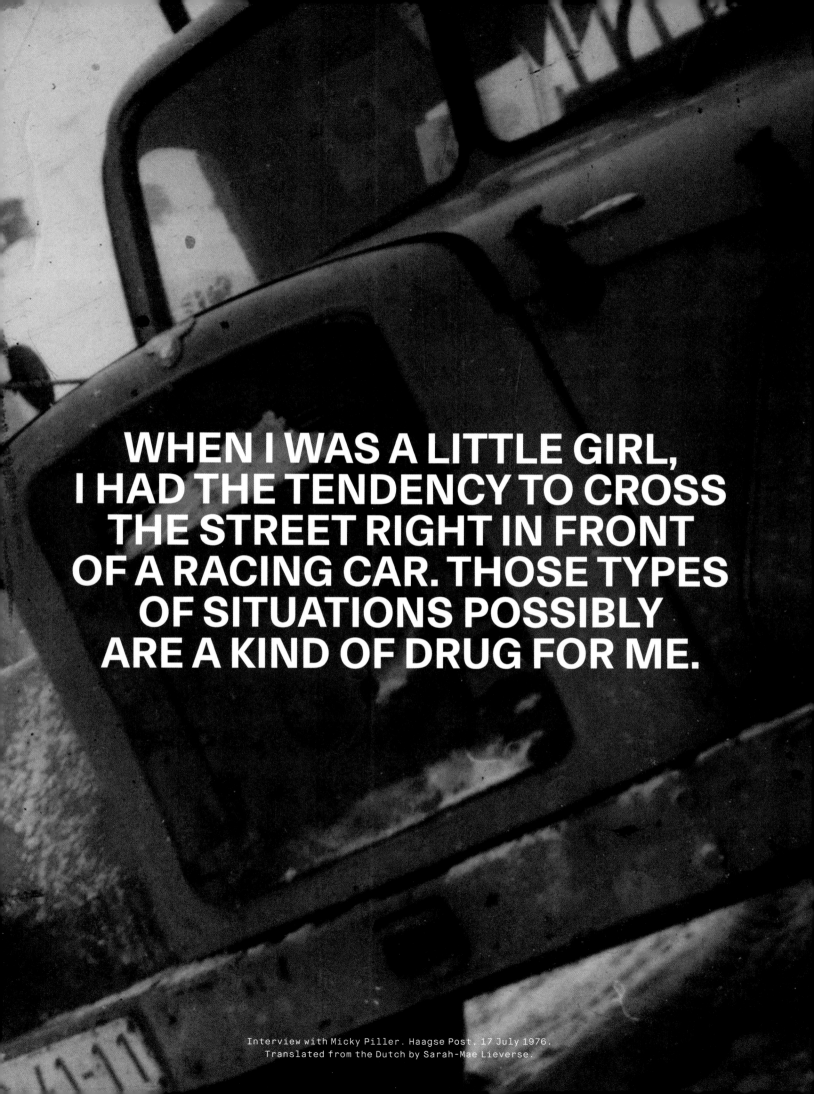

WHEN I WAS A LITTLE GIRL,
I HAD THE TENDENCY TO CROSS
THE STREET RIGHT IN FRONT
OF A RACING CAR. THOSE TYPES
OF SITUATIONS POSSIBLY
ARE A KIND OF DRUG FOR ME.

Interview with Micky Piller. Haagse Post, 17 July 1976.
Translated from the Dutch by Sarah-Mae Lieverse.

e on your mind?
d me why I became an artist.
t question once, too, when

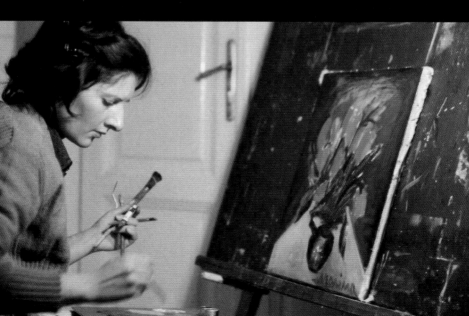

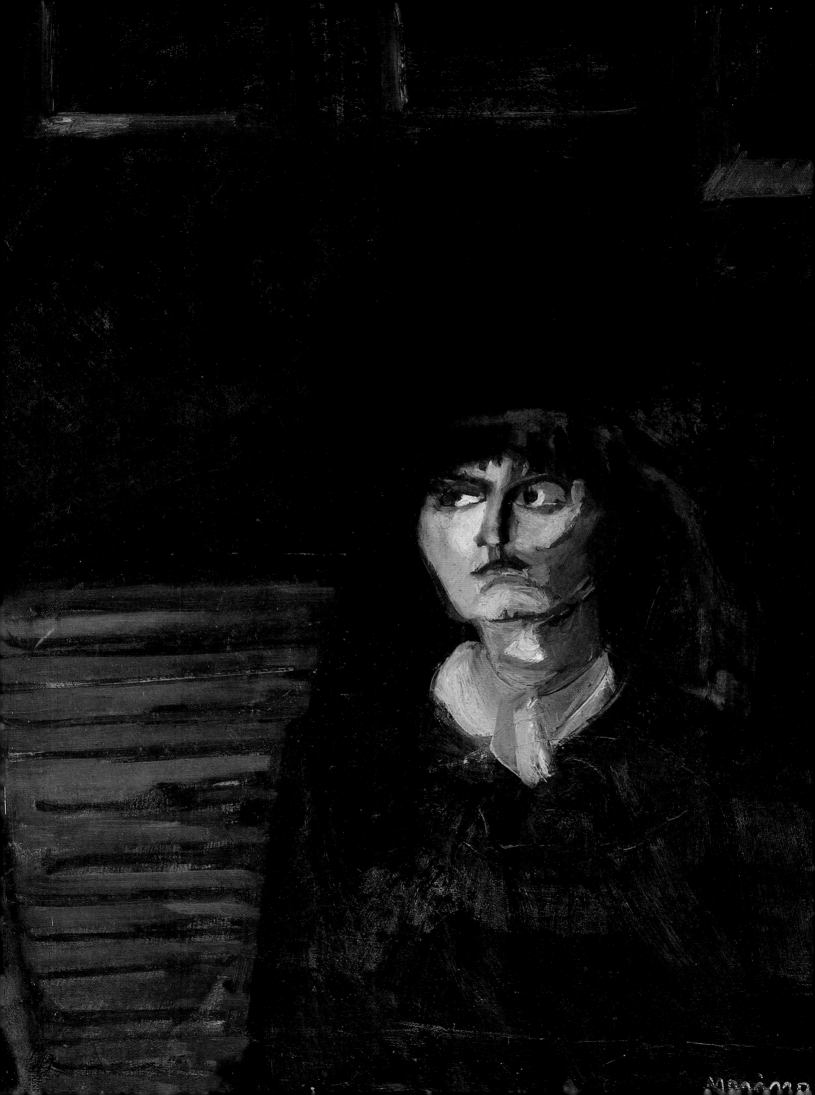

t studios
I was a child,
here was one
ayed Albinoni
. She was tiny,
tooed on
at Auschwitz.
artist.

She told me she'd wa
friend to death in t
fell in wet mud face
it, she saw the face
before the rain wash
she started sculpti
memory. That's how
forgot this story.

Everything about the time was disturbing and nervous. Even the apartment we lived in was taken from a Jewish family killed in the Holocaust. The Partisans who liberated Belgrade – people like my mother and father – were given these apartments. Everything we possessed was from this Jewish family. I didn't know this until much later. But I always felt the apartment was full of ghosts.

All through my childhood, I had nightmares about World War II. Dreams that I was helping Hitler against my parents, and that I was part of the wrong army. I would wake up sweating, with a terrible sense of guilt.

We talk about World War II in every conversation. Don't you think it's in your art? No. Not in a conscious way. I found nothing abnormal about postwar Yugoslavia while

I was living it, not the green light that made everybody look sick, not Tito's picture everywhere. My grandmother lived on a main street in the centre of Belgrade. One day I looked out the window and saw hundreds of people walking in total silence, all dressed in dark colours. This was a silent march. I remember the sense that something terrible was going to happen. It was around the time Tito and Stalin split.

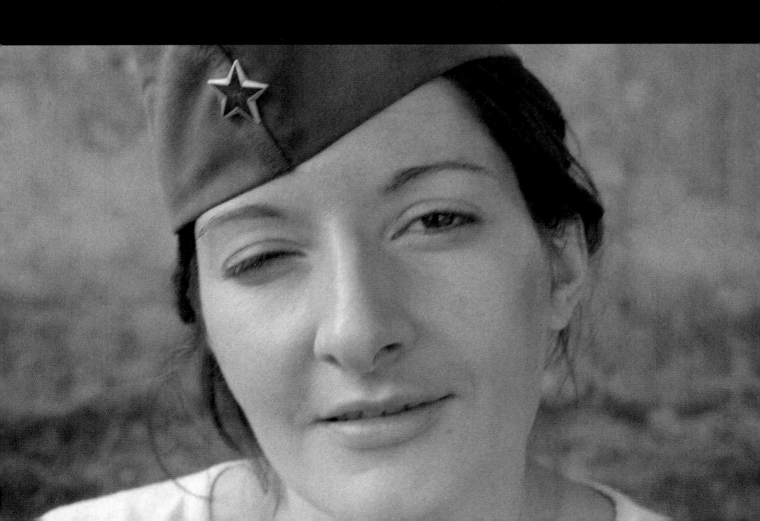

It's entirely possible I would remember that from age two, because it was so intense. People were waiting for an invasion. It was heavy in the air.

My father secretly loved Russians – many Montenegrin people did, and they became political prisoners if anybody found out. My father had to testify all the time. He was often in court. Some of his closest friends were sent to prison.

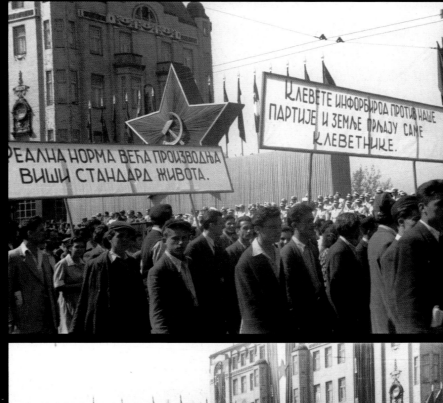

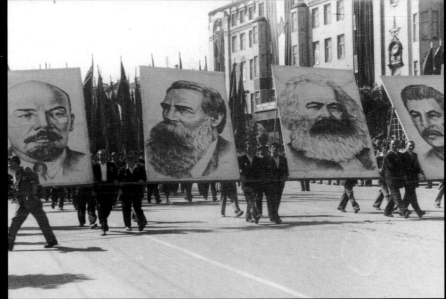

I SHOULD FIND MY OWN WORDS, AND UNTIL THEN I'LL BE QUIET AND LET THE QUIETNESS GROW INTO ONE GREAT SILENCE.

From the artist's personal journal, aged 17. 25 February 1964.

I hated all the restrictions of my young life. Now I think, maybe it was better than having total freedom and not knowing what to do with it. You need discipline if you want to do what I'm doing now. Without discipline, believe me, you will never make artwork that makes somebody cry.

Now I stage the things I am most ashamed of, and I can do it without embarrassment, with humour. Shame is the most difficult feeling but it is also universal. That's why I think anybody can project my biography onto their own.

02

TITO'S CULTURAL CENTRE

YUGOSLAVIA
1965—1975

PAINTING, SOUND, MENTAL FUGITIVE

of, I had a very old
all of us – 25 people
and said: 'The most
to have balls.

If you don't have balls
artist.' I panicked. I
balls, no artist. I car
Not for a minute did I t

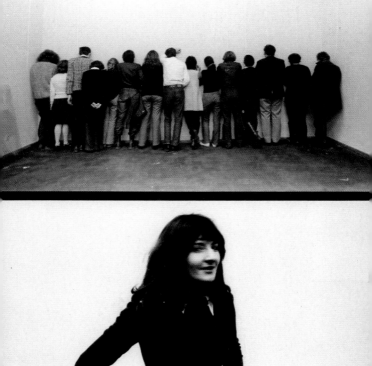

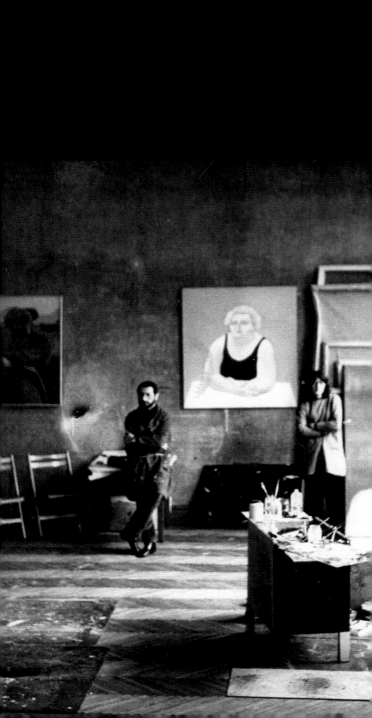

In reality, I didn't have permission to do anything else but be an artist. I was obsessed. I worked and worked. My mother didn't permit me to stay out late, I couldn't go to parties, I didn't go out drinking. So, I painted. My hands were always dirty. My nails were green and blue with paint. It was very intense.

What did you paint?
Whatever I was told to paint. I did exactly what anybody wanted. Tulips half-closed or half-open, a full moon through a window with the curtain pulled aside… They wanted a pomegranate, a piece of lemon, a fish? Sunflowers, country flowers, fields? Anything. I would paint it for them.

Представљамо вам...

АБРАМОВИЋ МАРИНУ

Мото: Птица се пробија из јајета. Јаје је свет. Ко хоће да буде рођен, мора да разори један свет. (Хесе)

1. Објасни нам прелаз из дечје љубави према слици у сликарство.

У почетку, то је било само обично цртање, један вид игре детета. Ти први изражаји у оловци, пастелу, темпери, били су без равнотеже логичке стварности, и свему томе претила је огромна опасност потпуне пропасти, као што се то касније десило са мојом поезијом. Требало је бити јак у хтењу и вољи и прећи мост који одваја и истовремено спаја две обале: обалу игре где се човек мора предати цео, да би доживео сликарство пуно дрхтавог живота, који као да долази са дна времена да би утицао у реалност.

2. Боја у твојим сликама игра јако важну улогу. Иде ли она на уштрб фигуративног:

У сваком случају, боја је за мене један од одлучујућих фактора. Фигура је такође јако важна. Међутим, интимно, боја за мене представља моментално далеко веће поље интересовања. У томе можда лежи и опасност занемаривања фигуре.

3. Какав је однос између реалног света и света који уметник креира?

Спољни свет се у сваком човеку различито прелама, према његовом душевном склопу. Ту слику света који из реалног прелази у интимни, сликар преноси, стварајући тако нов свет.

4. Каква је онда улога слике у усавршавању друштвеног живота?

Одговор се логички наставује на претходни. Човек је пре свега сплет осећања, у супротном би према свему био равнодушан попут робота. Зато се свуда и увек на првом месту мора водити рачуна о духовном свету појединца. Уметност је оно што ту улогу најсавесније врши. Искрено потекла из огромне потребе за стварањем, на основу свега оног о чему смо већ говорили, она директно делује на посматрачев осећајни свет, потресајући га из учмалости и стварајући му широке хоризонте усавршавања.

5. Које ликовне уметнике највише цениш?

Ел Грека и Шагала.

6. Два љубимца из сасвим различитих епоха и са сасвим различитим начином изражавања несумњиво говоре о твом свестраном интересу. А кога издвајаш из осталих, неликовних области?

У литератури — Хермана Хесеа, Сен — Џон Перса, Миодрага Павловића. У музици — Баха, Албинонија, Моцарта.

7. Моментално се у сваком разговору ове врсте неизбежно намеће једно актуелно питање: шта мислиш о поп — арту?

Поп — арт није ни ликовна ни примењена уметност, али је неопходан. Он није толико потребан сликару колико обичном човеку, нестзараоцу, јер му открива динамику и живописност фактуре предмета у свакодневној потреби, коју они несумњиво имају, а која без поп — арта сигурно не би била запажена. Баш због слепила које према овом посебном свету влада у обичном животу, ја бих оно што нам поп — арт доноси назвала и егзотичним.

8. Већ нам је познато да си имала једну самосталну изложбу, на радничком универзитету „Ђуро Салај", ове године. Постоје ли скоре могућности за нове изложбе?

Постоје. Била сам веома обрадована добивши позив да овог лета излажем у Галерији Розињског музеја. Постоји, такође, могућност да излажем у Титограду и наравно, као и сваке године поводом 22. децембра, излагаћу у оквиру Ликовне групе Дома ЈНА.

Разговор водила

Вера Илић

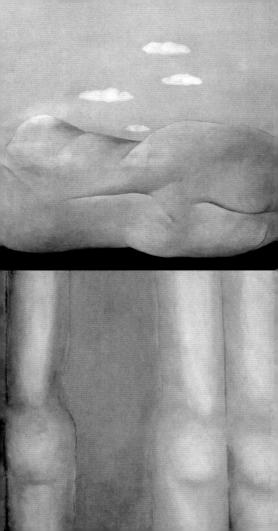

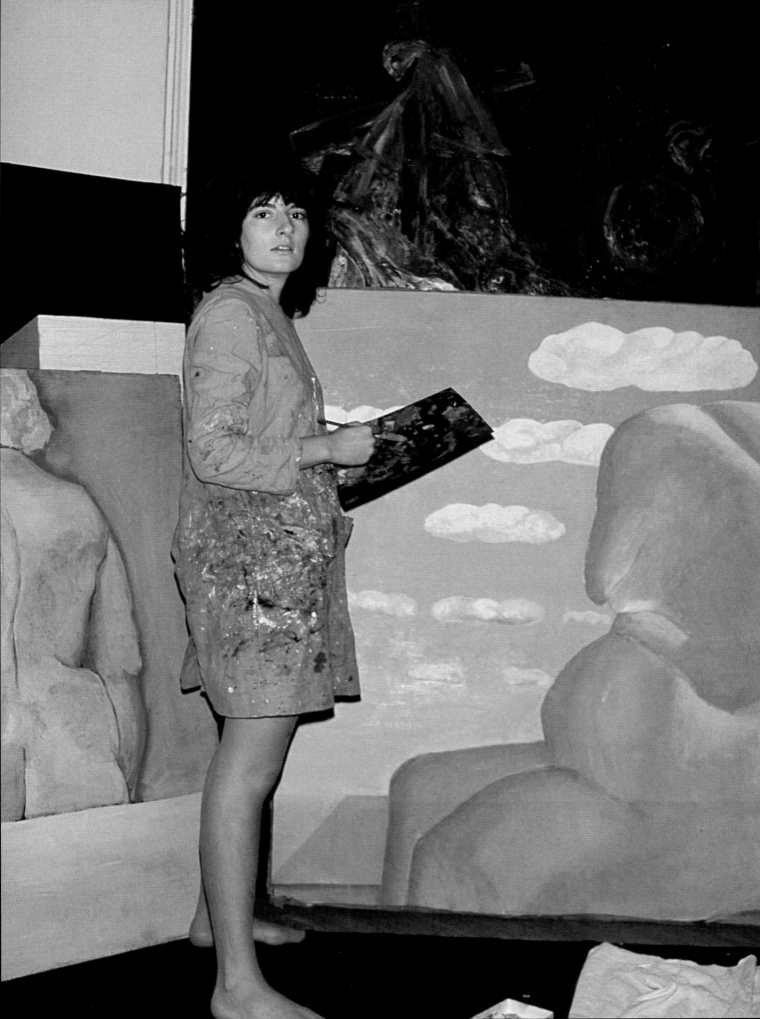

I know you will say I was looking at Réne Magritte. But I was also trying to do something conceptual. I painted the same model for years and only from the back. Her back was huge, and I regarded it as a landscape: mountains, rivers, grass fields.

I went deep into the flesh. On our last day working together, I asked my model to turn around for me. It's funny, there is so much more information in the body. For me, her face was totally empty.

r paintings?
ck from our relatives.
re all arranged on her
s, which sent me into
ould see them together
n an enormous 'Marina'.
ina '63', 'Marina '65'.
tory.

now?
took them. I have them
them – just like my old

love letters t
Ivana's eleme
was learning h
30s now.

Why do you sav
It's a problem
saved everyth
a napkin, she
attitude beca
maybe because
can eventuall

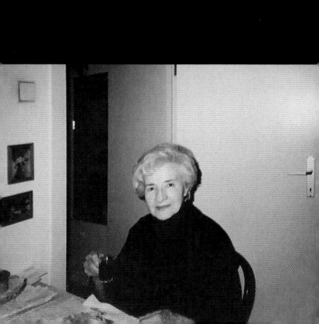

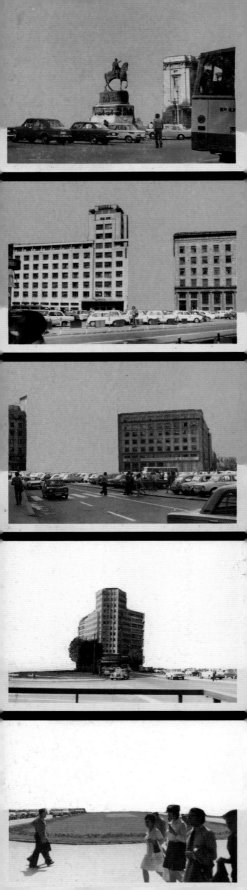

I AM SCARED AND MORE AND MORE I REALIZE IT IS IMPOSSIBLE TO RUN AWAY...

From the artist's personal journal, aged 18. 31 October 1965.

Did you ever believe in it? Communism?
I did. I was proud of my red scarf [worn by Young Pioneers]. I kept it next to my bed, perfectly folded, ironed, clean. My father once used my red scarf as a bandana to keep his hair up, and I was terrified. I thought that scarf was sacral, holy!

Your father became disenchanted with Tito?
I told you how many of his friends became political prisoners. It was almost him. But he never said anything to me. My father was the one who took me to Tito's speeches, to demonstrations and parades. I didn't know how he felt until much later. So, I became

Tito Eating the Caountry, 1967.

a member of the Communist Party, like my
mother and father. I was president of the
Communist Party of our art academy. I led
the demonstrations in 1968, when students
petitioned Tito for reforms, for freedom
of the press, higher minimum wage…

How does an embarrassed young girl become
her art school's Communist Party leader?
What happened to you?

I was infected by the [postwar] communal
enthusiasm. I was impressed that people would
volunteer to go build a highway or a railroad;
that a teacher would volunteer for months
of heavy labour. And then Tito. I didn't even
understand what he was saying as a child – and
he spoke with a heavy Croatian accent, by the
way – but it didn't matter, it was electrifying
how he connected with enormous crowds.

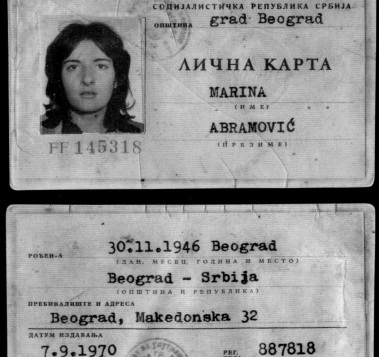

You weren't frightened?
It's interesting you say that because
I'm still attracted to places that have
thousands of people in them, half a million,
like a rock concert. When I gave a lecture
in Kaunas, Lithuania, in front of 6,000
people in a basketball stadium [2022] – it was
incredible, that energy. This was shortly
after Russia invaded Ukraine. I asked everyone
to close their eyes for seven minutes of total
silence and think of Ukraine and the people
of Ukraine with unconditional love.

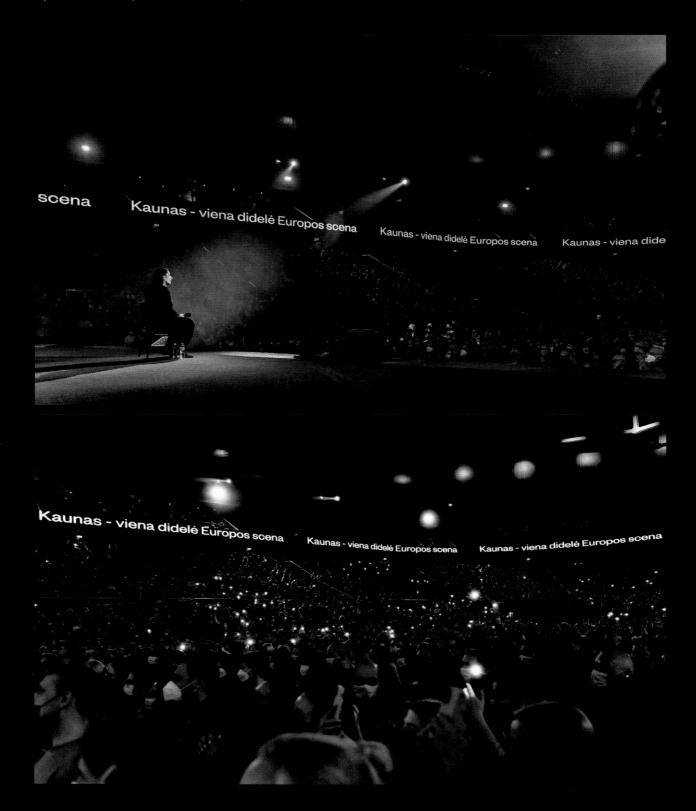

How does your 1968 demonstration end?
Tito announced he was going to give a speech.
Before he said a word, the other student Party
leaders started planning a celebration.
I said: 'But we don't know what he will say!'
and they looked at me like I'm an idiot, a 'true
believer'. I had actually thought I could
change something! They told me: 'Marina,
whatever he says, it's over.'

What did he say?
He raised the minimum wage and gave us students
a cultural centre.

Did you celebrate?
I went home and burned my Party membership
in a fire.

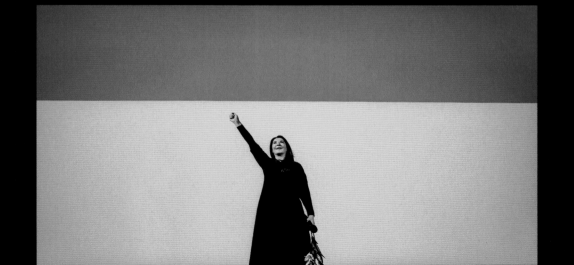

...m. that night?
...0 p.m. I had a hermetic
...ut it did include a little
...house. Can you imagine?
...ave your own studio.
...ole family in two rooms.

The man I married – Nesa...
mother and father all toget...
and a kitchen. He slept on c...
by a curtain. That's why, e...
married, I never spent one...
It was impossible.

How old were you when you married Neša?
Twenty-four, almost 25.

And your mother wouldn't allow him to live with you?
With my mother, the truth always caused a slap in my face. You know, my mother never found out I had a key to our apartment's back door?

I didn't use it for much. At night, my friends and I would go behind the theatre and take the old scenography backdrops they put outside. We would stretch huge canvases from them. This was my big secret from my mother. I was always trying to escape her. I married Neša just so I wouldn't have to come home at 10 p.m.

I MARRIED NEŠA JUST SO I WOULDN'T HAVE TO COME HOME AT 10 P.M.

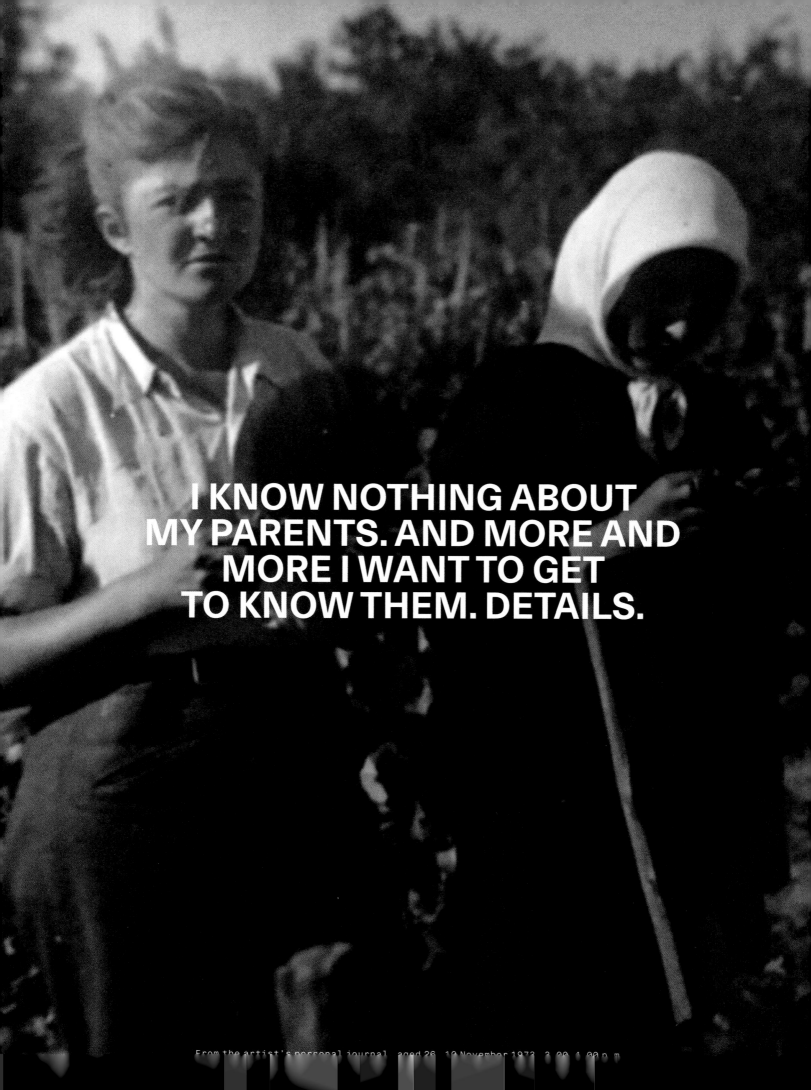

I KNOW NOTHING ABOUT
MY PARENTS. AND MORE AND
MORE I WANT TO GET
TO KNOW THEM. DETAILS.

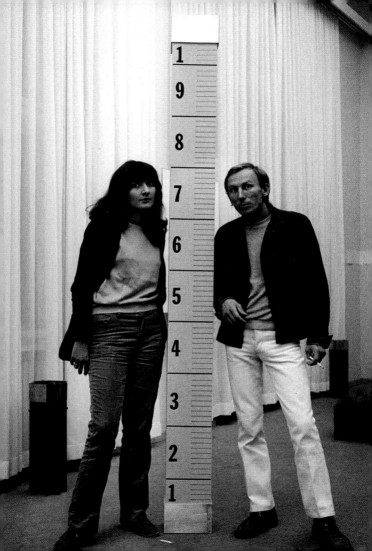

were part of a group of six artists
...ys and me, I was the only woman. After
...e Student Cultural Centre [SKC] from
...really came into our own. The SKC
...second home to us. I would spend all day
...scussing art, looking through books,
...riends.

All the guys were artists, and their
girlfriends were art historians. We wer...
capsule, isolated from the official gov...
art scene. The director of the Centre, D...
Blažević, was the Croatian culture mini...
daughter, and because of this, we had fr...
and protection. Nobody bothered us.

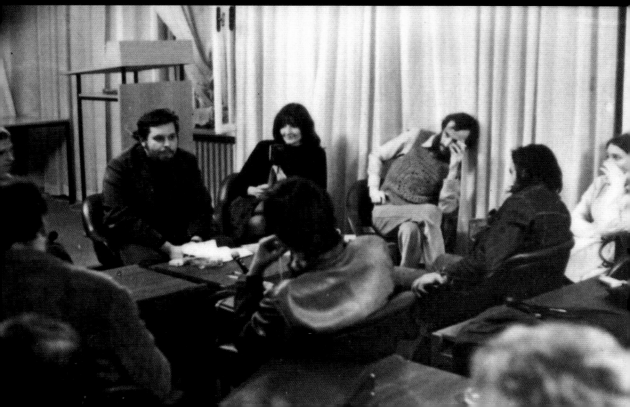

Dunja was the one who brought Joseph Beuys
to the Centre?
And not just Beuys. So many artists.
Jannis Kounellis, other Arte Povera people…
She was incredible.

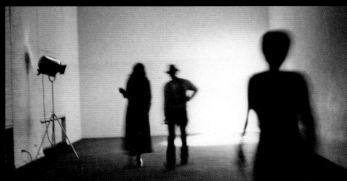

I HAVE TO TELL YOU A FUNNY STORY.

I have to tell you a funny story. When a French conceptual musician came to visit us in Yugoslavia, he wanted to stage a huge event, with 250 balloons, 22 pianos and 80 machine guns. Of course, we said 'yes' to everything, knowing very much that we only had one badly tuned piano and no balloons. We could definitely find machine guns, though. That was never a problem. So, the guy arrives. We show him all the machine guns. That's great.

we start convincing him that one piano is enough. And then a friend and I, we get a blank cheque from the Student Cultural Centre, go to the pharmacy and buy 250 condoms. The pharmacist came out with all these package and said, very seriously: 'Congratulations, students.' [Laughs.] Then we spent hours, all together, painting the condoms to look like balloons. I will never forget that.

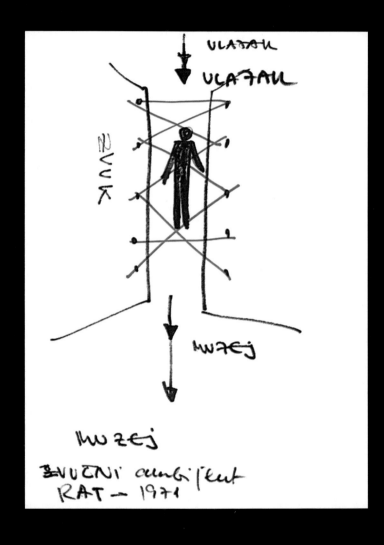

Sound Corridor (War), 1971. Sound installation (amplified sound of machine guns).

I come from a country where nothing ever worked.
Everything was impossible, but we always found
a way. The impossible was always possible. This
is the attitude I still have.

At this point you're still painting?
I'm still painting but also making sound

installations. This was very immaterial
work. Really, just sound. This was a country
where you had to ask three years in advance for
permission for a spontaneous demonstration.
You know this funny saying: one person is OK,
two people are a conversation, three people
is a demonstration.

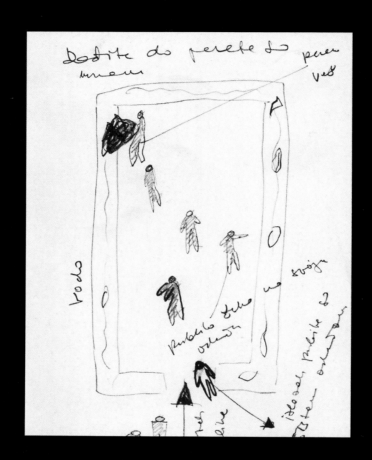

With my sound installations, there was always somebody I had to ask for permission – some government or bureaucratic body. And the answer, even before I asked, was 'no'.

These are some of your rejected art proposals?
Yes, in *Come Wash with Me* [left] I proposed to wash, dry and iron the public's clothes while they waited. In the untitled piece [below], I was going to change slowly into clothes my mother had picked out for me, followed by one round of Russian roulette.

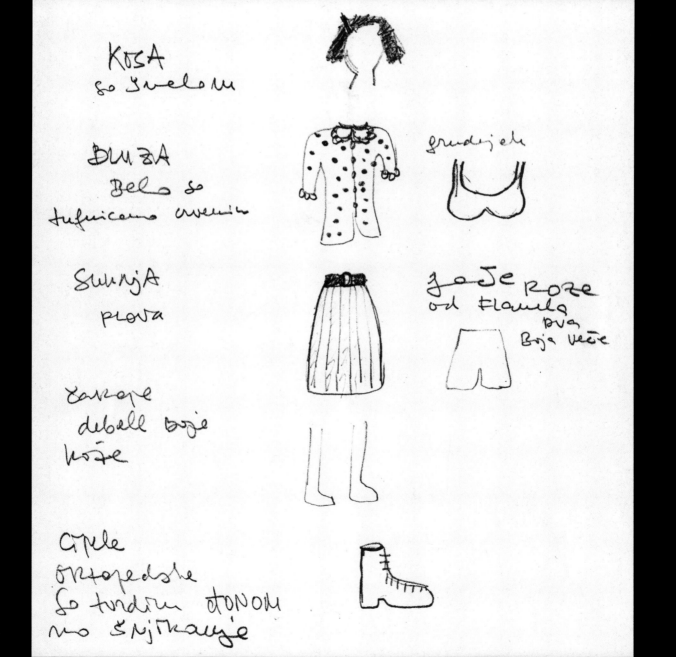

But you were quite protected at the Student
Cultural Centre.
It's true. We had our own system. But our
isolation meant that nobody from the larger
public went there or saw anything we were
doing. One thing I did, I placed a loudspeaker
in a common area of the SKC [left], announcing
international flight departures. Of course,
most of us had never been outside the country.

You know, we were one of the only families in
Belgrade to even have a washing machine. I was
so fascinated, I accidentally got my hand stuck
in the automatic wringer. My grandmother didn't
know how to stop the machine and got a strong man
off the street to help. He pulled the wringer
apart and got an electric shock. My mother came
home, called an ambulance for both of us and
slapped me in the face. Much later, when I found
a similar washer at a garage sale in upstate
New York, I had to buy it [below]. I coated the
wringer in gold leaf, for the hand I almost lost.

Warm memories…

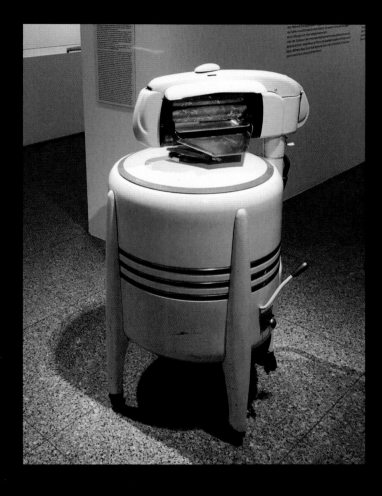

The Cleaner, ca. 1958, installation image from Bundeskunsthalle, Bonn, 2018.

I don't have any kind of nostalgia. I lost it a long time ago. But I remember waking up every morning, going to the academy, being there all day, the snow outside. Walking with friends down the main boulevard and talking. We would just talk. In the summers, I worked on restoring mosaics for basilicas, painted buildings and washed floors, got a little extra money for books that I loved. Those books were my inspiration then. I only had my inner world. It wasn't until I left Yugoslavia that life became my inspiration.

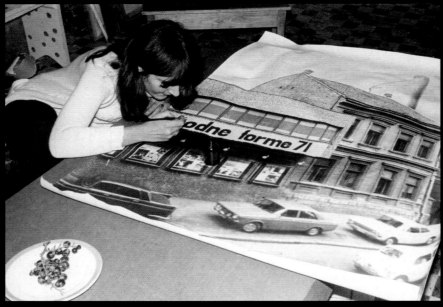

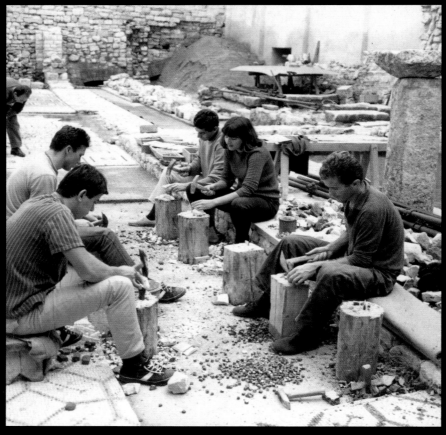

Opposite: Sick-looking tree outside the SKC with
amplified sound of tropical birds, to lighten the gloom.

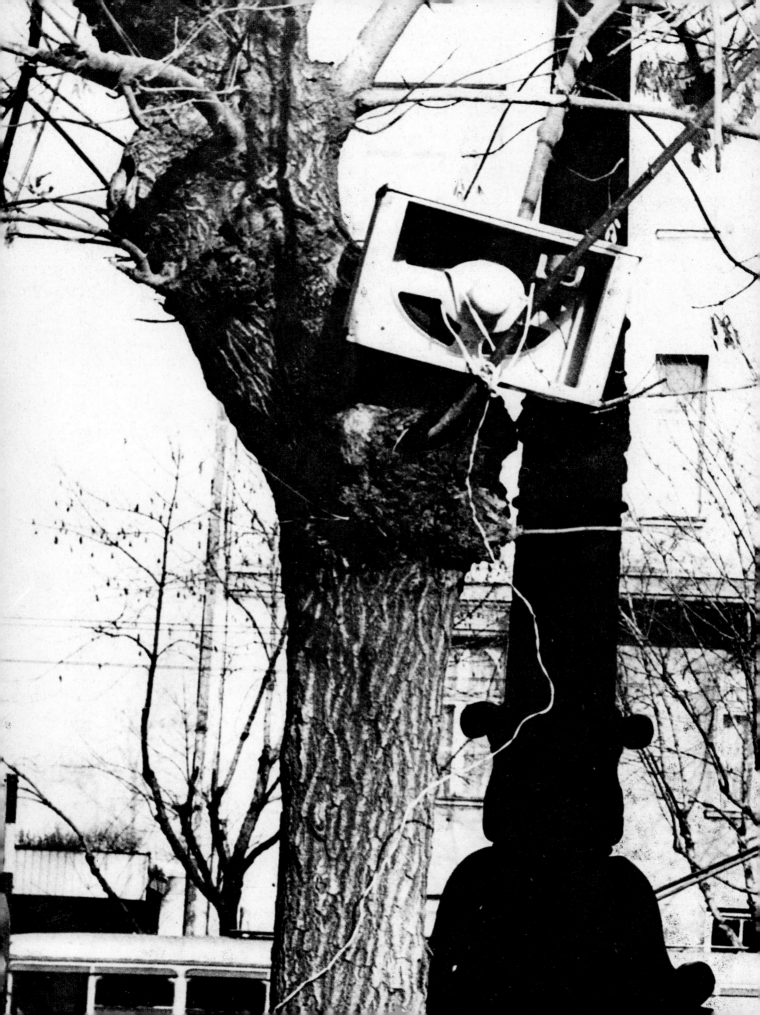

ART WAS A REAL EXIT FOR ME. FROM MY HOME LIFE. LATER, FROM MY COUNTRY.

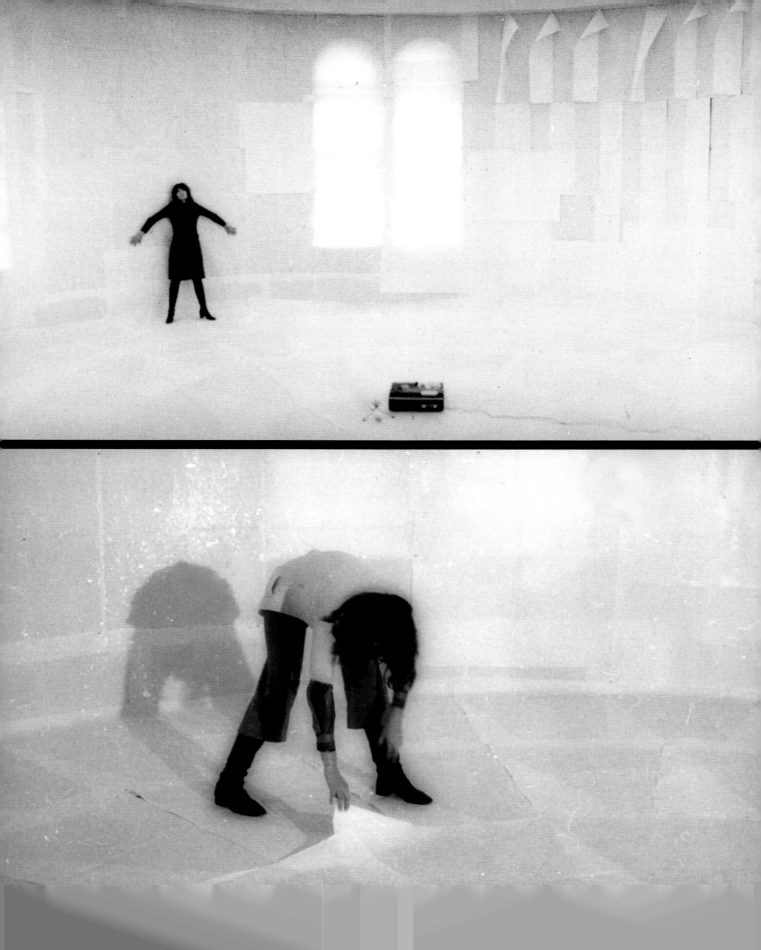

This is an installation with the sound of wind, birds, animals, footsteps… I instructed the public to walk, run, breathe and feel as if they are in a forest, then write their impressions on the wall. It's another project on the theme of escape.

Art was a real exit for me. From my home life. Later, from my country.

<u>Was there ever a moment you thought you would stay in Yugoslavia and be happy as an artist there?</u>
No. Never.

Above and opposite: *The Forest*, 1972.

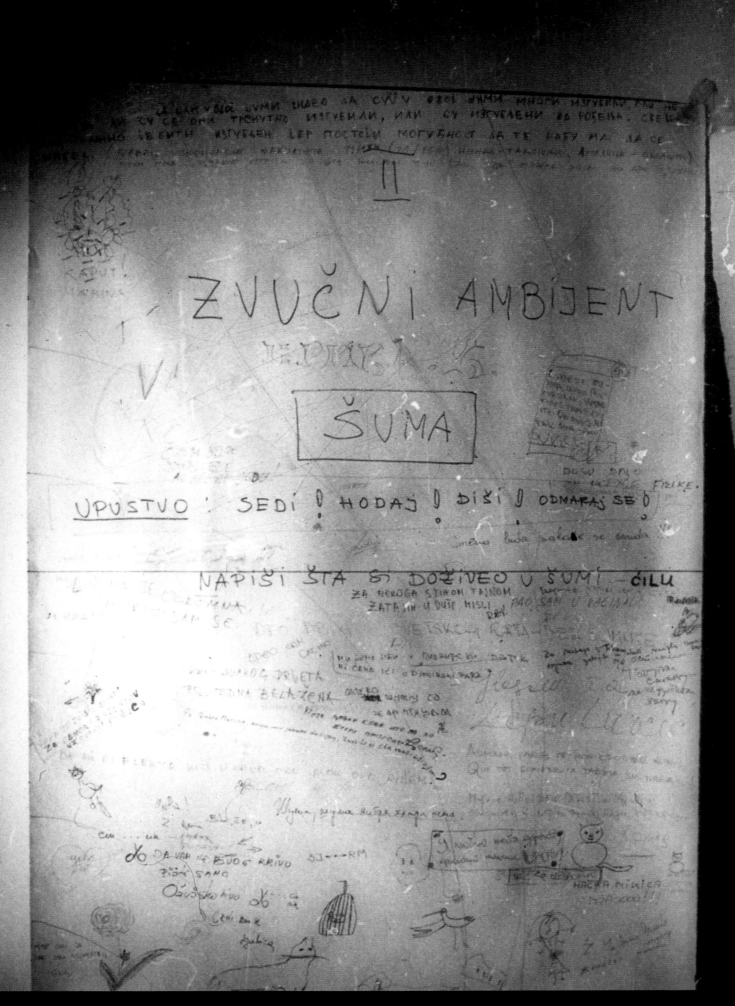

The moment my sound installation started to involve my own body, that was the moment I had to stop painting. I realized I had entered a different medium. That was performance. And once I understood that performance was what I had to do, every artwork I made became a scandal in my country. I remember my first performance, *Rhythm 10* [below], intensely. I knew I would never go back to the studio to paint. This would never happen. Because it's not my medium. I'm very lucky. A lot of artists go between different mediums because they never find exactly the right one. When you find the right one, you don't give it up easily.

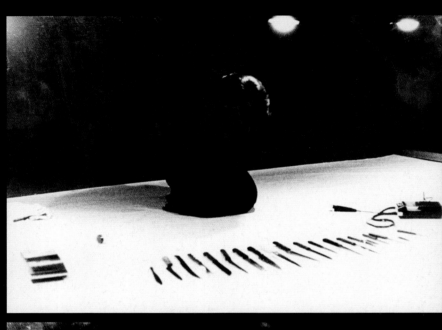

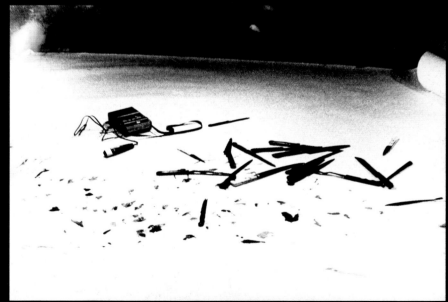

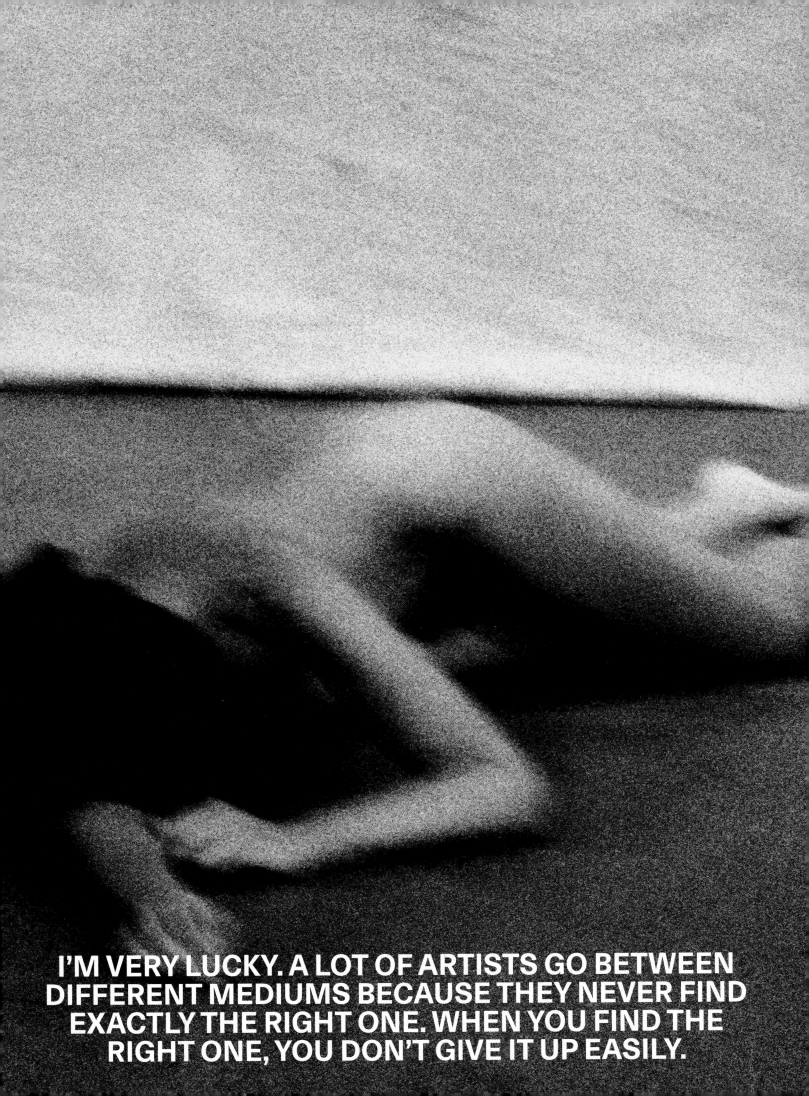

I'M VERY LUCKY. A LOT OF ARTISTS GO BETWEEN DIFFERENT MEDIUMS BECAUSE THEY NEVER FIND EXACTLY THE RIGHT ONE. WHEN YOU FIND THE RIGHT ONE, YOU DON'T GIVE IT UP EASILY.

03

CROSSING BORDERS / BOUNDARIES

ESCAPE
1974–1977

EXODUS, PAIN, PERFORMANCE

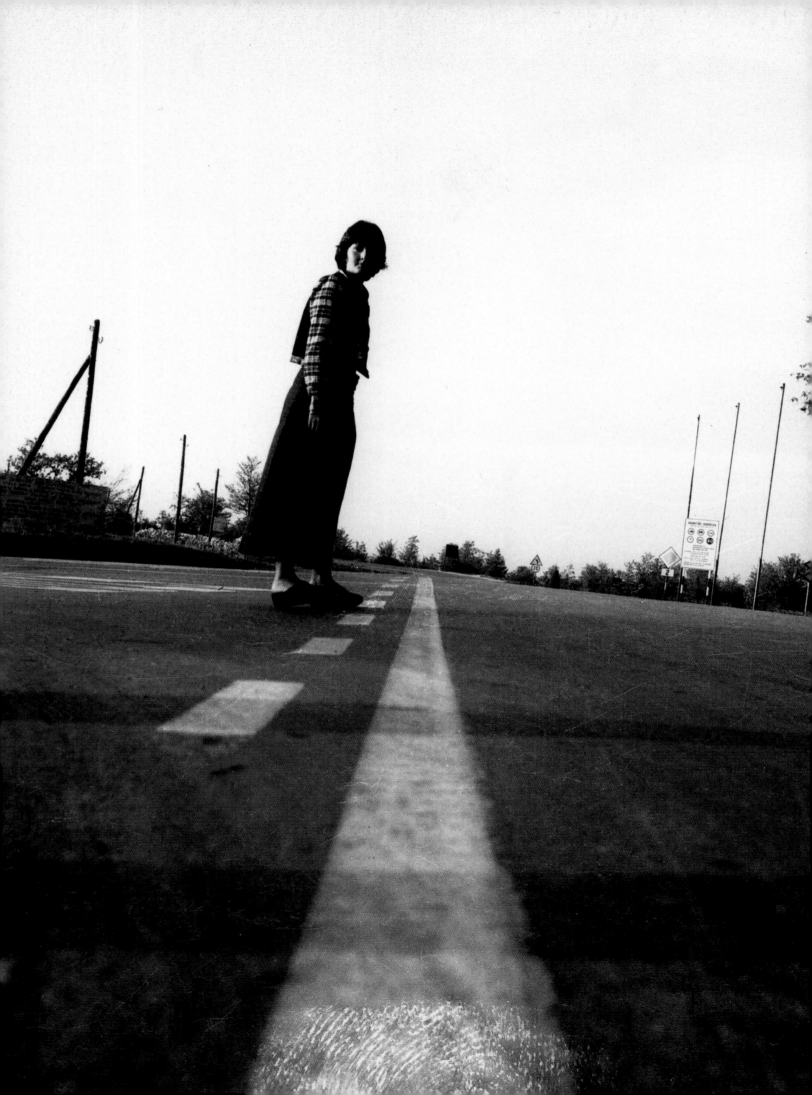

I didn't want a traditional marriage.
I didn't want children. I didn't want anything
binding me. My freedom is important to me.
Free. Free. Free.

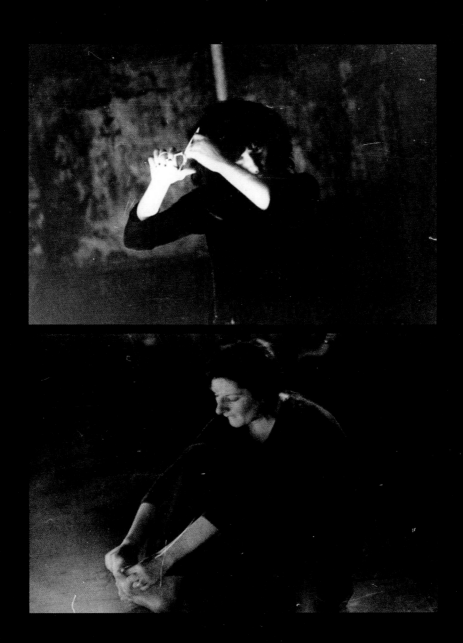

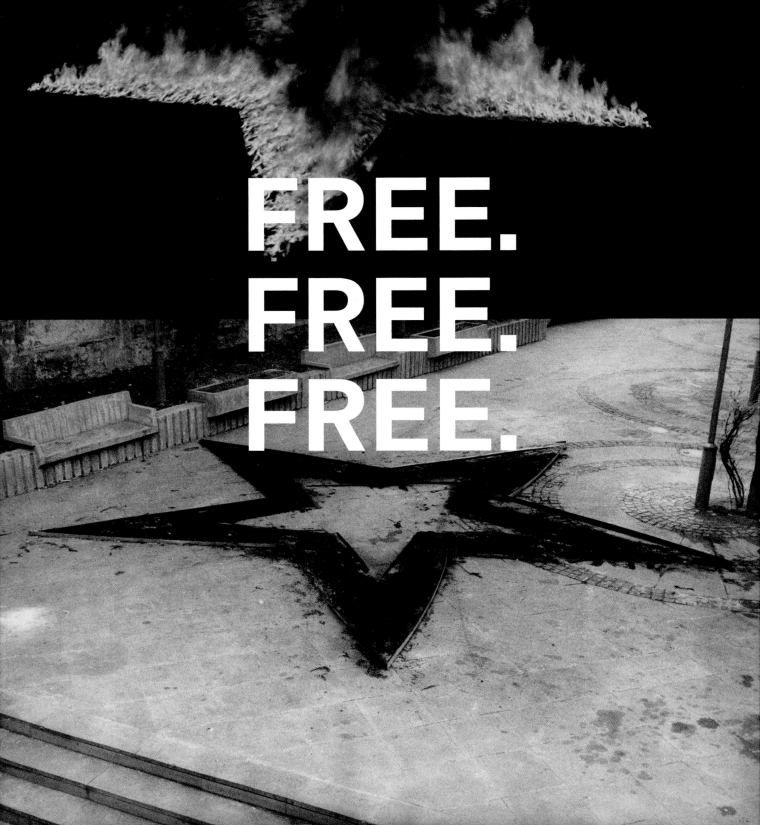

s?
two places you could go — Russia
or the rest of the world, you had to
it was really a question of *how can*
problem with money?

rogramme. She bought art for the
, so she travelled outside the
l the time. She brought me books and
from her trips to Paris. She took me
nice Biennale since I was 14. One of
od things between us [laughs].

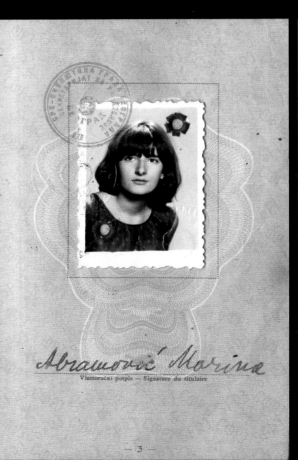

Abramović Marina

Vlastoručni potpis — Signature du titulaire

— 3 —

VIZE — VISAS
U. S. IMMIGRATION

004379

B-1
11 JUNE 1976
ONE
MARINA
ABRAMOVIC
GRATIS
" TO STUDY ART EXHIBITS "

— 37 —

My God, you must have been a window to the west for the other artists in your group.
Very few travelled, that's true. But you know this story, about Era [Milivojević] from our group. He told me that coming from a small

village in Serbia to Belgrade was enough for him. He didn't need London or wherever I was going. I know many talented people who suffer at home but are nostalgic as soon as they leave it. Endless regret.

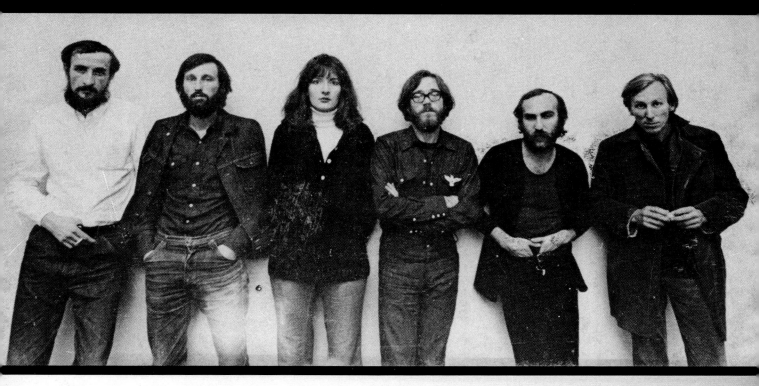

ot me. I was always the one most interested in
utting the rules. I wanted to establish a life
ithout any sentimentality for the past.

In 1972, [Scottish curator] Richard Demarco came to Yugoslavia looking for avant-garde artists. And you know what the Yugoslav government showed him? *Споменик Незнаном јунаку* [*Monument to the Unknown Hero*]! By chance, just as he was leaving, somebody told him about 'an interesting group of artists around the Student Cultural Centre'. That night, we were in his hotel room showing him our portfolios. When Demarco sent us an official invitation to perform at the 1973 Edinburgh Festival, the government said: 'NO. THESE PEOPLE CANNOT REPRESENT OUR COUNTRY.'

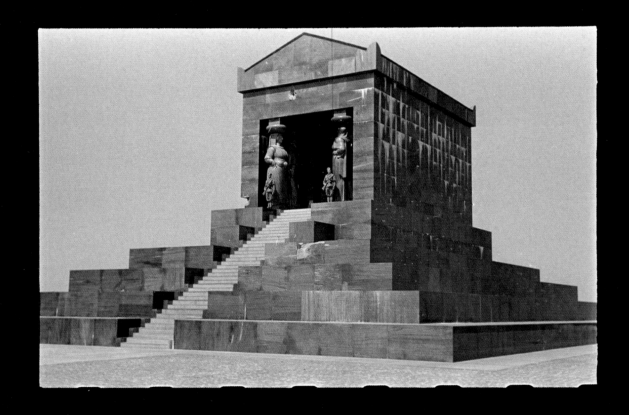

Monument to the Unknown Hero, Avala, Belgrade.

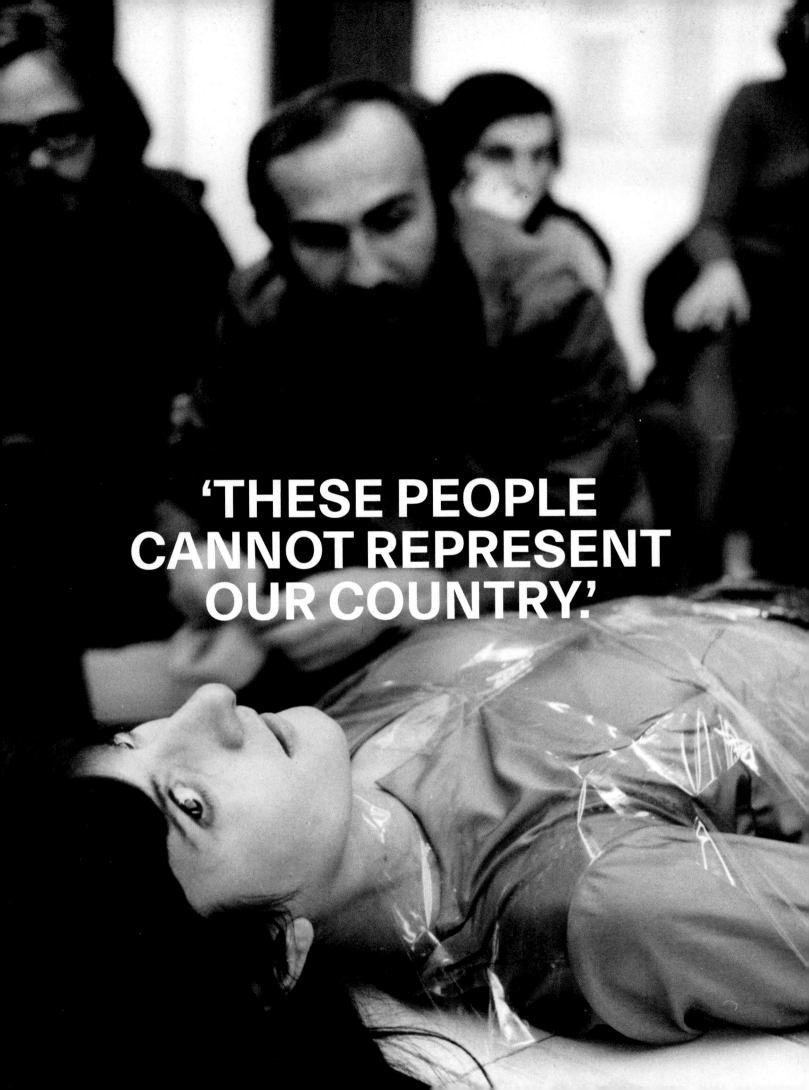

'THESE PEOPLE CANNOT REPRESENT OUR COUNTRY.'

So, he wrote to us personally: 'Find a way here, we will take care of the rest.' We all got to work and made enough money to go to Edinburgh. That was a really important trip for me.

Yes, and Beuys saw my performance that night. He really supported my work. Whenever there were festivals after that, he gave my name.

Above: Marina with Dunja Blažević and Joseph Beuys. Opposite: _Rhythm 10_, 1973.

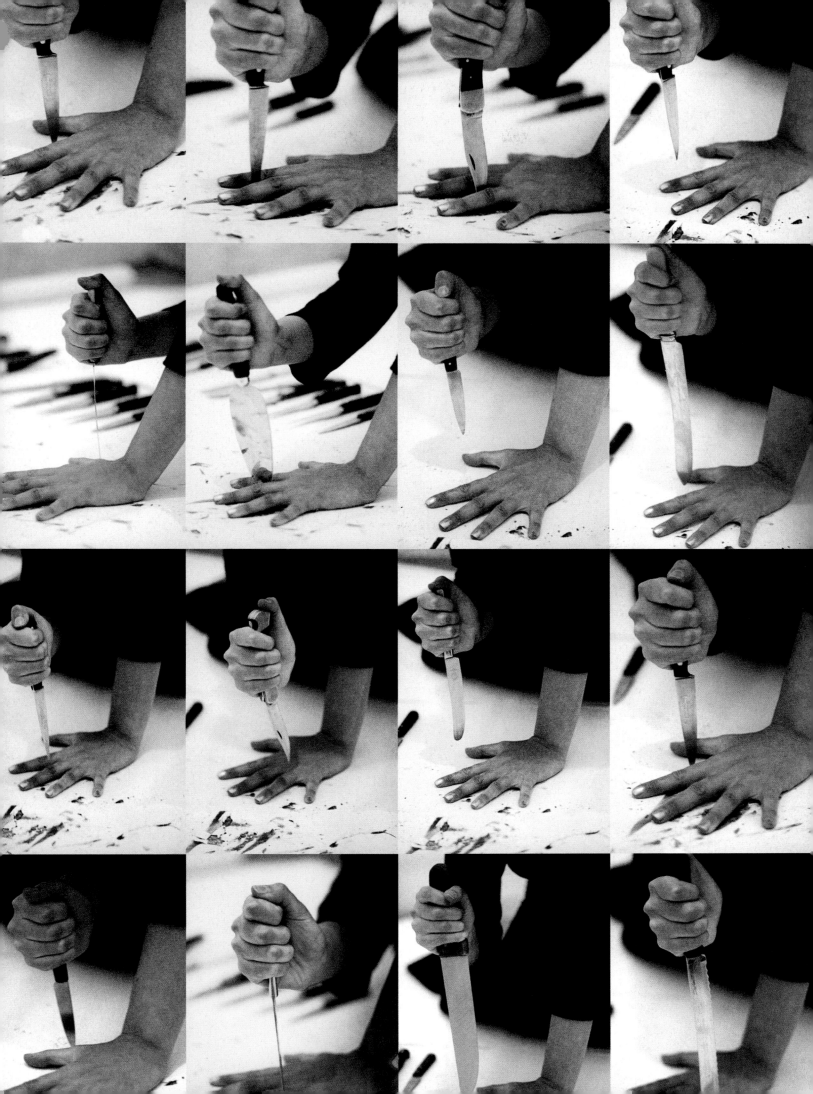

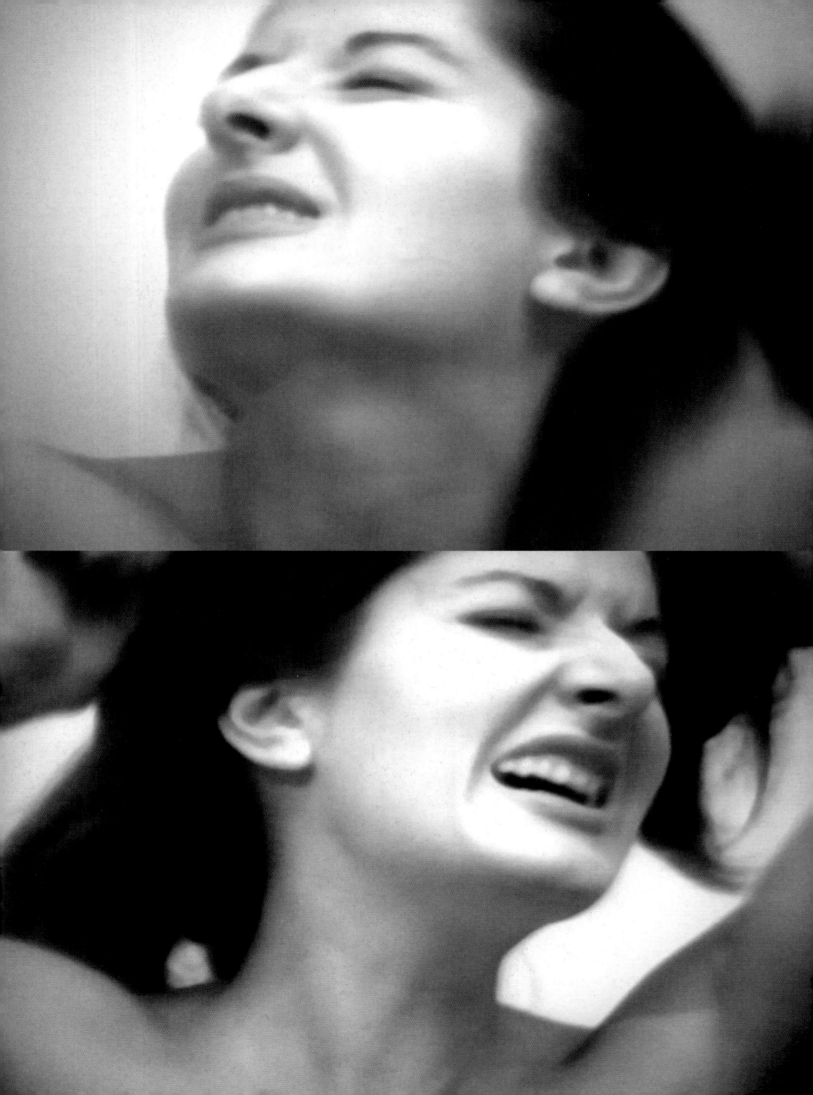

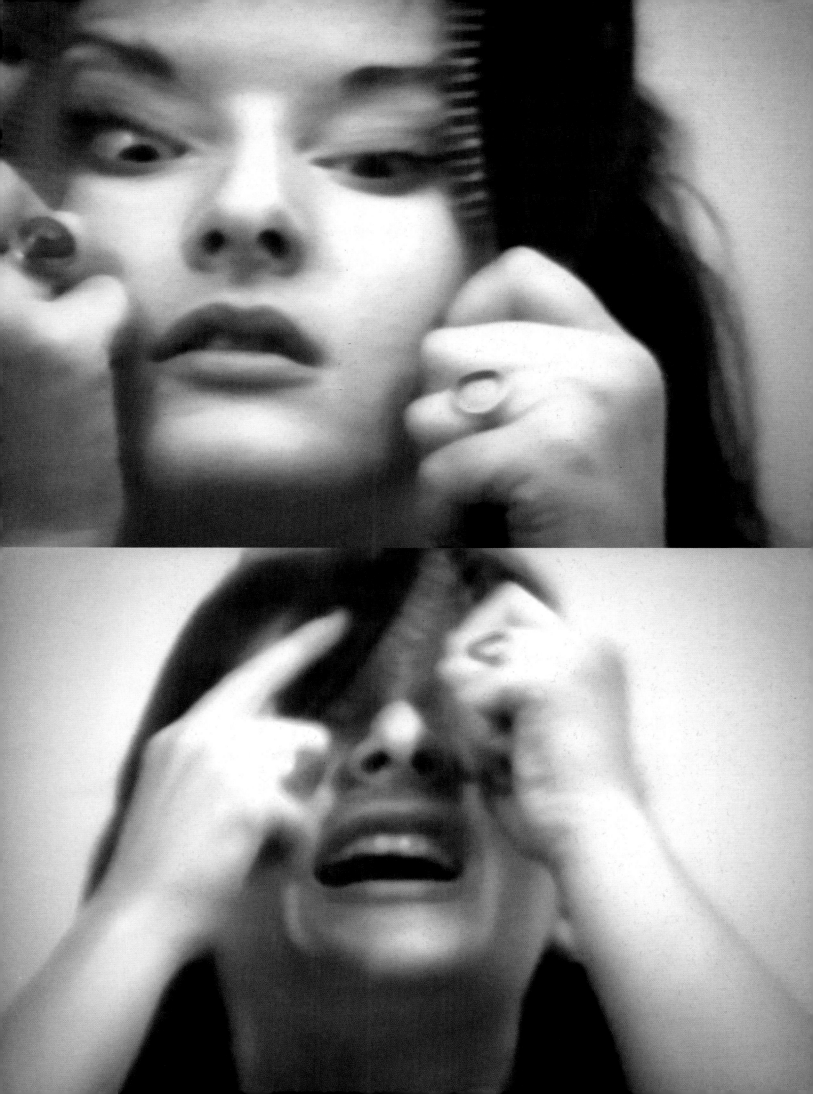

I started being invited around Europe,
which opened a lot of possibilities for me.
I stayed in London for a year, working
every job I could find: delivering mail,
painting floors, working in a toy factory,
decorating a restaurant, creating
a French menu. I didn't want to go back
to Yugoslavia.

Wow, my mother. I had made excellent marks
in university. She couldn't understand why

I was being so stupid! So, she applied for
a teaching job for me at an art academy outside
Belgrade. Without asking me.

<u>She was worried?</u>
Oh, definitely. Her big dream was for me
to marry a lawyer, doctor or an architect.
A professional who would take care of me.
You know, this idea of normality, which
I could never apply to. But I did go to the
academy interview, and I got the job.

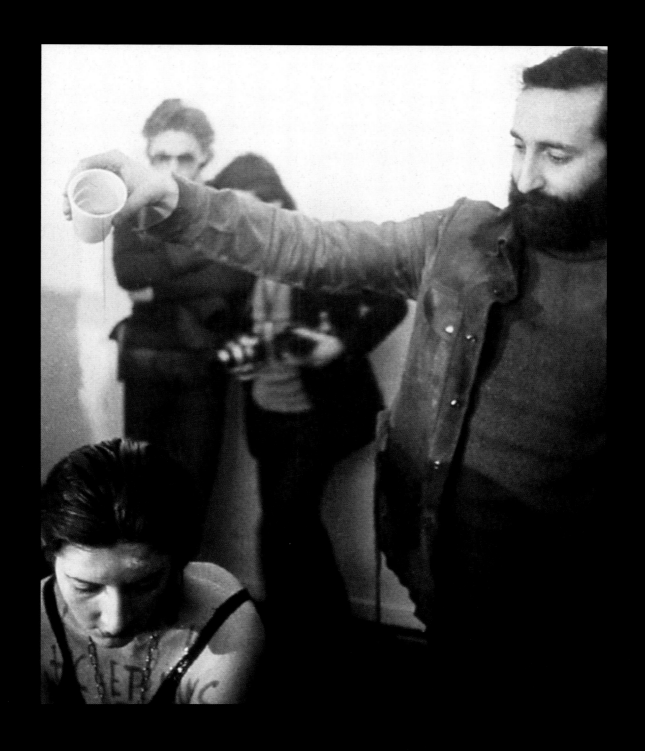

Rhythm 0, 1974, Naples.

LIST OF OBJECTS ON THE TABLE:

GUN
BULLET
BLUE PAINT
COMB
BELL
WHIP
LIPSTICK
POCKET KNIFE
FORK
PERFUME
SPOON
COTTON
FLOWERS
MATCHES
ROSE
CANDLE
WATER
SCARF
MIRROR
DRINKING GLASS
POLAROID CAMERA
FEATHER
CHAINS
NAILS
NEEDLE
SAFETY PIN
HAIR PIN
BRUSH
BANDAGE
RED PAINT
WHITE PAINT
SCISSORS
PEN
BOOK
HAT
HANDKERCHIEF
SHEET OF WHITE PAPER
KITCHEN KNIFE
HAMMER
SAW
PIECE OF WOOD
AXE
STICK
BONE OF LAMB
NEWSPAPER
BREAD
WINE
HONEY
SALT
SOAP
CAKE
METAL PIPE
SCALPEL
METAL SPEAR
BELL
DISH
FLUTE
BAND-AID
ALCOHOL
MEDAL
COAT
SHOES
CHAIR
LEATHER STRINGS
YARN
WIRE
SULPHUR
GRAPES
OLIVE OIL
ROSEMARY BRANCH
APPLE
SUGAR

Rhythm 0, 1974, Naples. The artist is also an object.
The audience can do with her whatever they want.

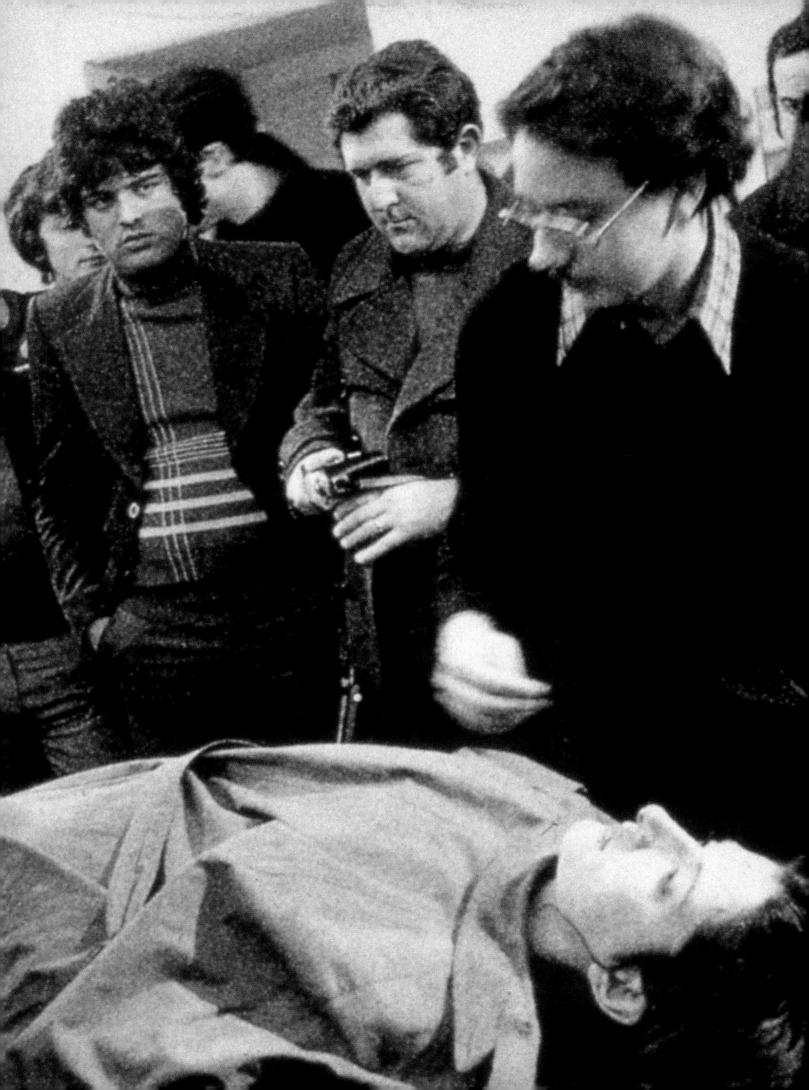

I was back to living at home with my mother. But now I had money to travel. I taught once a week and left all the time. Every short trip resulted in a new work somewhere.

This is not my work [below]. It is a piece by Hermann Nitsch. He asked me to participate but after 12 hours, I stopped. I felt it was not my thing and didn't want to put my energy into it.

<u>Was he angry that you stopped?</u>
No. He was not.

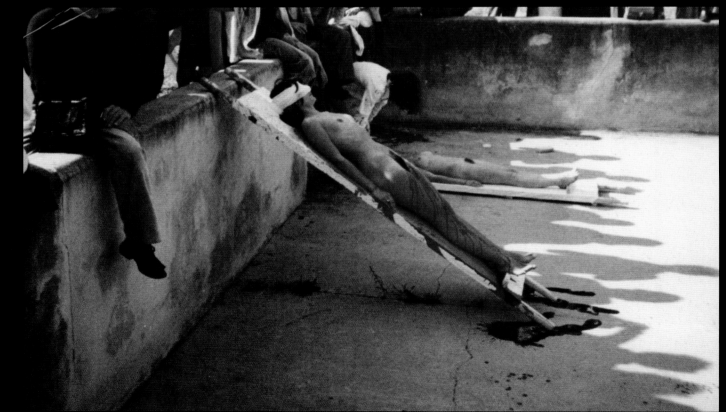

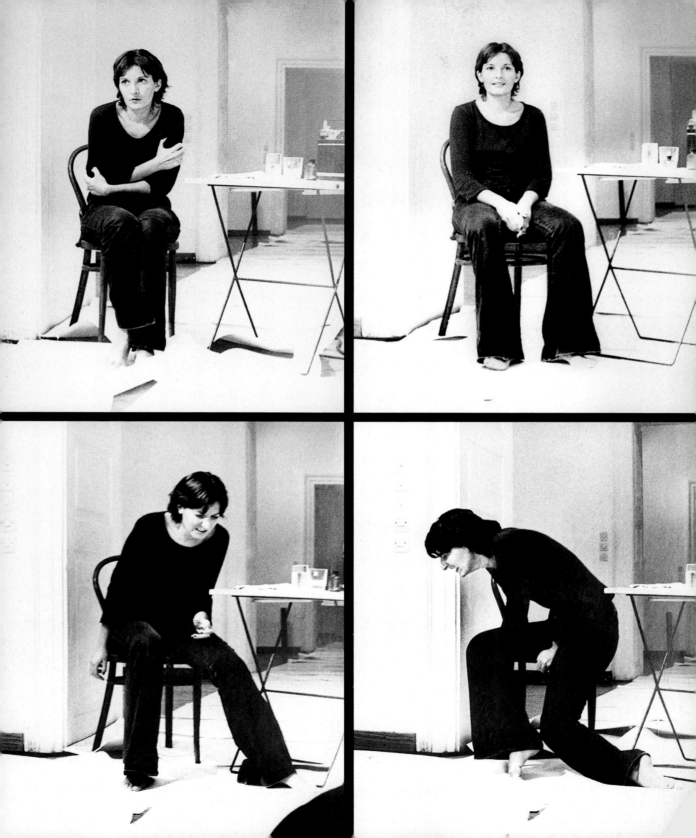

My father? I saw him kissing a woman in the street and he pretended not to know me. We didn't talk to each other for years. It was horrible. I loved my father.

What did you teach at the art academy?
My main topic was: *get the hell out of here*

provincial town. Their world was narrow and mediocre. I showed them material and artists they would never have seen. I showed them the outside world and told them to leave.

Why was it so important for you to say leave?
Because nobody had ever said it to me.

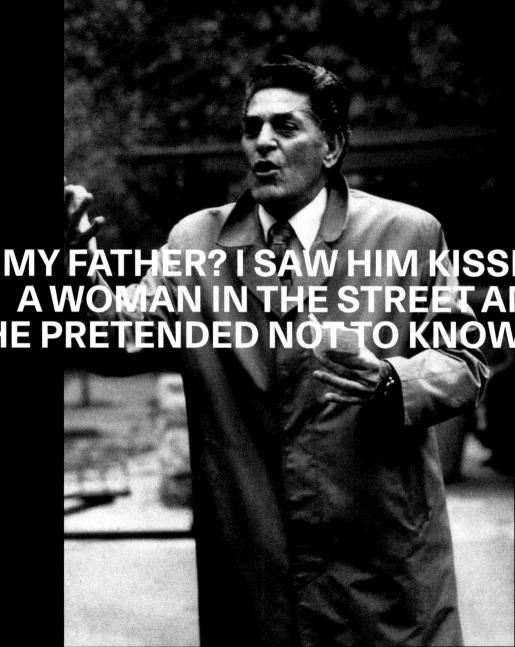

The problem came when an Italian magazine put me on the cover of their magazine completely naked, for *Rhythm 4*. Friends told me the school was going to ask me to leave, so I resigned. I didn't let them fire me.

<u>What took them so long?! You had already done *Rhythm 5*, *Rhythm 10*, *Rhythm 2*…</u>
That's so true [laughs]. And the local criticism I was getting at that period was jus terrible! Some of my best work received awful criticism at first. Now I know bad press can mean I'm just doing something people aren't used to. They need time.

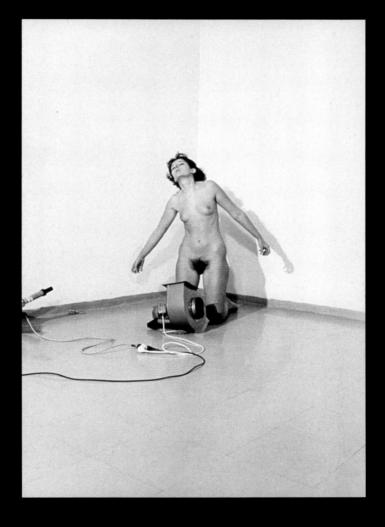

Above: *Rhythm 4*, 1974, Milan. Opposite: *Rhythm 0*, 1974, Naples.

But I didn't compromise. Never in my life.
I never made work to please others.

What happened after you resigned from your
teaching position?
The beginning of a new freedom. I was still
in my mother's apartment, but I made my own
huge wooden postbox and put it there. I wrote
to galleries all over the world.

Above: Postbox recreated by Alexei Tylevich at the artist's request.
Opposite: *Lips of Thomas (Star on Stomach)*, 1975, Innsbruck.

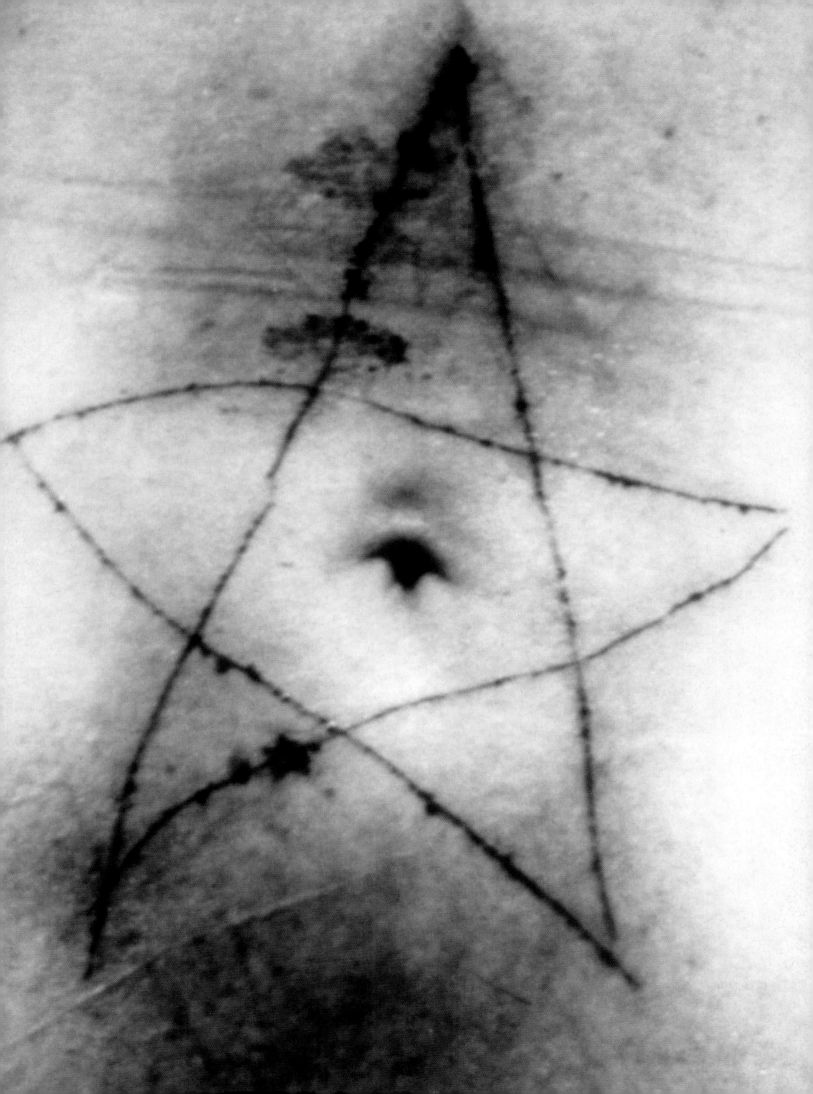

Do you still have the 1975 letter from
De Appel gallery inviting you to perform
Thomas Lips in Amsterdam?
I don't think so. That's funny because I save
all my letters. I don't open or read them.
I just want to have them.

Are you superstitious?
Totally.

Do you try to fight your superstition?
No. I take it as a fact of life.

That reminds me of how you work.
How?

You don't question the rules you invent.
They can't be questioned. They must be
followed, or you lose consciousness,
or you die.

'THE PERFORMANCE SHE DID AT DE APPEL WAS THE MOST RADICAL I HAD EVER SEEN... PEOPLE ASKED HER WHY SHE ATE ALL THAT HONEY. MARINA THEN SAID, "BECAUSE I HATE HONEY." I WANTED TO PROTECT HER AGAINST THE PATHETIC QUESTIONS OF THE AUDIENCE.'

Ulay, about his first meetings with Marina. Interview with Gijs van Tull,
Vrij Nederland, 19 April 1980. Translated from the Dutch by Sarah-Mae Lieverse.

You are still married to Neša when you meet Ulay.
I am. Neša is too nervous to come to any of my shows.

Nervous to see you hurt yourself?
Exactly. It seems I'm too much for everybody. And he didn't want to go – to leave somewhere, I mean. That was a problem.

Neša's best work came after I left him. He made a Super 8 film of himself jumping from roof to roof in Belgrade. Beautiful. He really was talented. It was nothing, back then, to get a divorce. You just signed a piece of paper. He didn't come for the opening of my retrospective when I came to Belgrade [in January 2020].

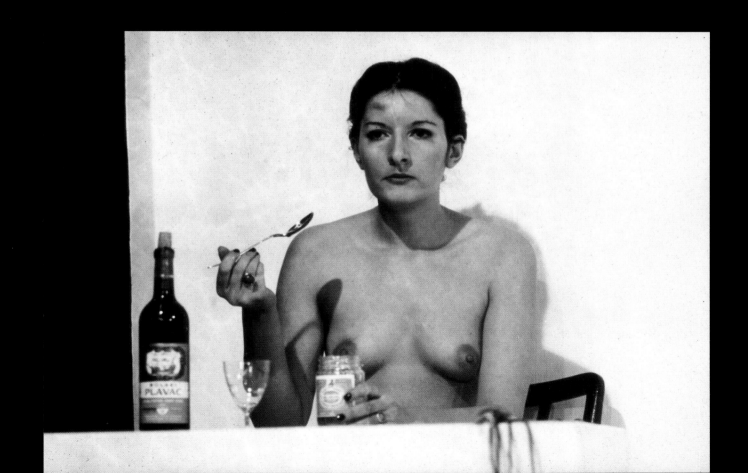

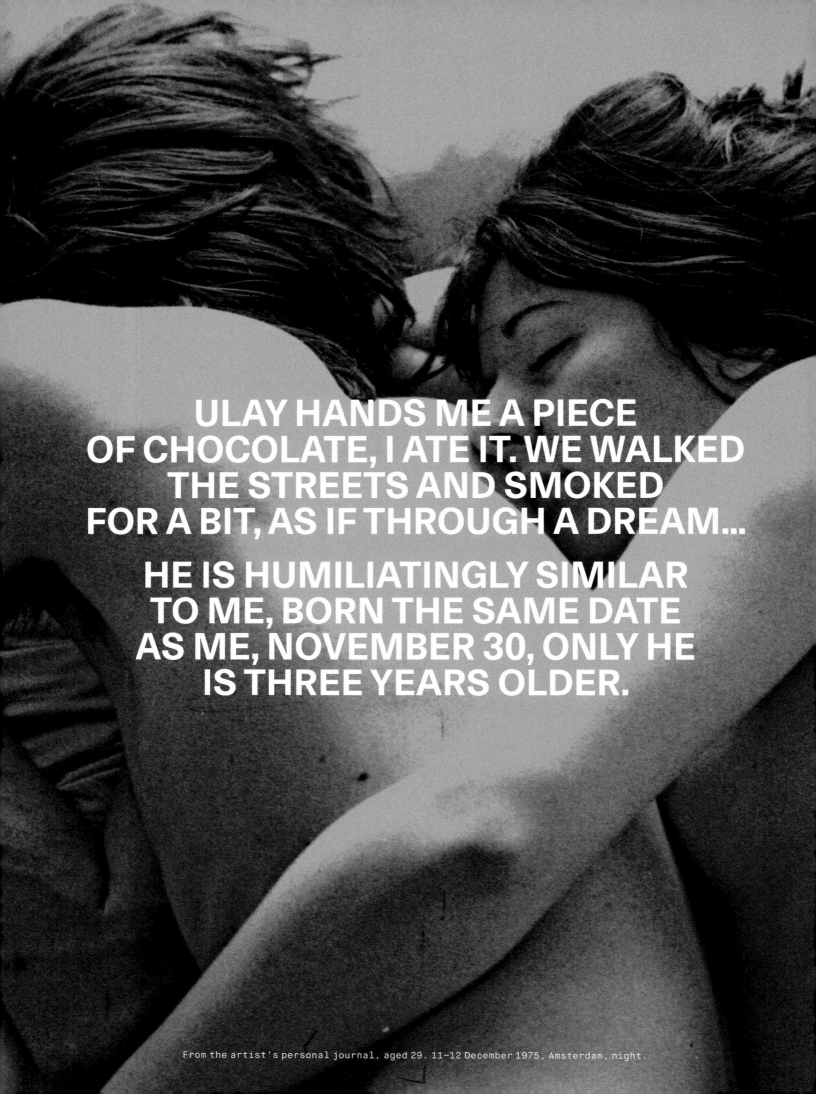

ULAY HANDS ME A PIECE OF CHOCOLATE, I ATE IT. WE WALKED THE STREETS AND SMOKED FOR A BIT, AS IF THROUGH A DREAM...

HE IS HUMILIATINGLY SIMILAR TO ME, BORN THE SAME DATE AS ME, NOVEMBER 30, ONLY HE IS THREE YEARS OLDER.

From the artist's personal journal, aged 29. 11–12 December 1975, Amsterdam, night.

BY AIR MAIL
PAR AVION

MARINA ABRAMOVIĆ
32 MAKEDONSKA

YU-11000 BEOGRAD

JOEGOSLAWIË

LILAY-HICLEYNDERTWEG 791
AMSTERDAM-NOORD
HOLLAND

th Ulay
only took my
This is just
ack to Mama.'
e life in
able life
back.

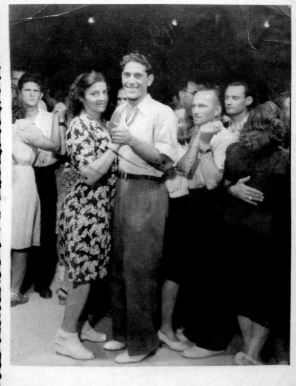

CERVENICA foto Ivančić

IK BEN
MARINA ABRAMOVIĆ!

I CAME TO AMSTERDAM TO BE FREE!

MY WORK IS UNDERSTOOD HERE!

...o load, the guys looked at me like I m
This is all the Dutch I know,' I said.
e me Dutch citizenship for the effort.

...od, it was a liberation, that passport
wonderful. When I travelled, I no longe
a letter stating I wasn't a Communist.

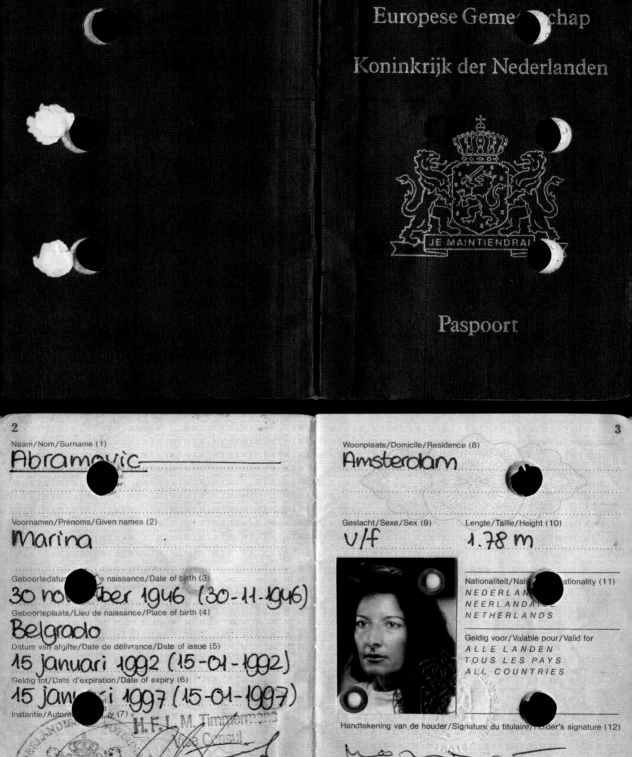

My biggest problem in Amsterdam was that I didn't have any restrictions anymore. I didn't know how to be free. The first piece I made there was exchanging roles with a prostitute. She replaced me at a gallery opening and I replaced her in the red-light district. It was the most forbidden thing I could think of! I went through her pimp and split my gallery money with her. I had asked for six hours of her time, and she agreed to three. 'I'm not Mother Teresa,' she told me. That was great [laughs]. Later, she would invite me for coffee on her slow days. She called herself a social worker – said most men just wanted to talk, anyway. She could totally separate her emotions from her body. This fascinated me. I couldn't do it. Not Mother Teresa [still laughing]. Can you imagine my mother?

COMMUNIST BODY
FASCIST BODY

Amsterdam
1979

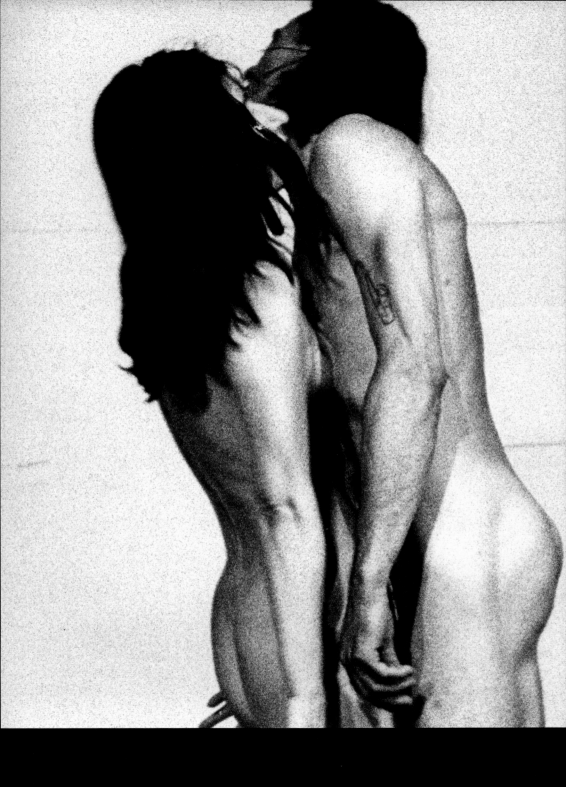

Relation in Space, 1976.

Did you eventually make peace with freedom?
No, I needed restrictions. I became the
restriction. I started imposing strict
boundaries on myself within the conditions
of the work.

When you and Ulay started working together,
were you nervous about sharing control of your
art? Are two artists together too much?

No! Never. I thought two was much better than
one. Two ideas together instead of one. We were
'That Self', the energy of us together. Only
our last three years did things stop working.
I was so deeply ashamed. I said nothing. It was
a huge defeat. I hate defeats. But we were
twelve years together. In our good time, we
called each other 'Glue', we were so close.
Like one body.

Light/Dark, 1978.

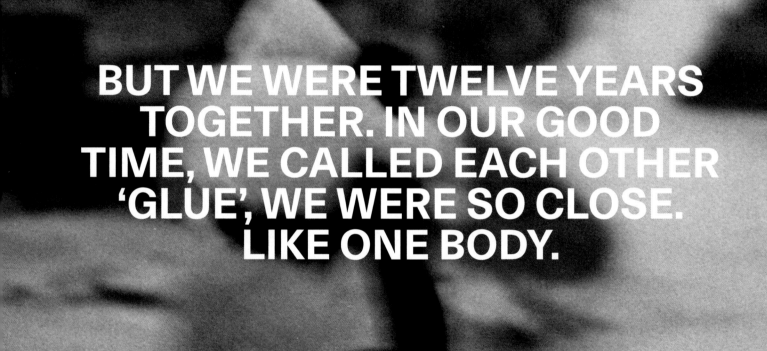

BUT WE WERE TWELVE YEARS TOGETHER. IN OUR GOOD TIME, WE CALLED EACH OTHER 'GLUE', WE WERE SO CLOSE. LIKE ONE BODY.

04

FOUR YEARS
NO ADDRESS

THE CITROËN VAN
1976–1980

ART IS LIFE, LIFE IS ART

Is this chapter going to be hard for you?
No, it's easier to talk about Ulay now. We made peace before he died. I'm telling you, old age gives you this. It's hard to forgive when you're young. My first six months in Amsterdam were terrible. Ulay would wake up in the morning and brush his teeth with Courvoisier [laughs]. All day, we would go from one bar to another, drinking and talking. It was the '70s in Amsterdam. I felt like I was wasting time, and this was an impossible idea to adopt.

to work with me. We did *Relation in Space*, which was a big breakthrough for him. Then we moved into the van and everything became perfection. Ulay stopped drinking. Life became meaningful. Work, life and love became one thing. We drove from performance to performance. We had total symbiosis.

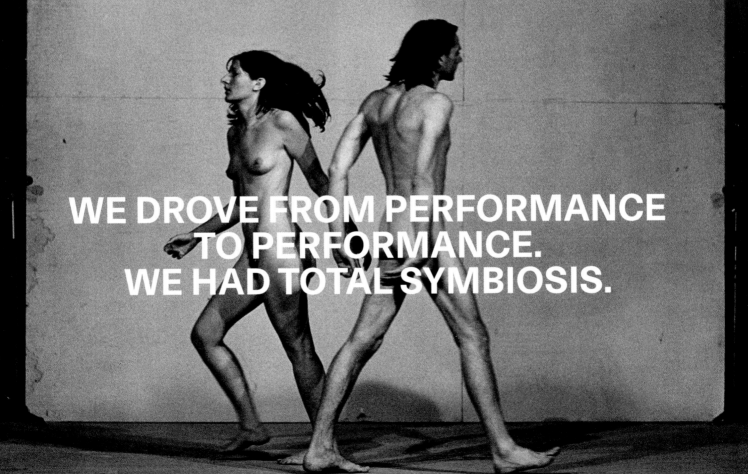

WE DROVE FROM PERFORMANCE TO PERFORMANCE. WE HAD TOTAL SYMBIOSIS.

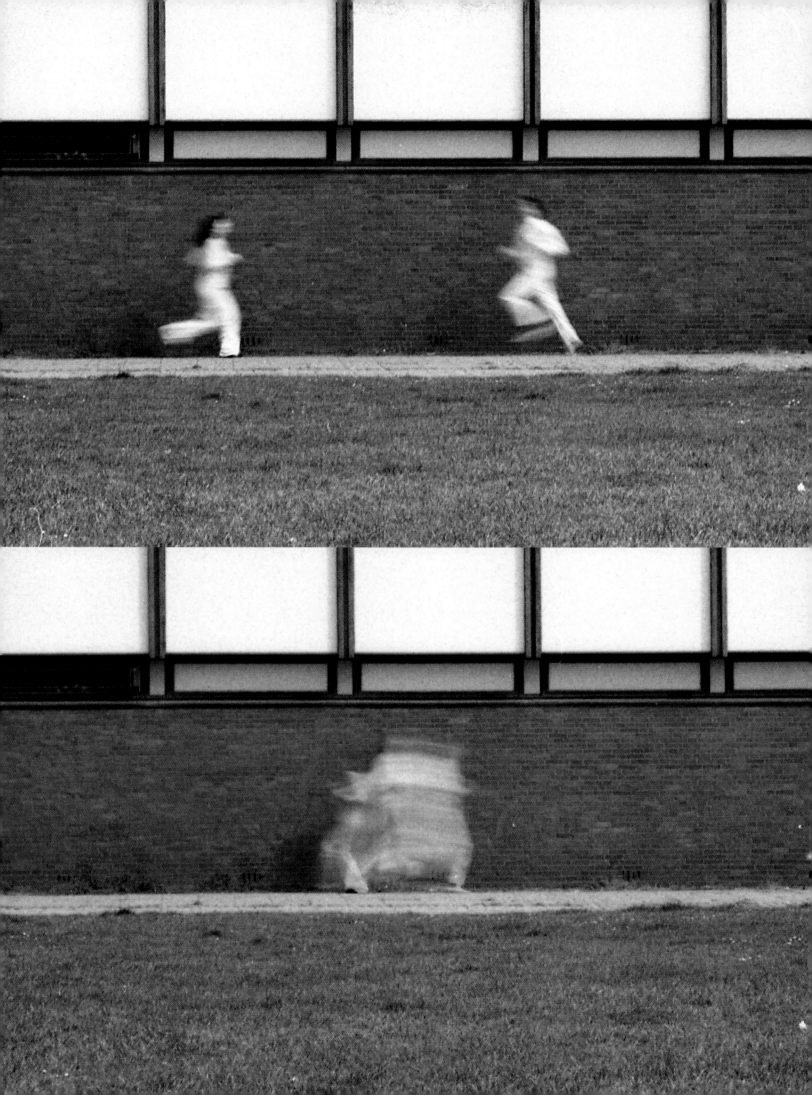

ART VITAL

NO FIXED LIVING PLACE
PERMANENT MOVEMENT
DIRECT CONTACT
LOCAL RELATION
SELF-SELECTION
PASSING LIMITATIONS
TAKING RISKS
MOBILE ENERGY
NO REHEARSAL
NO PREDICTED END
NO REPETITION
EXTENDED VULNERABILITY
EXPOSURE TO CHANCE
PRIMARY REACTIONS

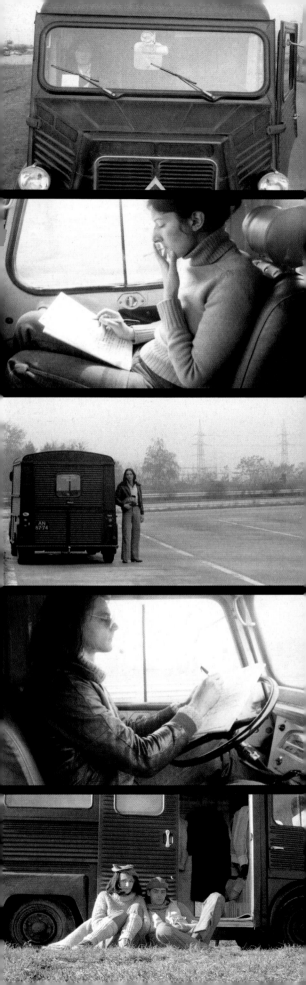

1976
VENICE
GENEVA
ISTRIA
CROATIA
TUBINGEN
GERMANY
ZAGREB
KOSOVO

1977

BELGRADE
BOLOGNA
COLOGNE
DUSSELDORF
FERRARA
ISTRIA
MILANO
AMSTERDAM
APRICA
GROZNJAN

ZAGREB
KASSEL
PARIS
PREMANTURA

1978

AMSTERDAM
SWITZERLAND
APRICA
BITTI SARDEGNA
ISTRIA
CROATIA
ORGOSOLO SARDINIA
USA

1979–1980

ZOUTKEETSGRACHT
TASMANIA
THAILAND
INDIA

We divided our lives very 'male and female'. Ulay always drove. He wrote all the grants on his typewriter, sent the letters, got us money. And I cooked all the meals, washed our laundry, took care of our dog.

<u>Were you happy with this division?</u>
Very happy. Now I have to do everything myself [laughs]. But in our work together, there was no division. We were one body. The idea for every performance was simple: whoever ran out of energy first would stop. We never knew exactly what would happen. We called it 'unpredictable end'. Sometimes he would stop, and I would continue. Sometimes I would stop, and he would continue. This time [right] I left first and the mirror fell but did not break. It was incredible.

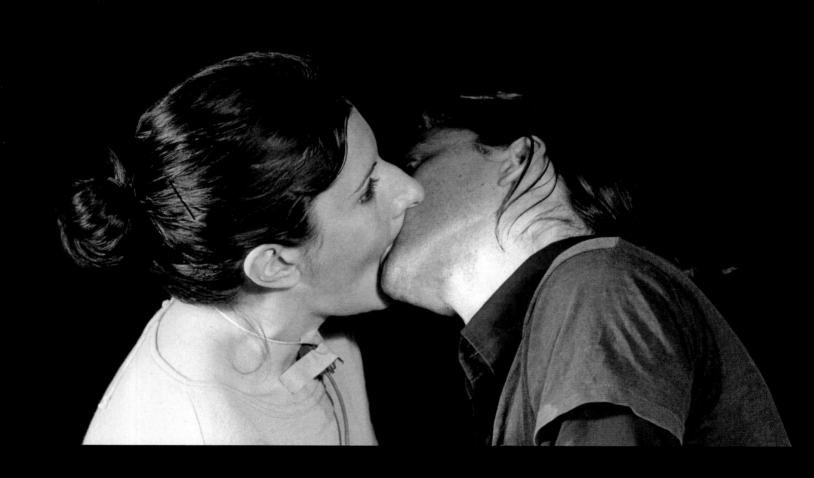

Above: *Breathing In/Breathing Out*, 1977, Belgrade.
Opposite: *Balance Proof*, 1978, Geneva.

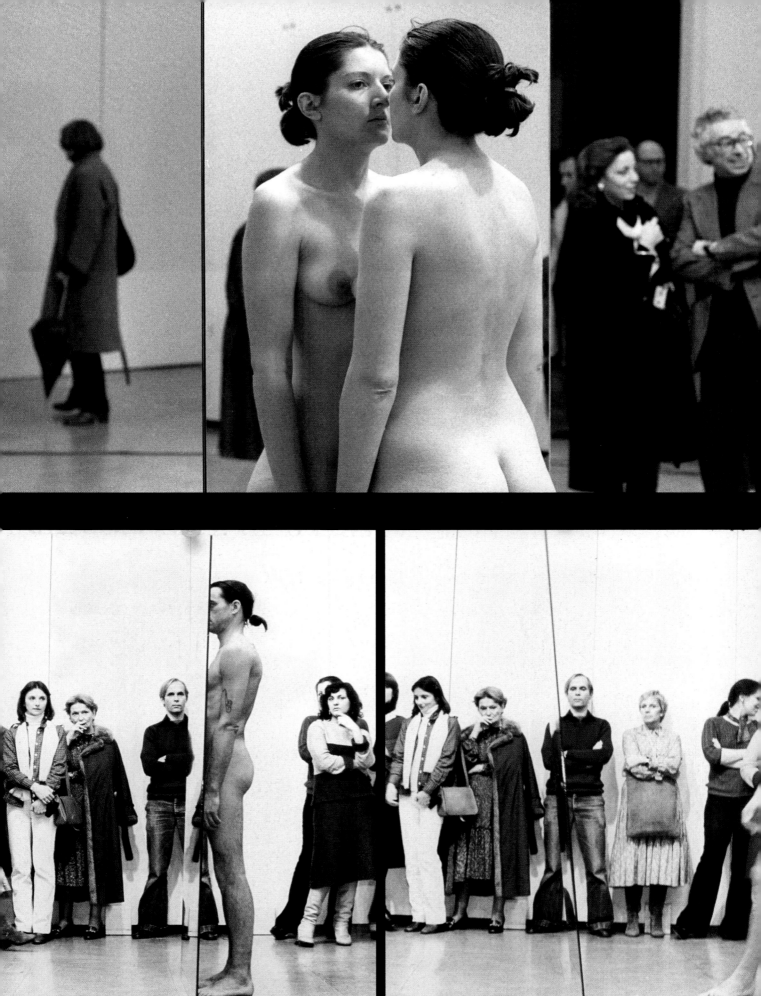

Ulay starts photographing everything you do.
These photos feel like love…
But I am the one who asked him to start
taking photographs. I wanted no separation
between life and art, and I was comfortable
with the idea of constant documentation.
My mother was always composed in case she was
being photographed. My mother, the Communist
in couture dresses. It's like she gave me
a format.

A format for being surveilled?
With my background, yes. And for some reason,
I had a feeling everything I did could be
historical someday. Strange for a girl who
felt so unloved.

Did you and Ulay have a sense of humour?
We did, actually. I was always telling terrible
Slavic jokes. I love dark humour. I love jokes
about war.

I WAS ALWAYS TELLING TERRIBLE SLAVIC JOKES. I LOVE DARK HUMOUR.

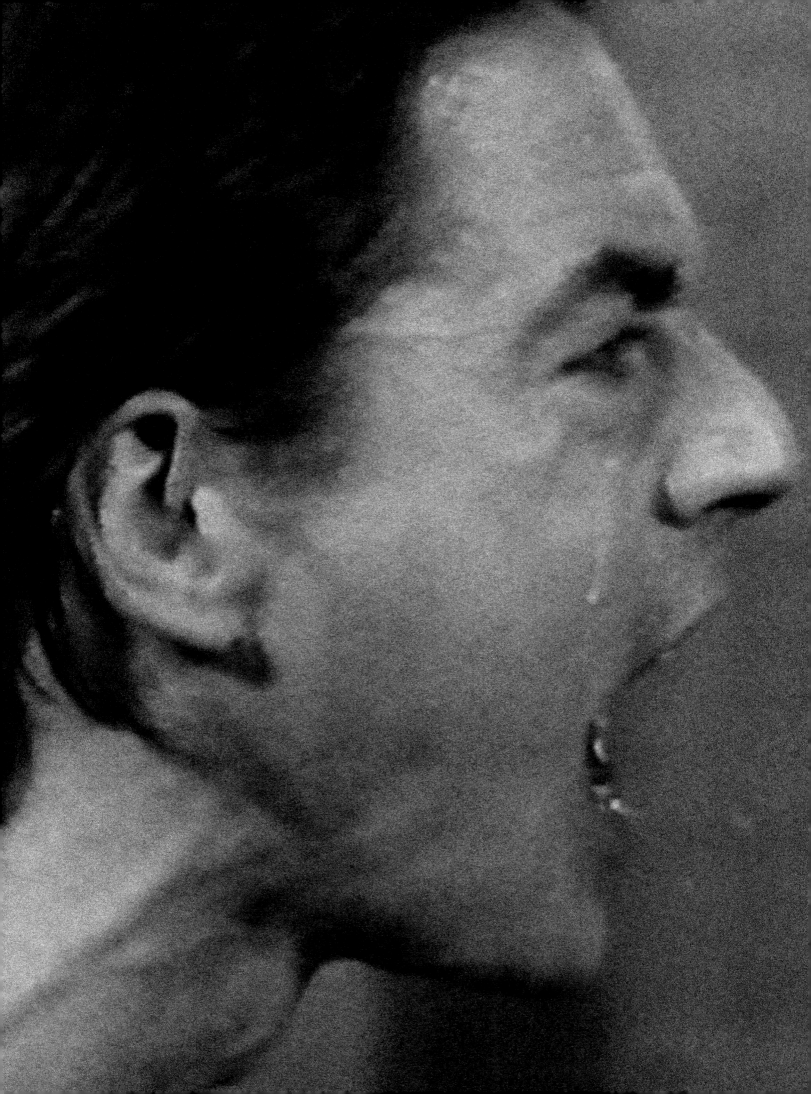

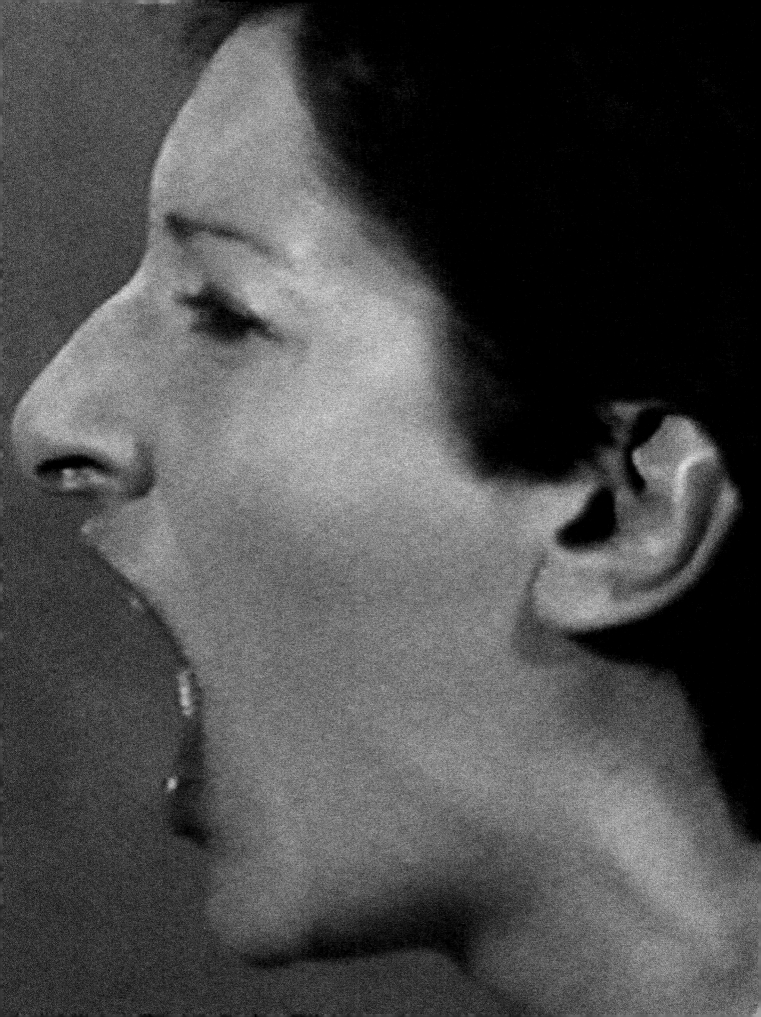

In general, coming to the West was very funny. I would order a drink and the straw would be bendable. Unthinkable! I sent about 50 bendable straws back to my friends in Belgrade, to show them how decadent it was in the West, where you don't even have to bend your neck to drink lemonade. Really, the freedom was intoxicating. Freedom in our work, in our life. We didn't belong anywhere, weren't attached to any kind of political system. Didn't have insurance, didn't pay rent or a telephone bill.

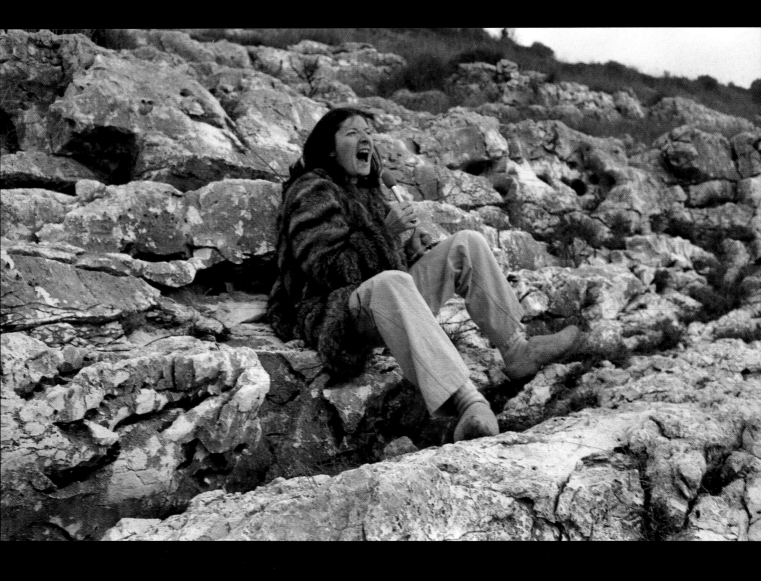

Previous spread: *AAA-AAA*, 1978, Liège.

No, Ulay just told me to run through the street
in Milan. Nothing special.

Just freedom [laughing].

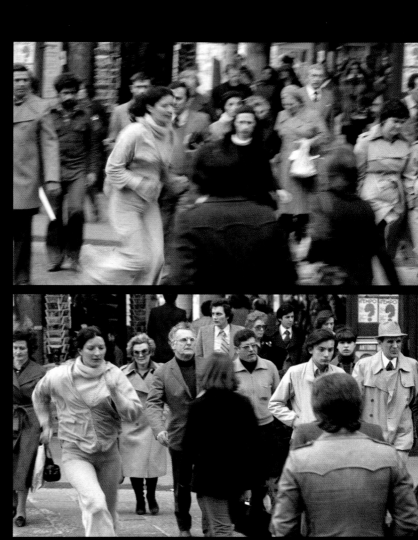

Sometimes we slept in the car without the
windows covered. We looked very suspicious.

<u>Friends of yours?</u>
I have no idea what's happening here.

WE LOOKED
VERY SUSPICIOUS.

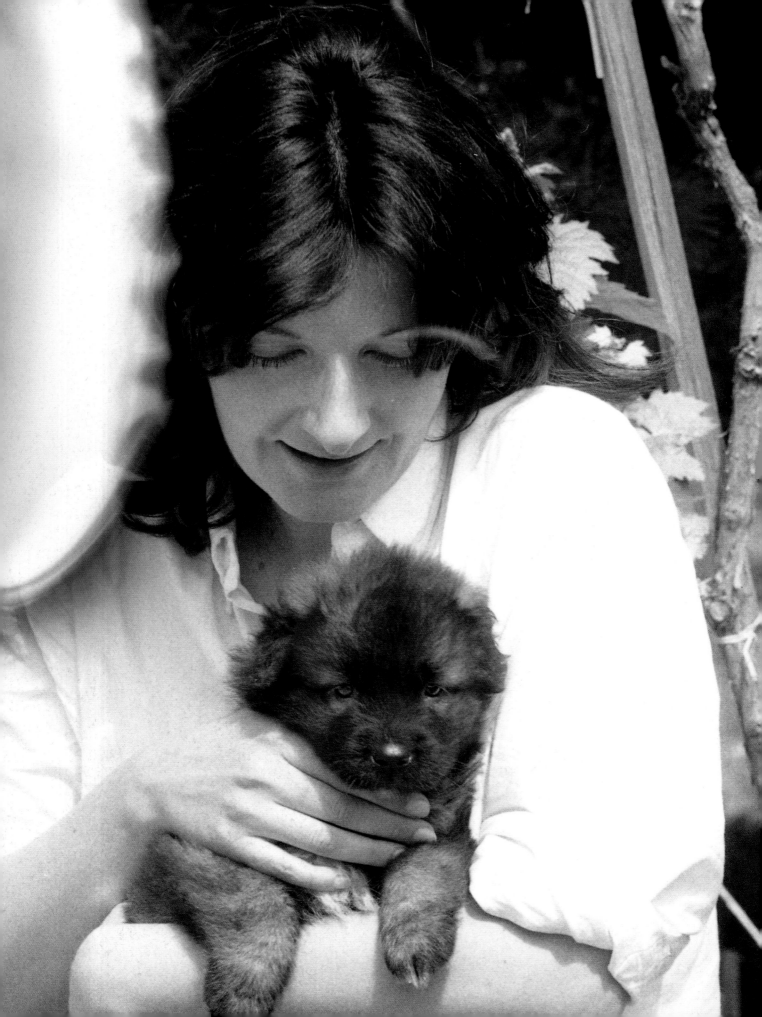

to get the dog?
se. He wanted dogs. He wanted
I went crazy over an Albanian
treet once. So, as a surprise,
a puppy. Alba became my baby.
e was sick. Everything I felt,
an incredible connection.

This is when Ulay and I were invited to
spend 24 hours in the Chauvet Cave in France,
in total darkness.

Was it memorable?
It was, because Ulay wanted to make love and
make a baby there. So, OK, we made love, but
we didn't make a baby. For me, nothing is as
important as my higher cause.

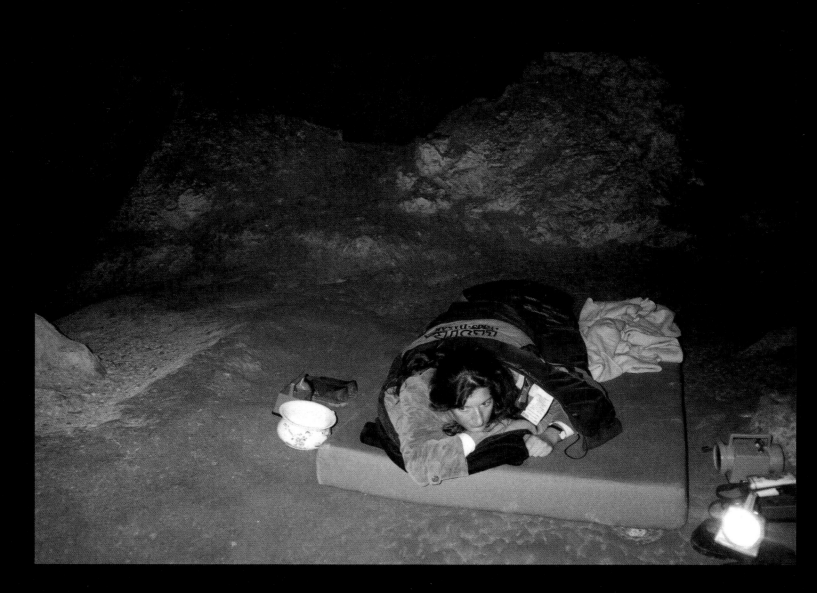

You say it comes from the stomach. But in photos, your work looks logical and consistent. Because from the very beginning, I had control of how it looks. I am always aware of the camera. I am always aware of the frame and how to document real action. All my work has instructions for the person filming.

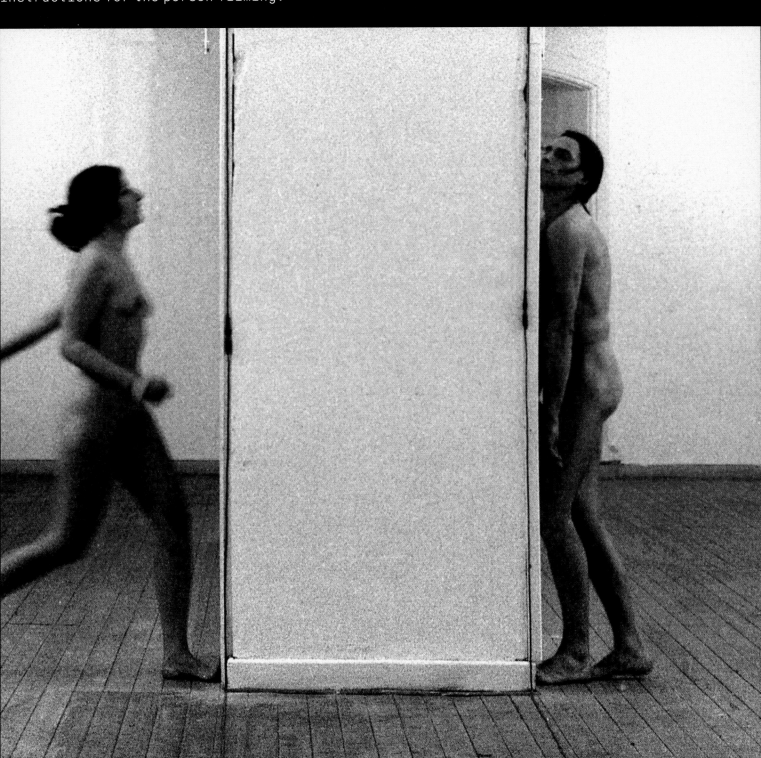

ULAY

MARINA

PARIS 11-9-1977 / ULAY

ur early work, before Ulay?
. At the time, he was studying
my. He was the genius of the
e used to be very close, we
er all the time, now we don't
n I had my show in Belgrade
0], he went on television to
t disgusting work of art he'd

This is when he was in military
[below]. It was my mother who ma
draft him, through her contacts
She forced her own son into the
the kind of woman she was. He go
shape, though.

He never wanted to leave, like y
No.

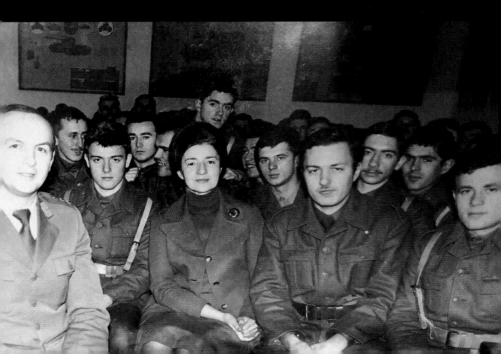

MARINA

... HUMOR IS A TOOL FOR OPENING THE SOUL AND SHOULDN'T BE AVOIDED IN ART.

VELIMIR

I AGREE THAT HUMOR IS A RELEASING TOOL, LIBERATING US FROM ALL THE BOUNDARIES OF THE MOMENT. RISING TO THE LEVEL OF HUMOR, YOU JUST FEEL BETTER, BUT IT IS NOT CLEAR WHY YOU FEEL BETTER THAN YOU DO WHEN YOU CRY.

Conversation between Marina and her brother, Velimir.
Published in the catalogue *Artist Body*, 1998.

u know how superstitious
iting for someone else to cross
ke the bad energy. I got all
dmother. She used to pour water
re a big exam, for good luck.
ing outside. My hair would
ick to my jacket.

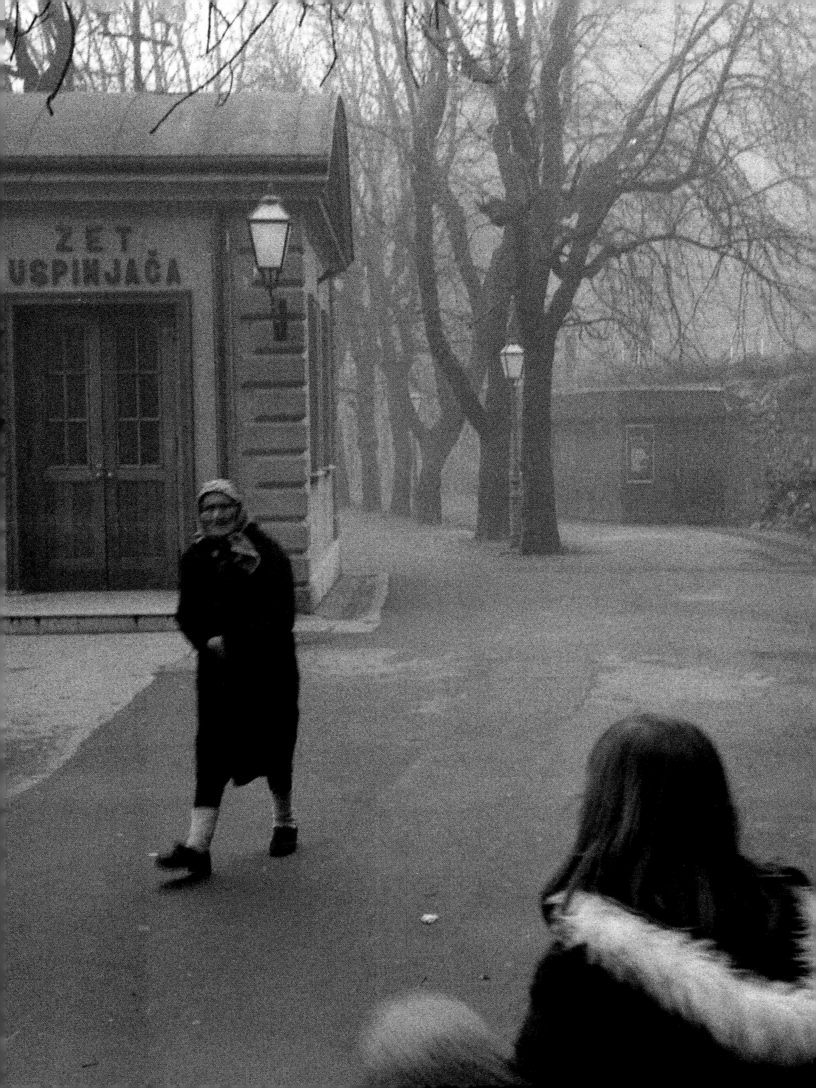

You never talk about your paternal grandmother.
Because my father never talked about her.
He never talked about his family. I met his
mother only a few times. I made a painting of
her. She lived on the 15th floor of a Belgrade
apartment and never left because she was afraid
of elevators. She knew all of Tito's speeches
by heart. Her youngest daughter – my aunt – took
the first vacation of her life at age 60, only
after this grandmother died at age 101. When my
aunt came back, she found out my father had sold
her apartment and moved her to a smaller one in
a different neighbourhood. He needed money for
his new wife. My aunt ran to the bathroom and cut
her wrists. End of story.

You're father told you this?
No, my father told me nothing. He only talked
about the war. And at that time, we weren't
talking at all. The first year in the van, I was
waking in the middle of the night, screaming my
father's name. Finally, Ulay made me sit down
and write to him. I wrote: *I love you, I don't
care that you have a new wife, I want to see you.*

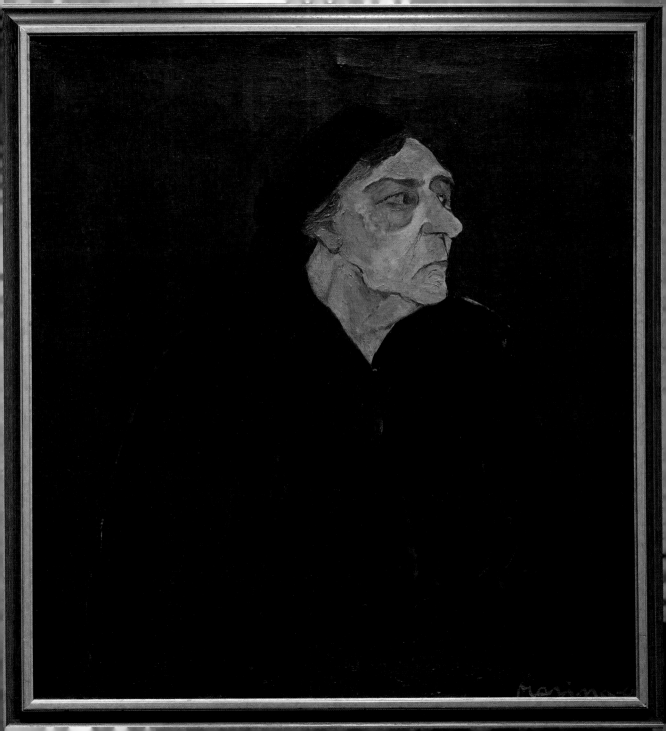

<u>Is this your father's second wife in the photo?</u>
I don't know. That's my brother. But this can be any woman from that time.

My father never answered my letter. But later, his new wife told me he kept it in his pocket and cried whenever he read it. When Ulay and I finally came to visit Belgrade in 1977, my father threw a huge celebration for us.

<u>How did you feel back in Belgrade?</u>
It reminded me of the restrictions I had left.

<u>Had you missed your family?</u>
I loved my father. But, Katya, this is how you and I are different. I never understood why I was put in my family. I never belonged with them. I made my real family only when I left Belgrade.

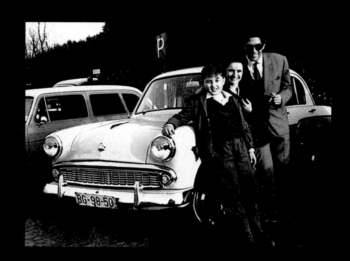

I NEVER UNDERSTOOD WHY I WAS PUT IN MY FAMILY. I NEVER BELONGED WITH THEM.

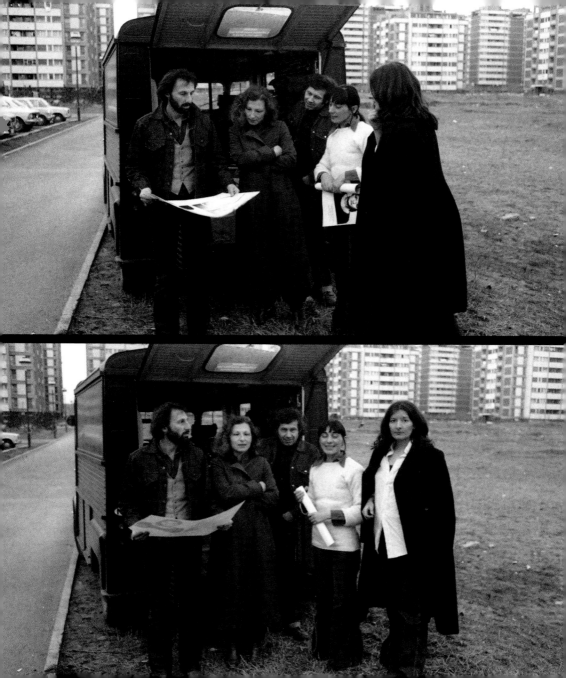

Relation in Time [previous spread] was the first project I really understood what it meant to get energy from the public. We were like this for 16 hours, past the point of exhaustion. You only understand by doing it.

<u>Did you feel like it was just the two of you in the world?</u>
No, I felt like we had friends everywhere we went. We had a guestbook people signed at every stop. I don't know where it went. Ulay and I, we could park our car anywhere and just *be*. We didn't die from hunger. We'd milk goats or a stranger would offer us something. Ninety per cent of our attention was taken up by existence – what to eat, where to sleep. Nothing else entered that van. Then we started to have success, money, clothes... We got a studio in Amsterdam. We started travelling around the world together. USA, Thailand, India. It was different.

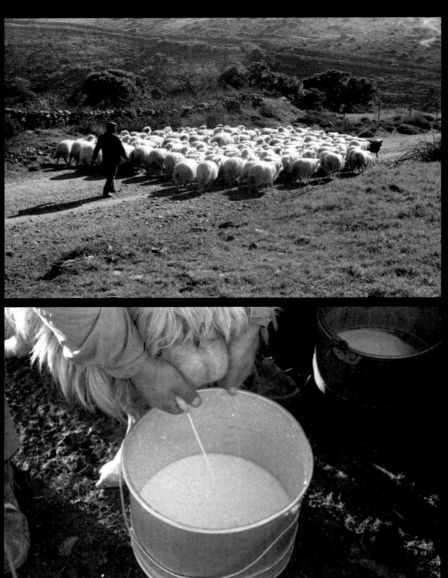

favoured me. One critic didn't even mention
Ulay's name. The two of us are smashing our
bodies together, and the critic didn't even
mention his name!

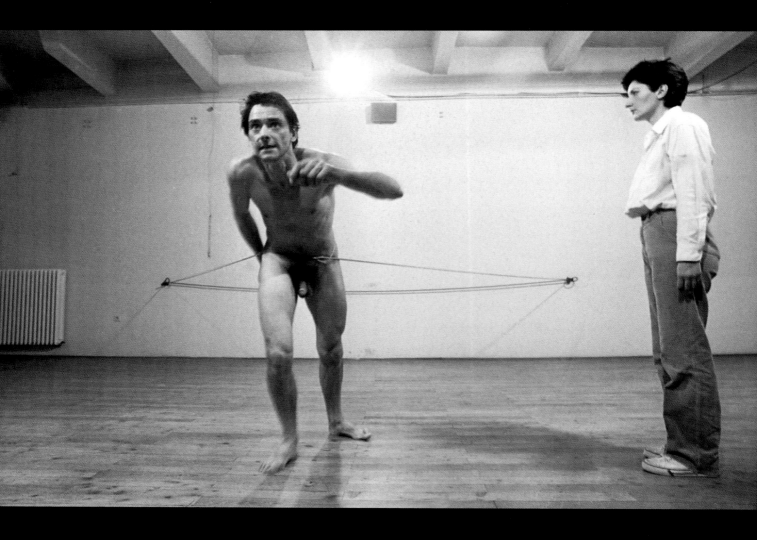

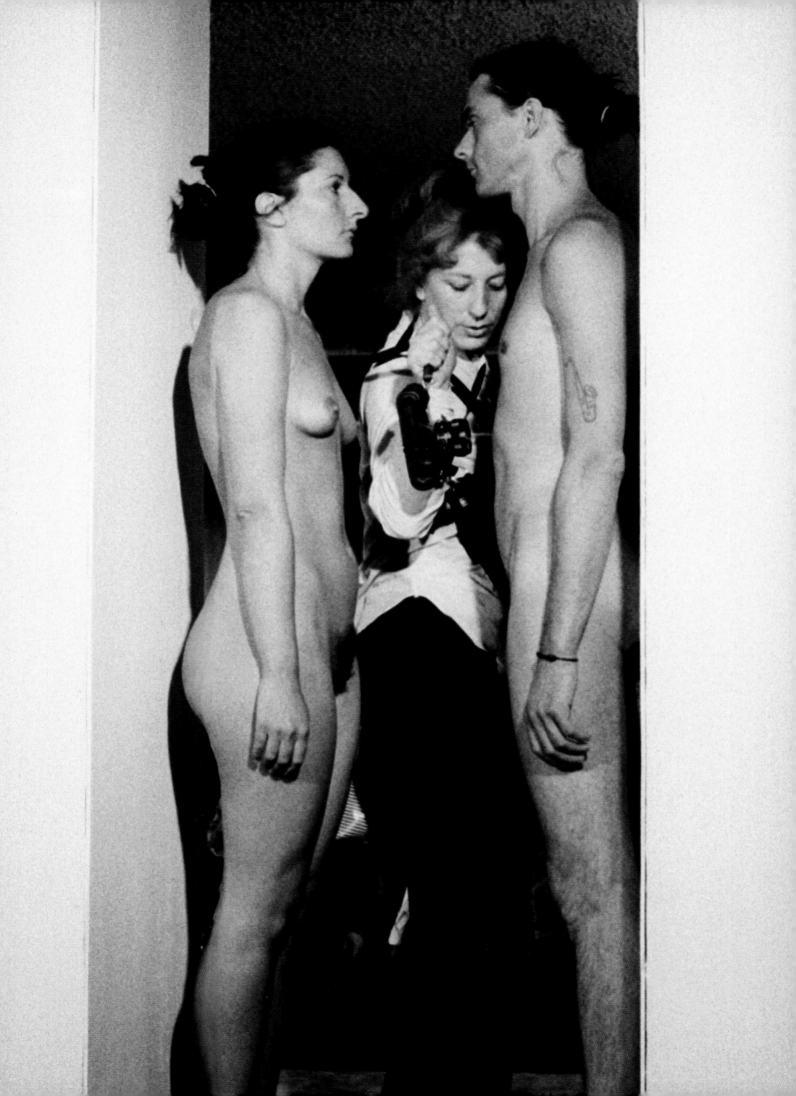

think this is your ~~...~~mmetrical
work. Your hair is different. You're
dressed differently.
But I am wearing his shirt and his jacket.
So, I don't think the change was so sudden.

you are still "one body"?
Yeah, though you see our fingers never meet?
This is an image of the space between us.

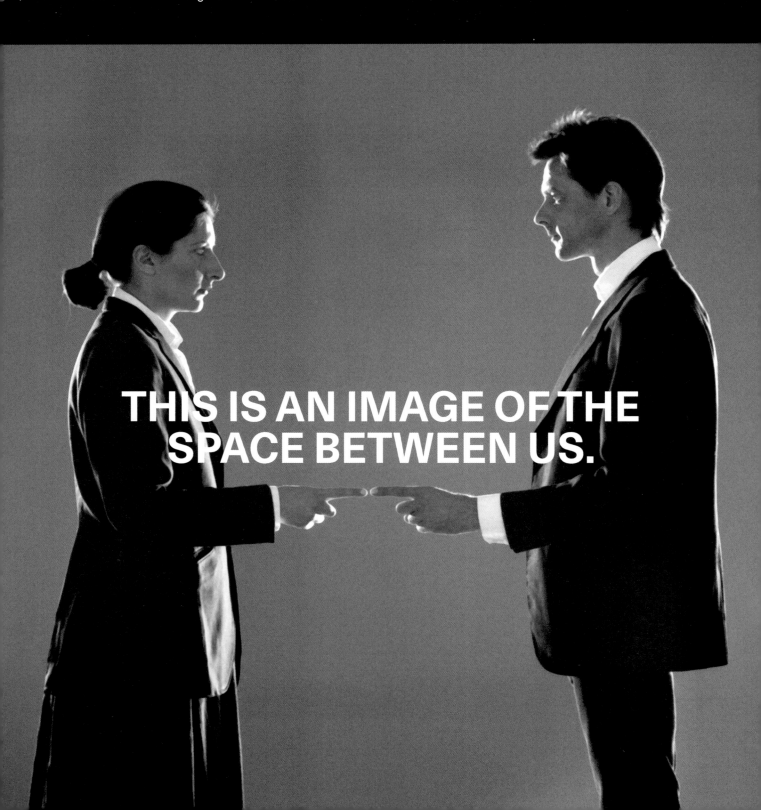

THIS IS AN IMAGE OF THE SPACE BETWEEN US.

you, you won't see it in this
en we're slapping each other
g. It's later. When we start
ng' – it's when our work becomes
It's when we received an
o perform in Australia and sold
t was the beginning of the end.

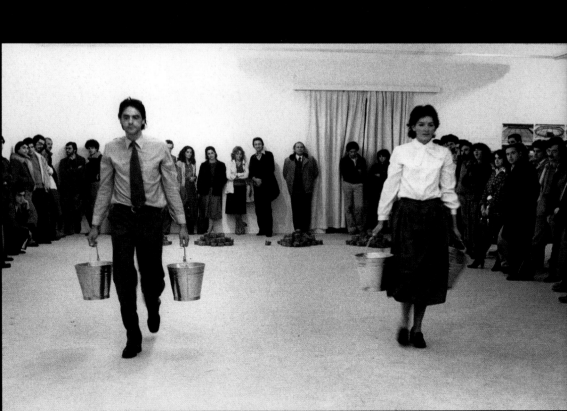

car?
problem. I don't know whose car

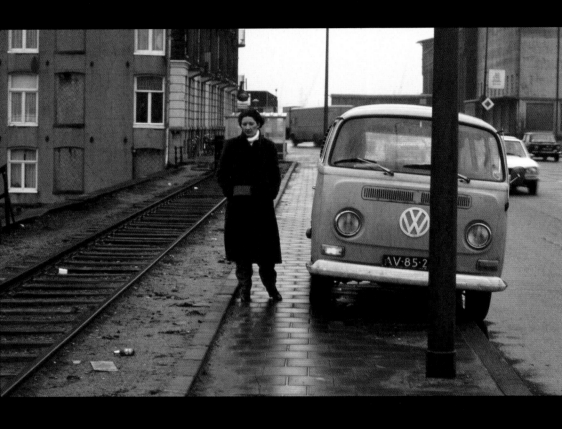

Opposite: *Rest Energy*, 1980, Dublin.

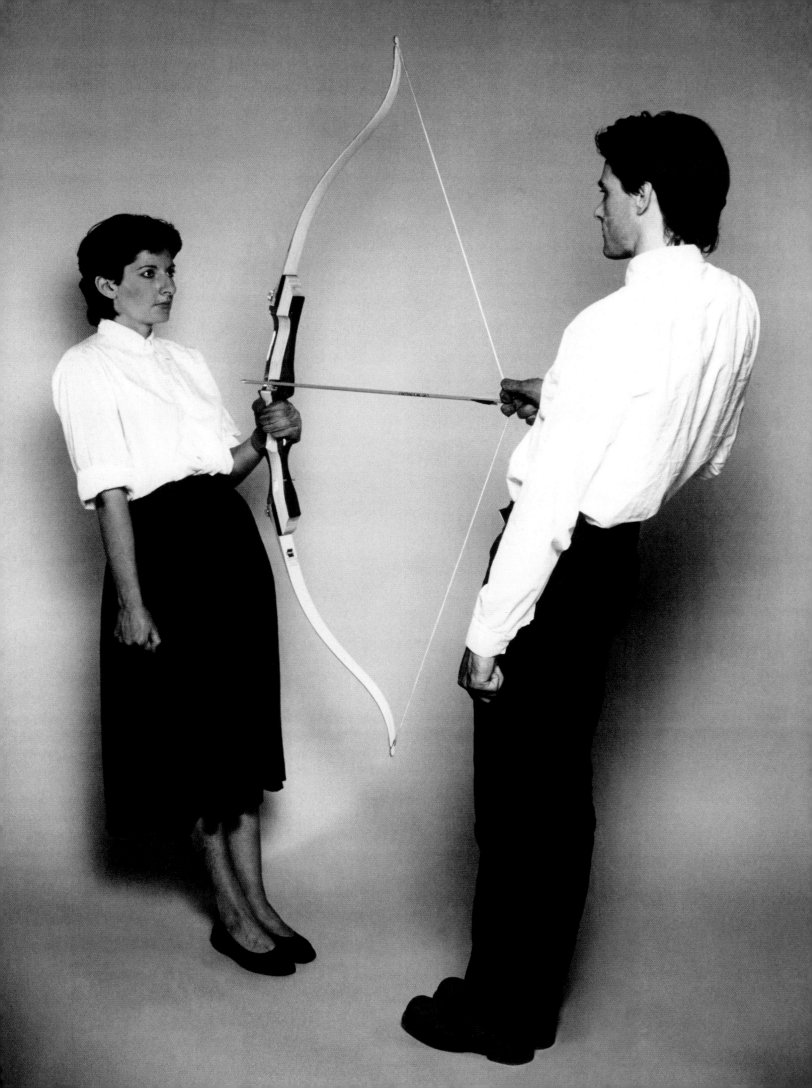

05

SOMEWHERE WEST OF LAKE DISAPPOINTMENT

AUSTRALIA AND WORK IT INSPIRED
1980–1987

DISCOVERY, STASIS, STRUGGLE

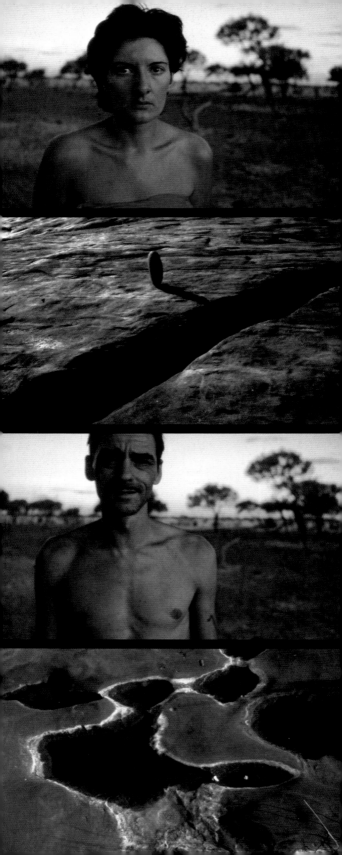

I WAS NOT HAPPY IN AUSTRALIA. I WAS ECSTATIC.

was not happy in Australia. I was ecstatic.
After we did a performance in Sydney, we knew
we had to come back. The next year, we sold
the van in Europe and were driving around the
Outback in a used Jeep.

Was it like life in the Citroën van?
Totally. Our whole life was in the car again.
Except Alba stayed home with friends in Europe.

And if we wanted to sleep outside in Australia,
we had to burn a fire first, to deter snakes and
spiders. There are spiders so poisonous there
they could kill you in 30 seconds with one bite.
It took some time to get used to everything.
But we were open to every adventure. Everything
was interesting. One day we woke up without
any flies on us and understood nature had
accepted us.

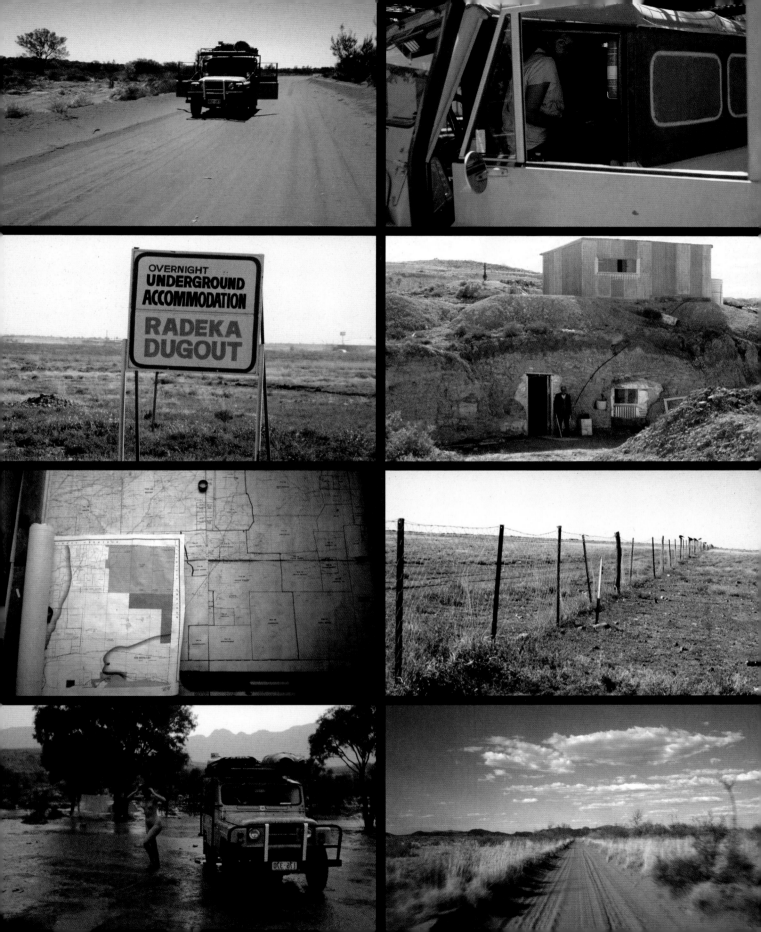

gh these opal mine towns, where
s underground: supermarkets,
) people living and looking for
ing to get away from the 50°C heat.
ually bought an opal mine for
of land, but an old law stated
ing below it – all the way down
s centre – was ours. We found 250g
've since changed the law.

A Croatian man ran one of the underg
He thought it would be a good idea t

<u>And you thought it was a good idea,</u>
Why not? My grandmother had done it
already, why not one more time? He t
water in a white nightgown.

We also met an ex-Nazi who'd made a
was building himself an undergroun
They said he got drunk on weekends a
up and down a hill dressed in unifor

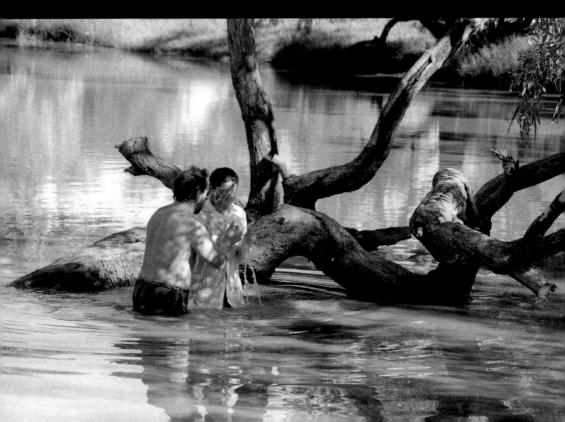

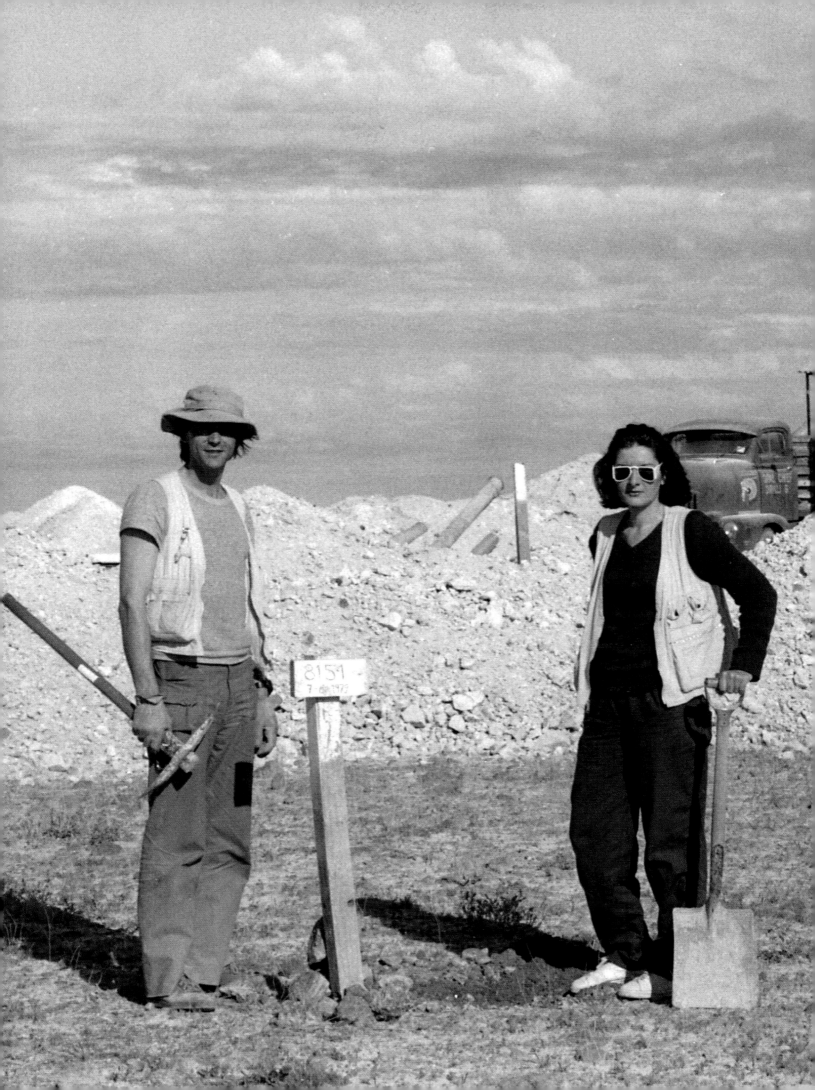

real. Everything seemed
ve next to the Dingo Fence
ng married in the middle
hina. When there were
ust stopped at people's
 from them. Some invited
r. We met a lot of people

Who's this?
Frederika. I saved her from a pig farmer,
an ex-soldier, a disturbed individual, who
invited us to sleep over. We didn't know he
hunted kangaroo. She was in the pouch of one
he'd killed to feed his pigs. I wrapped her in
a pillow case and she slept with me for months.
One day, she left without saying goodbye and
went in the direction where she'd last been
with her mother.

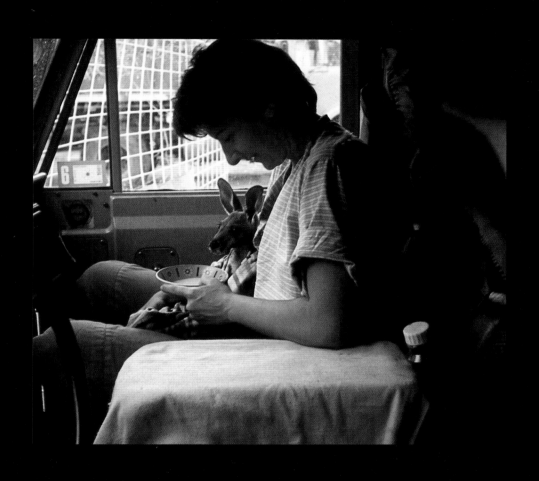

But we came as artists, not as tourists.
We received special permission to live with
indigenous people in the Great Victoria Desert.
We wanted to learn from them. We lived with
the Pitjantjatjara and Pintupi people. They
deserve to be treated with the highest respect.

I learned that they are nomadic and don't
care about possessions. I learned that ceremony
can be a way of life, that everything is in
the here-and-now, and that perception can be
developed to a much higher level. I learned this
from them, and I was profoundly moved by it.

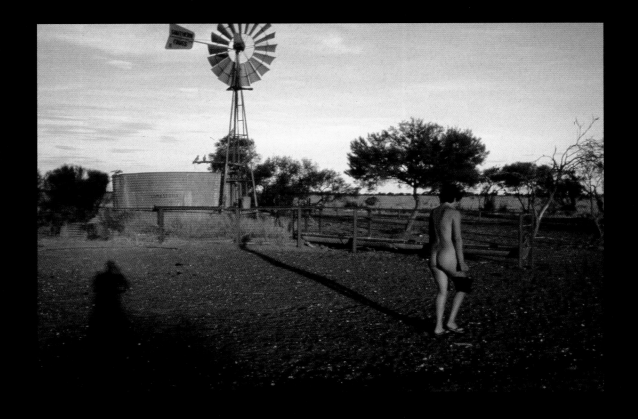

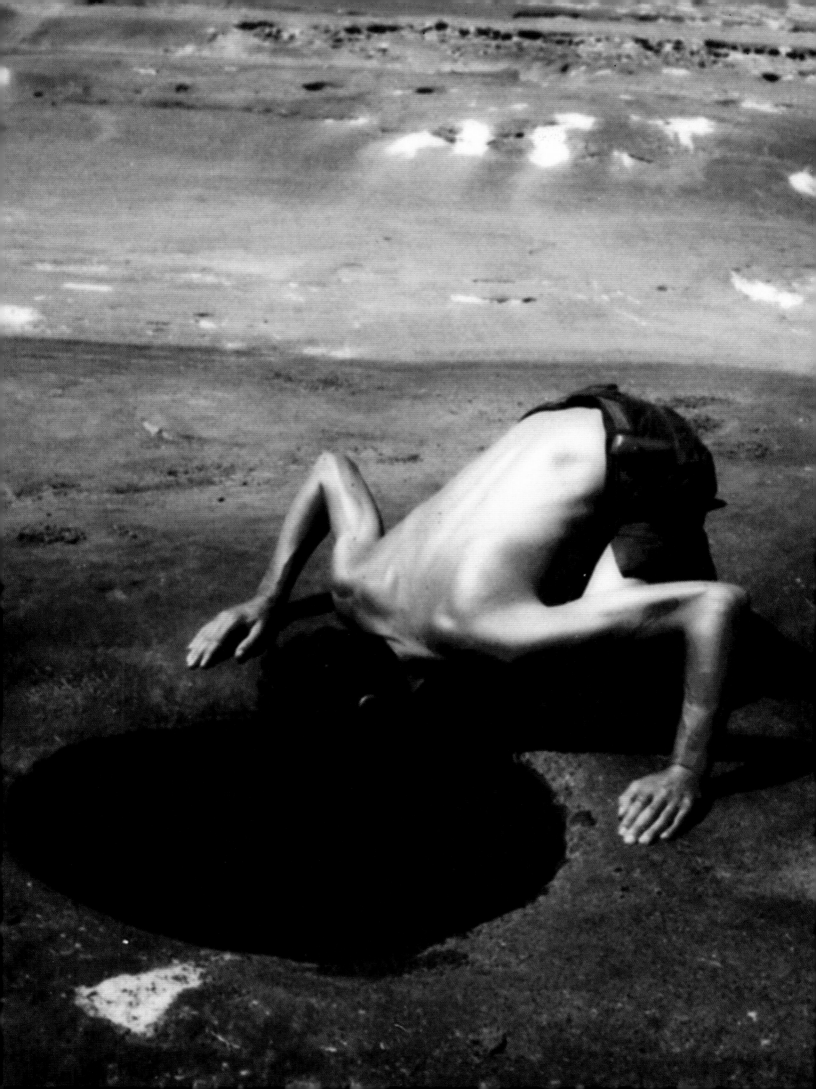

FOUR WHEEL

ALL CONV
VEHICLES N
THIS

ALL VEHICLES
THIS ROAD
OWN

DRIVE ONLY

ENTIONAL

T TO PASS

POINT

TRAVELLING

DO SO AT

RISK

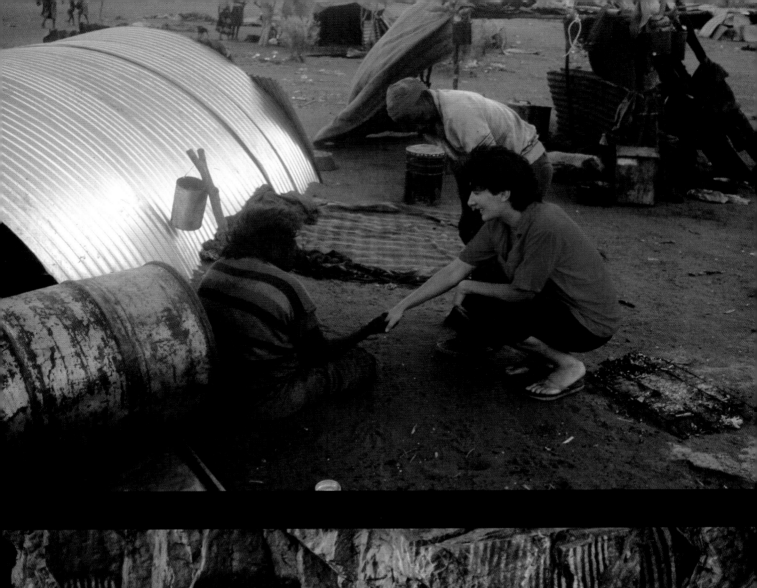

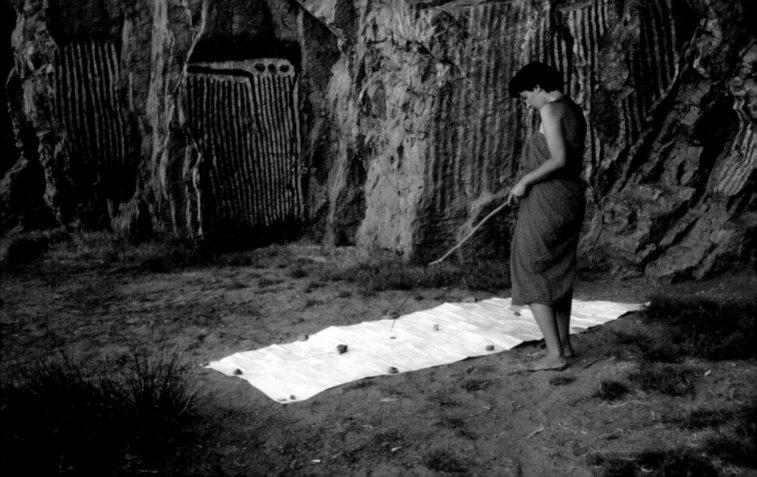

<u>According to custom, for part of your stay,
you lived with the women and Ulay with the
men. Was this separation difficult for you?</u>
Nothing was difficult. Everything was too
interesting to be difficult. I felt like a kid
seeing life for the first time. During the
full moon, men and women stayed together. One
night, sleeping on the ground with Ulay, I woke
up because of a strange noise and saw hundreds
of wallabies jumping on the ground. I will never
forget this moment. I return to it whenever
I can't sleep. The two most important moments

in the day became sunrise and sunset. There was
such a beauty instilled in us, such a beauty in
being connected with the ground and just being
alive. The only difficult part of the whole trip
was leaving. I kept thinking, why? Why leave
this incredible feeling of harmony?

<u>So why did you leave?</u>
Because the urge to be an artist was stronger.
We re-entered our own culture. And decided
to create *Nightsea Crossing*.

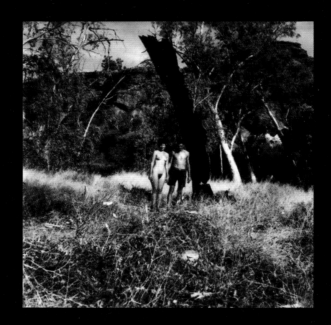

Somewhere west of Lake Disappointment.

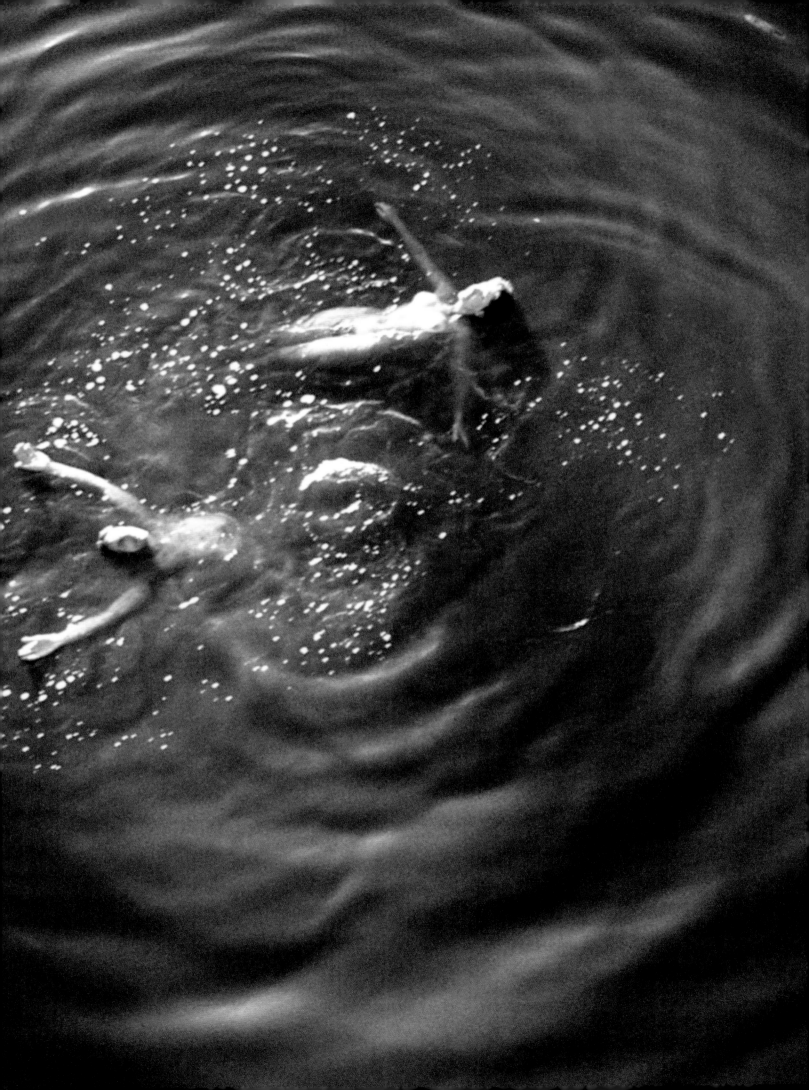

We sat motionless across from each other for 90 nonconsecutive days. We did this across five years, around the world. On performance days, we had no food, only water. No talking.

Why 90 days?
It's an auspicious number.

Was *Nightsea Crossing* about the harmony you experienced in Australia?
It was about the experience of every single moment – including the experience of extreme pain. Being motionless is so painful. You say to yourself: 'I could faint,' but you don't. A universal energy replaces your own. Then you can go on forever. But you can't just read about it. You can only experience it.

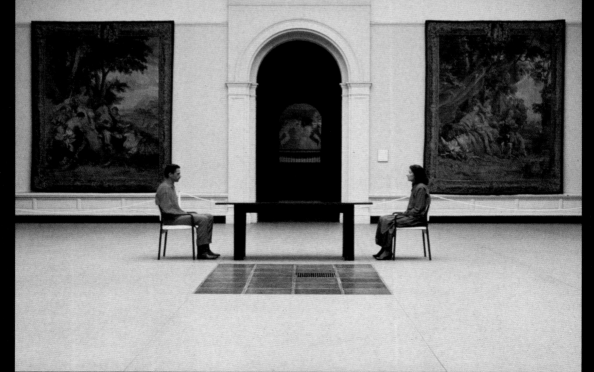

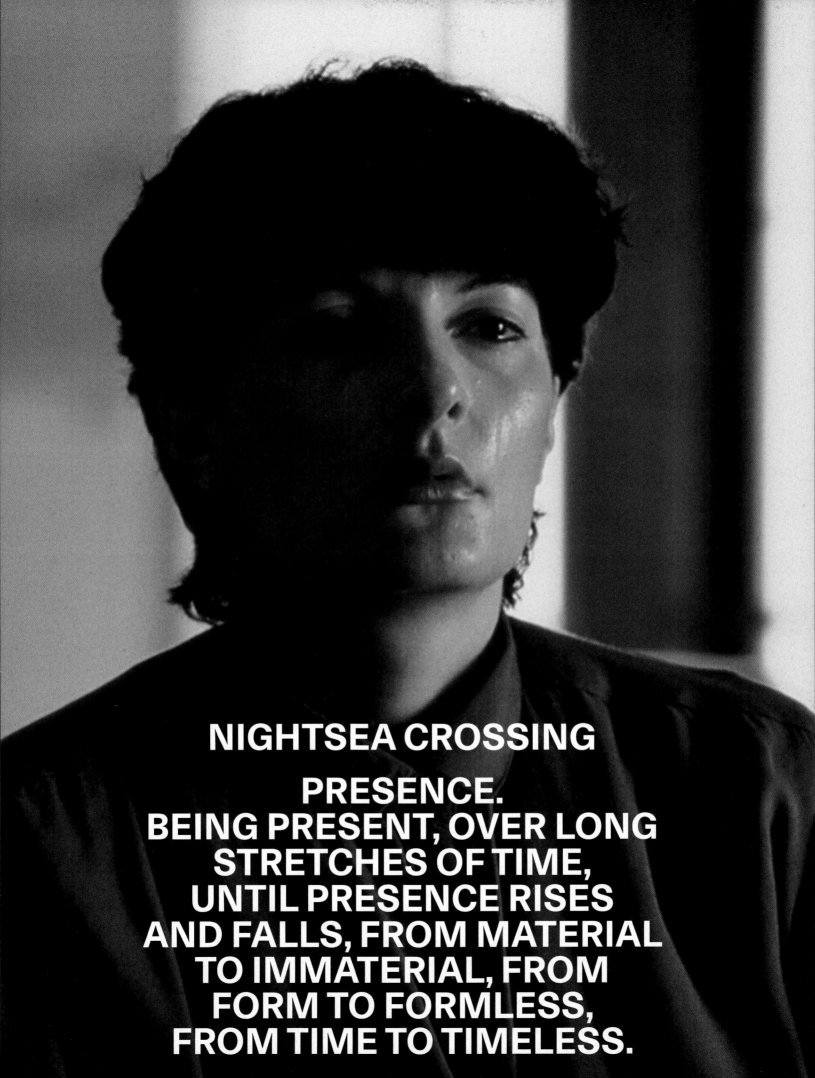

NIGHTSEA CROSSING

PRESENCE.
BEING PRESENT, OVER LONG
STRETCHES OF TIME,
UNTIL PRESENCE RISES
AND FALLS, FROM MATERIAL
TO IMMATERIAL, FROM
FORM TO FORMLESS,
FROM TIME TO TIMELESS.

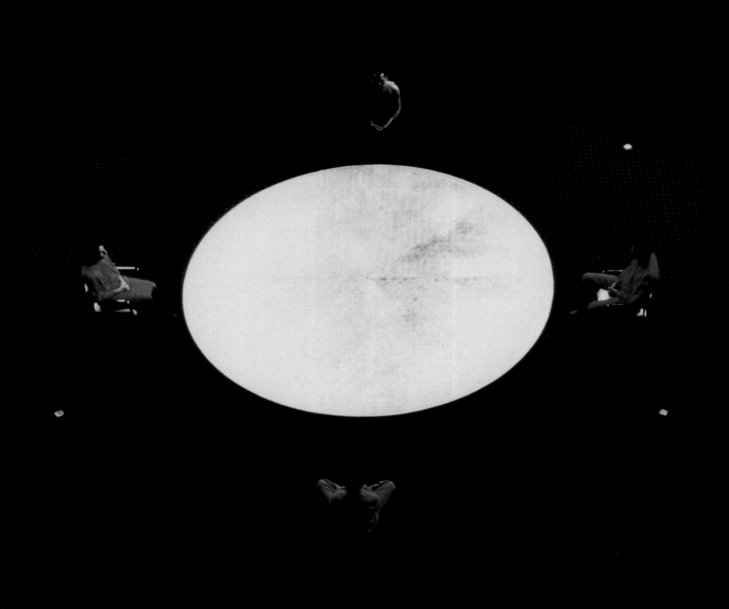

Above and opposite: *Nightsea Crossing: Conjunction*, with
Ngawang Soepa Lucyar and Watuma Tarruru Tjungarrayi, 1983, Amsterdam.

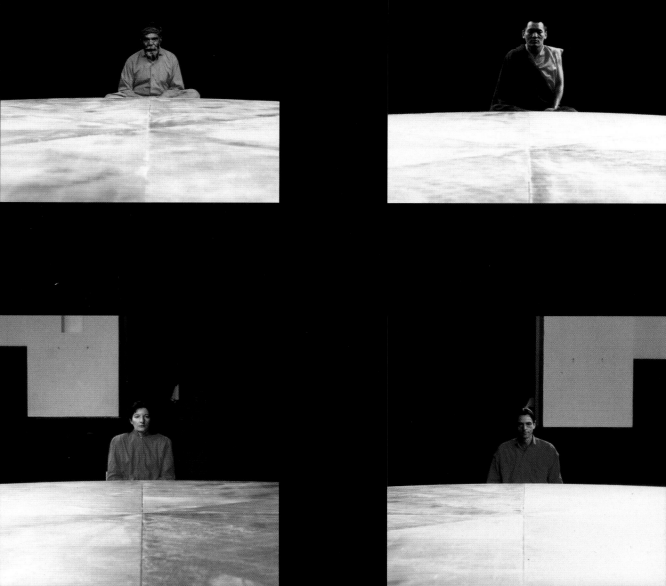

The few people who have actually gone through this process, they become like your family. You speak the same language. [Looking at previous page.] For *Nightsea Crossing: Conjunction*, we invited a Tibetan Lama and an indigenous medicine man from Central Australia to perform with us. These two cultures don't otherwise have contact with each other.

<u>Do you ever have trouble convincing people to participate in your artwork?</u>
Never.

We became interested in meditation and high spiritual experience. I started travelling the world to monasteries and meditation retreats. I wanted to learn willpower, concentration and to be in the present. I've had moments where I've seen blue light and felt I'd reached full consciousness. I don't think Ulay ever had that kind of experience. Sitting in silence, in meditation, it totally pulled us apart.

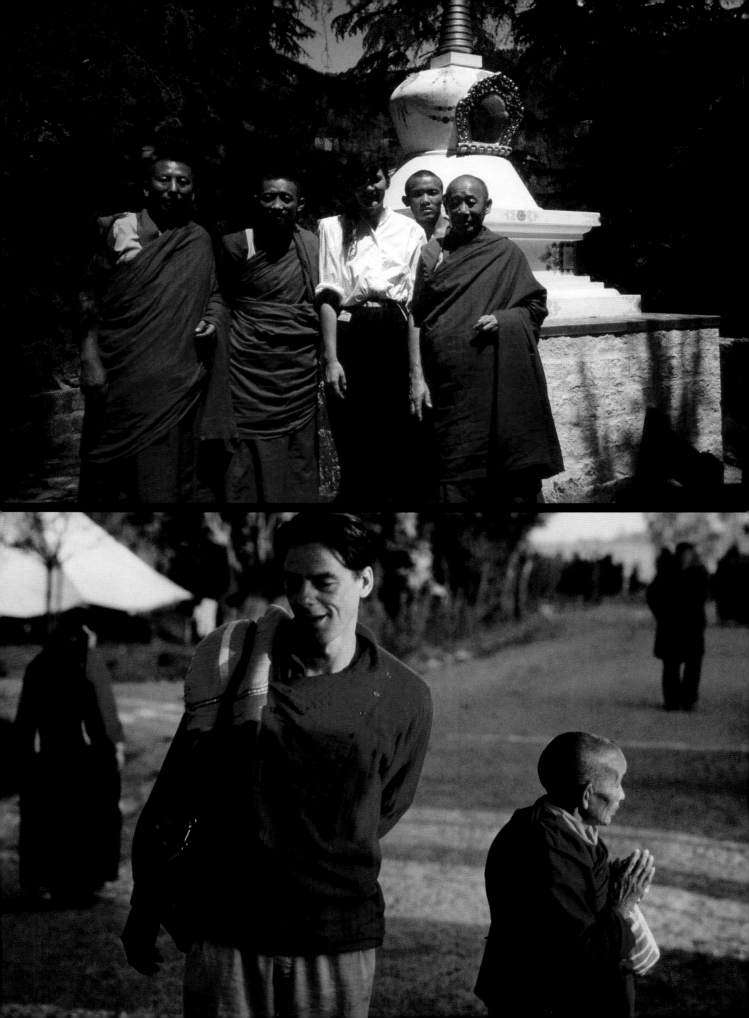

SITTING IN SILENCE, IN MEDITATION, IT TOTALLY PULLED US APART.

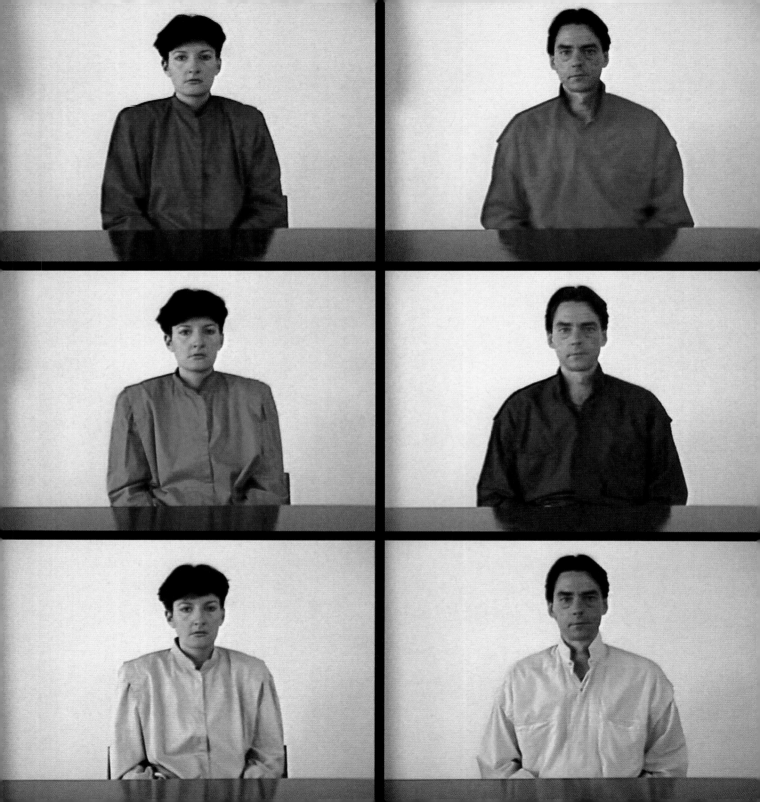

MARINA

GLUE, I THINK WE SHOULD PUT A FENCE, BECAUSE
YOUR AURA CHANGES WHEN PEOPLE ARE AROUND AND
YOU SHOULD NOT USE YOUR HAND TO TELL THEM TO GO!

ULAY

THE AUDIENCE BECOMES MORE LIKE A BARRIER
TO A SACRED PLACE. THESE BARRIERS
BECOME MORE AND MORE, ALSO NEGATIVE SINCE
WE CANNOT KNOW WHAT'S TO COME.

MARINA

MALI* GLUE, LIFE IS SO BEAUTIFUL – EVERY DAY
WE MUST ENJOY IT, AND WE MUST LEARN TO LOVE
EVERYTHING AND EVERYBODY. LIFE IS WONDERFUL.
WE'RE RECEIVING COSMIC ENERGY NOW.

MARINA

MALI, IF YOU HAVE TERRIBLE PAIN – JUST STAND OR WALK,
BUT BE IN THE SPACE OR GO TO TOILET AND BACK – NOW
AFTER 12 DAYS FASTING AND SITTING IT IS NORMAL
FOR EVERYTHING TO HURT. WE ARE NOT SUPER-HUMANS.

ULAY

THE WHOLE FLESH IS LIKE DEAD, NO FEELING,
IT'S NOT ONLY THE SKIN.

*Mali means 'little' in Serbian.

...

Notes passed between the artists during the first 16-day
performance of *Nightsea Crossing*, 1981.

We dressed ourselves according to the Vedic Square, an ancient tool corresponding to colours, numerology and the planets. Colour affects your energy and the mind's experience. For example, blue is calming, but it is hard to sit still in yellow. When you are too energized, red can make you restless.

Ulay was very skinny. He was sitting on his bones. That caused him a lot of pain. At one point, he had to go to the hospital. When we did *Nightsea Crossing* in Documenta in 1982, it was too painful. He stood up and left. And he was so angry that I didn't stand up and leave with him. I said: 'Why should I stop? You reached your limit, but I didn't reach mine.' It was a complete disaster. It was our only physical fight. I'll never forget it. In the forest, he slapped me in the face. It felt like such an act of desperation from him. He couldn't deal with this piece. I could and he couldn't. That's really when the relationship started falling apart.

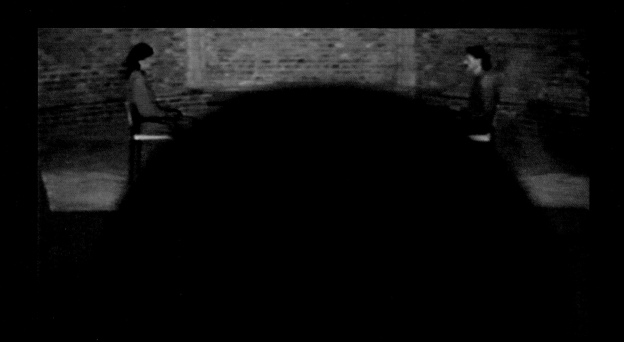

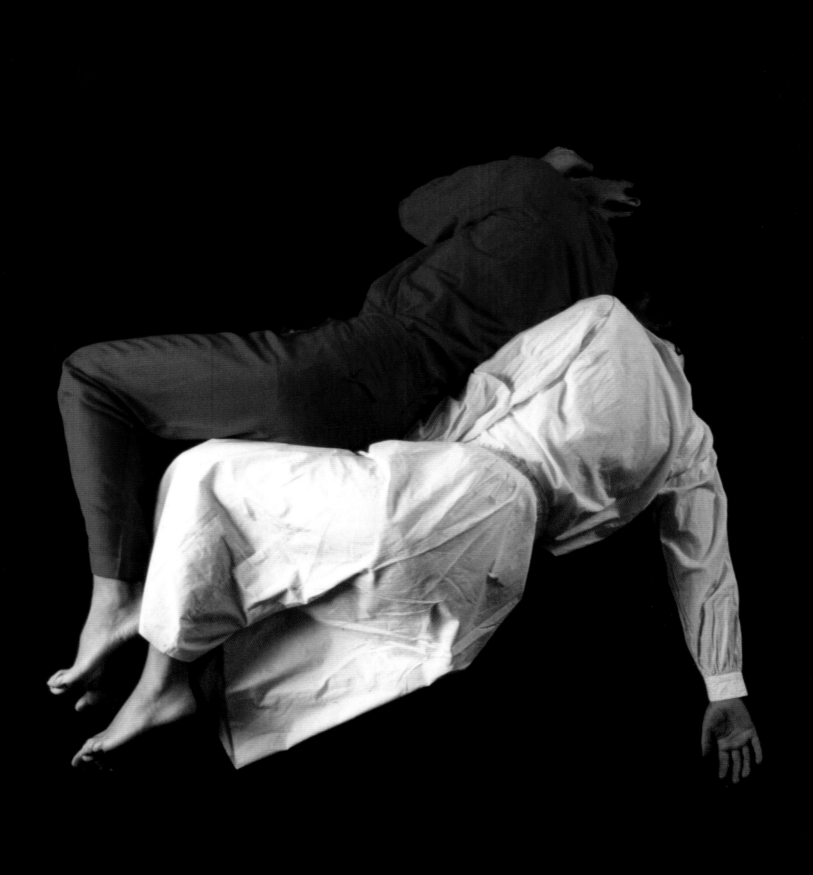

Anima Mundi (Pietà), 1983.

Look, *Nightsea Crossing* was not great for our relationship. But it was fantastic as an experience for me. It was life-changing. I experienced such a deep state of meditation, it would take someone else 50 years to reach it.

I guess you're not talking about getting married on the Great Wall of China at this point.
But we are still talking about our art. In 1985, on a plane to Tokyo, Ulay had a dream that we made *Nightsea Crossing* inside the earth.

<u>Wow! You did it. It looks like a grave.</u>
It was his dream. It was not mine. I had a dream that I handed Ulay lights for a chandelier, one by one, until the room and both of us disappeared in the brightness. We made that work, too.

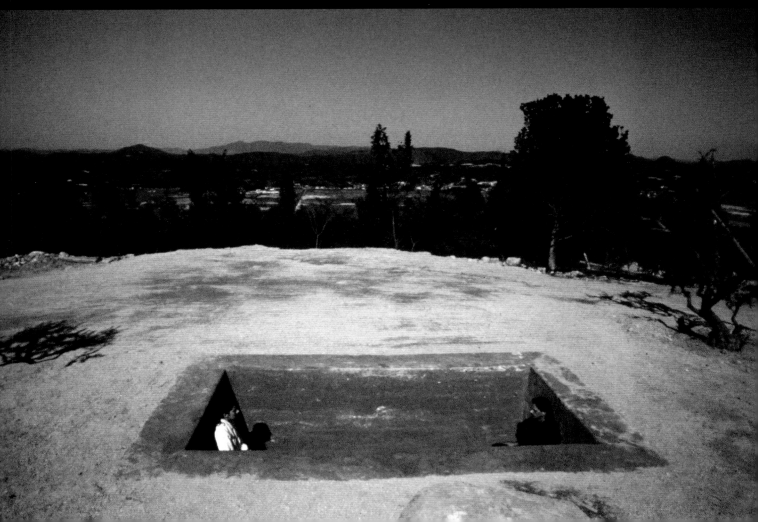

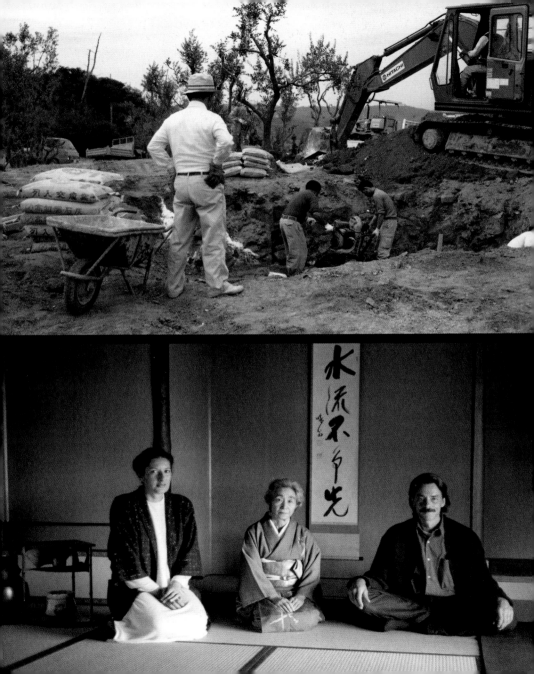

SOME OF US ARE
SENTENCED TO DEATH.
OUR GRAVES ARE READY.
THEY ARE SHAPED LIKE
SHOE SOLES FLOATING
ON A RIVER. THEY
ARE MADE OUT OF SOME
KIND OF GREY CLAY.
WE ARE TOLD TO STAND
WITH OUR LEFT LEG
ON THE FLOATING SHOE
SOLE AND TO WALK
WITH OUR RIGHT LEG IN
THE RIVER TILL WE DIE.

Text and still from *Everything Will Be Alight*, 1980.

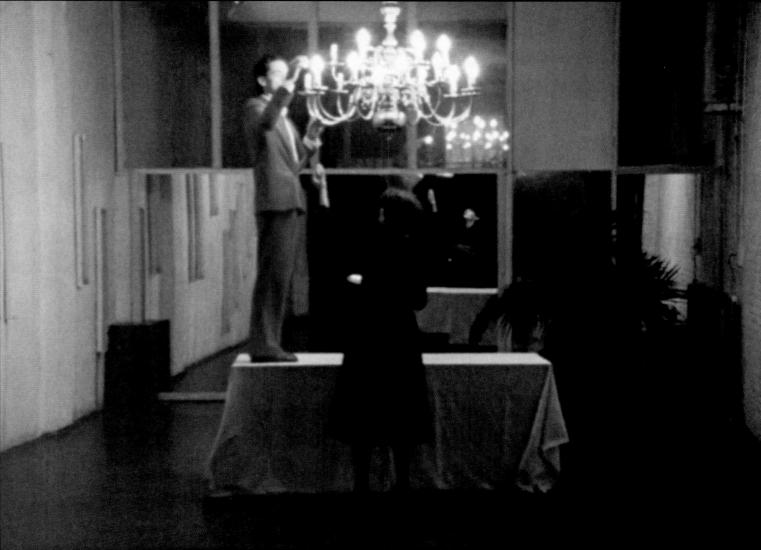

We made a series of large Polaroid photographs.
We had only this box as a prop. I chose a full
box, he chose an empty box. That says everything
about our relationship then.

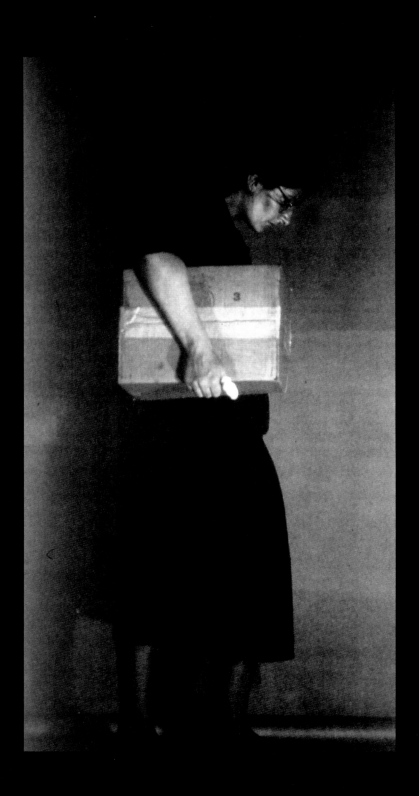

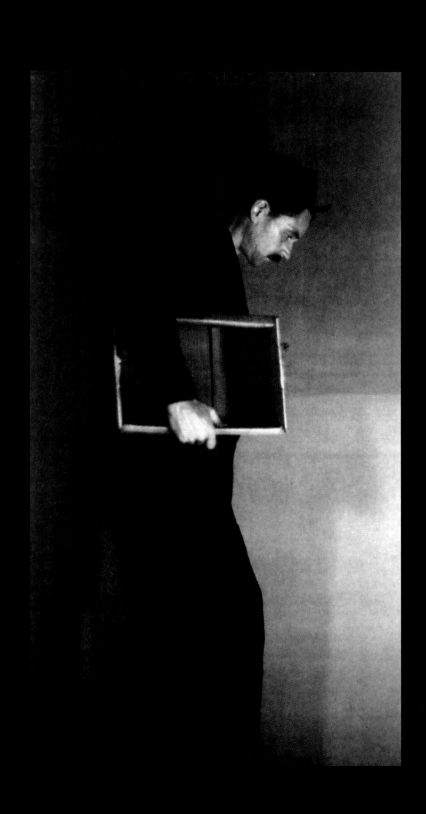

?
e was painting on our
 The ones we'd use for .

experience?
rlier work together?
 about it.

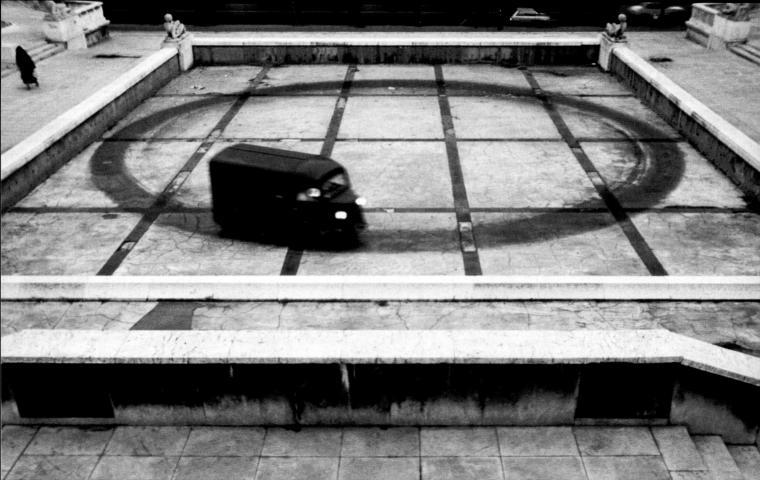

This was his dream, too. I think it predicts
that he will die before me. You see, he falls
into the water, and I am left standing alone.
I have a theory that an artist always predicts
his own death in his art.

<u>Are you referring to the death of
your relationship?</u>
No, to death itself.

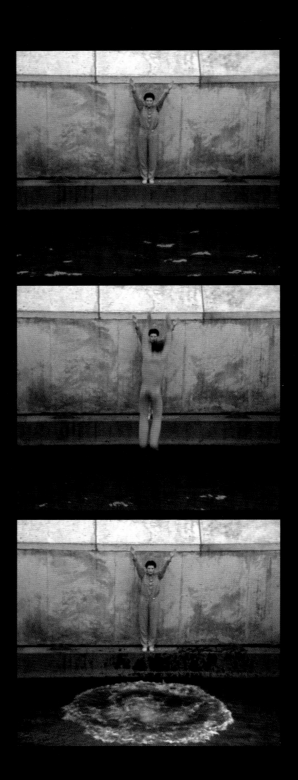

Nature of Mind, 1980.

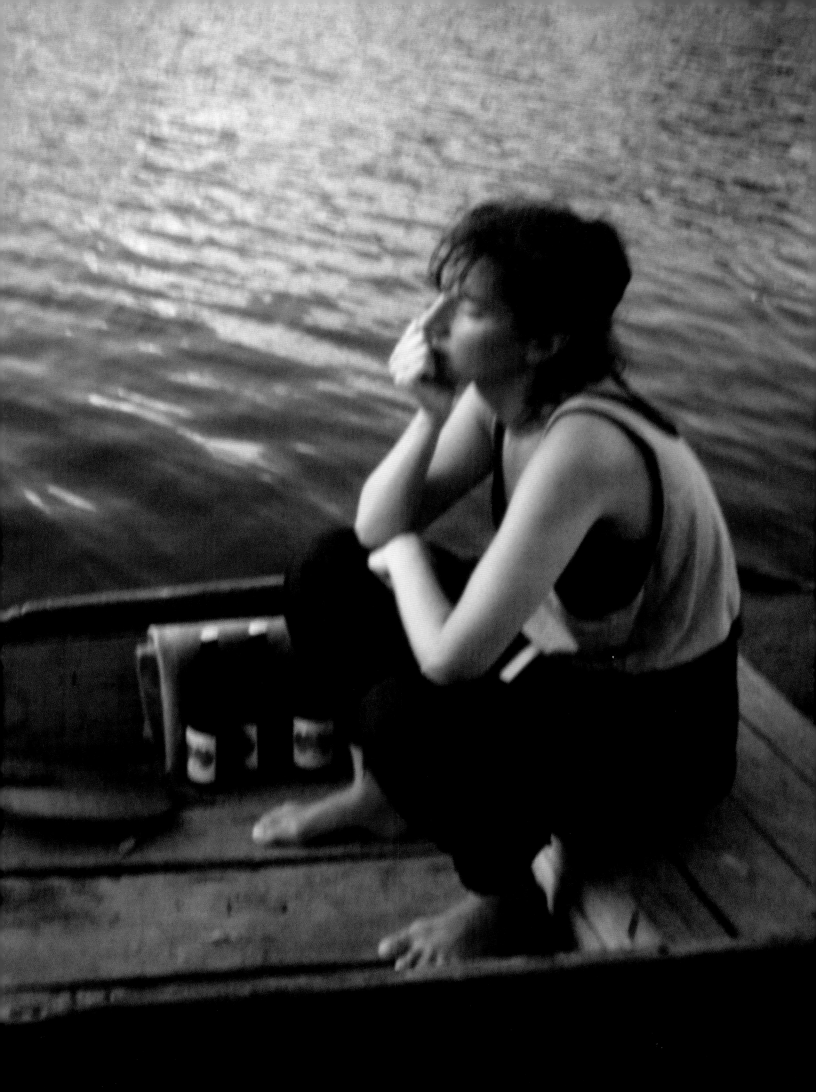

06

A COLD HANDSHAKE IN CHINA

THE GREAT WALL
1988

BUREAUCRACY, AMBITION, SEPARATION

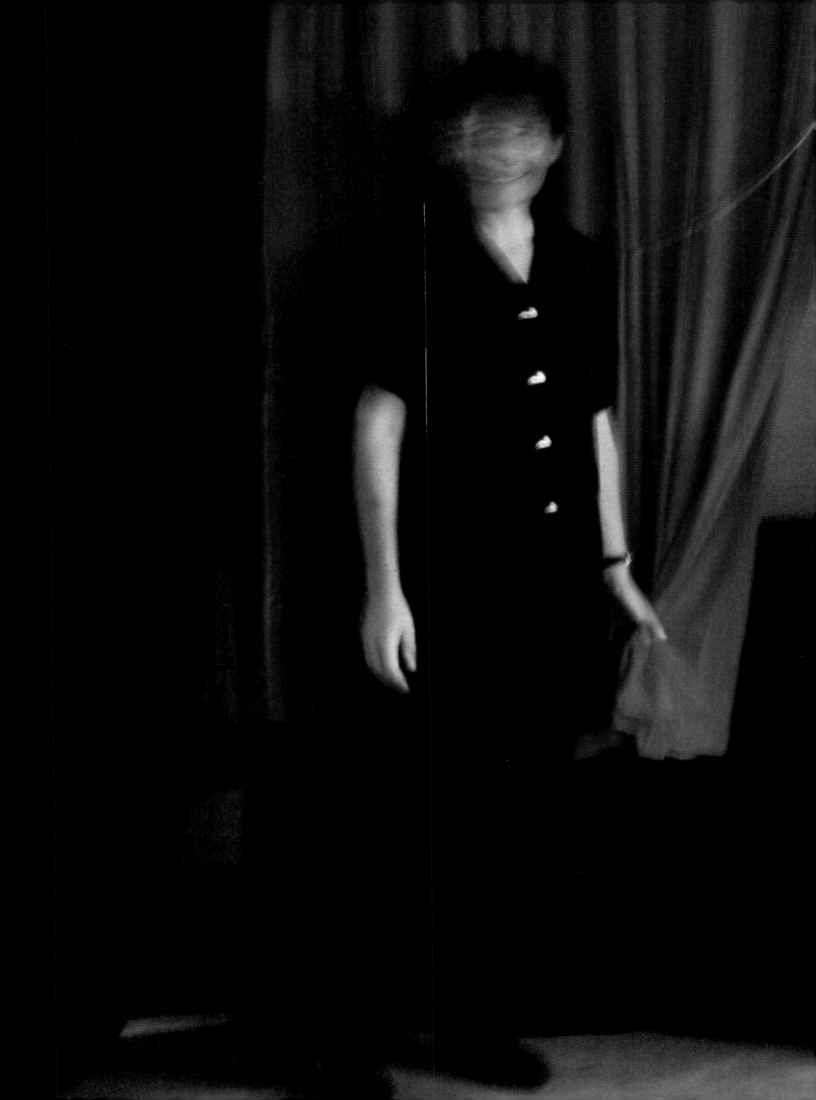

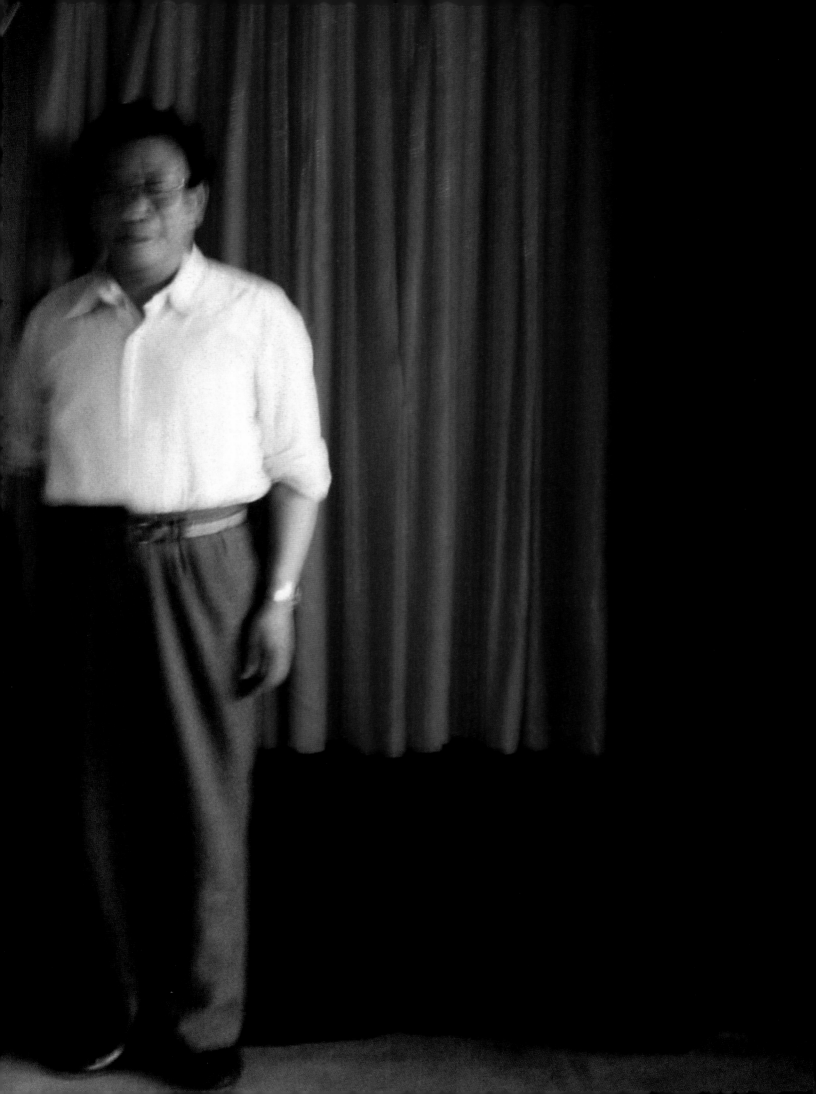

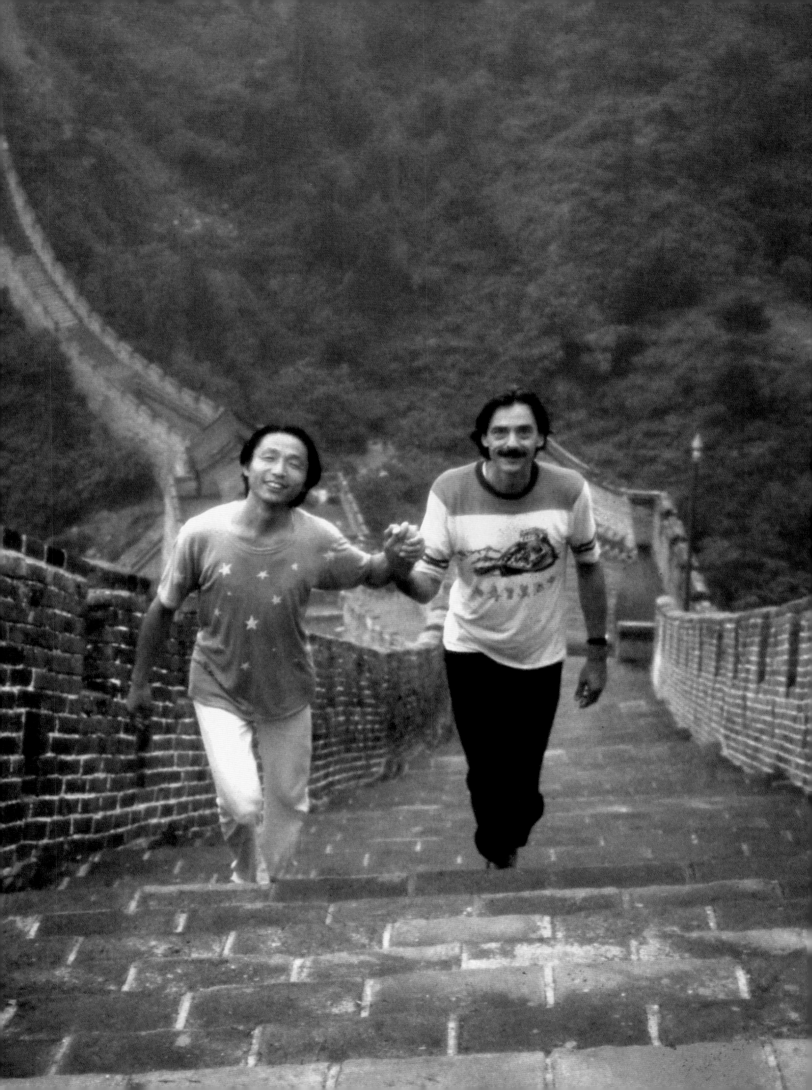

It took eight years, from start to finish, for us to do *The Lovers*. We wrote letters to the Chinese government for eight years about walking the Great Wall. Finally, a diplomat friend read their responses and laughed. He said: 'In the Chinese language, there are 17 ways to say no, and you've just heard all of them.' But if you say 'no' to me, then we're just getting started. I never give up. It helped when the Dutch government signed a contract to build submarines for Taiwan and needed a way to repair their damaged relationship with China. They proposed our work. 'Two Dutch artists walk the Wall, friendship, togetherness, blah blah.' The Chinese government responded positively and asked for a huge amount of money. Done. But not before they got a railway clerk from one of the provinces to walk the Great Wall first. It had never been done before. They couldn't let two foreigners do it first. We took a lot of photographs with him. It was all fine. Then the Chinese government asked for more money. And finally, we got to the Wall in 1988.

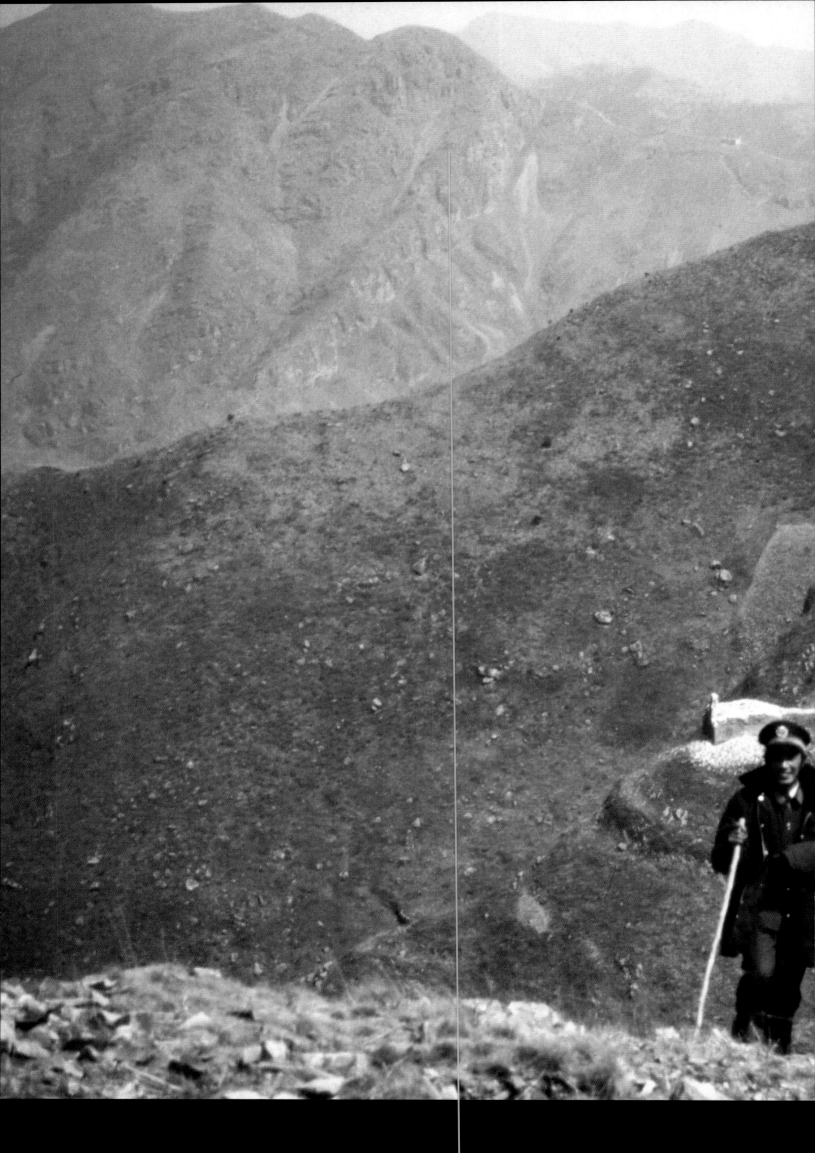

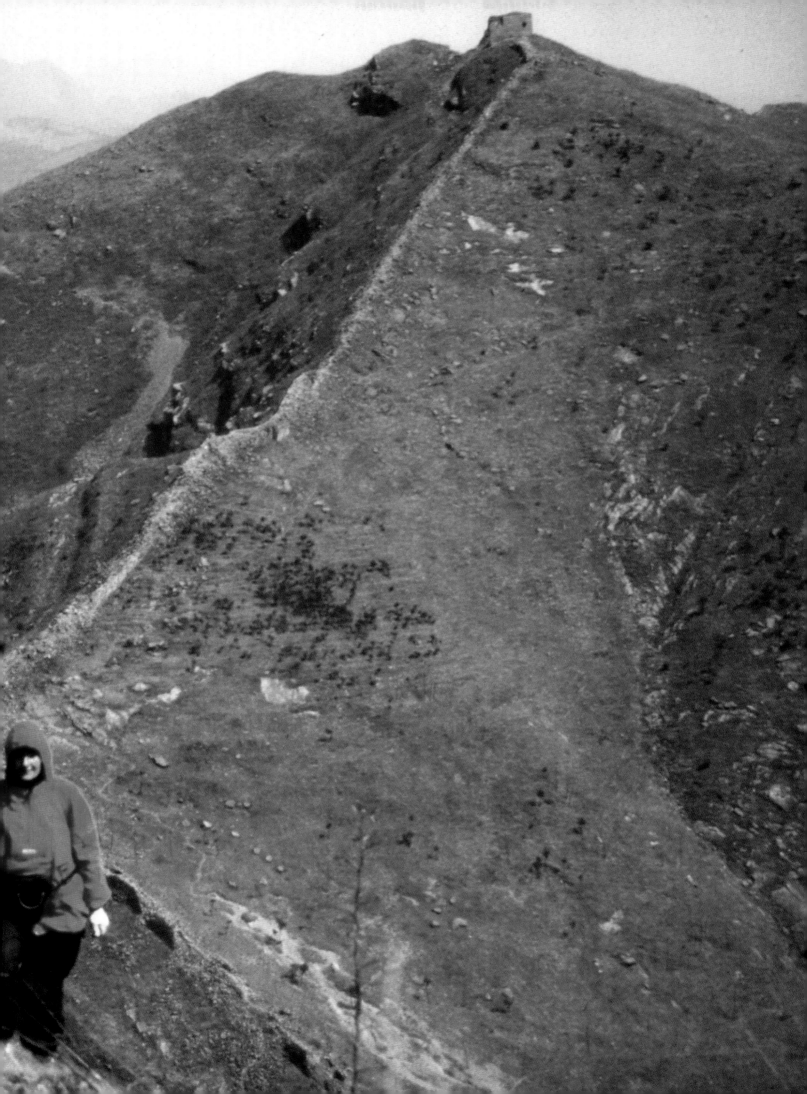

The initial idea was a one-year journey, with me and Ulay walking alone from either side and meeting in the middle. But this was a government deal and there was money involved. The condition was that we had three months. We had to rush. And instead of being alone, we both had six People's Liberation Army soldiers assigned to us and a guide. My guide showed up to walk the Great Wall in a grey suit and black dress shoes. He absolutely hated me. Within three days, his shoes fell apart, he had a cold and I started feeling sorry for him.

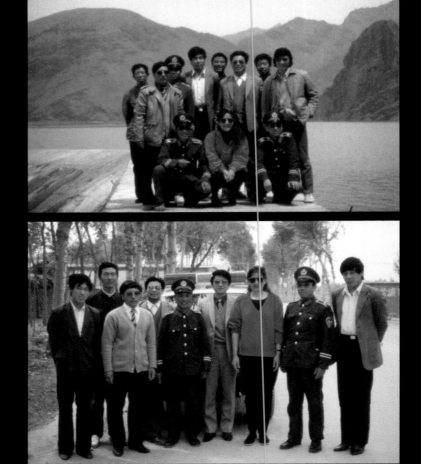

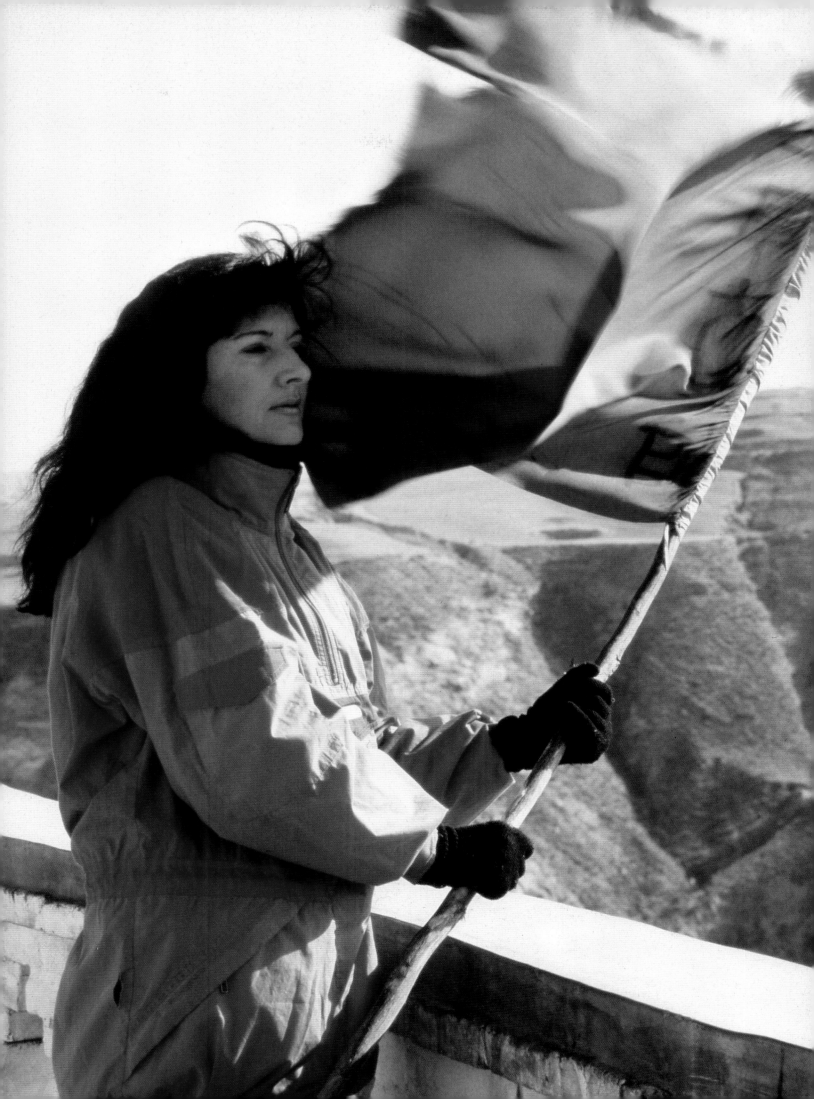

Opposite: Contact prints for *Le Guide Chinois*, 1988/1989

I gave him some of my equipment and a pair of shoes, and we started talking. He told me about travelling with Chinese delegations all over the world. On a trip to America, he had taken photographs of breakdancers, which he self-published as a little Xeroxed 'zine. It became a huge underground hit in China. Totally unsanctioned. As punishment, the authorities sent him to walk the Great Wall of China with me. As the walk became more and more difficult, we became better and better friends. I even made an artwork with him. After being punished with me, he asked for political asylum in America. But now I think he's back in China.

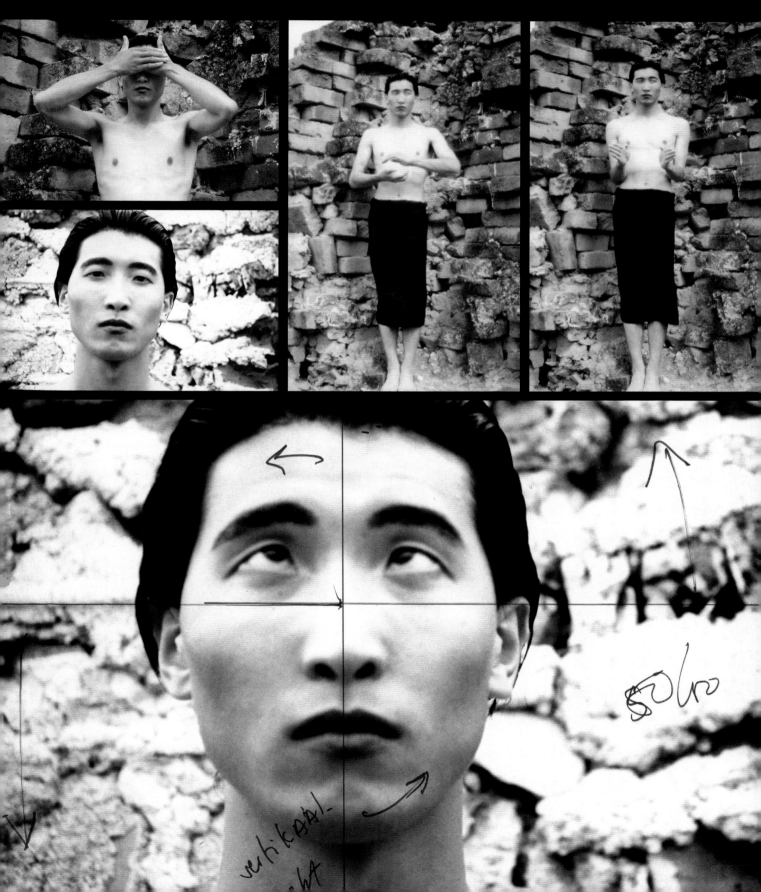

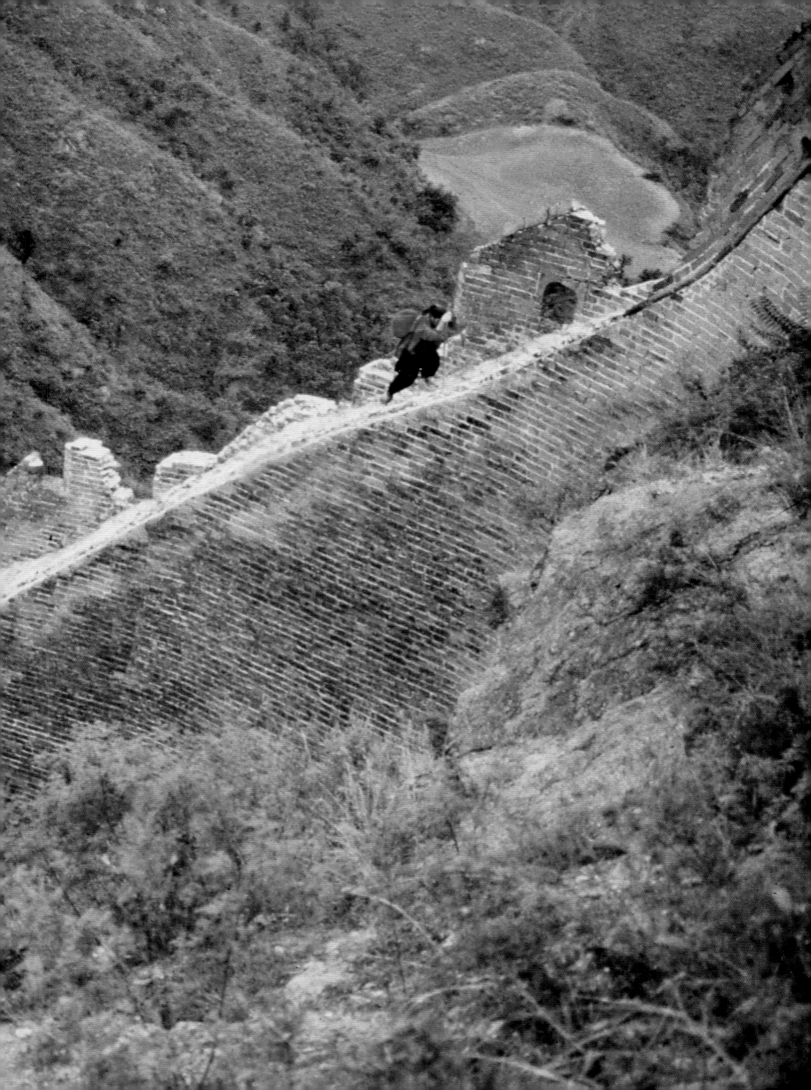

It was so hard in the beginning. My God. Mountains, mountains, mountains. Ulay had all flat, flat, flat, and I had all mountains. It's not Ulay's fault. The legend of the Wall is that it's shaped like a dragon. We agreed I would start from the female energy – the dragon's head in the sea. And he would start from the male energy – the dragon's tail in the Gobi Desert. I had the difficult part. And I always wanted to be first. I was sick, I had pain everywhere, and I still walked ahead of everyone. Finally, I asked my guide: 'Why don't you ever walk next to me?' He answered with a Chinese proverb: 'Only weak birds fly first.' Oops! I started walking with everyone a little more.

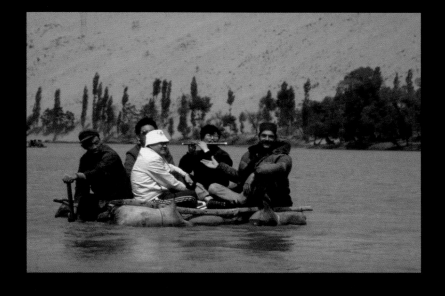

IT WAS SO HARD IN THE BEGINNING. MY GOD. MOUNTAINS, MOUNTAINS, MOUNTAINS.

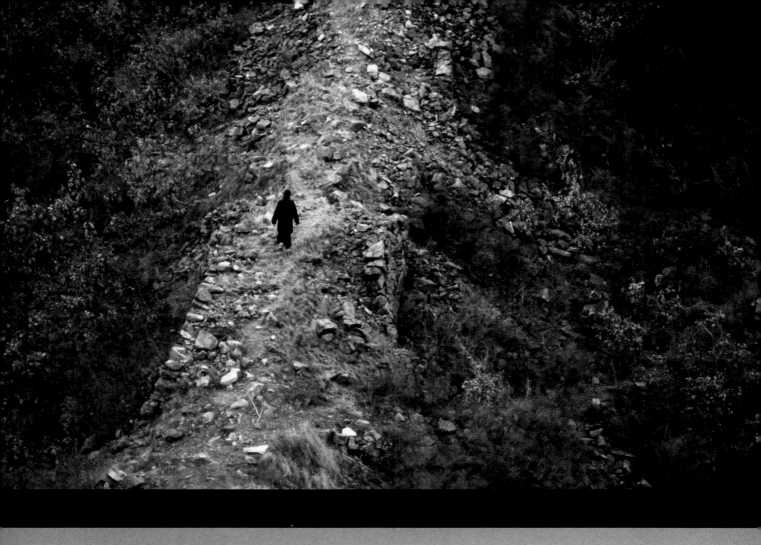
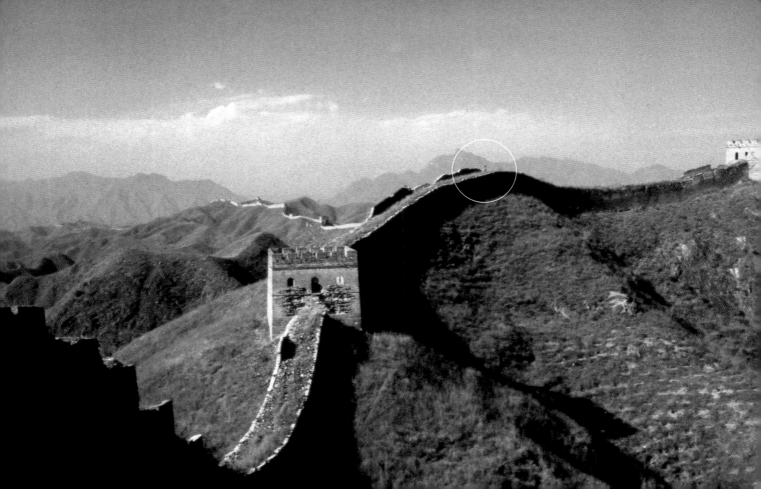

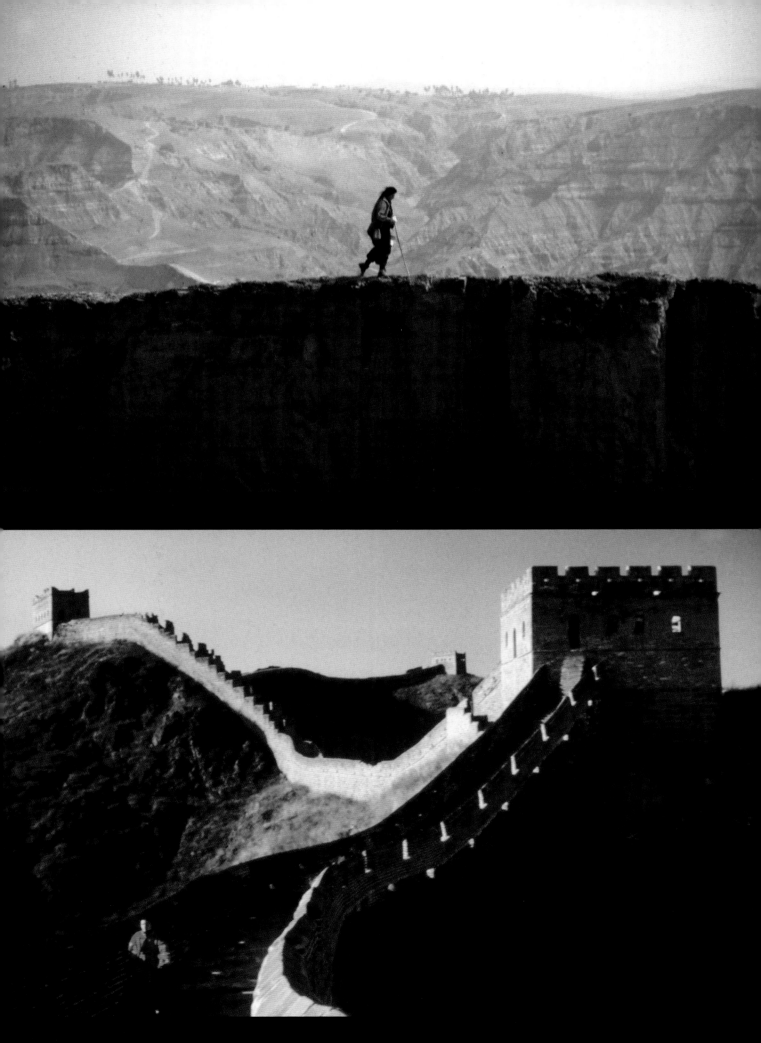

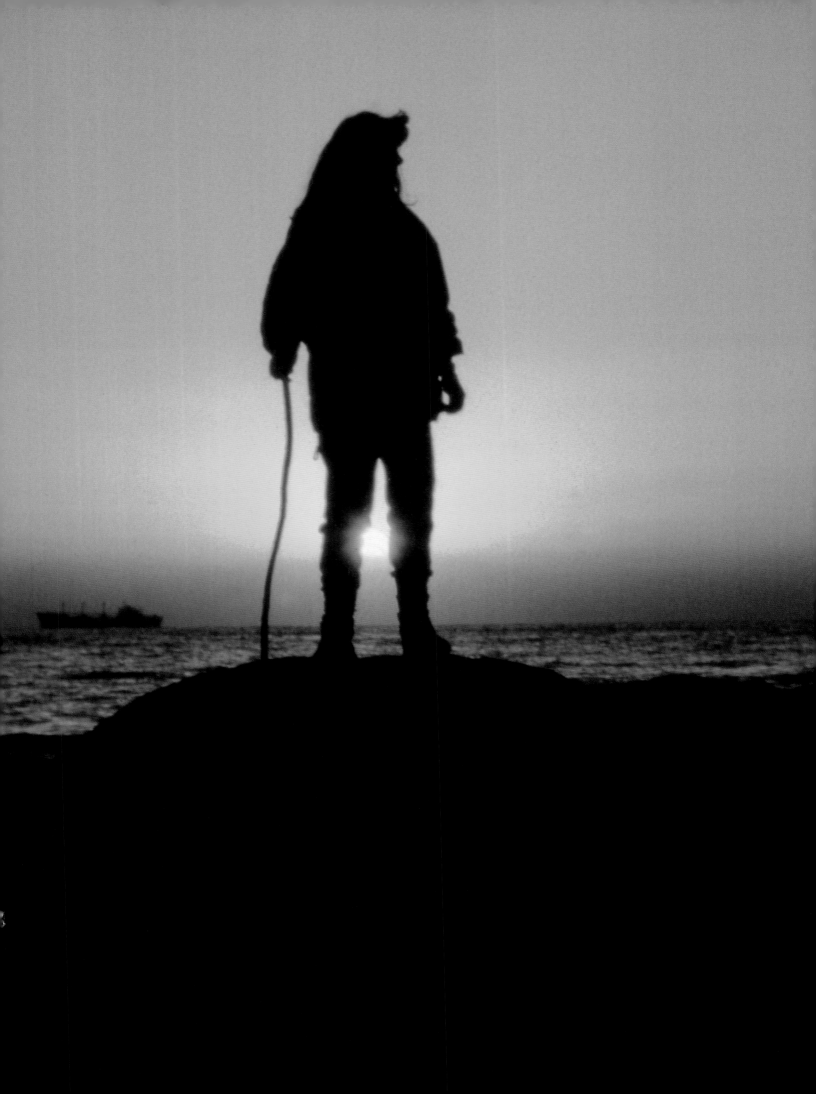

WE AGREED I WOULD START FROM THE FEMALE ENERGY – THE DRAGON'S HEAD IN THE SEA.

I had a tent and wanted to camp on the Wall, but we never did. The soldiers wanted to go down to the villages so they could eat as much food as possible at night. People would take us in. So we slept in the villages. Sometimes together with entire families. I understood the soldiers didn't want to carry canned foods and camp.

I also understood everything we did was predetermined by the government. Some places I was absolutely forbidden from entering as a foreigner. We had to cross those parts in a Jeep. Villagers came to look at me in silence. They were amazed. What the hell was I doing there alone, with no family of my own?

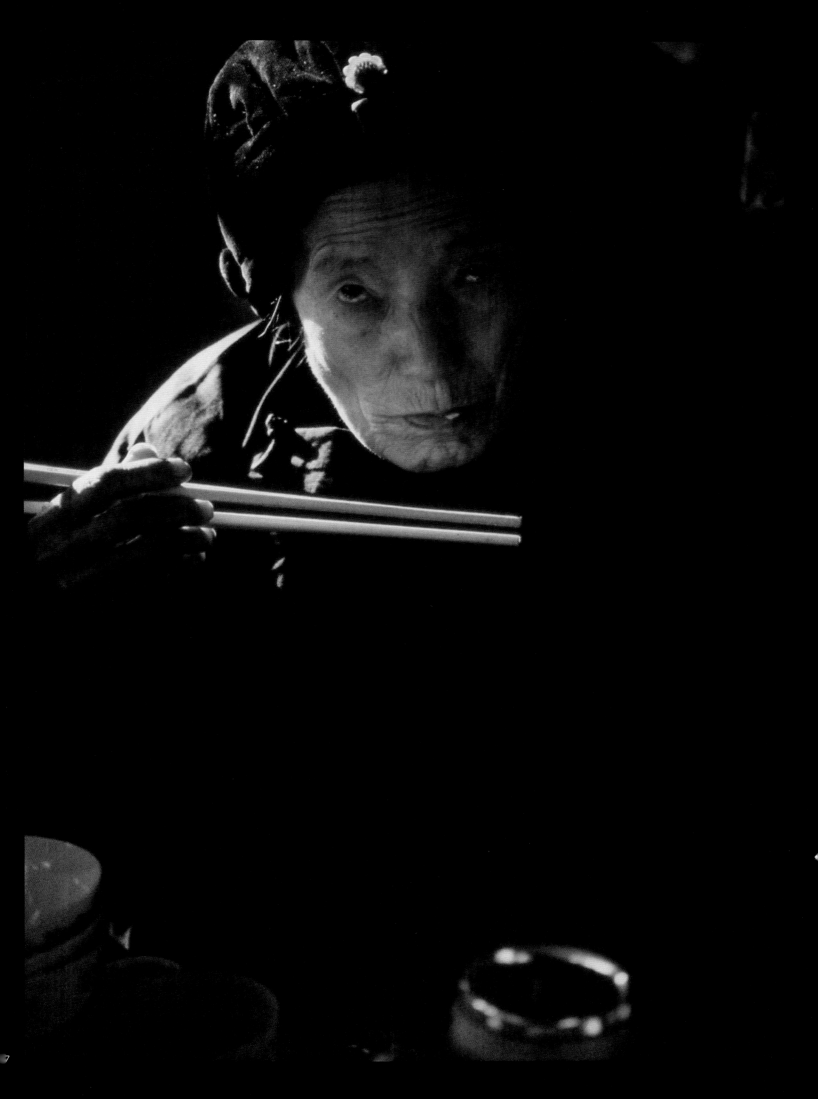

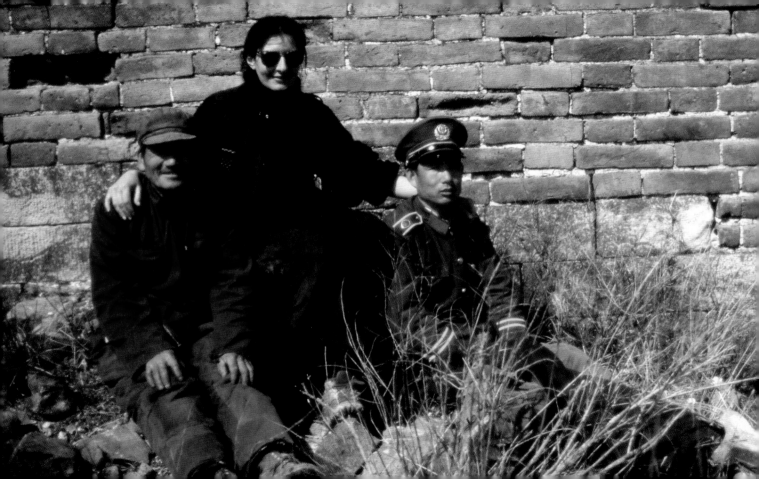

What was left from Confucius, from Taoism
and this wonderful inventiveness of China's
past was wonderful. But I also saw brutal
things. And there were so many restrictions.
Coming from Communism, though, nothing
surprises me.

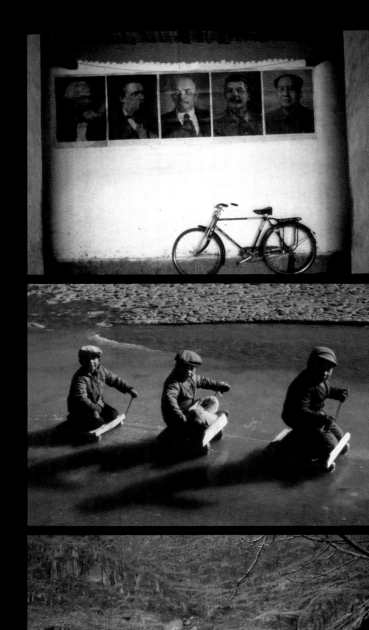

Before I started walking, I went on a three-month retreat to India, where I sat in a cell and repeated a mantra 1,111,111 times. Somehow I felt this would generate good energy for the project. I believed in the art. Then, as I got stronger, everything became like poetry. The landscape, the beauty of exhaustion, the villages, the people who met us…

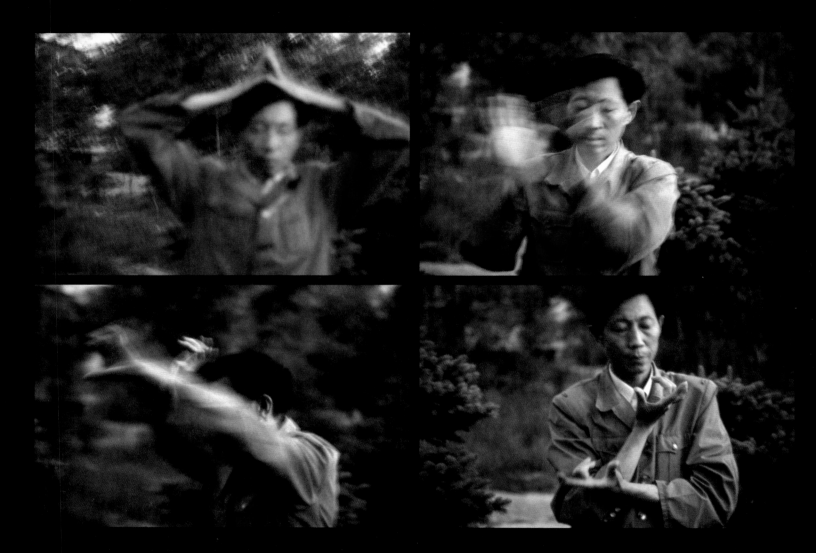

EVERYTHING
BECAME
LIKE POETRY.

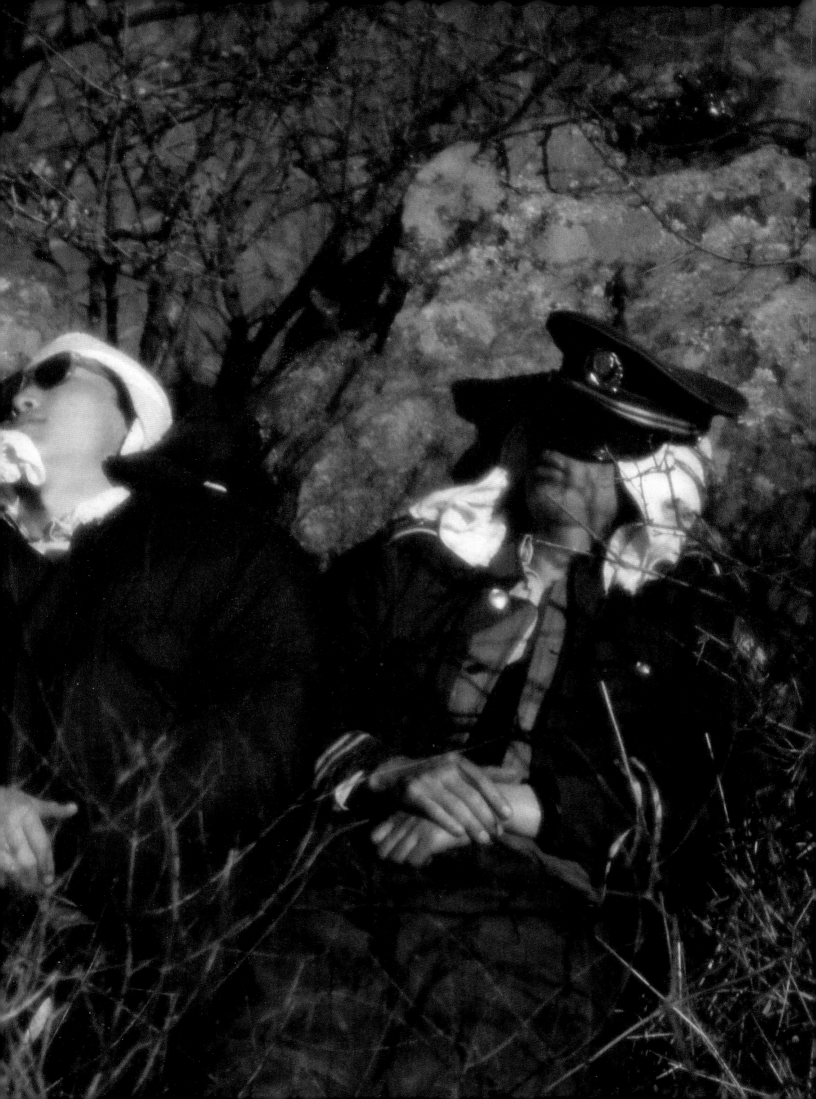

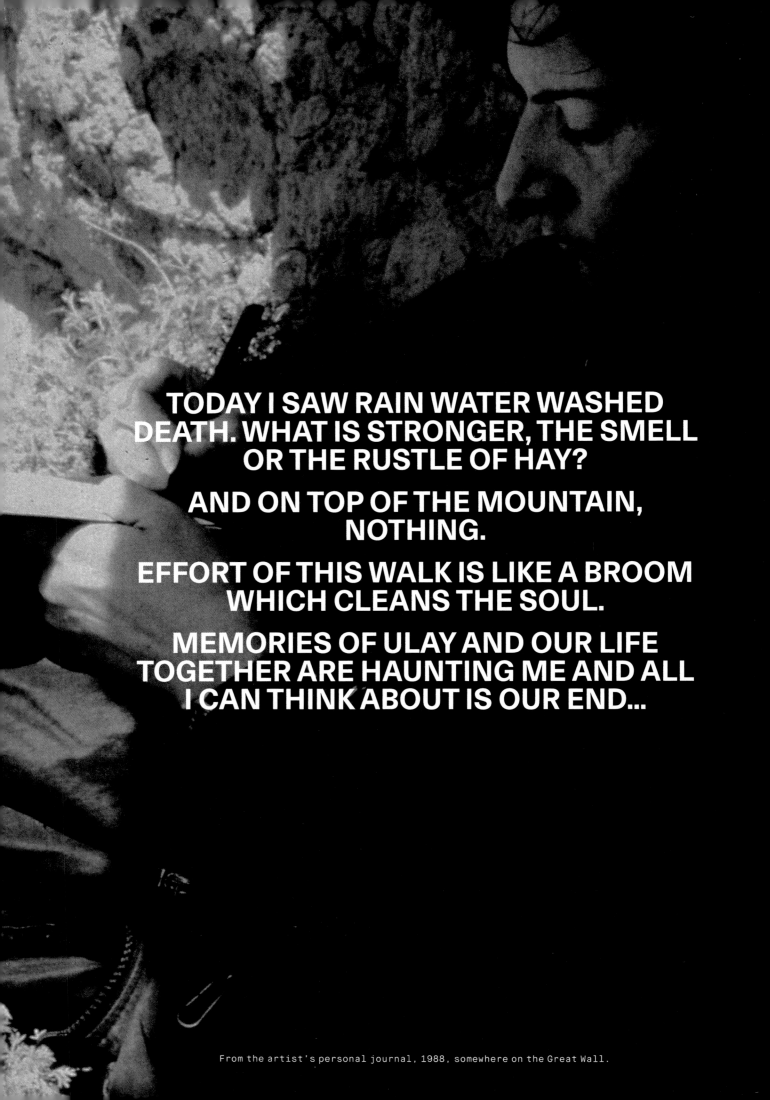

TODAY I SAW RAIN WATER WASHED DEATH. WHAT IS STRONGER, THE SMELL OR THE RUSTLE OF HAY?

AND ON TOP OF THE MOUNTAIN, NOTHING.

EFFORT OF THIS WALK IS LIKE A BROOM WHICH CLEANS THE SOUL.

MEMORIES OF ULAY AND OUR LIFE TOGETHER ARE HAUNTING ME AND ALL I CAN THINK ABOUT IS OUR END...

From the artist's personal journal, 1988, somewhere on the Great Wall.

ll that time I was thinking about Ulay,
f course. Because the end of this project was
he end for us. You understand, I wasn't just
osing a partner, I felt I was losing the work.
felt completely alone.

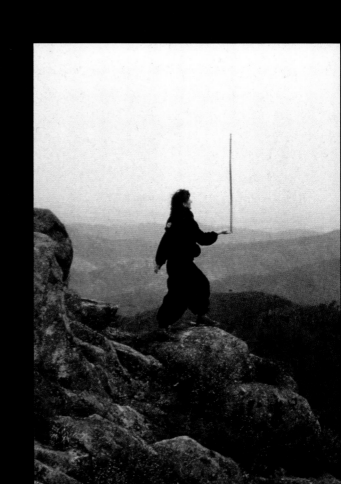

I WASN'T JUST LOSING A PARTNER, I FELT I WAS LOSING THE WORK. I FELT COMPLETELY ALONE.

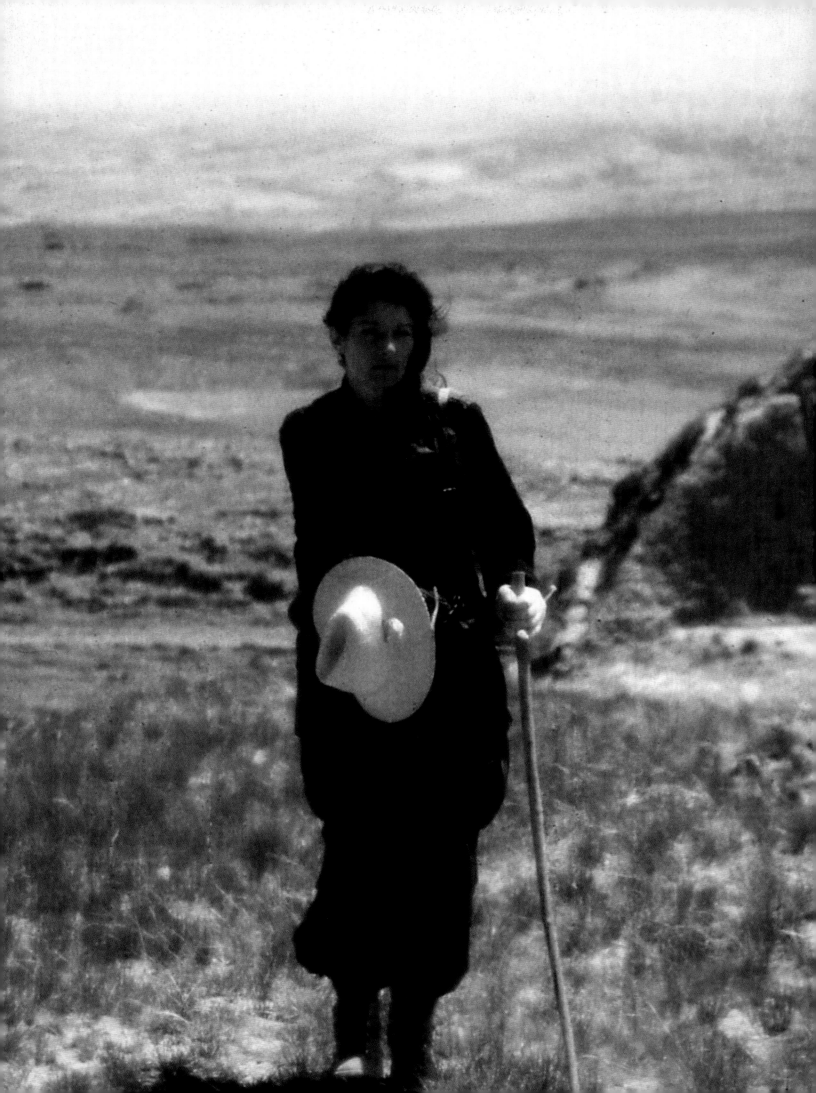

Let me tell you something different. I could not wash for days and days and days. One time, I got a very high fever and we had to stop the journey. As I recovered, I felt I needed to wash my hair. It was impossible. I couldn't run a comb through it. So, we went down to a village where there was a big well in front of a house. We got buckets of hot water, and one of the soldiers washed my hair for a long, long time. I was totally silent and just let it happen.

It was the most erotic experience I had in a very long while [laughs]. Another time, they didn't tell me I had been walking in the wrong direction for six hours. I remember stories like this. But I barely remember the meeting with Ulay. I only remember being sad and very angry. We were supposed to meet wherever we met. But he found a photogenic spot and waited for me there. I walked three days longer because of that.

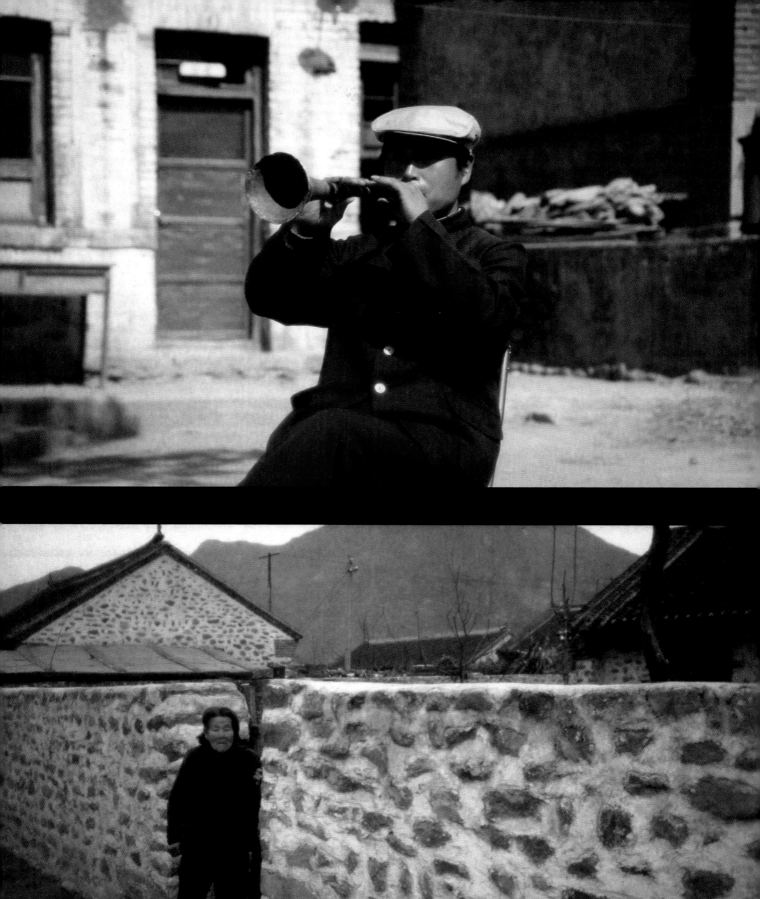

ANOTHER TIME, THEY DIDN'T TELL ME I HAD BEEN WALKING IN THE WRONG DIRECTION FOR SIX HOURS. I REMEMBER STORIES LIKE THIS.

Whatever he did, it didn't matter. After
my part, I could have easily walked his, too,
and been the first woman to walk the entire
Great Wall of China. We left in two separate
Jeeps. It took a week to get to a city. I booked
a five-star hotel. Took a bubble bath, cried
and left as soon as I could. We made it official.
That was it.

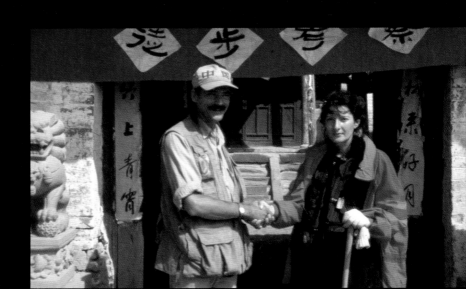

07

A DIFFERENT WAY

BRAZIL
1989–1992

<u>TRANSITORY OBJECTS, LIFE IN TRANSIT</u>

I needed to get as far from China and Ulay as I could. Around then, I became inspired by the black-and-white photographs of Sebastião Salgado, of men working in the Serra Pelada gold mines in Brazil. There is death everywhere in those photographs. I wanted to go there and make a project myself. I was thinking: 'When you see death in the news, you immediately look away. When you see stylized death in a theatre – in film, in opera – you stay, you identify with it, you cry, you love the drama.' I wanted to simultaneously show footage of real death next to staged operatic death, something of [opera singer] Maria Callas. It would be very alarming. I wanted costume designs by seven famous fashion designers. Yves Saint Laurent Karl Lagerfeld… The real footage would be from gold miners in Serra Pelada, who went there to get rich and in the meantime died. The conditions were so terrible. It was such misery.

Sounds brutal.
It was a great idea. It was called *How to Die*.

The artist calls this photograph: *I would rather die from a snake bite than a car accident.*

Everyone said, you're crazy, you can't go
there, especially as a woman. But I had to.
I took two planes. The second was a cargo
plane carrying 15 people, a guy with a gun
and a tranquillized donkey. If the donkey
had woken up, it would have gone crazy, and
the whole plane would have gone to hell.
The plane landed.

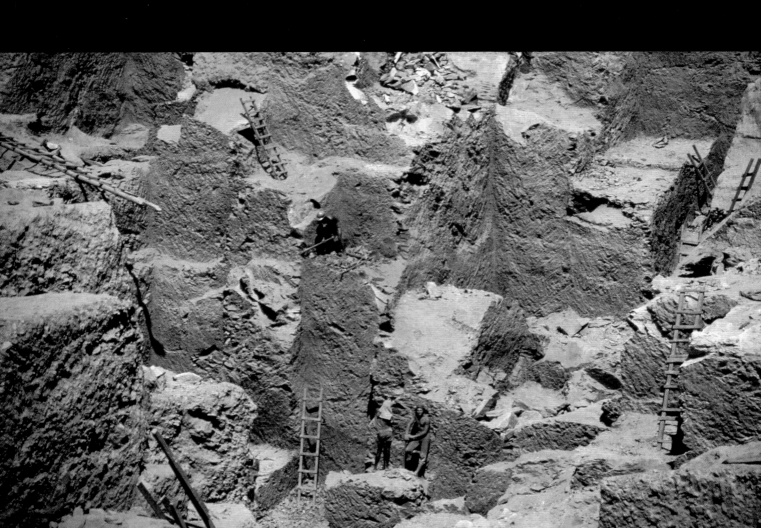

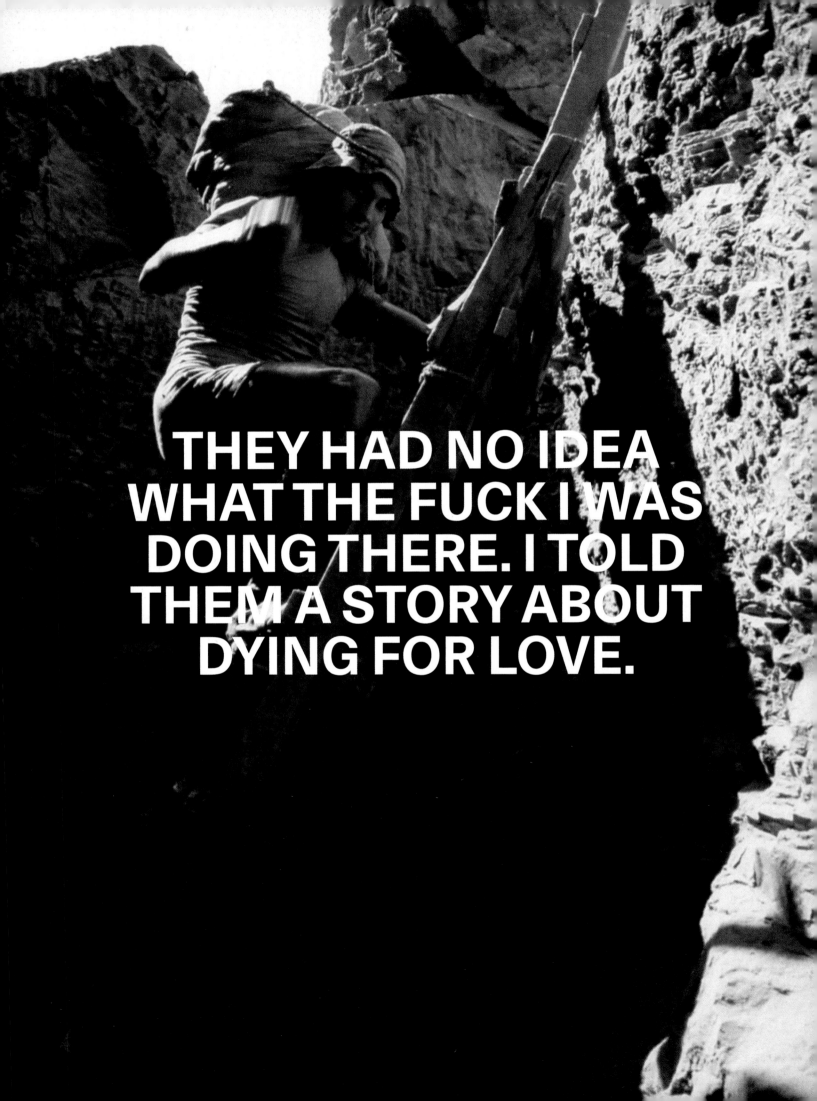

I had a crate of Coca-Cola with me to make conversation. They had no idea what the fuck I was doing there. I told them a story about dying for love. I told them the same things I'm telling you now. And they stared at me like I was from Mars. Nobody ever talked to them like this. Then one guy, he was Italian, started singing from the opera *Otello*. They said: 'Take any photos you like.' They even started taking photos themselves. And nothing bad happened to me. They completely took care of me. It was incredible.

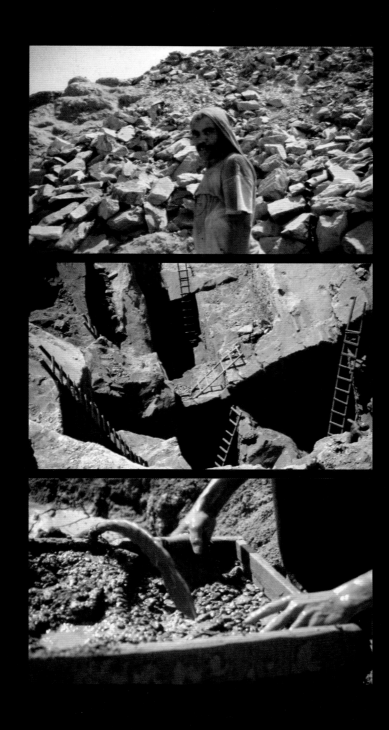

Overleaf: The artist's shrine to Maria Callas.

What happened to the project?
I went to the French government with my
proposal for *How to Die* but never got money
for it. I consider it my first attempt at making
7 Deaths of Maria Callas, which I only realized
30 years later. I was in Brazil a lot in those
years because I had found a new way.

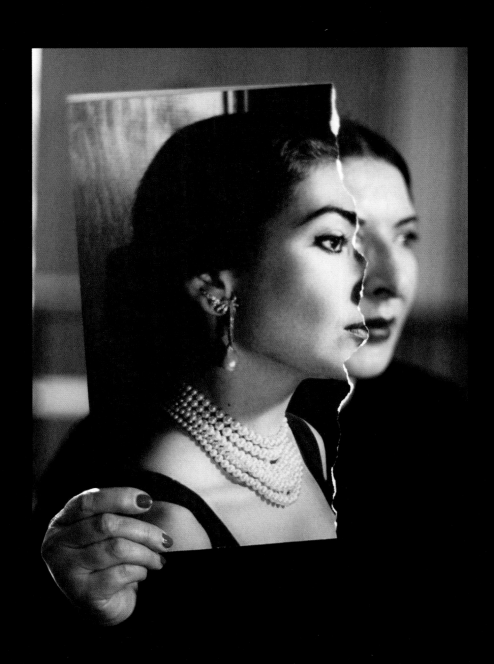

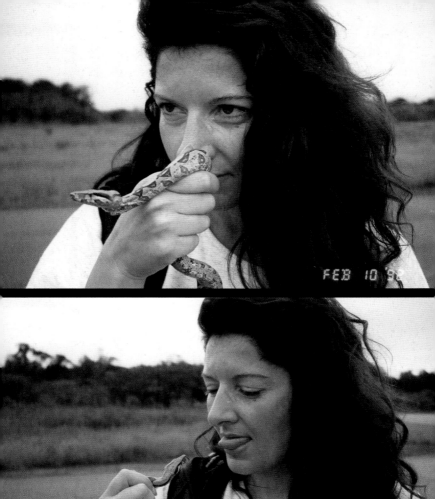

FEB 10 '92

FEB 10 '92

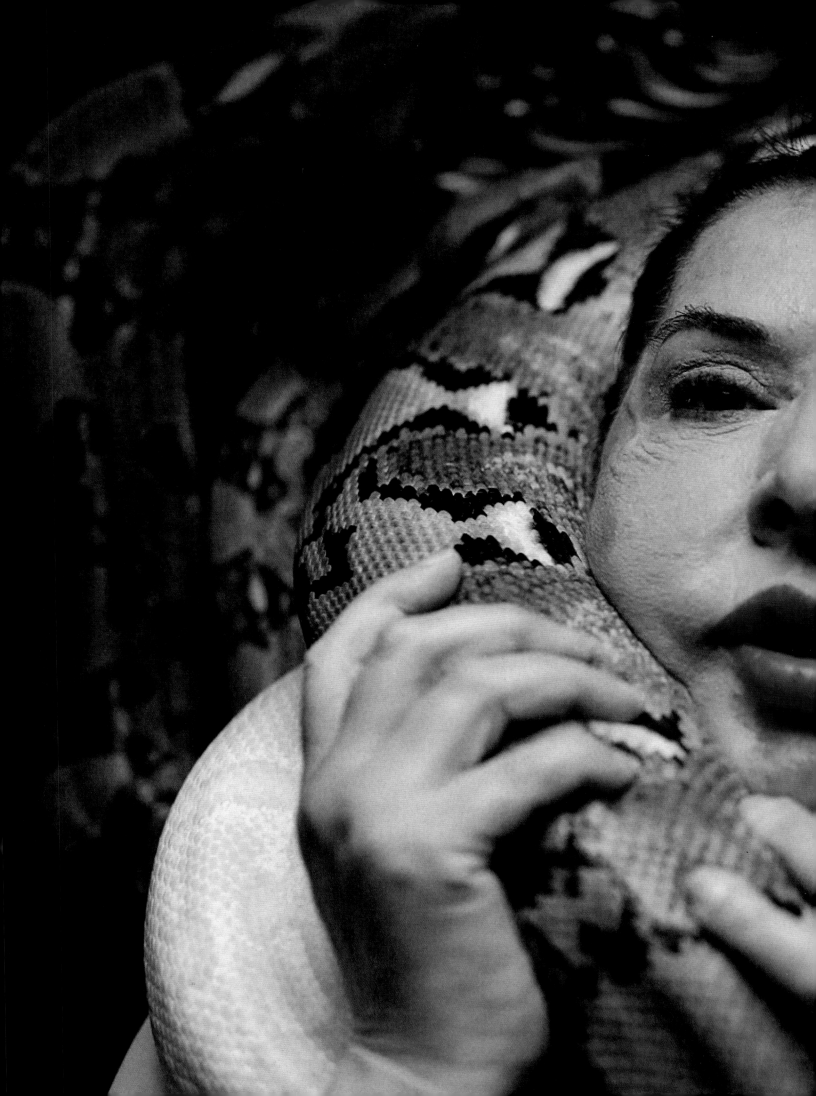

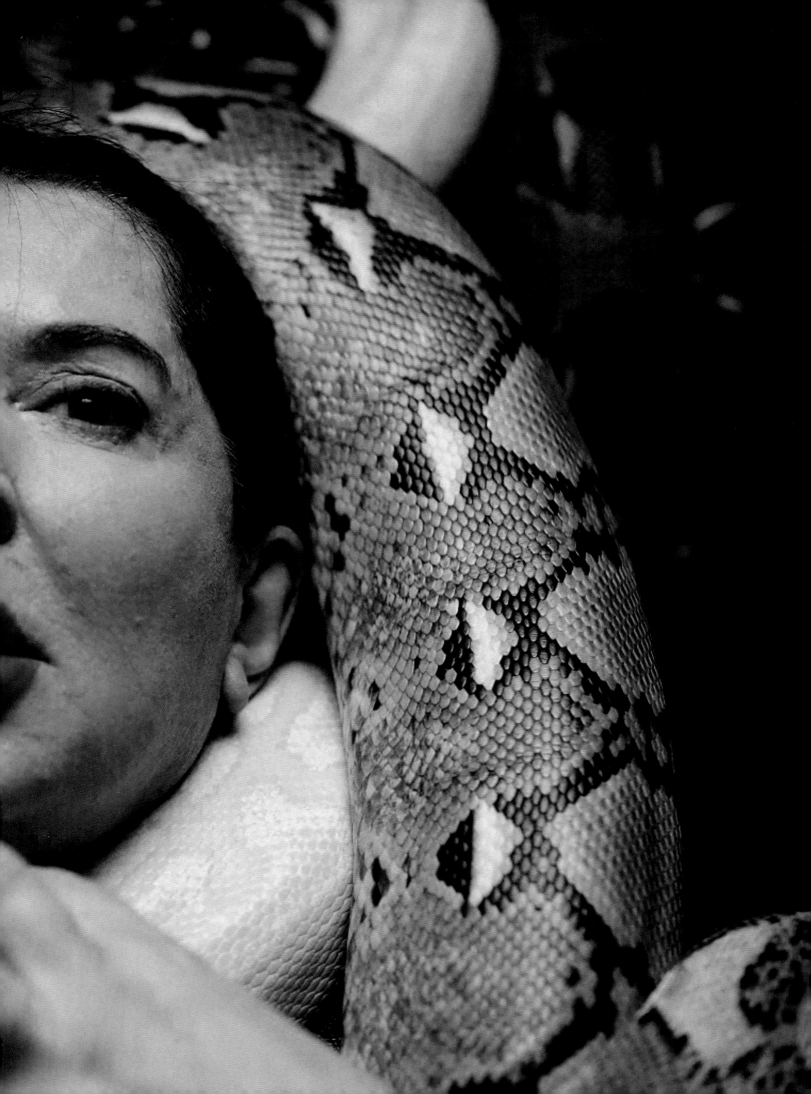

I felt connected to the earth. When I was walking the Great Wall, I realized I felt different depending on the minerals of the terrain below me. My energy changed. The same happened in Brazil, which is full of minerals. In the Chinese villages, I learned a lot of legends connecting the earth to the mind. I began to understand Earth as a human body: quartz crystals are the eyes and memory of the planet and tourmaline the liver. Hematite – iron – is the blood running through the planet, copper is the nervous system and amethyst the mind. I wanted to connect the public to this energy.

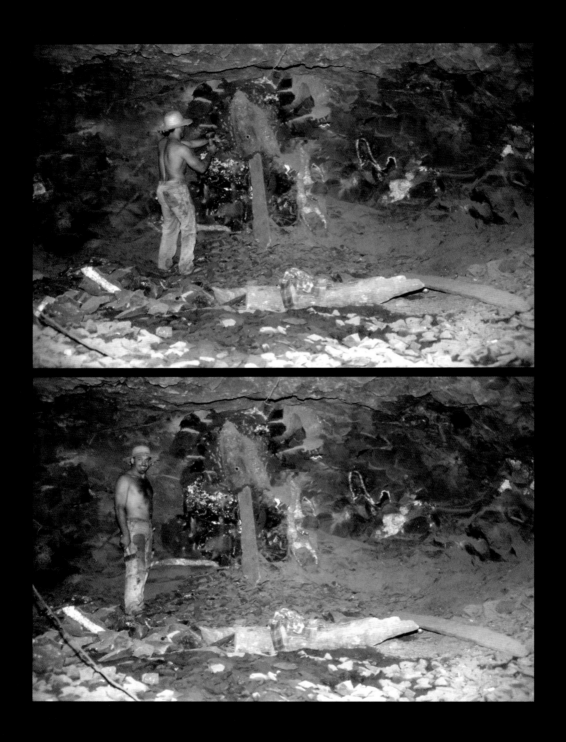

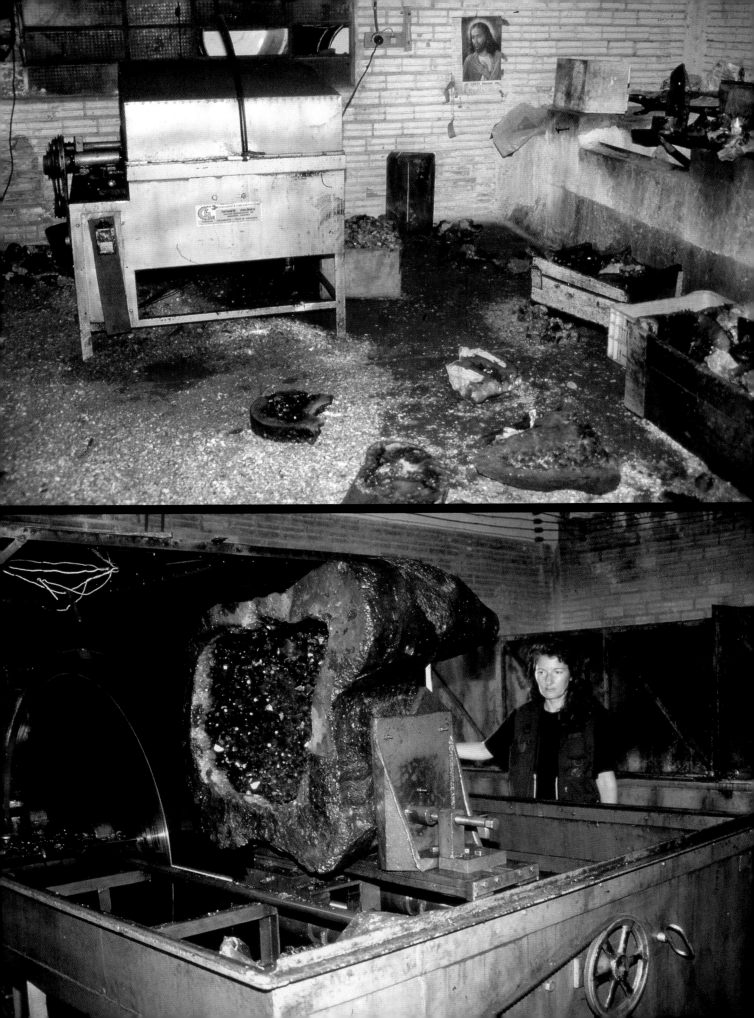

I TURNED 45 NOT LONG AGO.
I STILL DON'T FEEL MY YEARS, I FEEL
MORE LIKE I AM HEADING IN THE
WRONG DIRECTION ON THIS ROAD
OF AGEING AND DEATH. AFTER
THE WALK ON THE GREAT WALL
OF CHINA I DIRECTED ALL OF
MY ENERGY AND MY INTEREST
TOWARDS MINERALS. THIS INTEREST
IS WHAT LED ME TO BRAZIL...

Excerpt from the artist's letter to her brother, 1–2 April 1991, Ouro Preto, Brazil.

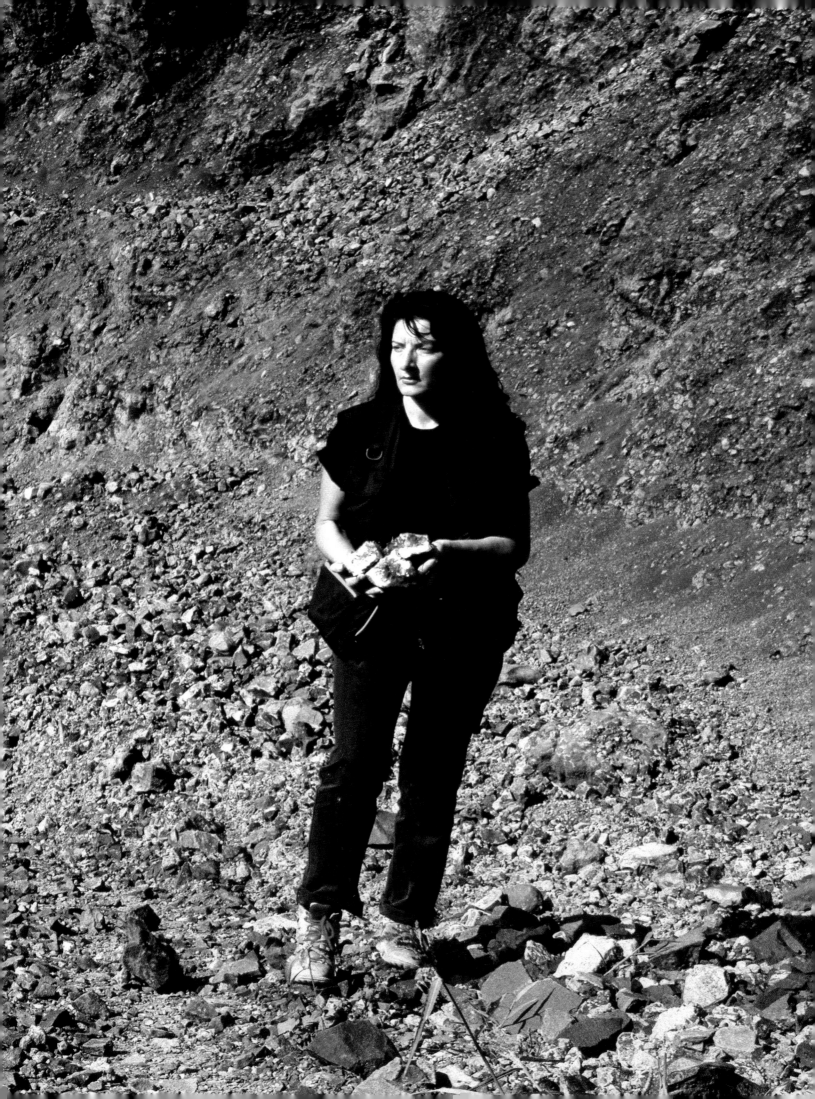

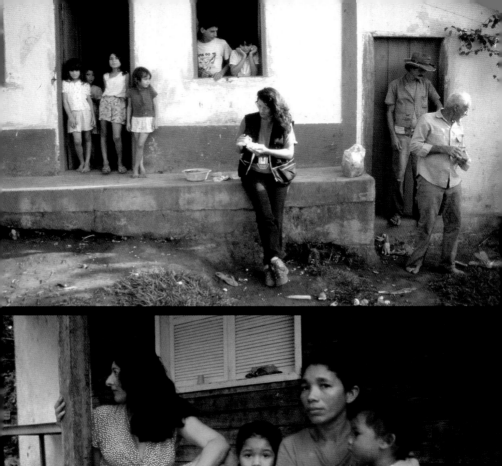

for the material to tell me what to do.

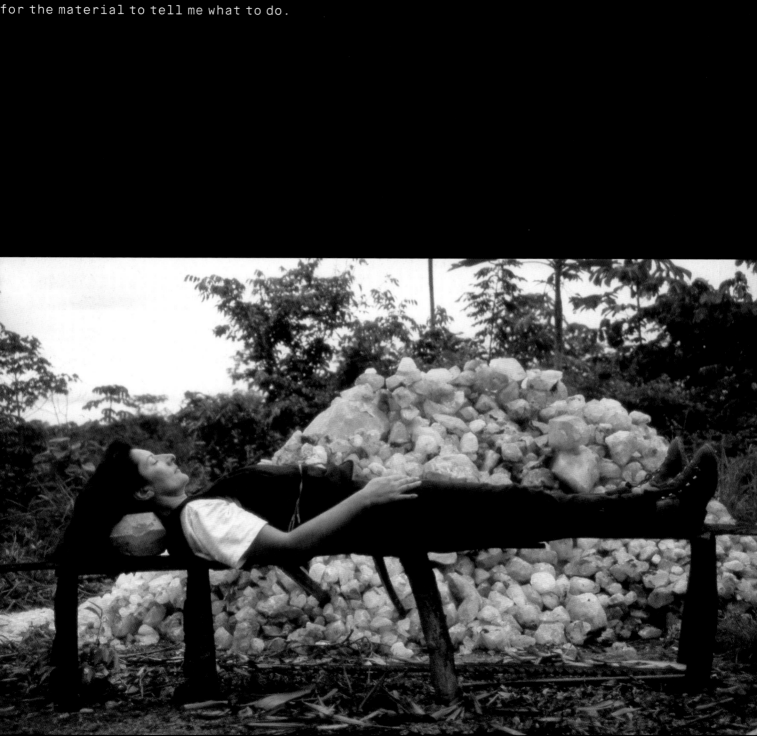

| CIPELE ZA NELJUTSKU UPOTREBU |

Skela kako nam humeine uze

 groce shoes

| kope za NELjutsku upotrebu |

Vlažne tenžene nage
bi ostavijale tragove
na kopru – koji bi se
pod kemiskim dejstvom
kiseline zaago pretvores
u prvo mrke, a posle
zelene tragove.

postavijene
na plesti
od klepca

oglazak

3mm. kerpeh
ploke

pelice to cipeli i torbu
(od prirodnog nebojenog drveta)

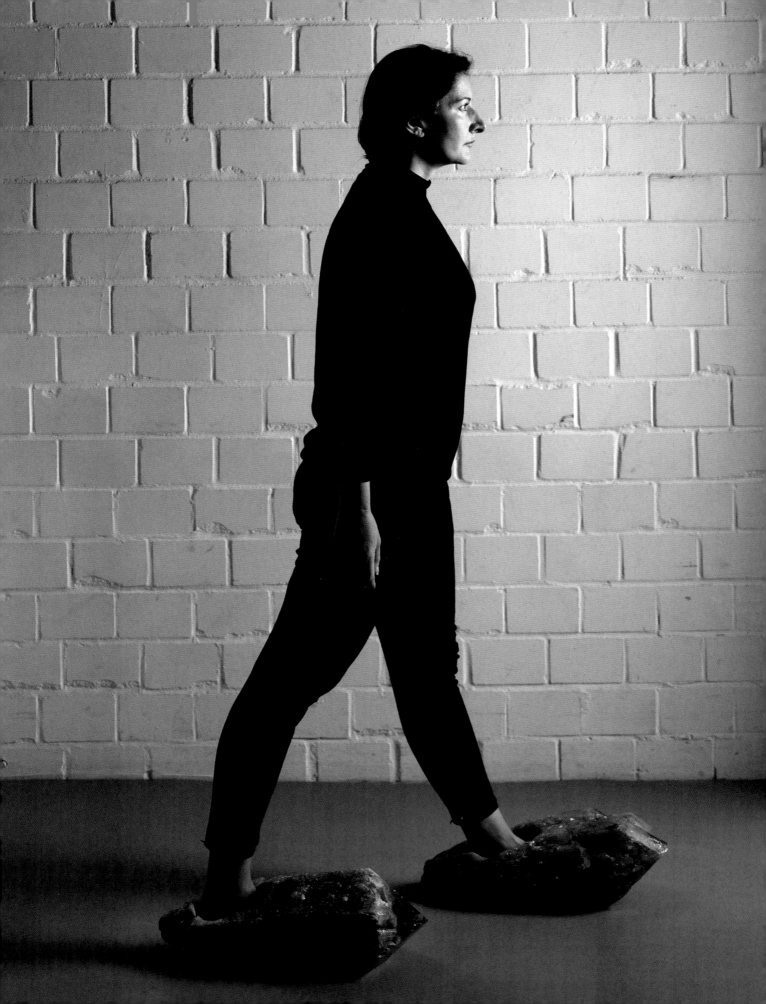

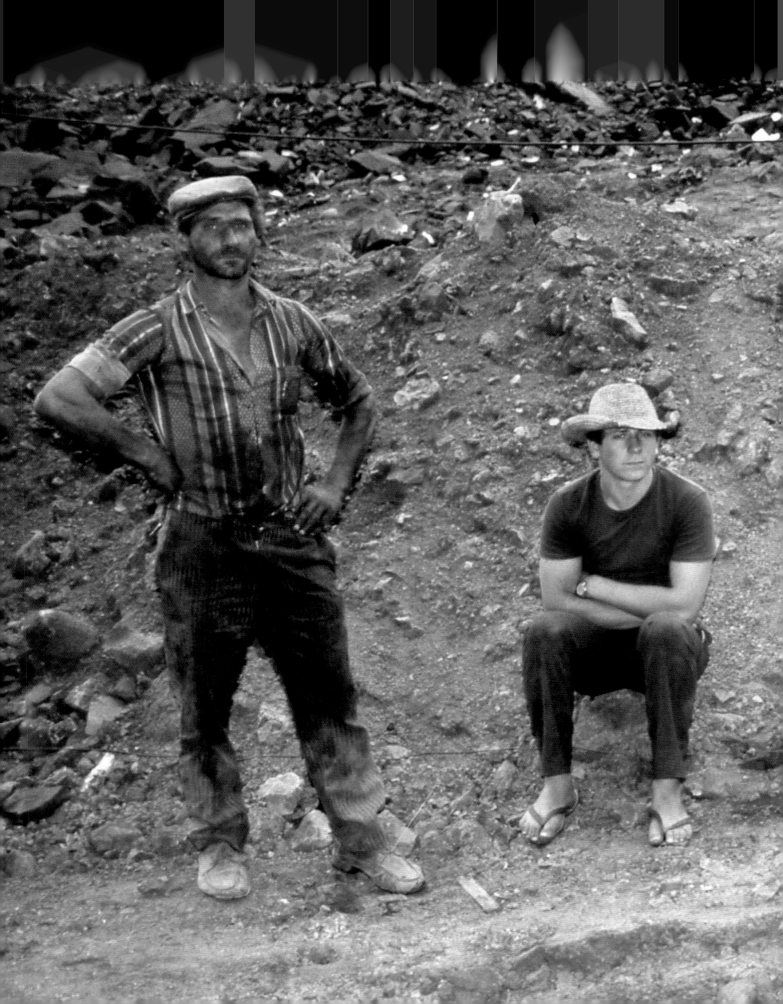

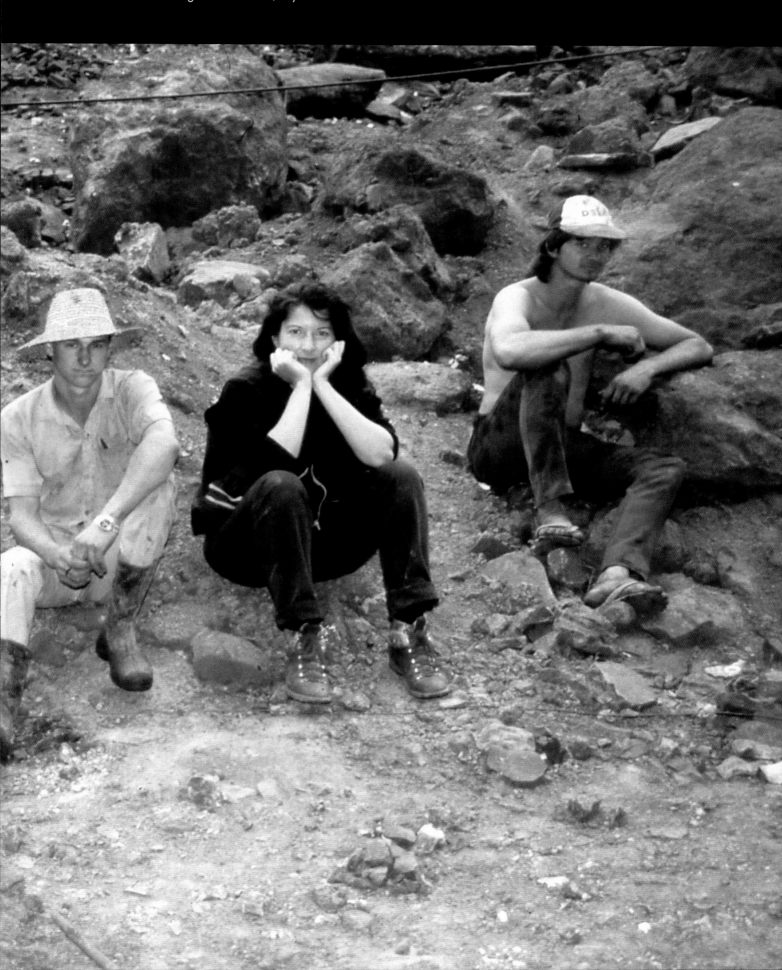

I THOUGHT I WAS DRINKING MEMORY FROM THE BEGINNING OF THE EARTH'S FORMATION. I GOT SO SICK, MY GOD.

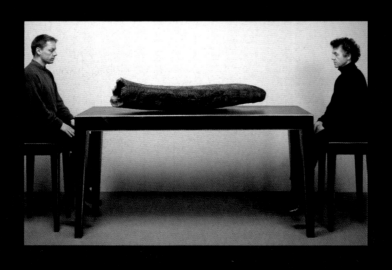

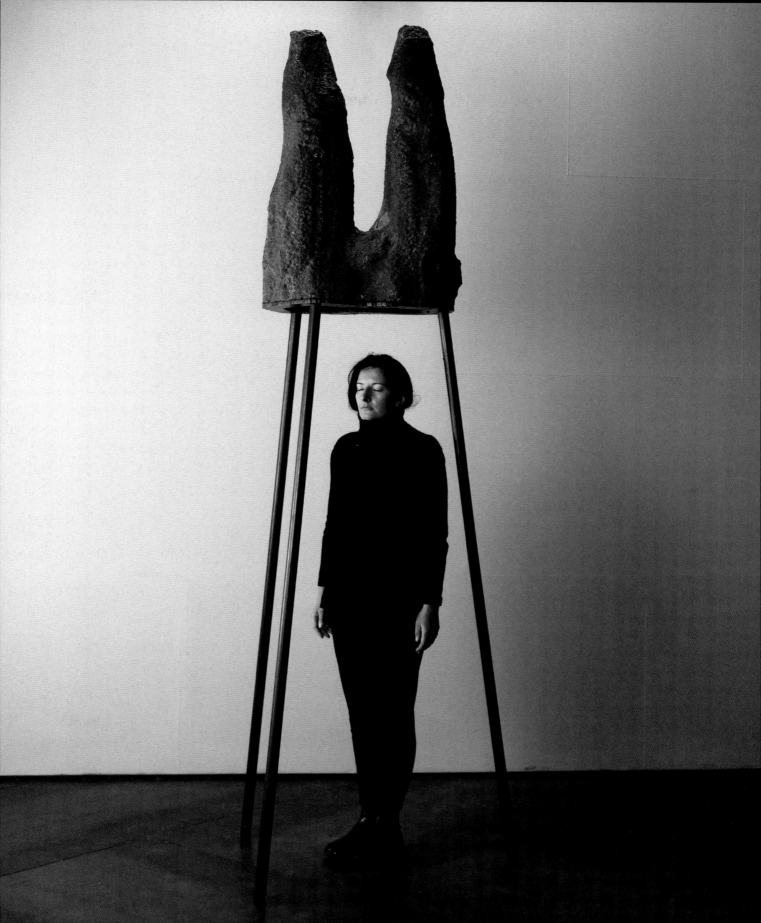

I SURPRISE MYSELF.
I FOUND AN
ENTRANCE TODAY.
DIFFERENT WAY.

From the artist's personal journal, 30 August 1992, Brazil

Then I had a revolutionary idea: *Transitory Objects* – mineral structures that the public presses the body against to trigger a response and receive energy. *Transitory Objects* are not sculptures. The public completes these works. The public's experience is the work. It is important to me that when you walk into the space, all you see is the public facing the wall. Only when the public leaves do you see a physical object. This work changes the functio between artist and public. The public is on the wall and the artist in the space looking at the work. This has never been done before.

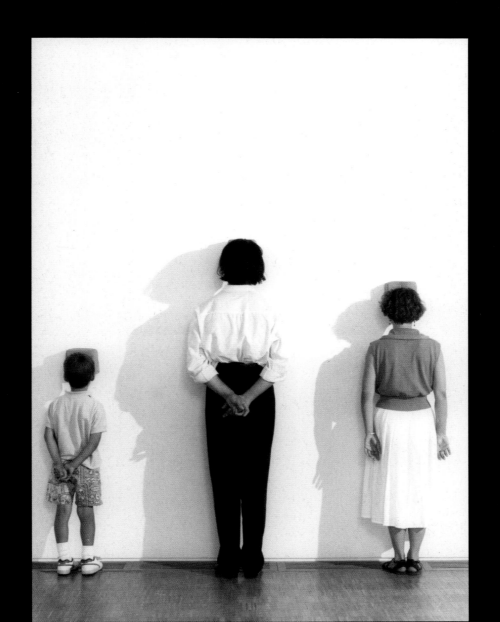

I WOULD LIKE FOR MY WORK
TO FUNCTION AS A CONSTANT
MIRROR FOR THE USERS
OF MY OBJECTS, SO THAT THEY
DO NOT SEE ME IN THEIR
WORK, BUT RATHER
THEMSELVES. THAT'S THE
FUNDAMENTAL THING.

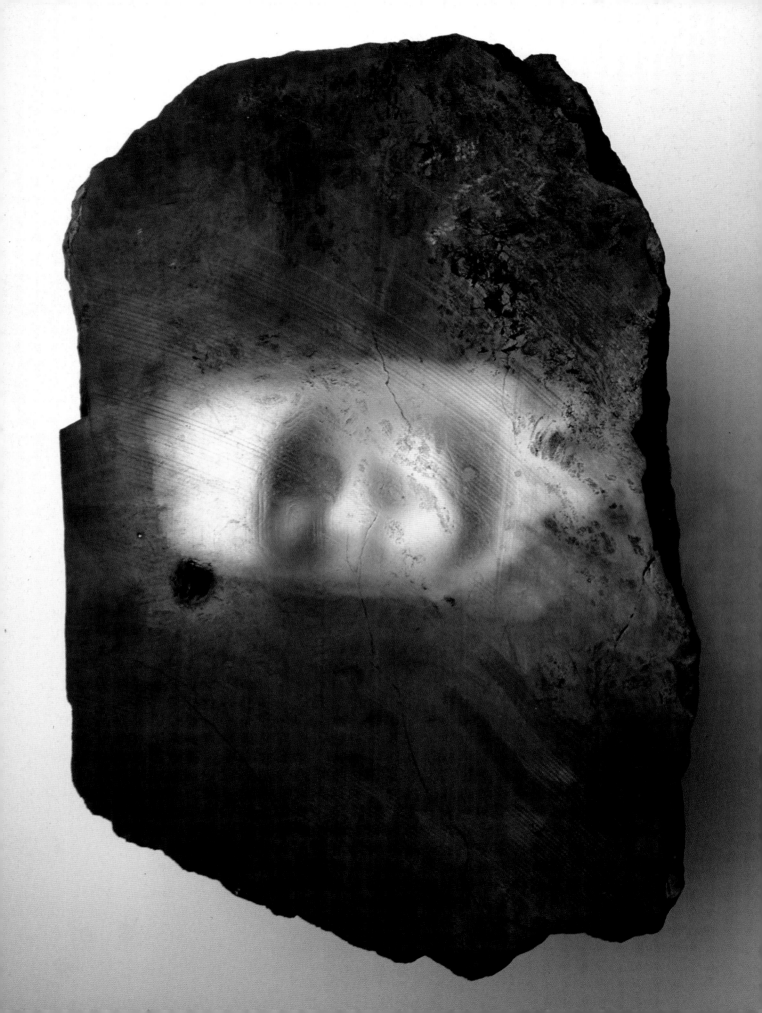

Were you based in Amsterdam at this time?
Amsterdam and Paris. The Pompidou invited
me to work in their studio for a year. I liked
living in a place where you had to dress up
just to buy a baguette. I used to think a good
artist couldn't wear designer clothes and
lipstick and nail polish. Then I thought:
'I fucking just walked the Great Wall of China.
I *am* a good artist.' I started enjoying myself.
I bought a house in Amsterdam. The bank sold
it cheap because a heroin dealer was squatting
there. In Amsterdam, it's very hard to get rid
of squatters. There were still addicts coming
to shoot up on the steps all the time. The dealer
and I agreed he could stay there for low rent if
he got the others out. We had an understanding.
While I renovated, he completely cleaned up his
life and moved out. The house was perfect.

But I couldn't stand being so close to Ulay in Amsterdam. After China, we had a travelling show together called *The Lovers*. We were a nightmare for curators. We had to have two press conferences, two dinners, two separate exhibitions in one place. Everything was separate. We couldn't talk to each other. So in my work, I replaced Ulay with the public. In my life, I did have a guy right after Ulay.

He helped me in Brazil. There were so many logistics with crating and getting government permissions to ship such large crystals. But he was a bad photographer. All of his photos were unfocused. So…

Honestly, what happened to me? Why I am so crazy? Every chapter in this book could be somebody's entire life.

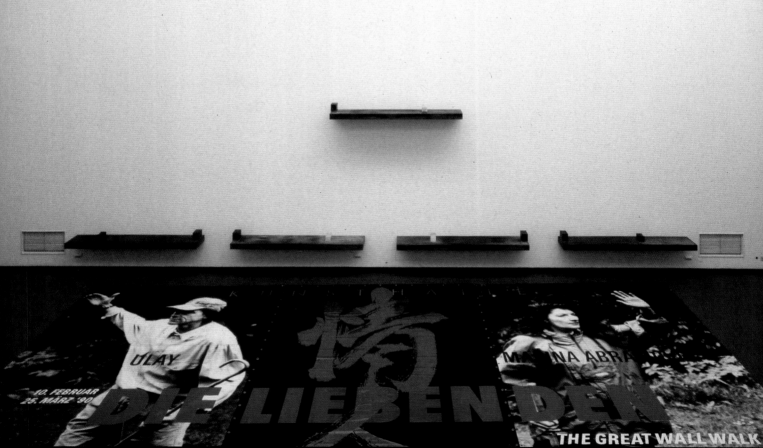

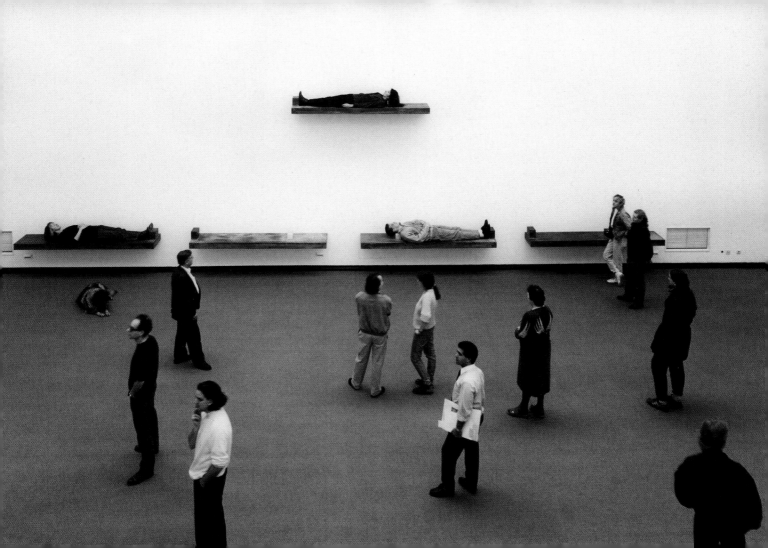

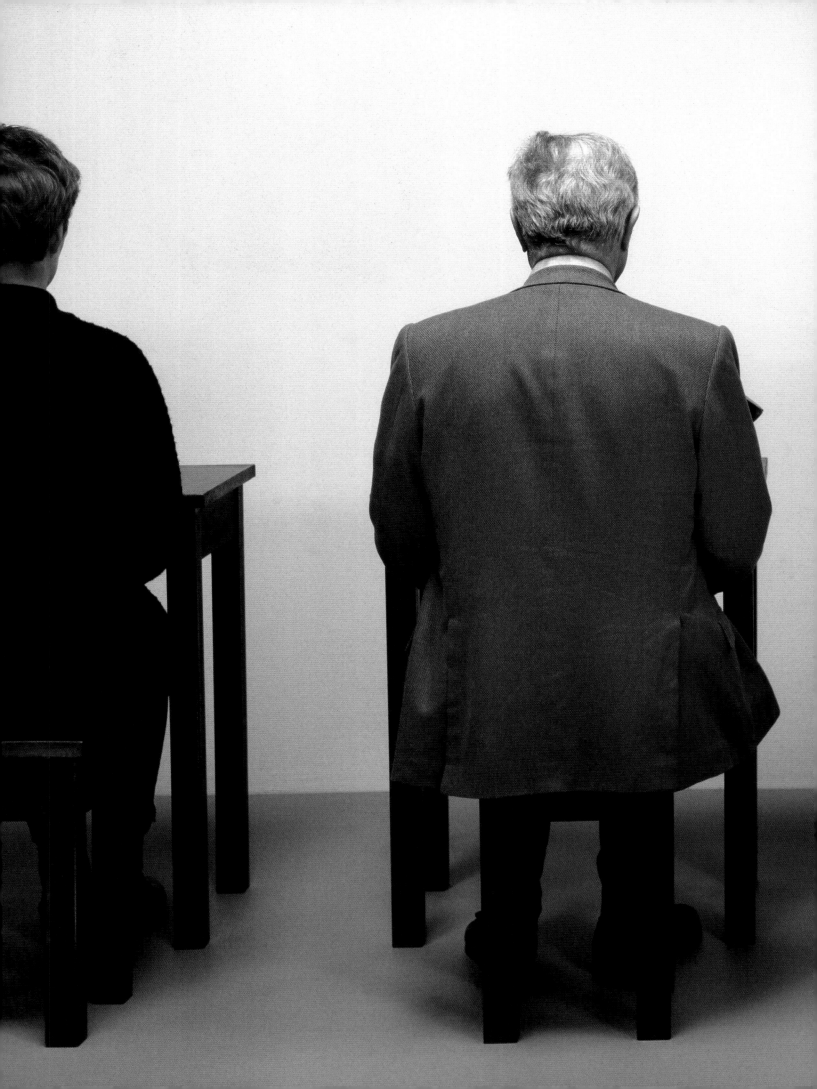

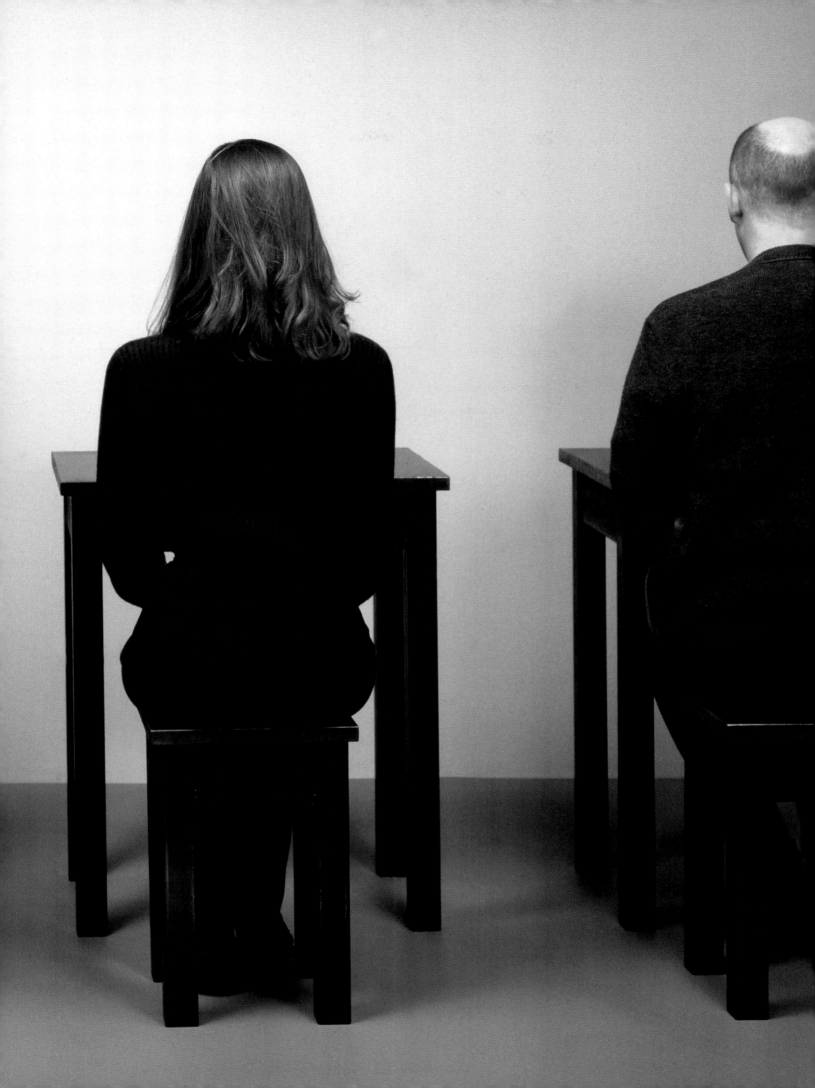

08

A PLACE
THAT
NO LONGER
EXISTS

FORMER YUGOSLAVIA
1992–2003

BLOOD, INSULT, PRIDE

I WAS INCREDIBLY
ASHAMED OF THE WAR.

<u>What was your experience during the war?</u>
I was incredibly ashamed of the war. I was so
ashamed, so ashamed. Artists from around the
world gave statements and made work about
the Yugoslavian War, and I couldn't do or say
anything. It was too horrible.

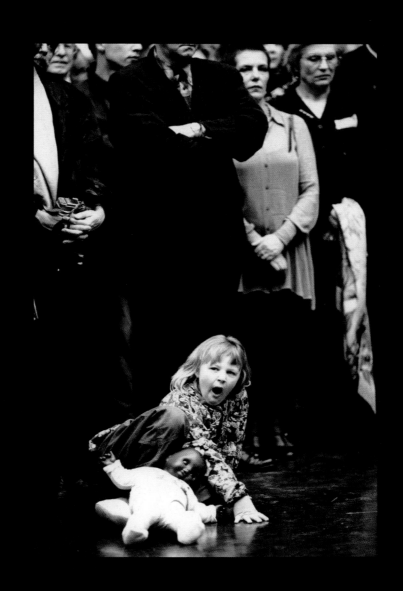

I went back to Belgrade a few times in the late '80s and early '90s. Before my mother's Alzheimer's got bad, before she stopped dyeing her hair, before the bombing of Belgrade. I hadn't had huge success as a public figure yet. My old friends still talked to me. This is my group from the Student Cultural Centre – I can name every person in this photo [right]. I took them all out to a notorious writers' club in Belgrade, where the tables used to be bugged. It's where all the great writers [of my parents' generation] would go, drink too much, tell dirty jokes, get arrested and go to prison. For political jokes: four years. For jokes about Tito and the Party: six years. I was able to invite 25 people out for foie gras and beer, and it was $50 for everything. That's what the time was like in Belgrade – before the supermarkets became empty.

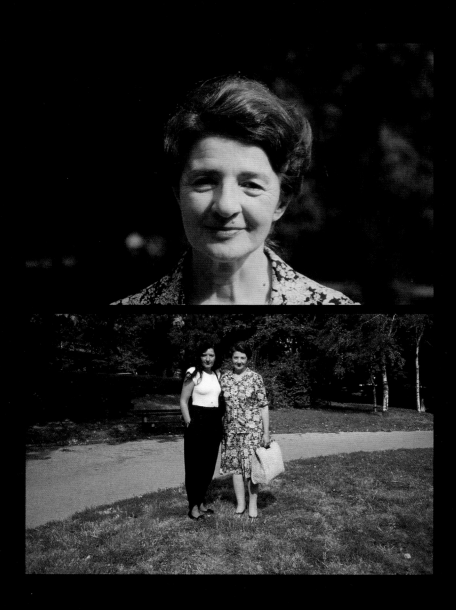

I WAS ABLE TO INVITE 25 PEOPLE OUT FOR FOIE GRAS AND BEER, AND IT WAS $50 FOR EVERYTHING.

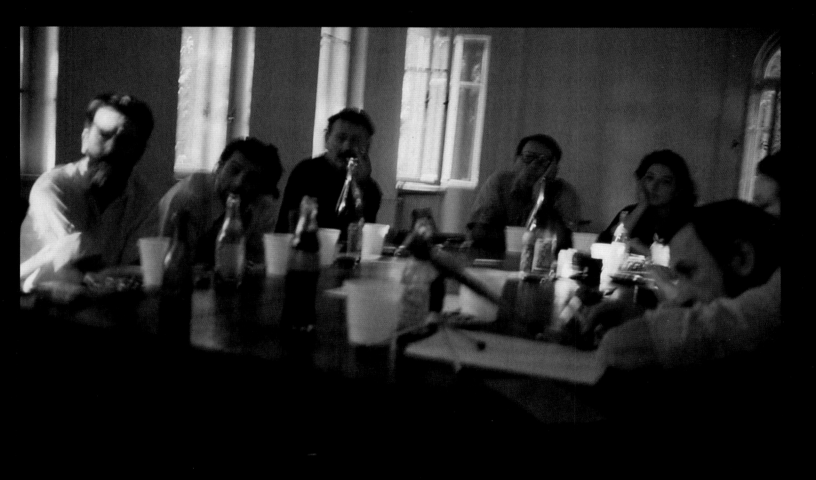

Me and my brother with my father in 1992.
You see all my paintings?

Your father hung *Tito Eating the Country*
in his living room?!
Oh, he was so disappointed in Tito. He cut him
out of all their old photographs together.

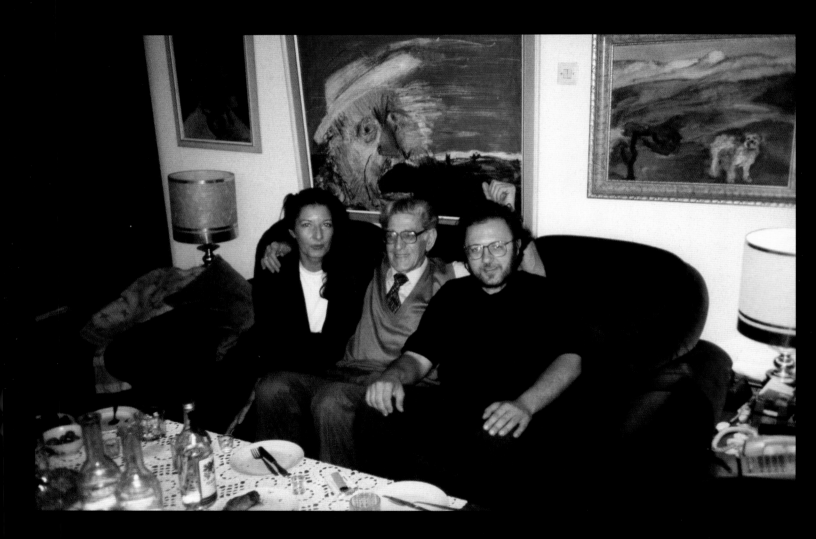

wife, 23 years
he loved her.
y language. They
ed. Everything
do with him. I think

this woman really got t
I came back, she was in
I wanted to help my par
needed money. My mothe
never accepted it.

...e. I was working
or] Charles Atlas.
d restaged my ongoing
formance. We were
n to a nightclub in my
Atlas. I started to
g – I sang.

I can't act—I acted. ...
in my life. I realized ...
old performances every...
the cuts needed time to...
just starting, I took C...
with me.

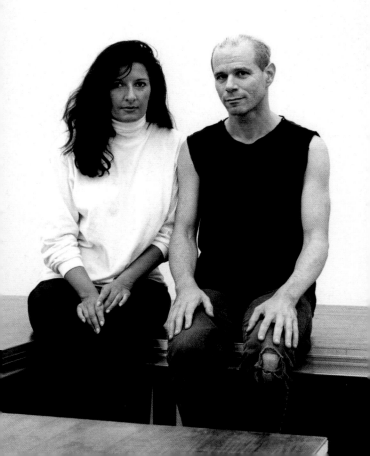

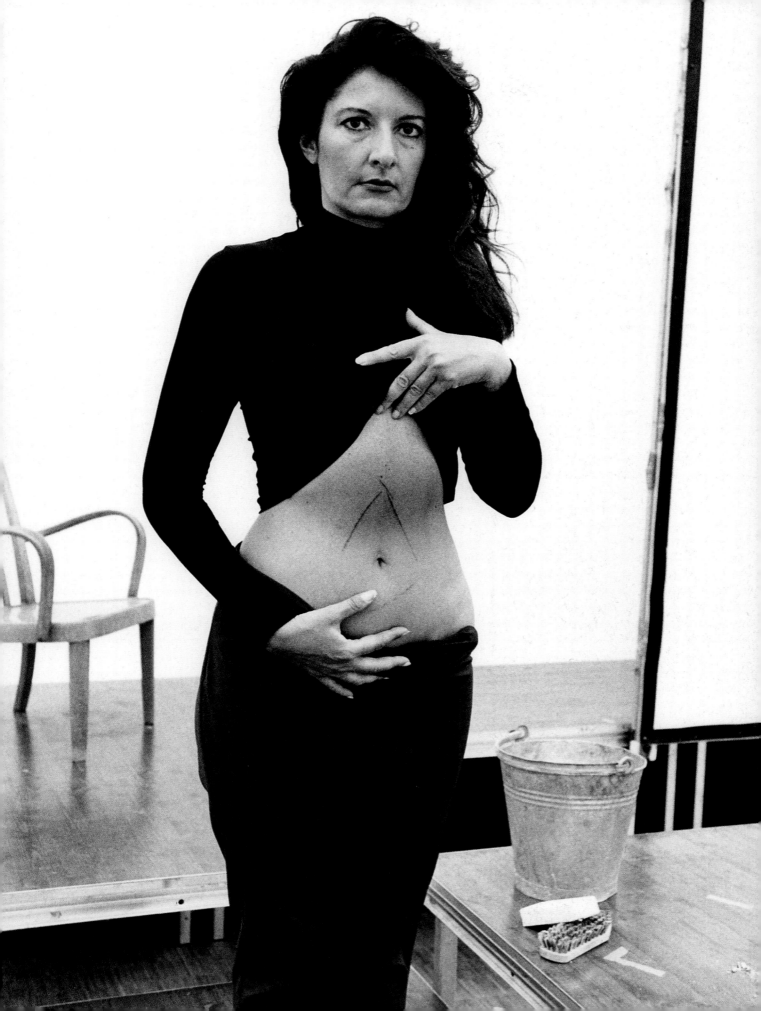

I had the feeling I needed to record my parents while I still could. My mother loved being on camera but wouldn't let us film in her apartment. She didn't want dirty feet in her home. She was crazy about hygiene. I once scrubbed my entire studio in Paris before her visit. First thing she did, she ran her finger over a surface and said: 'Hm. Relatively clean.' She was like a cold shower! So I rented an entire theatre just to film her in Belgrade. She showed up all dressed up, like Maria Callas herself [laughing] and gave a whole monologue, talking about how she never shows weakness, how nobody will ever see her in pain. She told me things I'd never heard before, about skipping school as a

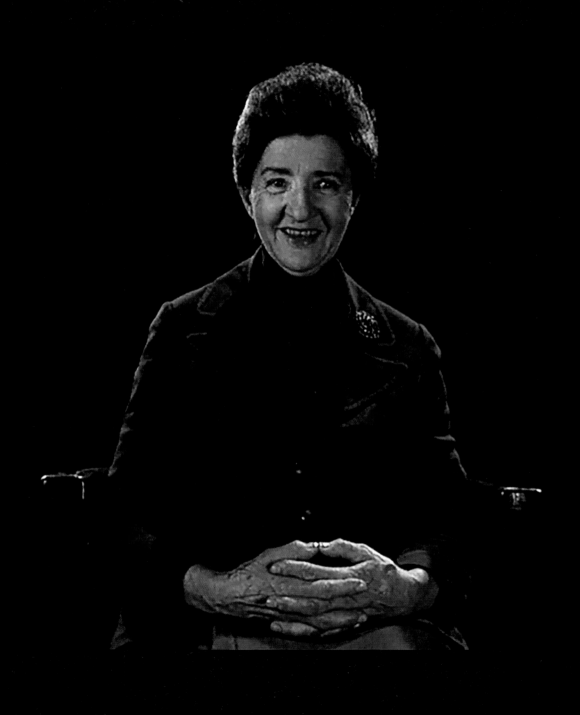

girl to see *Gone with the Wind* and being madly in love with [the character] Rhett Butler. When I asked why she never kissed me, she looked shocked. She said: 'So that I wouldn't spoil you, of course!' She looked so glamorous on that stage, in the dark.

My father – he not only let us into his house to film, he invited the whole neighbourhood. They roasted a pig, drank grappa and told war stories. He played the gusle, a musical instrument with only one string. He was completely in his element.

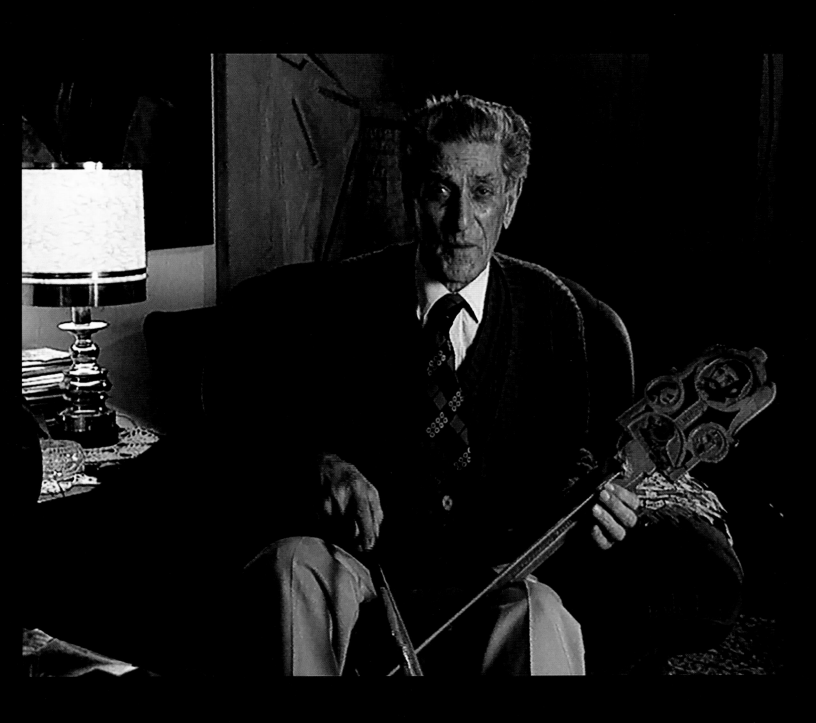

On that same trip, I interviewed Belgrade's expert rat-catcher. He explained that rats are very resilient. The only way to kill them is to starve the biggest male rat, gouge his eyes out, then let him free. That's the Wolf Rat. Out of desperation, he kills every other rat in his way, including his own family. The Wolf Rat represents the situation in the Balkans to me. What circumstances create people who will kill members of their own family? When I was asked to represent Serbia and Montenegro in the 1997 Venice Biennale, people told me not to accept. But I did. I felt it was the right moment for me to finally make a statement about the war, and to make *Balkan Baroque*. *Balkan Baroque* includes projections of my mother and father in Belgrade, a video of me as a doctor telling the story of Wolf Rat and, in the centre, 2,500 cow bones that I would wash and wash for four days and six hours.

blood from your

, Montenegro's

escinded my

ing letter in

ig scandal, and

ilion instead.

won the Golden

't name the one

person who voted a

in my life. A big s

steps in Venice wi

telling me how *Bal*

the ceremony, Mont

said nothing to me

me: 'You have a big

forgive us.' I ans

of Montenegrin pr:

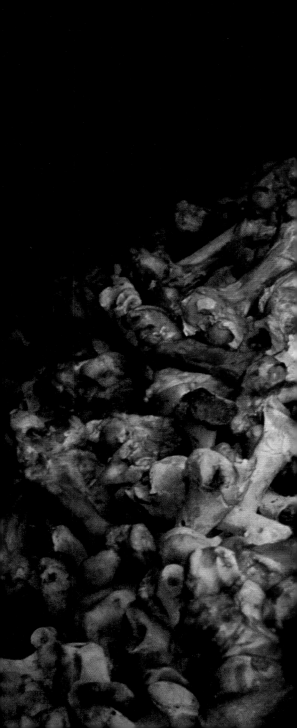

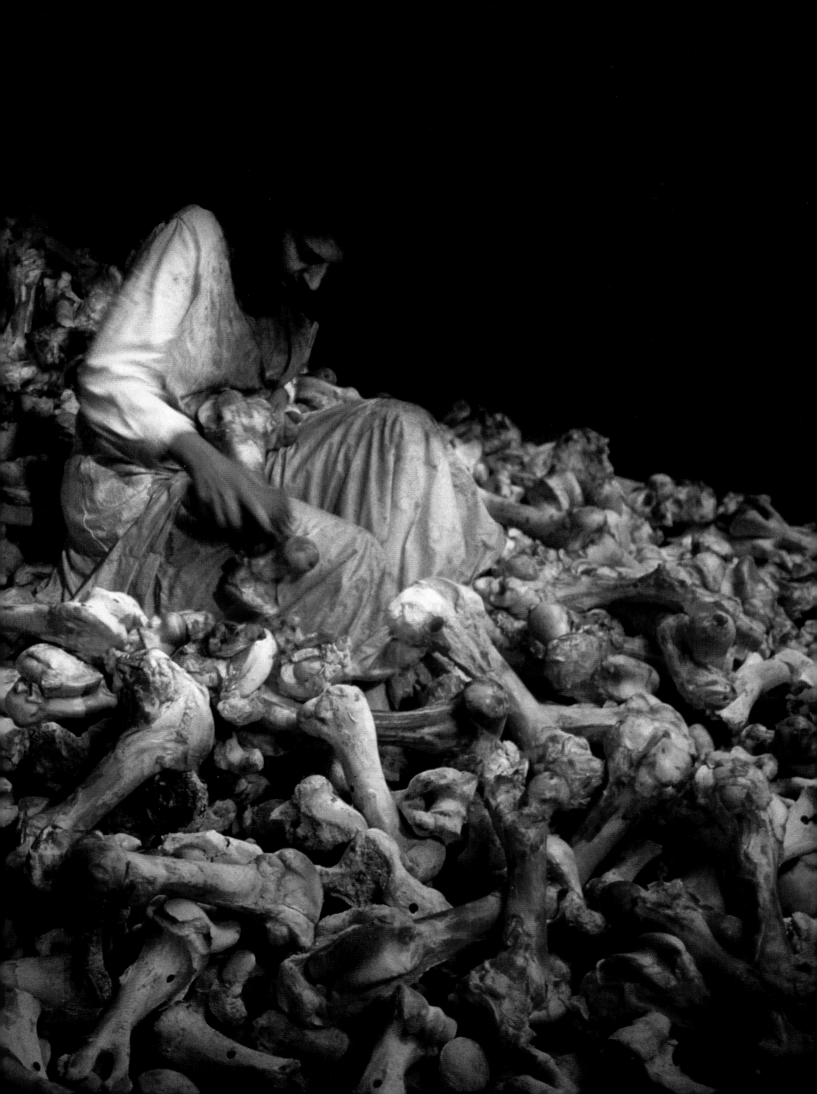

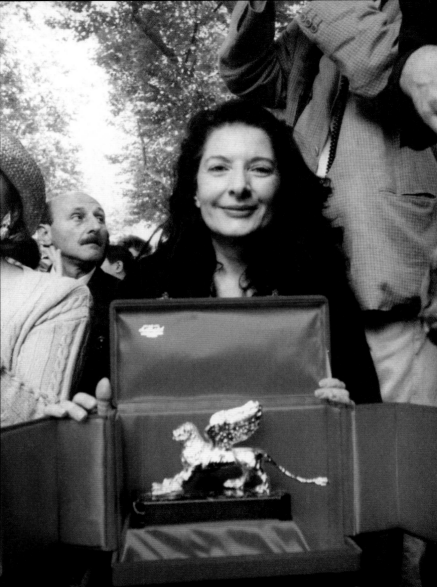

HAVE YOU EVER HEARD OF MONTENEGRIN PRIDE?

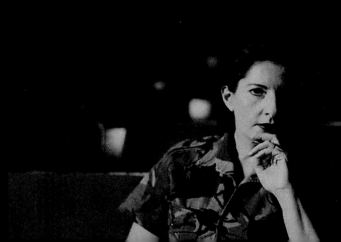

Soon after, Velimir and his daughter Ivana ran from Belgrade and came to stay with me in Amsterdam. Velimir didn't want to come. His wife was going through chemotherapy in Belgrade and couldn't leave. She made them go for Ivana's sake. They took the last bus out before the [1999 NATO] bombing of Belgrade. I was in Japan at the time. When I came back, Ivana's toys were all over my house. I asked her to clean up. And she looked at me very seriously and said: 'Don't you know that children are afraid of empty spaces?' Wow. I didn't say a word after that. Put your toys anywhere you want. Ivana is a very important person in my life. She is really the only family I still talk to.

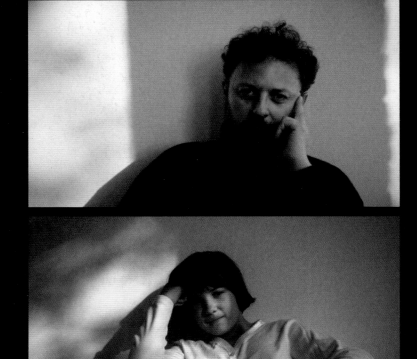

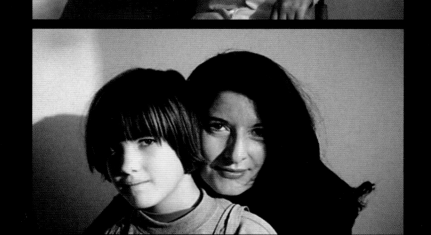

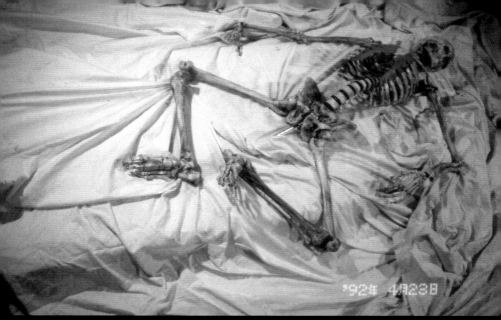

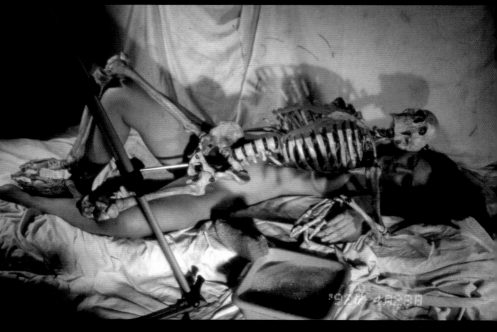

Above: Process stills from *Cleaning the Mirror nr. 2*, 1995.

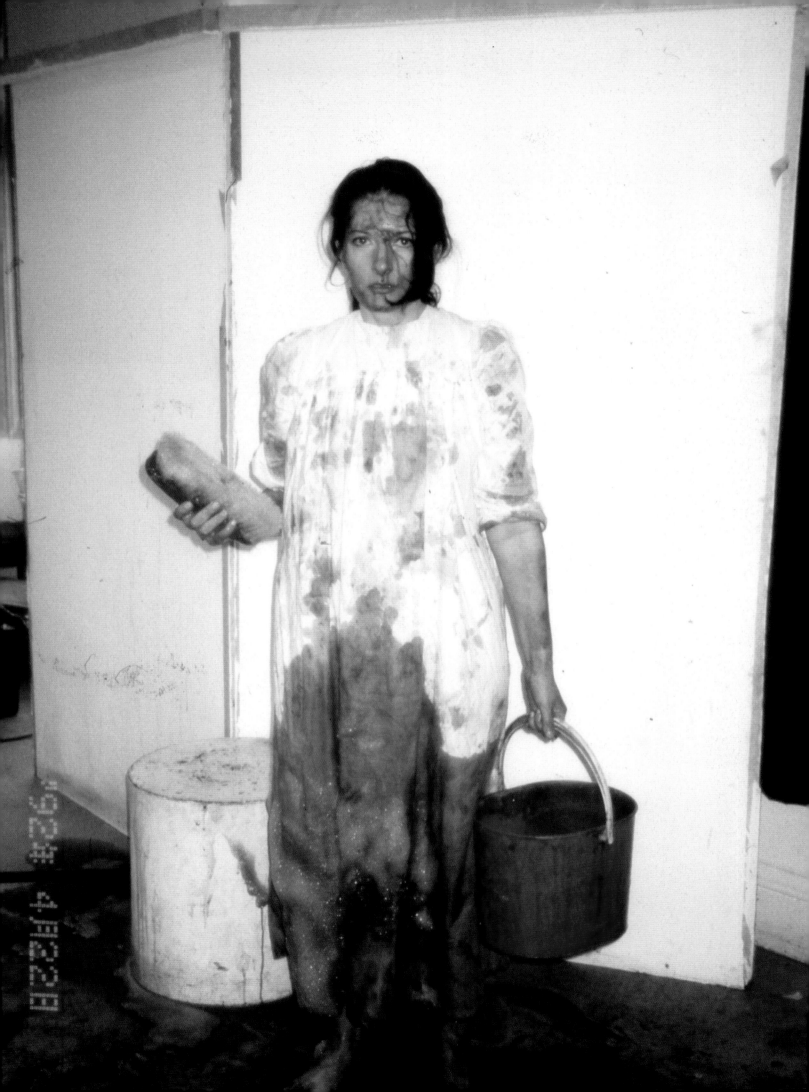

I visited my father's grave only after the war.
He had died of a broken hip and left everything
to his stepson, nothing to me or Velimir. It
was all so strange and sad. If I had grown old
in Belgrade, I would be going to these family
graves all the time and cleaning them. You know
all this nostalgic stuff. It's what you do
there. I don't have it in me.

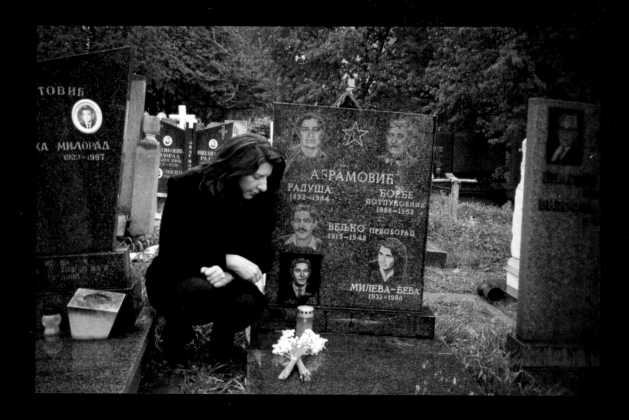

I paid for the graves to be cleaned for ten
years in advance. There. They're clean. I don't
want to talk about this now. I want to tell you
how my mother came to see my show at the Pompidou
[Centre in Paris] in 1990.

I arrived a little late, and she was already
outside in her pearls, surrounded by curators,
critics, photographers… She was talking about
my work like she knew everything! It was like
I was not needed at all [laughing].

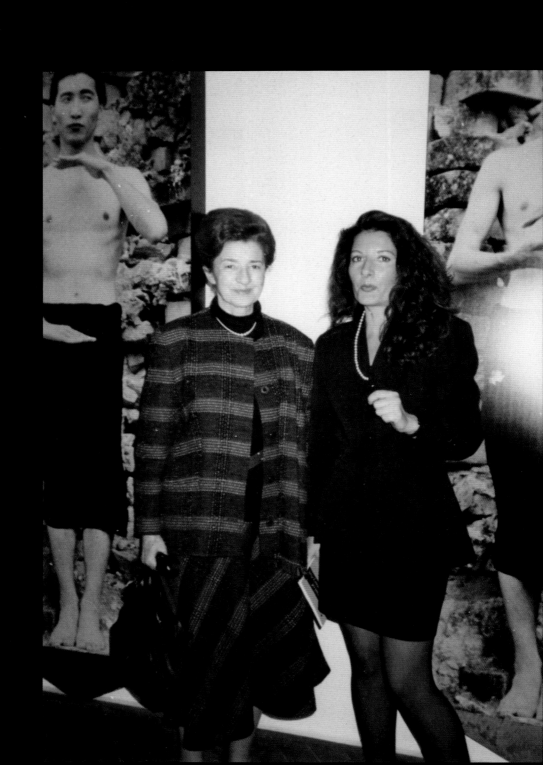

white hair. She never accepted my help. Even here, when she is in so much pain. She had a bullet lodged in her foot during World War II, which was too close to the nerve to remove. By the end of her life, my mother stopped walking completely. But it's funny, she was very, very attached to Ivana. She was a

woman stops dyeing her hair is the moment she's given up. That's it, the door is closed. I'm thinking, probably, I will never let my hair go white.

Marina, what language do you think in now?
English.

After my father's death, somebody saved his leather briefcase for me. It took me a whole year before I could open it. Inside, there were photos of me and my brother, and there were all of my father's war medals. And then there was this small, old pencil sharpener that my father had saved all these years. Oh my God. My father had been this heroic figure for me. All that's left of him is an old pencil sharpener? So I made a work in his honour, called *The Hero*. My father, the war hero on his horse, he never surrendered. But a white flag is the colour of surrender and of death. He was fun, my father. That pencil sharpener really broke my heart. I thought, is this really what life is?

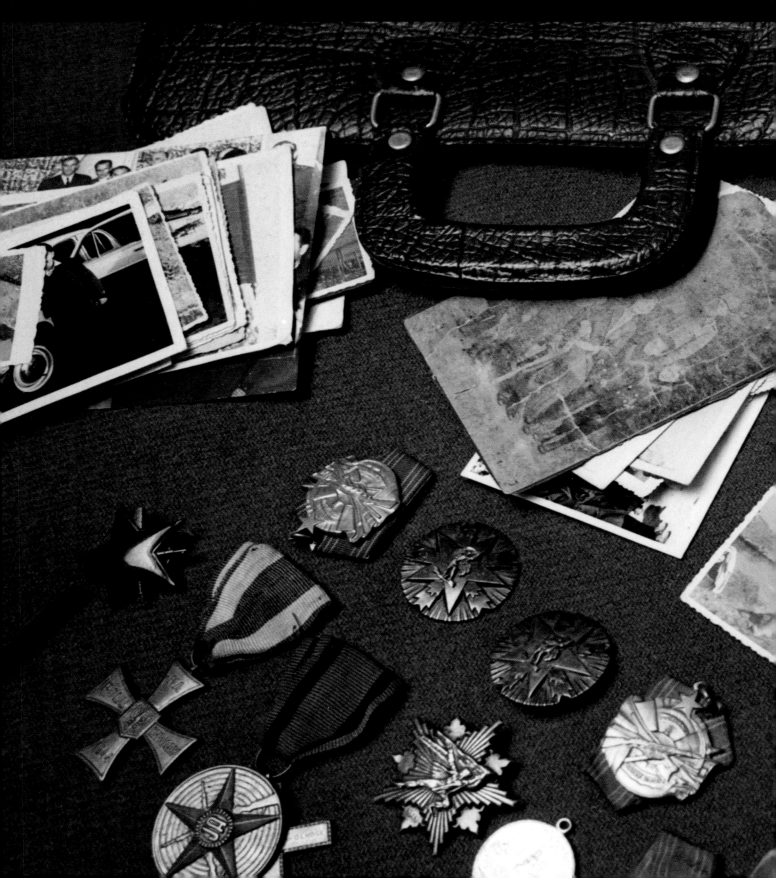

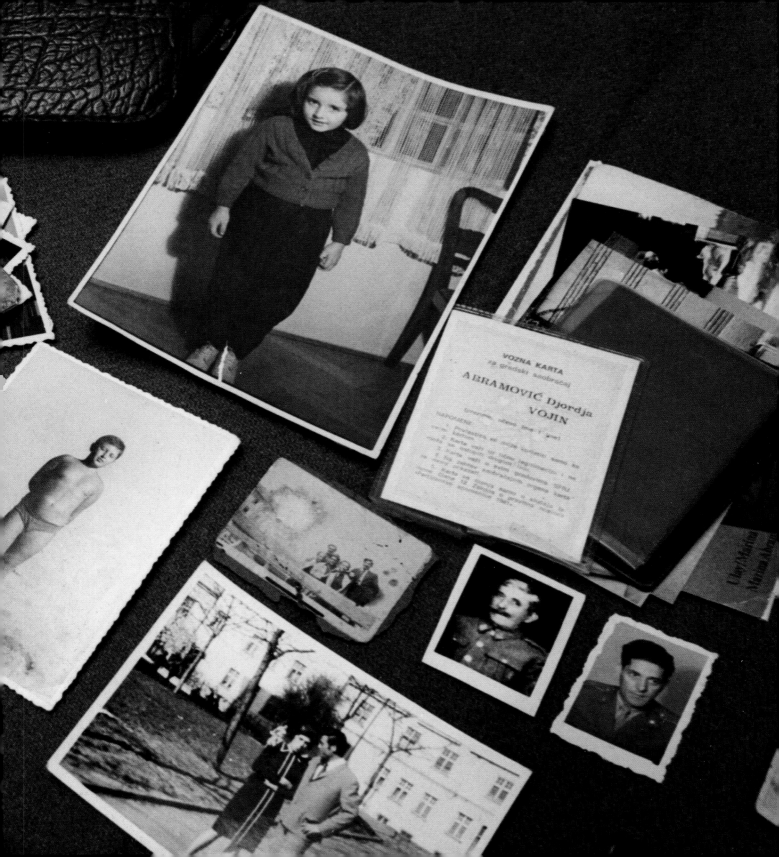

VOZNA KARTA
za gradski saobraćaj
ABRAMOVIĆ Djordja
VOJIN

MY FATHER HAD BEEN THIS HEROIC FIGURE FOR ME. ALL THAT'S LEFT OF HIM IS AN OLD PENCIL SHARPENER?

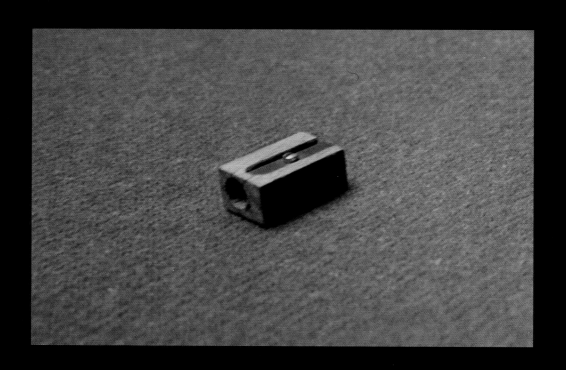

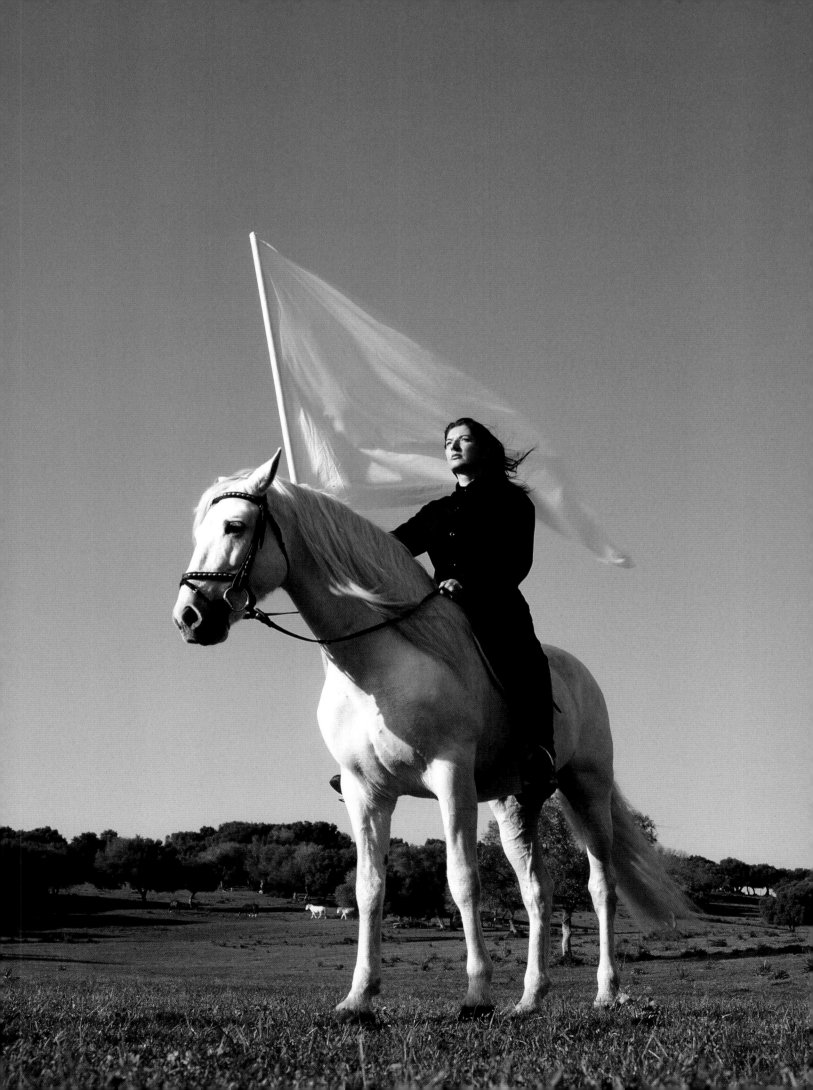

You start incorporating your life more
literally into your work around this time.
But my work always comes from life! It isn't
rational. I'm not putting stamps on lemons.
I don't sit and think about what I'm going
to do next. I have to be hit by it, afraid of
it and obsessed. That's life, not studio work.
To talk about my work you have to talk about
my life. This whole book is about life.

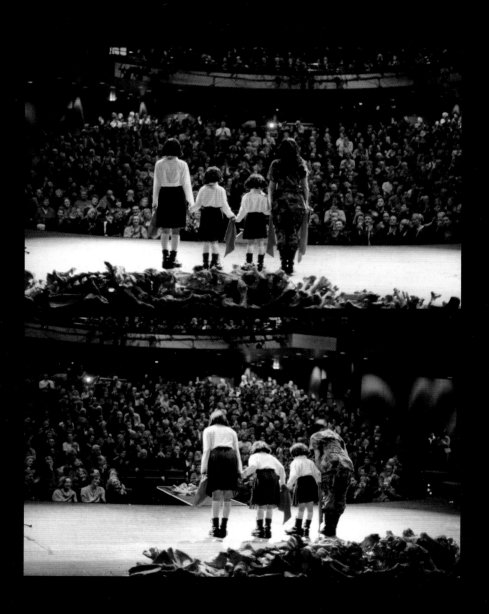

Above and opposite: *The Biography*, 1999.

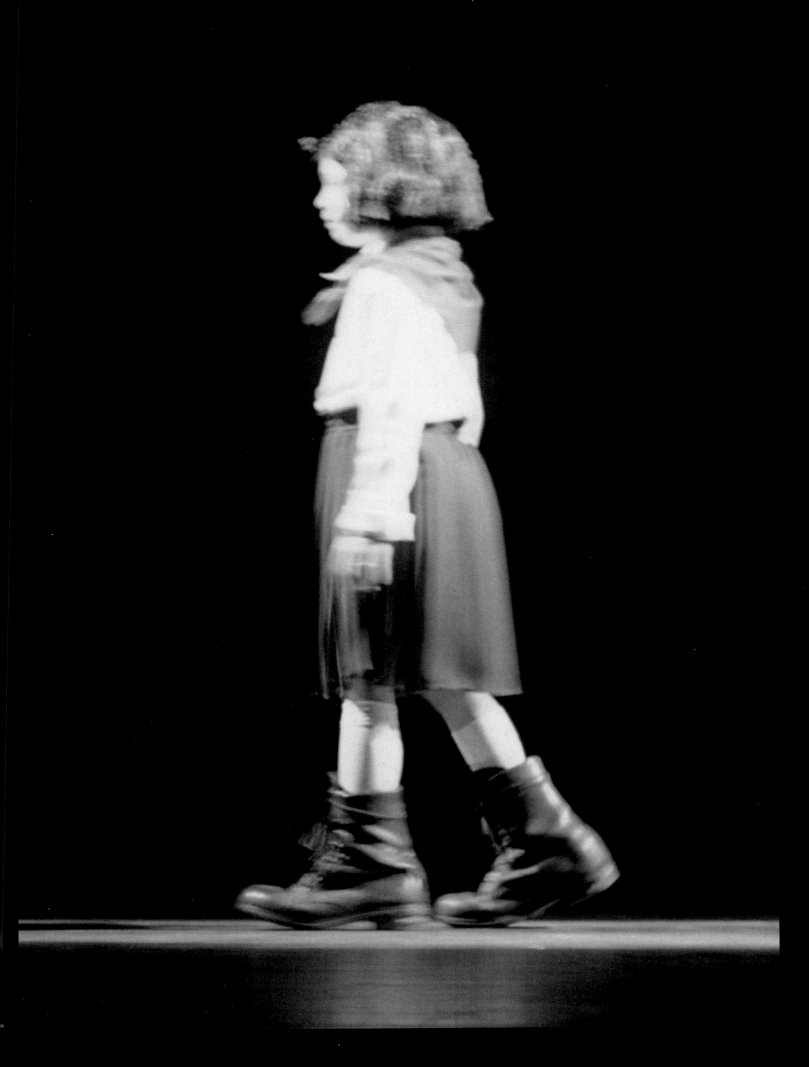

09

DREAM STATE / JET LAG

THE SPACE BETWEEN*
1990—2000

TEACHING, TRAVEL, FATIGUE

*The artist's preferred term for days of life between big events and projects.

Katya, why do you choose the most fucked-up photos?

These are from the workshops you teach [laughing]. You don't think there's something strange in the exercises themselves?
There is, there is [pause]… We did this one in the middle of an Australian bushfire. We literally had to move through fire to see the student performances. That was a very tough workshop. For one performance, two students measured a running river with a stick. The current was very fast. For another, a student went through a coyote fence. All the work they made that year was about survival and coming out on the other side. Really, all the workshops are about pushing through limits.

What is the framework?
Five days, no food, no talking, complete the exercises without complaining. After that, you can do your art.

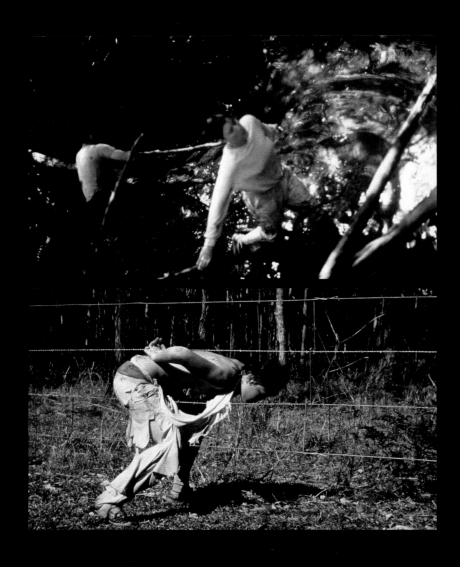

KATYA, WHY DO YOU CHOOSE THE MOST FUCKED-UP PHOTOS?

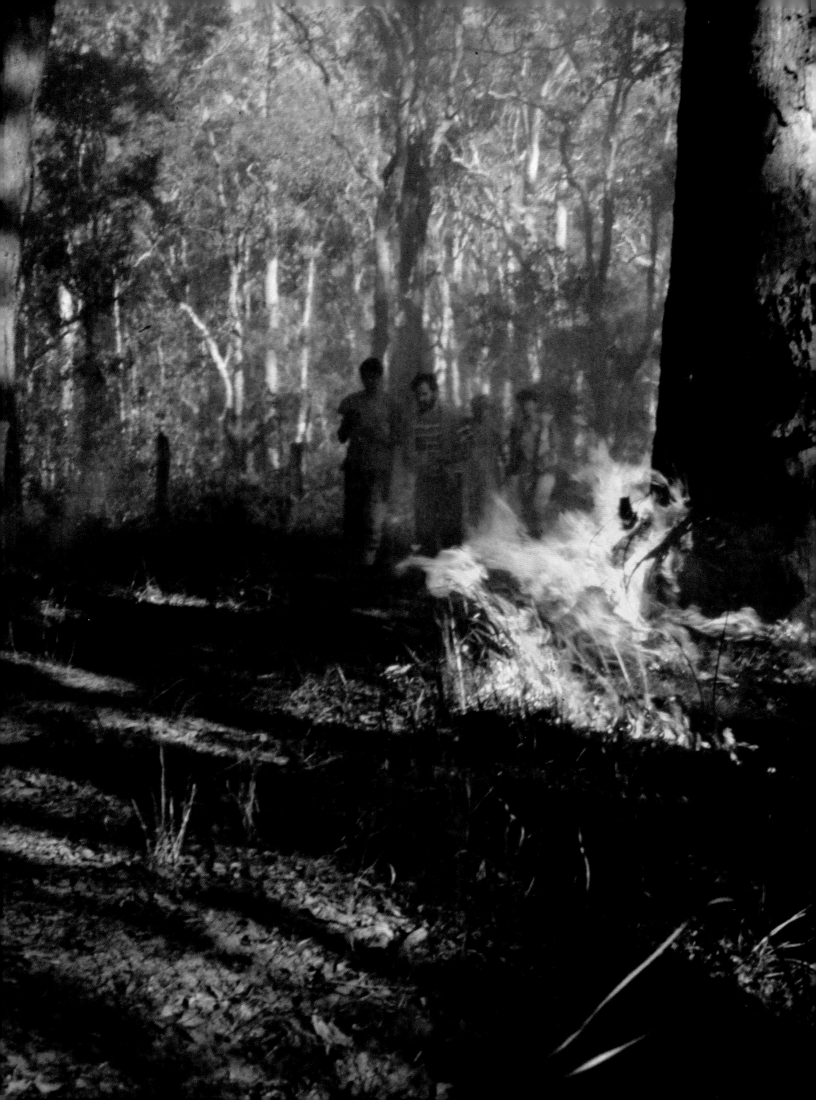

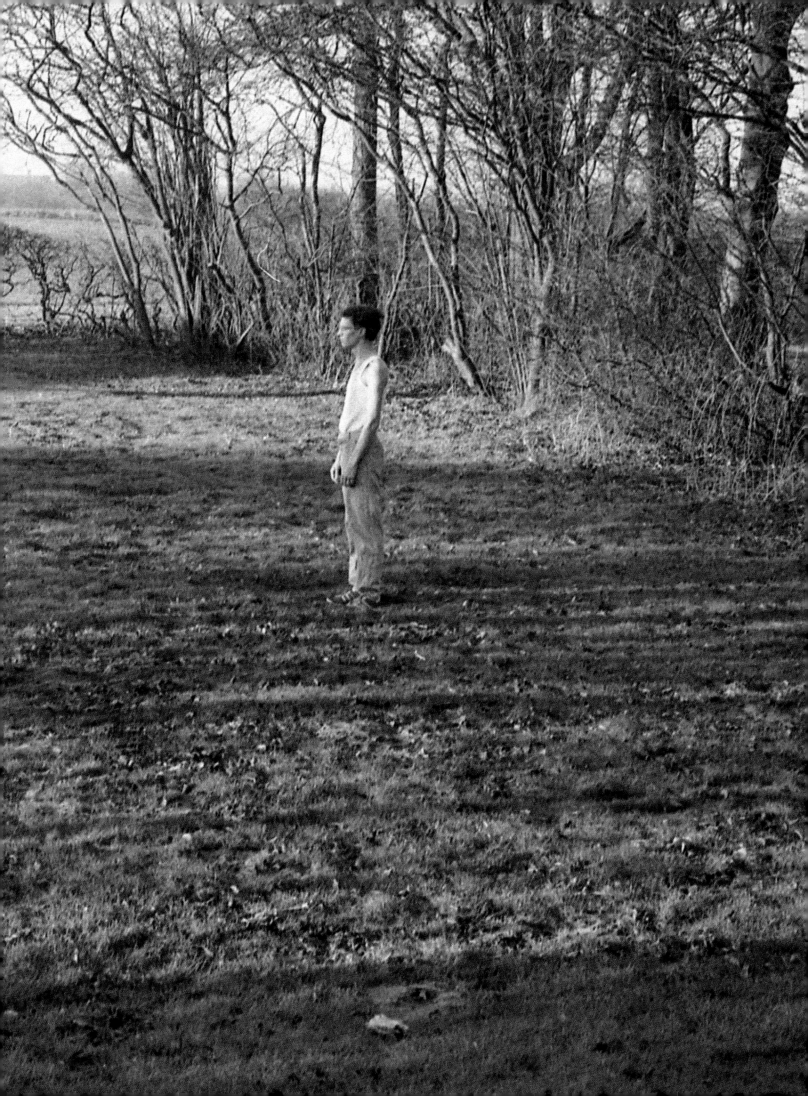

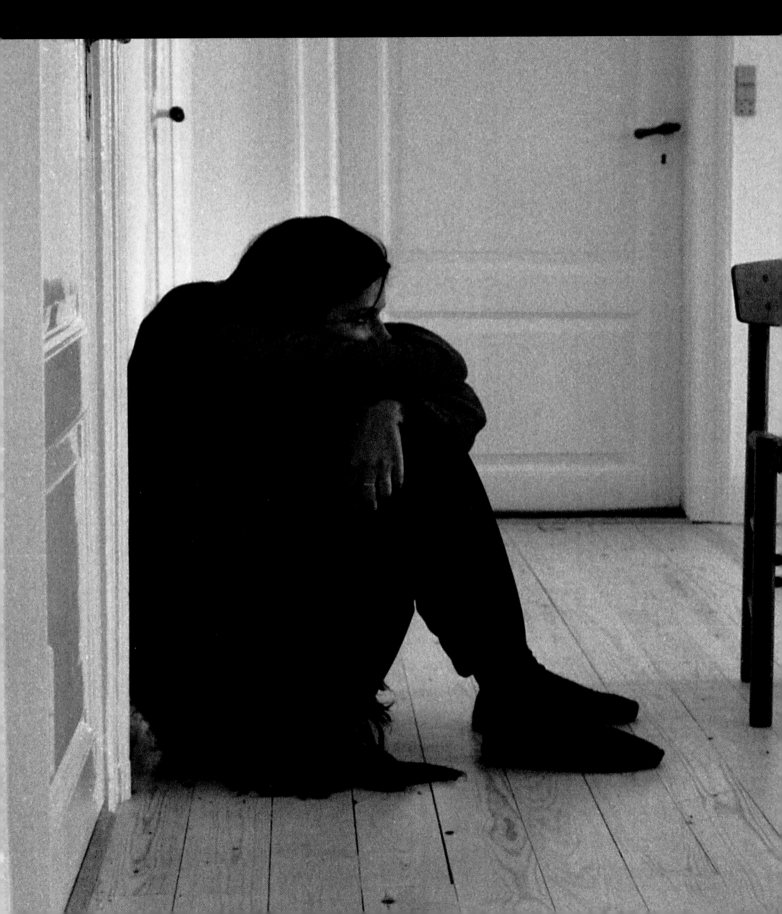

When did you start teaching workshops?
With Ulay, early on. We were invited to give artist talks and didn't want to be boring. We wanted to teach what we'd learned through our work and involve the audience. Our first workshop was called *Kill the Pillow*. Pretty

quickly, we started calling it *Cleaning the House* because the only house that matters is the body. We need to clean it.

What are some of the exercises?
Always different, depending on the group.

walk backward looking at a mirror, find something that smells repulsive in nature and analyse why it repulses you, find something you love and do the same. Open a door without entering or exiting for three hours, look

across from another person and look, feel another person's energy. When Ulay and I separated, we both continued the workshops, but with different methods.

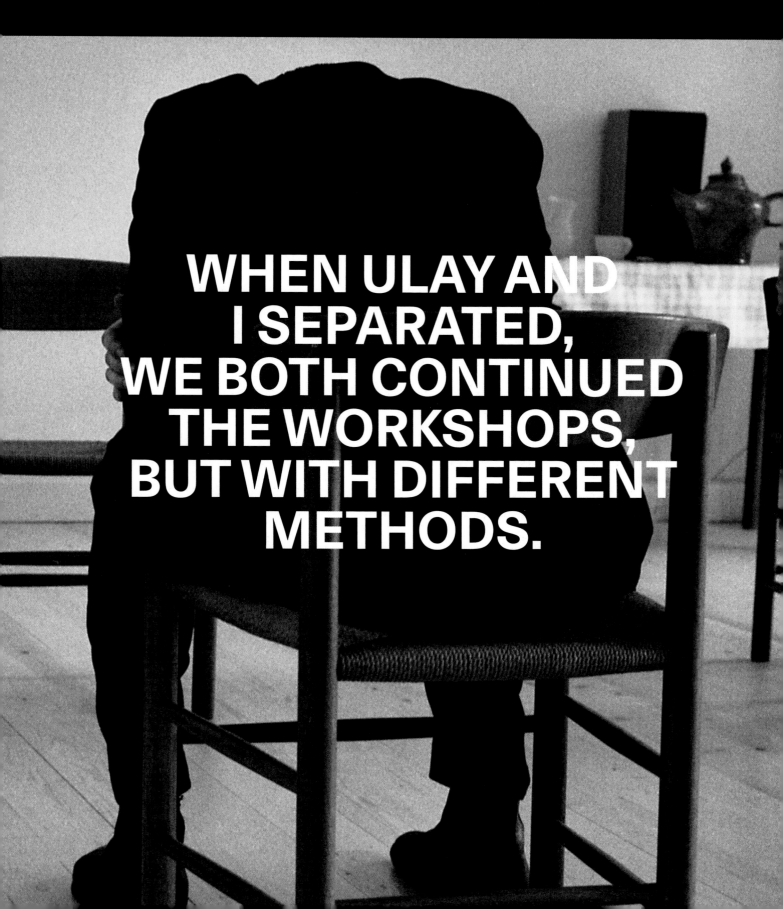

WHEN ULAY AND I SEPARATED, WE BOTH CONTINUED THE WORKSHOPS, BUT WITH DIFFERENT METHODS.

In my workshops, on the last day of fasting, I wake up at 4 a.m. I go from student to student with a flashlight and wake them up from a deep sleep. I put a piece of paper in front of their face. 'Write the first word that comes to your mind!' Such a shock! And they haven't talked in five days! They write a word. OK, OK, go back to sleep. The next morning I cook plain rice. They eat it slowly with their hands and drink a glass of water. Eyes closed. When they are finished, they can talk and I give them their assignment: based on the word you wrote last night – which came from your deep consciousness – make a performance. Oh, that's a hard thing to do. The purpose is to understand time, endurance, limits, relation to others and develop the sensitivity you need for long, durational work.

<u>Has anyone ever left early?</u>
Two guys sneaked out one night for a beer. They walked 7 km in the snow to the nearest village. When they came back, I had locked the door and wouldn't let them in.

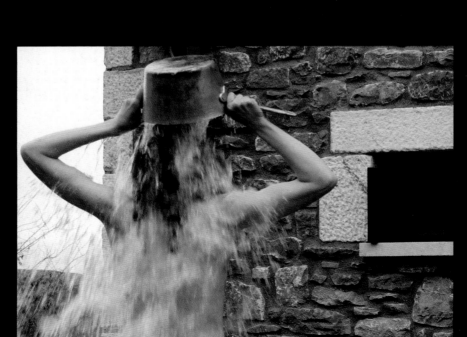

Everybody signs a contract when they join the workshop. These guys didn't keep their promise. They had to find their own way home. They couldn't believe it! I didn't care. The next year, the same two guys showed up at another workshop. This time they stayed for the whole thing. I am really proud of that.

I feel enormous responsibility for my st I was always interested in the Stanislav Method [of acting]. I was interested in [Polish theatre director Jerzy] Grotows Method. Grotowski – wow – he had his acto running through the Polish woods naked. hardcore. Even more than me.

So, now is the time for the Abramović
Method. The Abramović Method is exercises
that developed slowly from my workshops
and training. Anybody can do them. I can lead
an audience of six thousand people in these
exercises. I understand that the public
is tired of looking at something, they want
to be part of something. And in performance
there is no story to watch. It's about the
performance space, repetition and ritual.
It's about creating an energetic context.
There is no 'cure' at the end.

I try to cut my work down to its core. I clean the original idea until there is almost nothing. Then I say: 'OK, we are here.' The Method conditions the audience to exist in this space. It's not just the new work. My work has always been cut down to its essence. My projects seem diverse, but when you have an aerial view of my art and teaching, you see it's all connected.

Marina, do you participate in the workshops? Do you do the exercises with your students?
When physically possible, I always do. I want to share the same condition as my students. But sometimes I have eight workshops in a row in different countries. We are talking about the 1990s now, when I was going from country to country, teaching and working, always in a plane. I felt sick. I made a work about it, when I ate a raw onion whole and just complained.

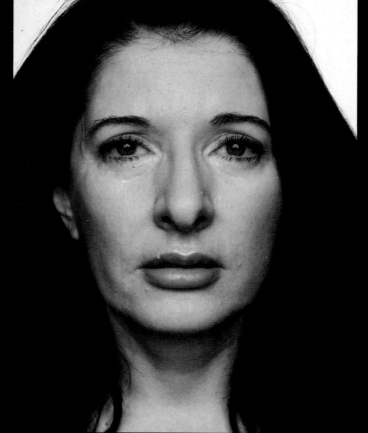

I AM TIRED OF CHANGING PLANES SO OFTEN. WAITING IN THE WAITING ROOMS, BUS STATIONS, TRAIN STATIONS, AIRPORTS. I AM TIRED OF WAITING FOR ENDLESS PASSPORT CONTROLS. FAST SHOPPING IN SHOPPING MALLS. I AM TIRED OF MORE CAREER DECISIONS, MUSEUM AND GALLERY OPENINGS, ENDLESS RECEPTIONS, STANDING AROUND WITH A GLASS OF PLAIN WATER, PRETENDING THAT I AM INTERESTED IN CONVERSATION. I AM TIRED OF MY MIGRAINE ATTACKS, LONELY HOTEL ROOMS, ROOM SERVICE, LONG-DISTANCE PHONE CALLS, BAD TV MOVIES. I AM TIRED OF ALWAYS FALLING IN LOVE WITH THE WRONG MAN. I AM TIRED OF BEING ASHAMED OF MY NOSE BEING TOO BIG, OF MY ASS BEING TOO LARGE, ASHAMED OF THE WAR IN YUGOSLAVIA. I WANT TO GO AWAY, SOMEWHERE SO FAR THAT I AM UNREACHABLE BY FAX OR TELEPHONE. I WANT TO GET OLD, REALLY OLD, SO THAT NOTHING MATTERS ANYMORE. I WANT TO UNDERSTAND AND SEE CLEARLY WHAT IS BEHIND ALL OF THIS. I WANT TO NOT WANT ANY MORE.

e, you don't talk, you go
mple rituals, you put
t with magnets, go into a
colour and you just sleep…

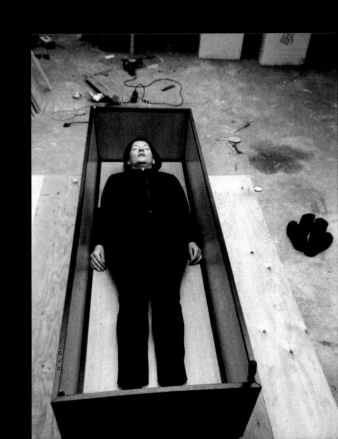

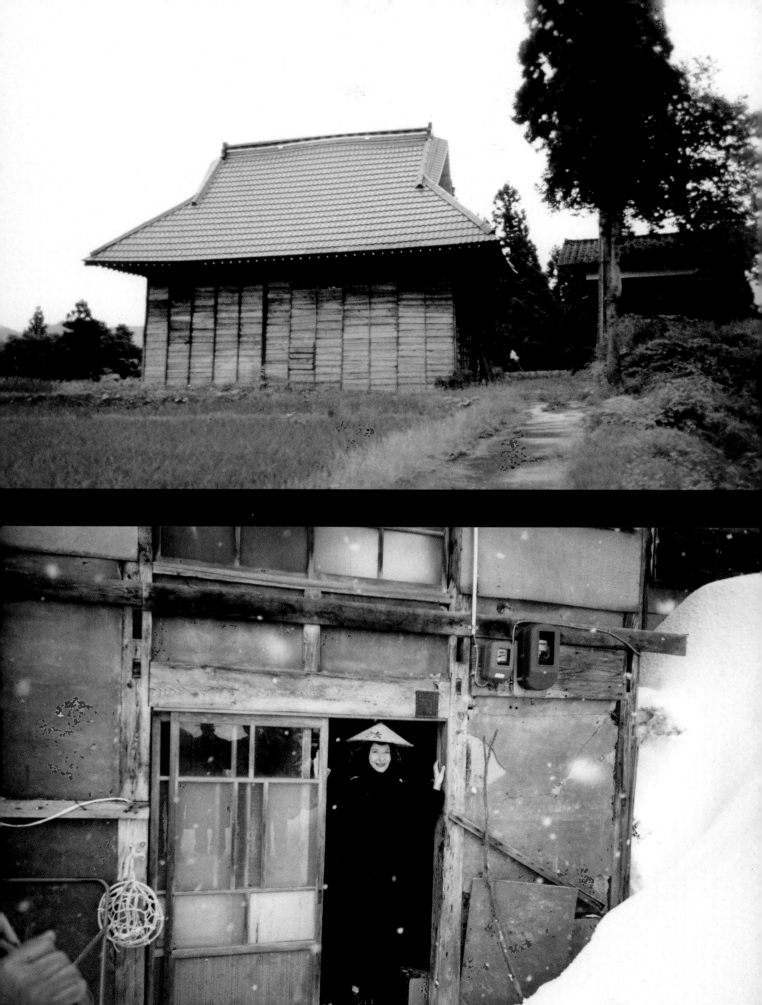

You don't just sleep. You sleep in a bed shaped
like a coffin! I went there in 2014.
Oh God, you did. And?

The woman who lives next door told me to yell
if I need anything [laughs]. She said her kids
did their homework in *Dream House* growing up.
That stayed with me.
You see? That's why it's one of the most
important works I've ever made.

<u>Why do you say that? It isn't a work many people have seen.</u>
Because it's a work of art that became part of daily life for the people around it. I want art to be relevant to different people. There were 36 people – mostly rice farmers – living in this region in 2000. I asked all 36 of them to stay overnight in the house before we opened to the public. They did it, and now they still care for the house, and art and life are inseparable. Now you remind me, I am doing another workshop next week, and we have a film crew following us. I want the film crew to fast with us. I want them to have the same condition as everybody else.

<u>And what does the film crew say about this?</u>
They say: 'We will see.'

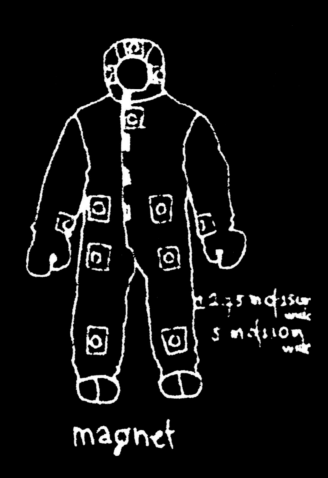

magnet

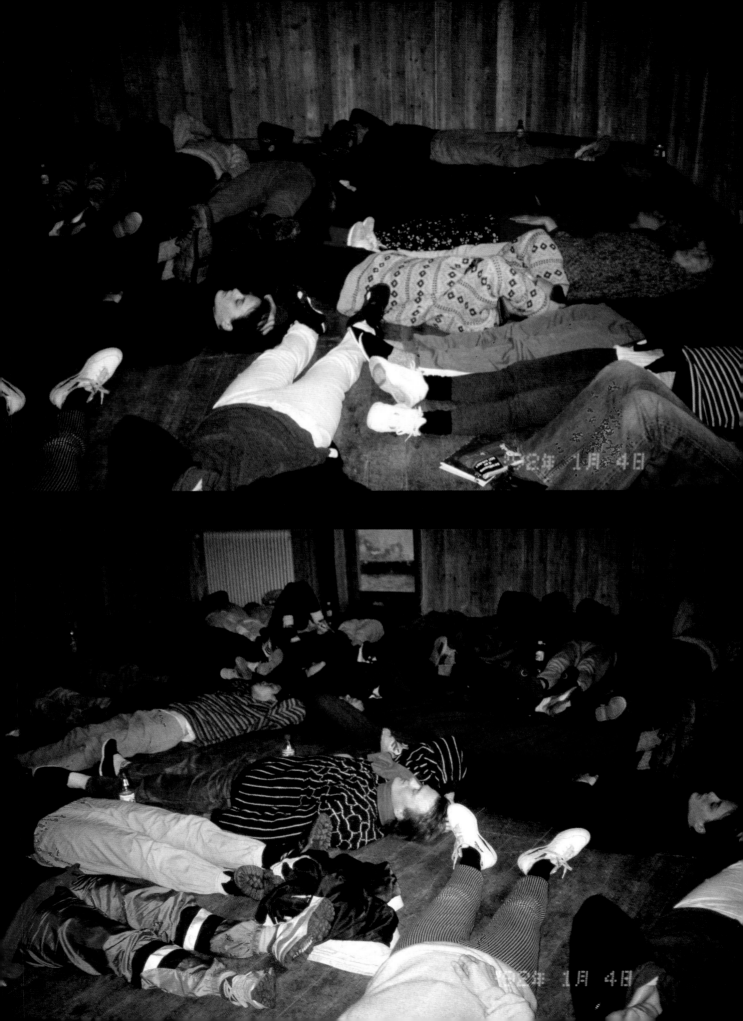

I had 250 students at this workshop, and just
me teaching. I used a megaphone to wake them up
in the morning. It was too much. It was all too
much. It's hard to remember everything from
this time.

I remember when Alba died, though. That night I had a dream, in which a profound, godlike voice said: 'In the name of a dog, the legend has to begin.'

What does that mean, Marina?
I was working on a book at the time, so to me it meant I had to write down this dream and say, I dedicate this book to my dog, Alba. But my friend [artist] Rebecca Horn said: 'Marina, everybody will think you're a pervert.'

[Laughing.] OK, fine. I just wrote: 'This book is dedicated to Alba.' I really loved that dog. I loved her. She died naturally in her sleep, at my friend's house in Mallorca. I would like everybody to die a natural death in their sleep. My grandmother did. I want to do the same. Of course, my mother didn't. She died from terrible dementia. My father didn't. He broke his hip and died from complications. And there was the Yugoslav war at that time… But let's hope for the best. I don't know.

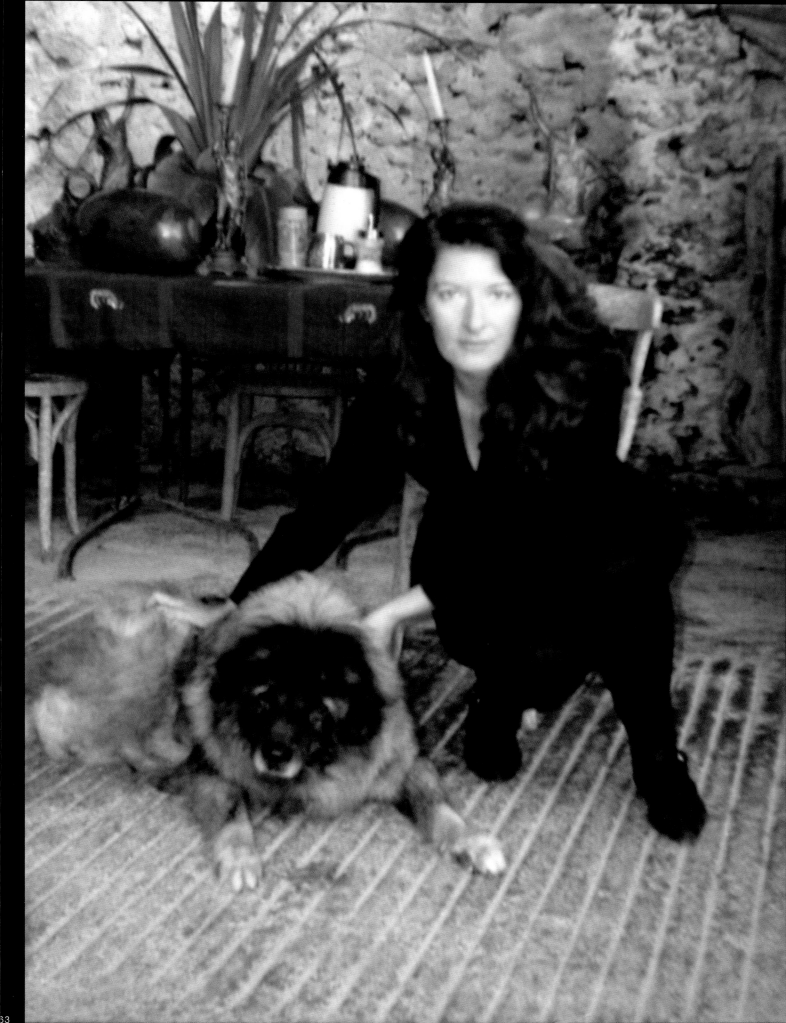

AN ARTIST SHOULD AVOID FALLING IN LOVE WITH ANOTHER ARTIST.

Excerpt from Marina Abramović's *An Artist's Life Manifesto*, ongoing.

10

CROSSING THE OCEAN

NEW YORK
2000—2010

OCEAN VIEW, SEA CHANGE

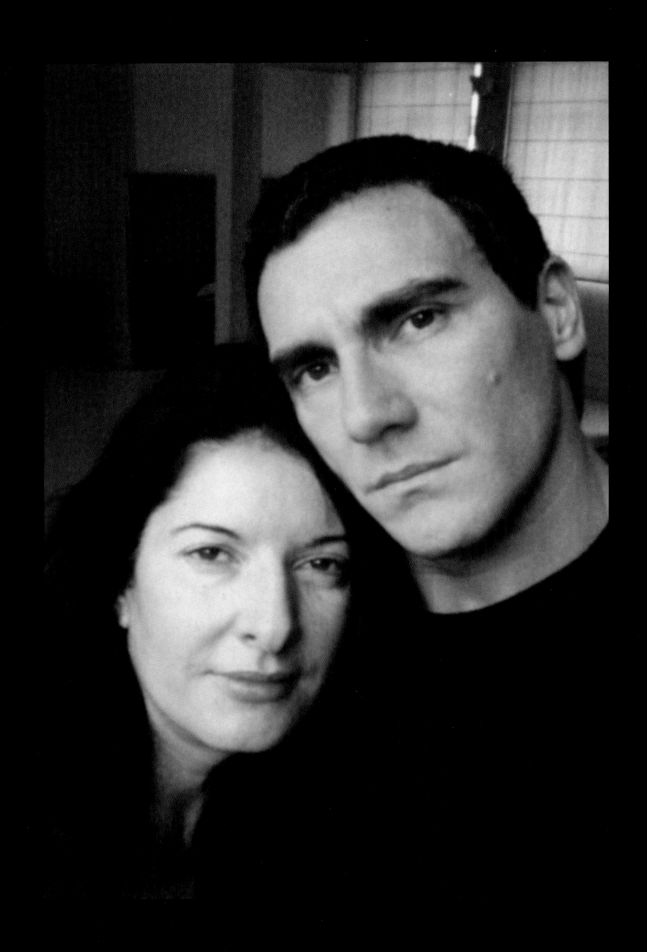

He was 17 years younger than me, extremely good-looking and an artist. I knew it wasn't a great idea, but he convinced me, and I fell madly in love. We had many good years. In Amsterdam, after I had renovated the house, things were perfect. But he hated the weather there. He wanted to start a new life together in New York. I was terrified. I was in my mid-50s, unknown in America. Then my gallerist Sean Kelly, saw a loft for sale near him in SoHo [New York]. I asked him the street number – 70. Seven is my destiny number in numerology, so I said: 'I'm getting it!' 'Are you crazy? You can't buy something you haven't seen!' But I did it. I moved to New York because of Paolo.

...oft had a wall going from
e learned two artists
uilt the wall when they
dn't have to see each
go.

Is that Sean Kelly doing co...
your loft?
[Laughing.] Yes, we had to
weekend without permission
from Europe; we didn't know
in America! We broke down t
with our own hands, but may
already. It was like a prem
Paolo and I would separate :

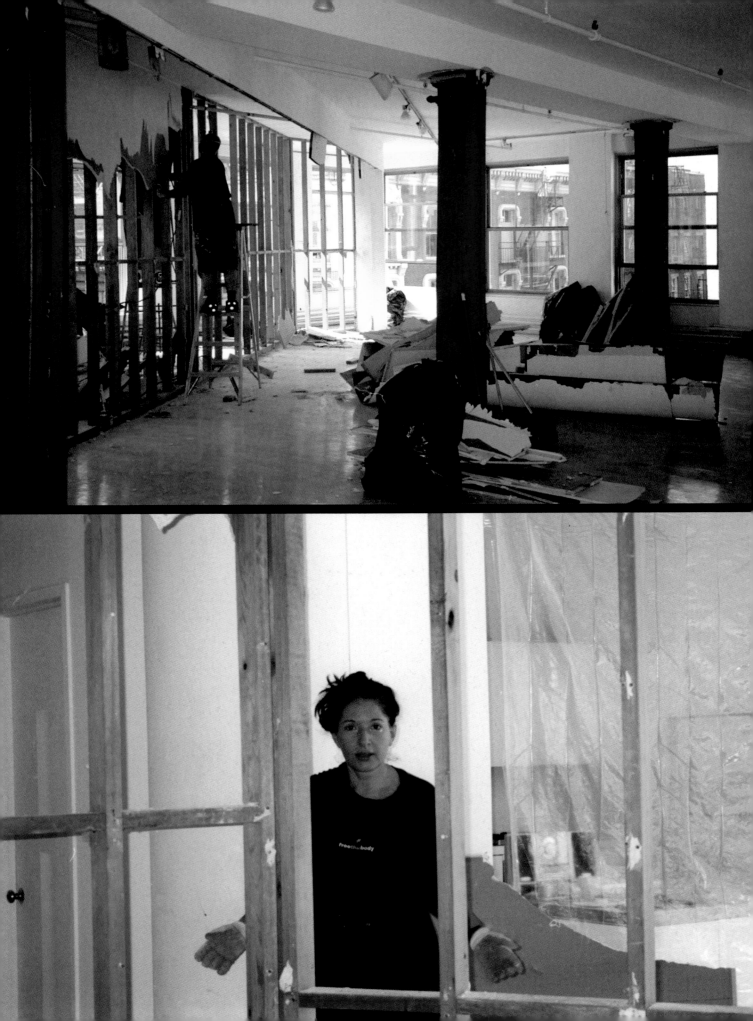

So, you bring down the Iron Curtain. Then what?
Then I asked myself: 'How can I conquer
New York?' Four hundred and fifty thousand
artists live here. How do I do something
different? Something nobody else is doing?
I began an intense period of work. First thing
I did: I hired a personal trainer and started

training every day at 5.30 a.m. I needed to be
strong. I wanted to do long, durational works.
I'm not talking one or even three hours. I am
talking about days and days. I understood one
thing: if I wasn't fit, I couldn't do it. There
is no other way but to be strong.

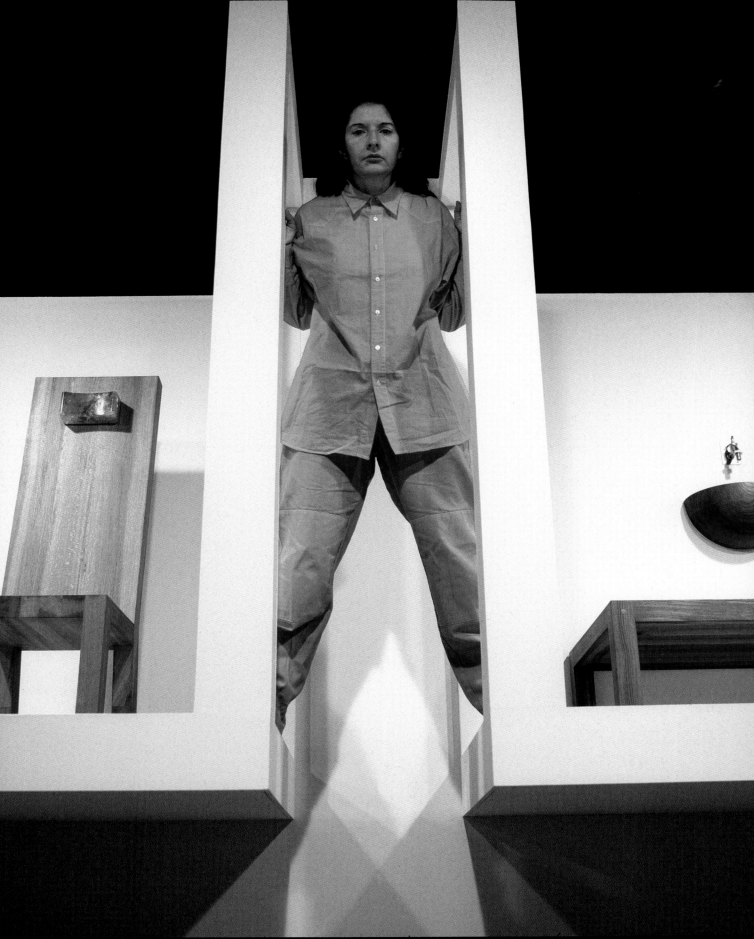

**CONDITIONS FOR
LIVING INSTALLATION:
ARTIST**

**DURATION OF THE PIECE:
12 DAYS**

**FOOD:
NO FOOD**

**WATER:
LARGE QUANTITY
OF PURE MINERAL WATER**

**TALKING:
NO TALKING**

**SINGING:
POSSIBLE BUT UNPREDICTABLE**

**WRITING:
NO WRITING**

**READING:
NO READING**

**SLEEPING:
7 HOURS A DAY**

**STANDING:
UNLIMITED**

**SITTING:
UNLIMITED**

**LYING:
UNLIMITED**

**SHOWER:
THREE TIMES A DAY**

Artist conditions for *The House with the Ocean View*, 2002.

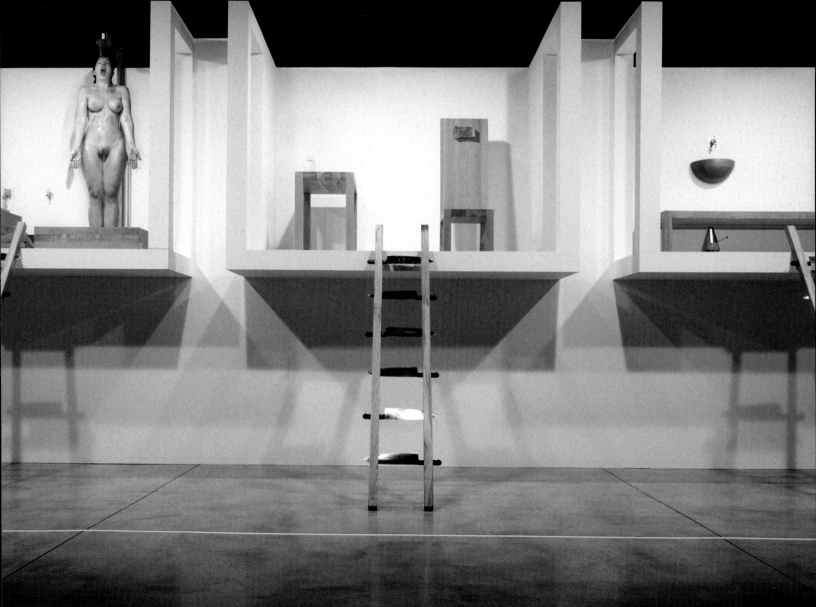

In the '90s, your body was not so involved in your work. Why, in New York, do you start doing durational performance again?

To introduce this concept to America, where nobody ever has any time. I had three major durational projects one after another – *The House with the Ocean View* (2002), *7 Easy Pieces* (2005) and *The Artist Is Present* (2010) – and all three received huge attention, critics' awards, *New York Times* coverage, all of this. And it changed my life. I became interested in being invited to the right exhibitions, the right galas, the right dinners, sitting at the right tables. I didn't know anything about dress code when we got to New York. I would wear the same skirt and blouse that I always wore in Amsterdam, and they started writing in social columns that I always wear the same clothes. So, I started getting more into fashion, and designers started giving me clothes for photoshoots – which then had to be returned.

What? Marina, you weren't sceptical that you're doing major, gruelling artworks and they're writing about your outfits?
No. I am not sceptical. I said to myself: 'OK, I am a stranger here.' It's a matter of fact. I don't come from this world. But I was interested in fitting in. I wanted to see if I could. And I did.

You adapt anywhere.
Absolutely right. I think of myself as a nomad. Looking back, I see how similar I am to my mother. She had so many contradictions. You know when she turned to Communism? While studying in Switzerland! She came from a privileged family. She left 50 pairs of shoes behind when she joined the Partisans but remained bourgeois in every possible way. Before every Partisan event, she would go to Paris and get wonderful, tailored dresses. I would wear them today if I had them.

MUSE
The Many Cosmos of Marina

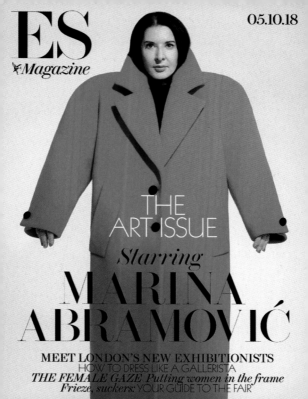

ES
▼ Magazine

05.10.18

THE ART ISSUE

Starring

MARINA ABRAMOVIĆ

MEET LONDON'S NEW EXHIBITIONISTS
HOW TO DRESS LIKE A GALLERISTA
THE FEMALE GAZE *Putting women in the frame*
Frieze, suckers: YOUR GUIDE TO THE FAIR

Do her contradictions bother you?
No. Contradictions don't bother me. I also
love expensive clothes. But, like her, I feel
my life is not as important as the higher cause.
I can sacrifice everything – my things,
my own pleasure – for it. I know I say it with
my closets full, but I believe it.

**Her higher cause was Communism. And yours
is what? Art?**
Absolutely. Art. It's elevating the
human spirit.

When I was doing the reperformance of Valie
Export's *Action Pants: Genital Panic* [right],
the Guggenheim was exhibiting Russian icons
on the other floors. Families with children
complained about me – not because they could see
my genitals, but because I was pointing a gun
at the icons. They called the police. But the
curator explained and my work was not shut down.

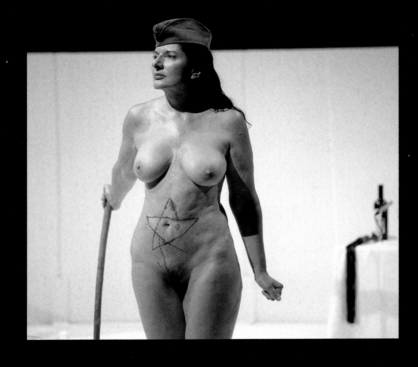

Above: *7 Easy Pieces*, performing *Lips of Thomas* (1975), 2005. Opposite: *7 Easy Pieces*,
performing Valie Export, *Action Pants: Genital Panic* (1969), 2005.

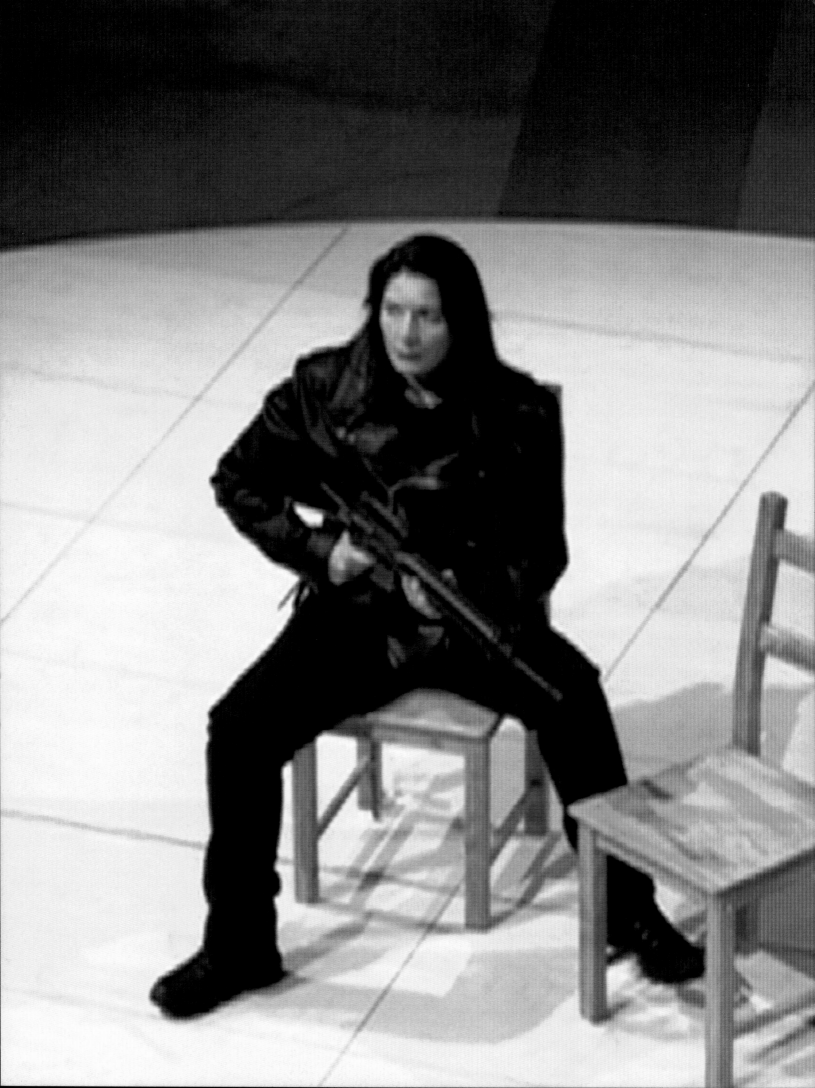

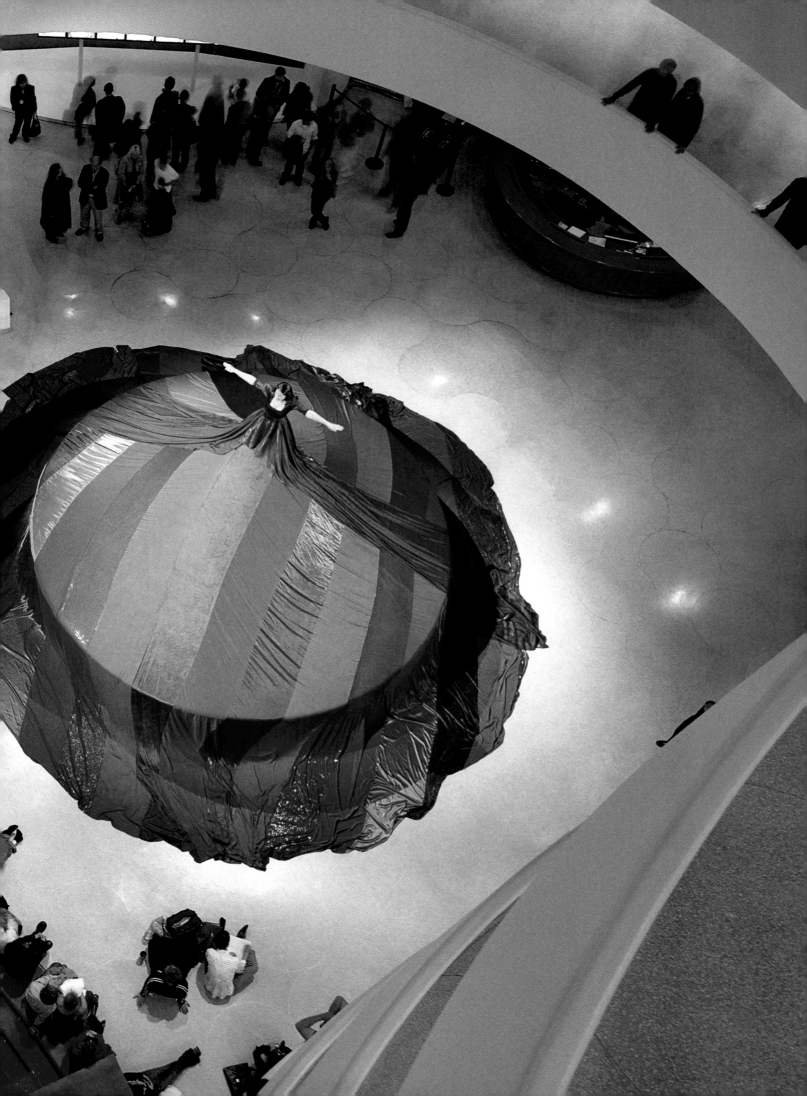

<u>You married Paolo.</u>
That was 2006.

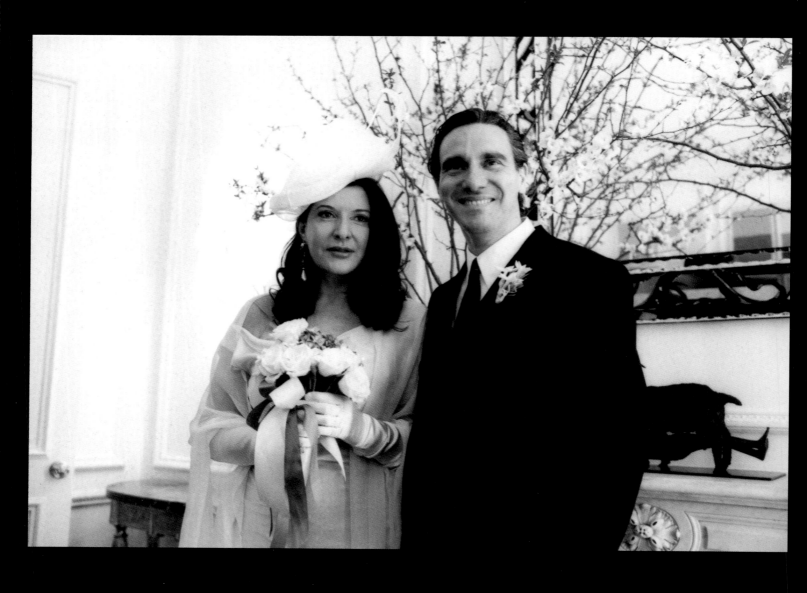

Previous spread: *7 Easy Pieces*, performing *Entering the Other Side*. 2005.

3

In 2007, my mother died. She didn't know who I was anymore, she couldn't recognize me. Still, she never admitted to being in pain. I did all I could for her in her last years. And when the family wanted to do an Orthodox funeral for her, I knew she would have hated it. I gave her an Orthodox funeral *and* a full military salute. Soldiers with rifles in the air. Then, for the first time in my life, I read all her letters and diaries. I finally understood how hurt, how incredibly unhappy she was. She was, what, 43 when my father left? In those days, it's like her life ended then. And her friends all came up to me and told me how funny she was. My mother, funny? There's so much I never knew about her.

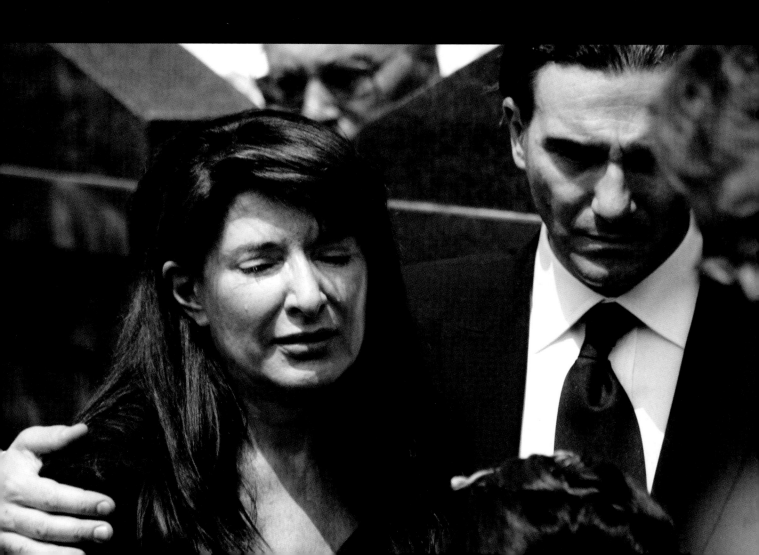

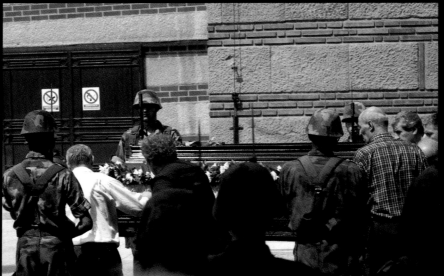

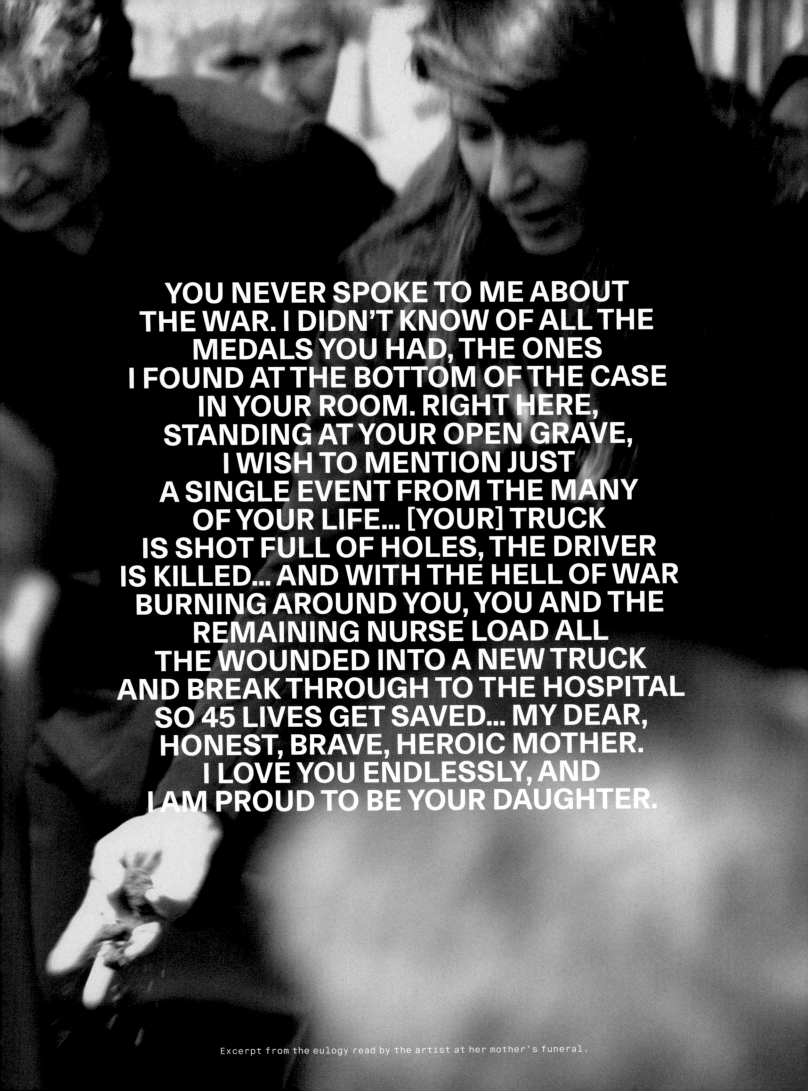

YOU NEVER SPOKE TO ME ABOUT
THE WAR. I DIDN'T KNOW OF ALL THE
MEDALS YOU HAD, THE ONES
I FOUND AT THE BOTTOM OF THE CASE
IN YOUR ROOM. RIGHT HERE,
STANDING AT YOUR OPEN GRAVE,
I WISH TO MENTION JUST
A SINGLE EVENT FROM THE MANY
OF YOUR LIFE... [YOUR] TRUCK
IS SHOT FULL OF HOLES, THE DRIVER
IS KILLED... AND WITH THE HELL OF WAR
BURNING AROUND YOU, YOU AND THE
REMAINING NURSE LOAD ALL
THE WOUNDED INTO A NEW TRUCK
AND BREAK THROUGH TO THE HOSPITAL
SO 45 LIVES GET SAVED... MY DEAR,
HONEST, BRAVE, HEROIC MOTHER.
I LOVE YOU ENDLESSLY, AND
I AM PROUD TO BE YOUR DAUGHTER.

Excerpt from the eulogy read by the artist at her mother's funeral.

<u>I can't find a childhood photo of you and
your mother together.</u>
There aren't many. Put this one in instead
[below]. It reminds me of my grandmother.
This is right after *Rhythm 5*, when I cut my hair
and almost died in the star. The next morning,
my grandmother gasped when she saw me and threw
a blanket over my head. She thought I'd been
possessed. We never said another word about
it [laughs].

Opposite: Still from *Count on Us (Star)*, 2003, made in Belgrade in the
aftermath of war and recalling the artist's *Rhythm 5* (1974).

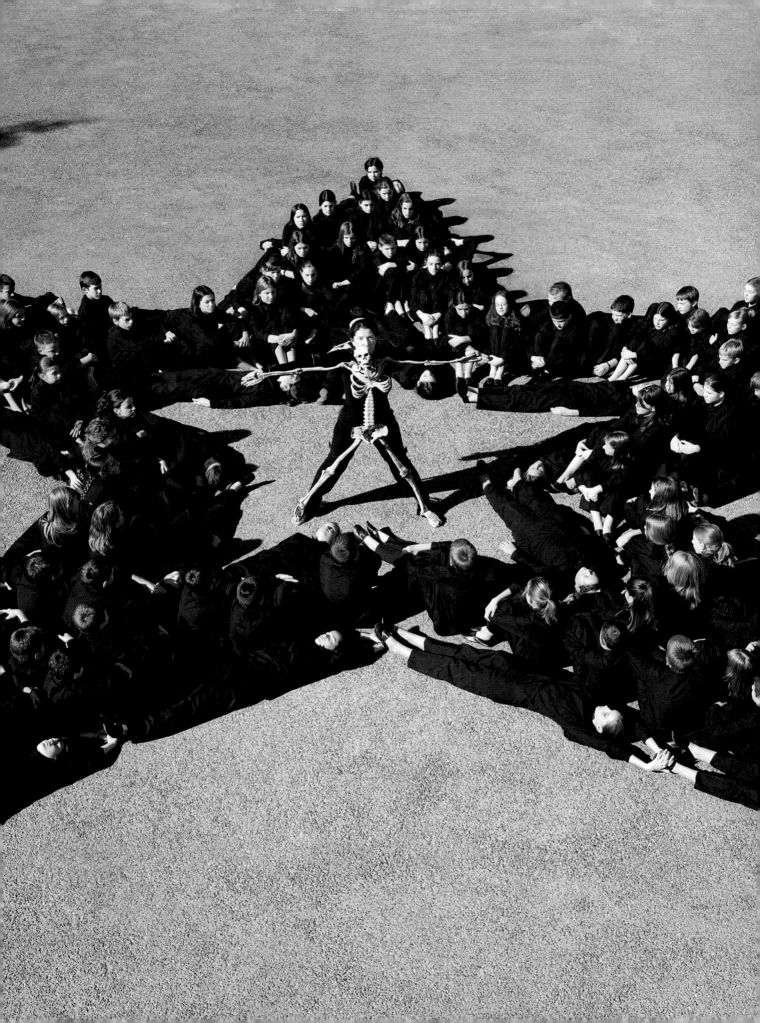

The same year my mother died, Paolo told me
he needed some space. I accommodated this,
until I found out he was actually with another
woman. 2008 we divorced. 2009 I went through
a terrible depression. 2010 was *The Artist Is
Present*. I'm telling you, that work saved me.
I put everything I knew into it, until there was
nothing left.

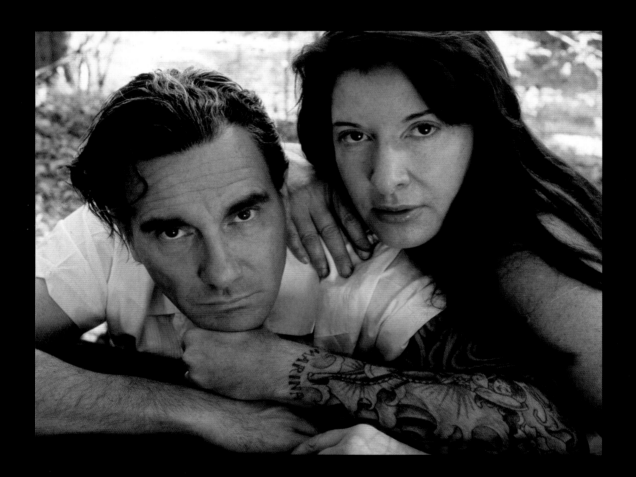

Opposite: *Carrying the Skeleton*, 2008

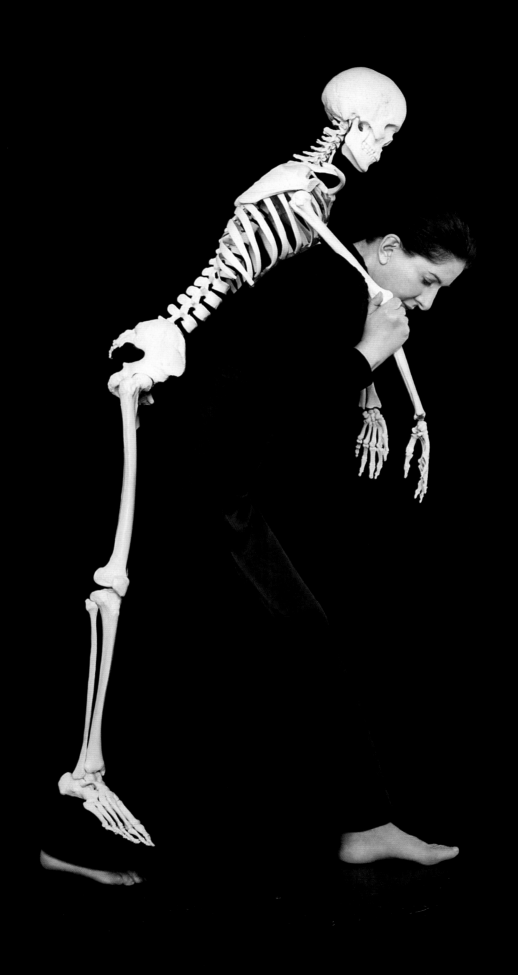

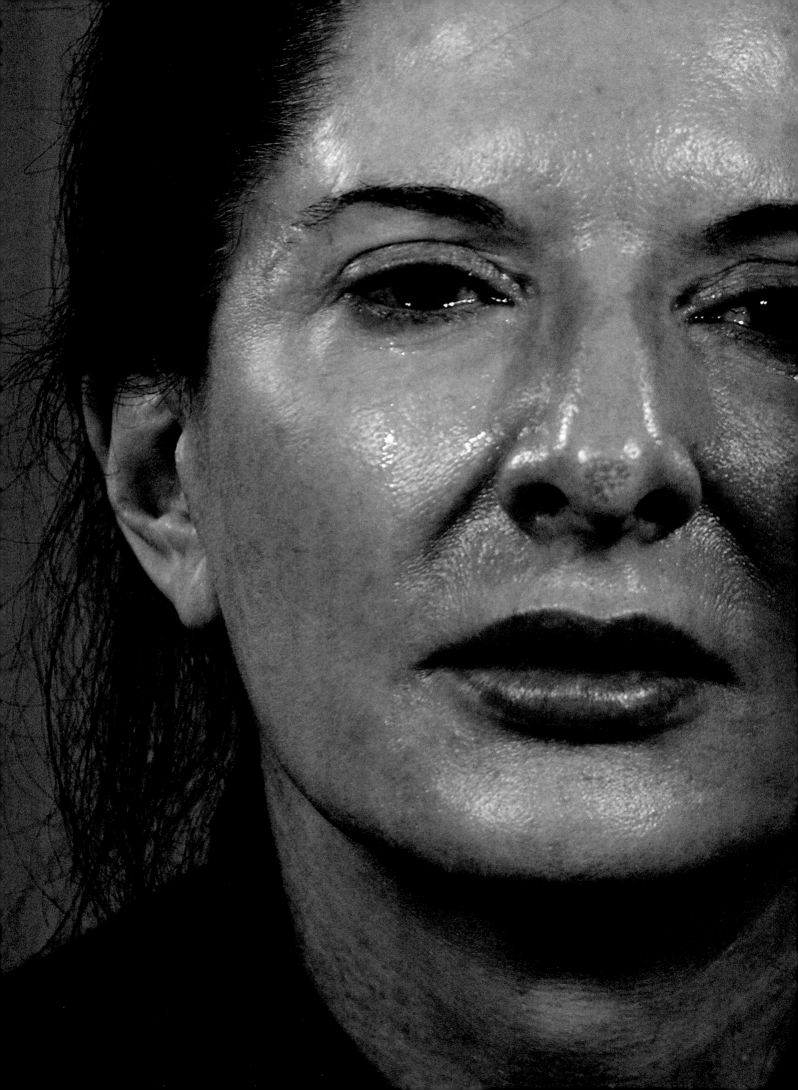

I PUT EVERYTHING I KNEW INTO IT, UNTIL THERE WAS NOTHING LEFT.

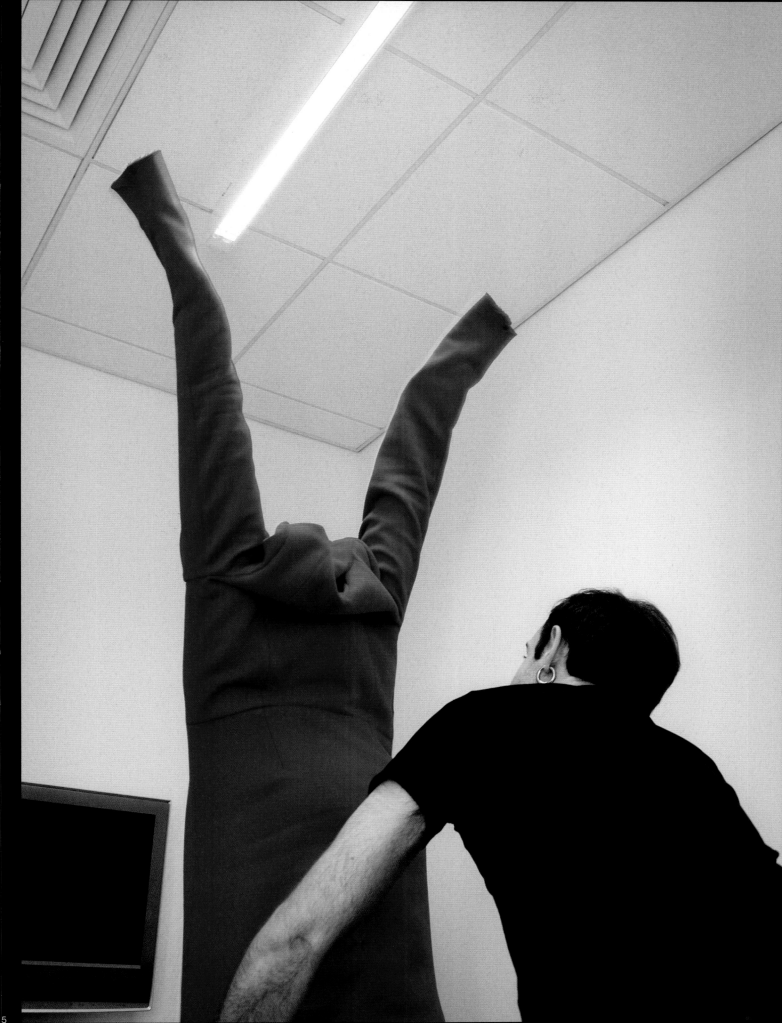

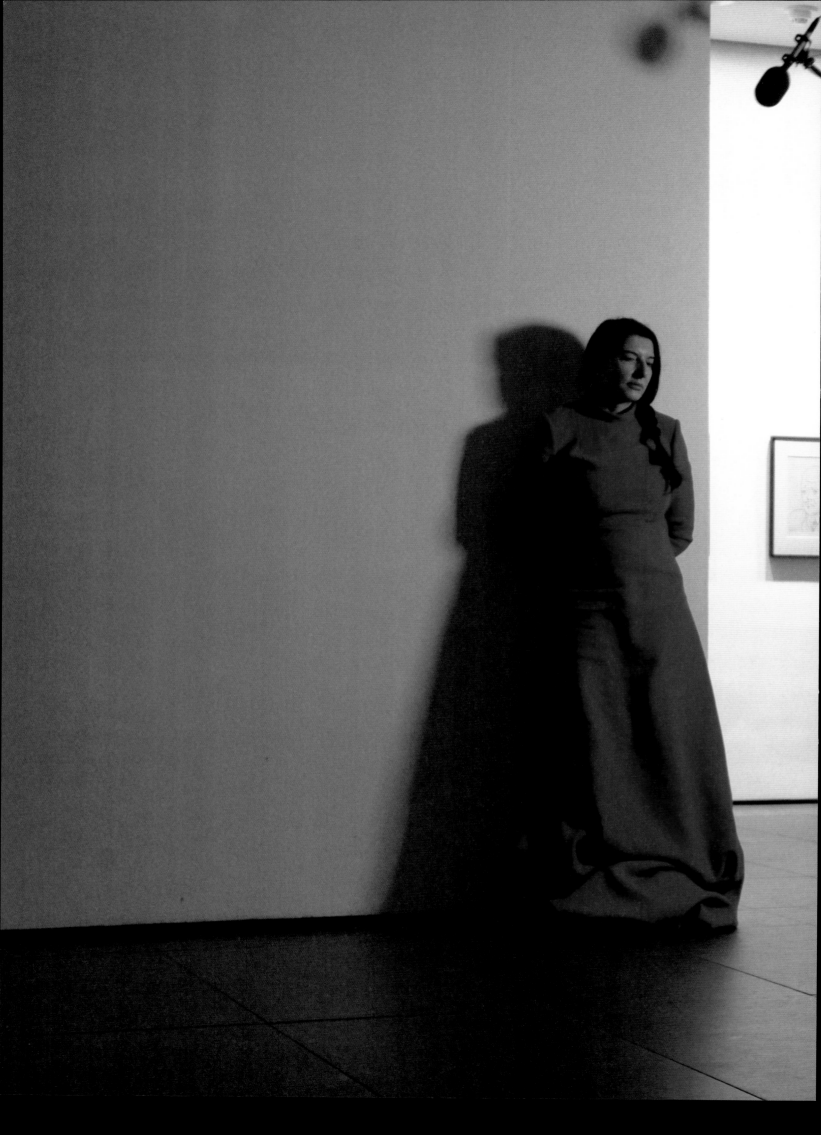

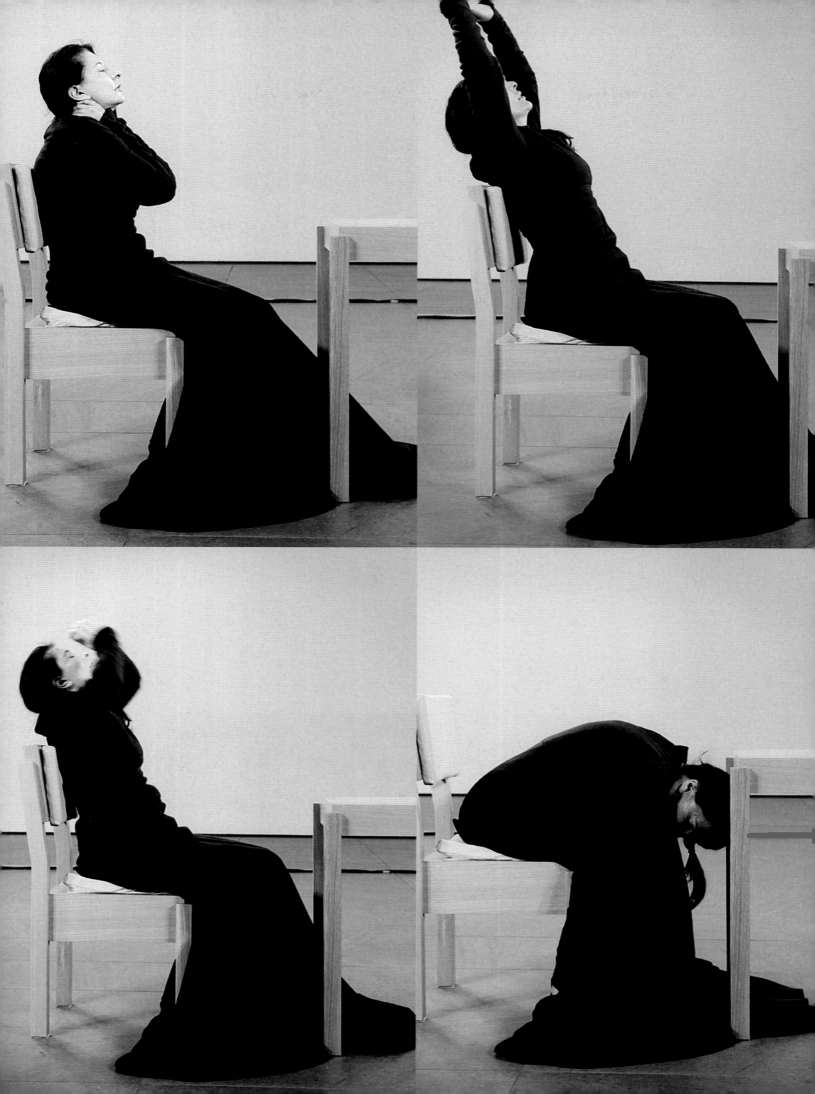

DURATION: 75 DAYS – 716 HOURS, 30 MINUTES

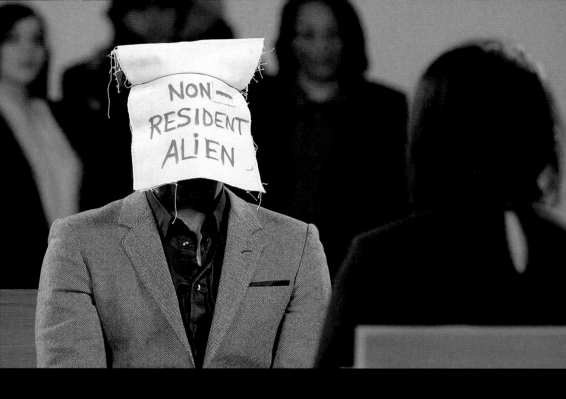

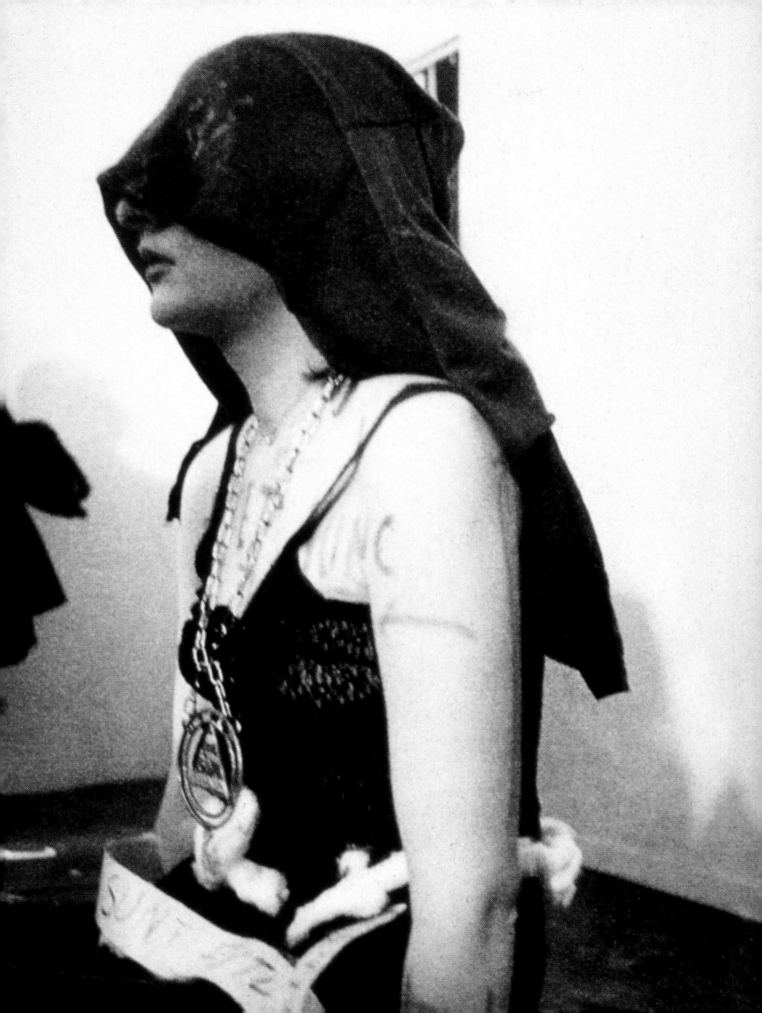

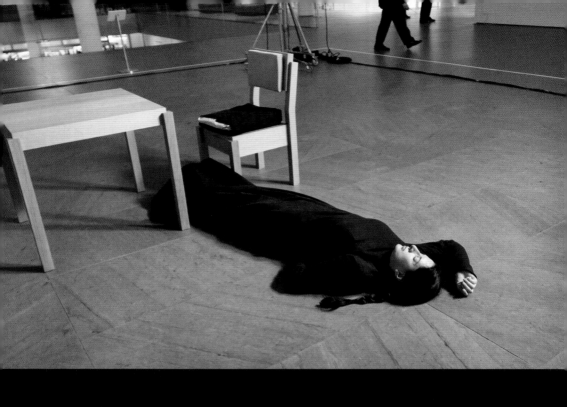

CONDITIONS:
VISITORS ARE INVITED TO SIT
IN FRONT OF THE ARTIST IN
SILENCE FOR AS LONG AS THEY
CHOOSE, WITHOUT ANY LIMIT

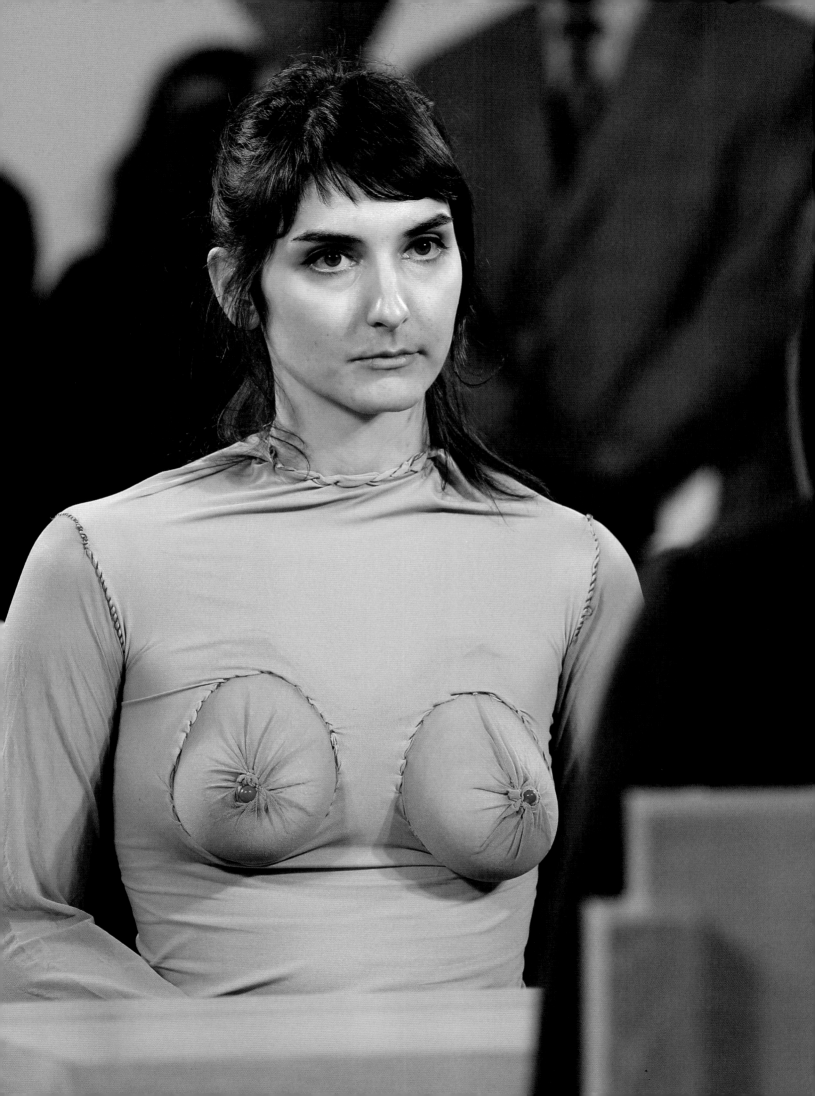

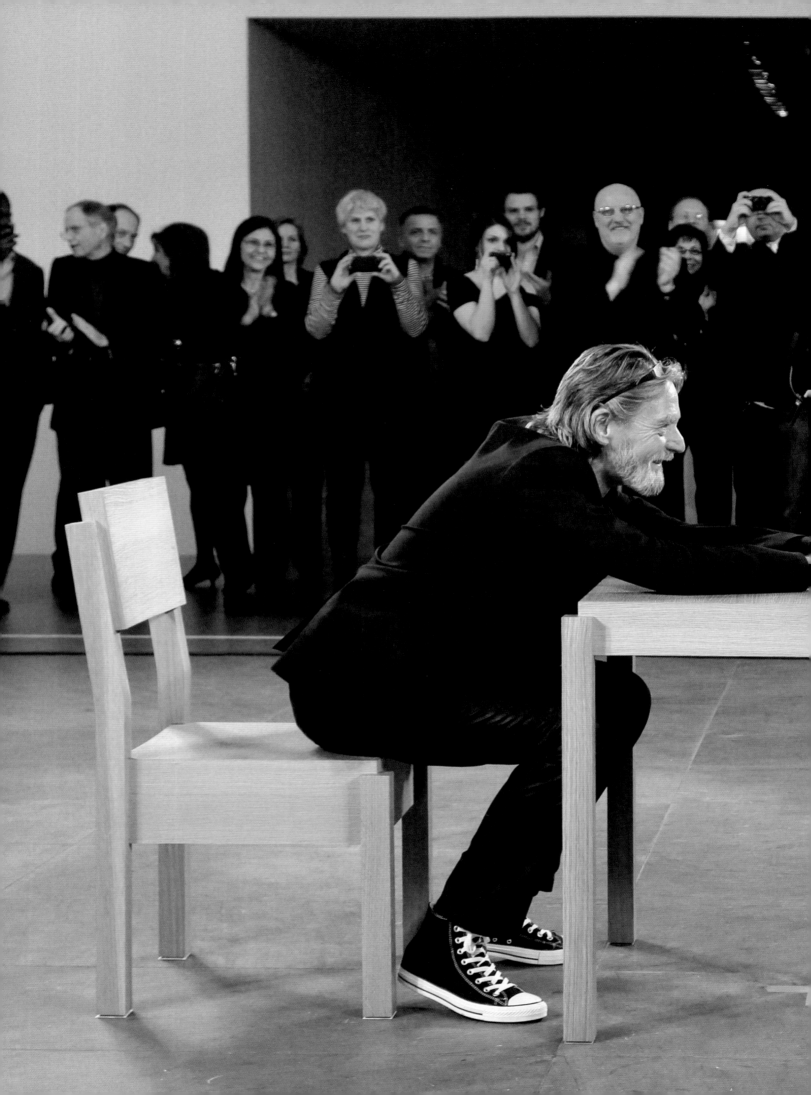

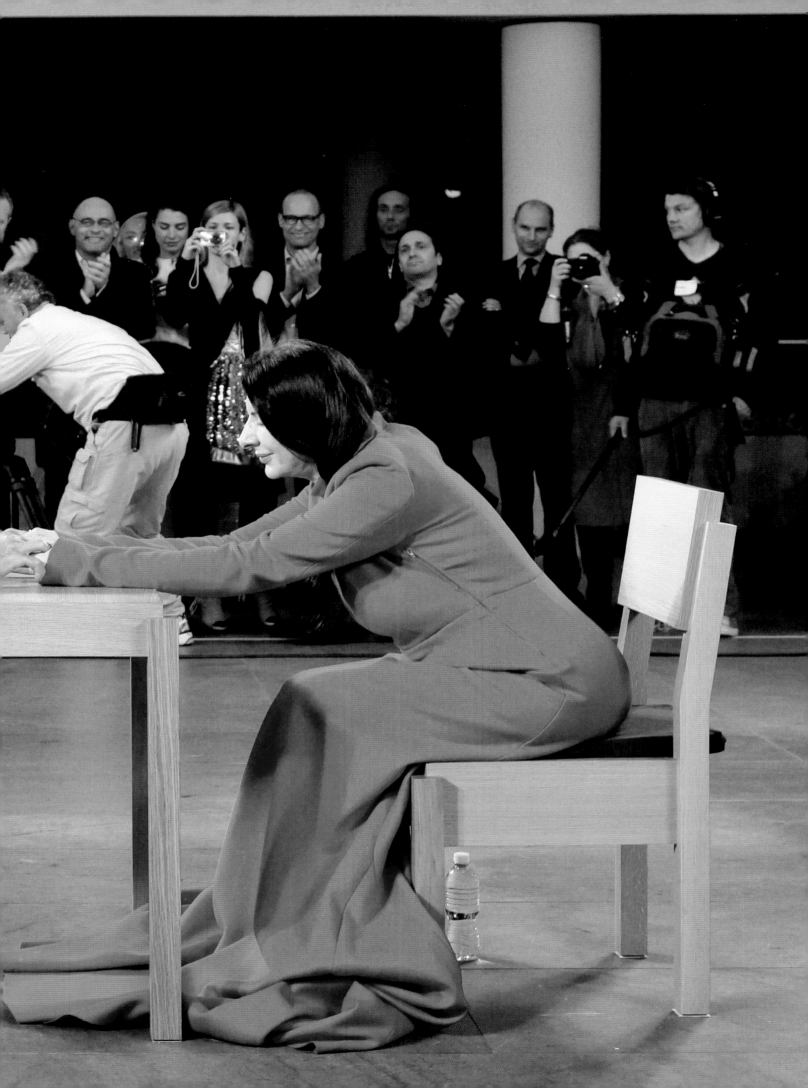

Now I understand why people protect
themselves from opening their heart in
this way. It can kill you. That work really
changed me. It changed my life.

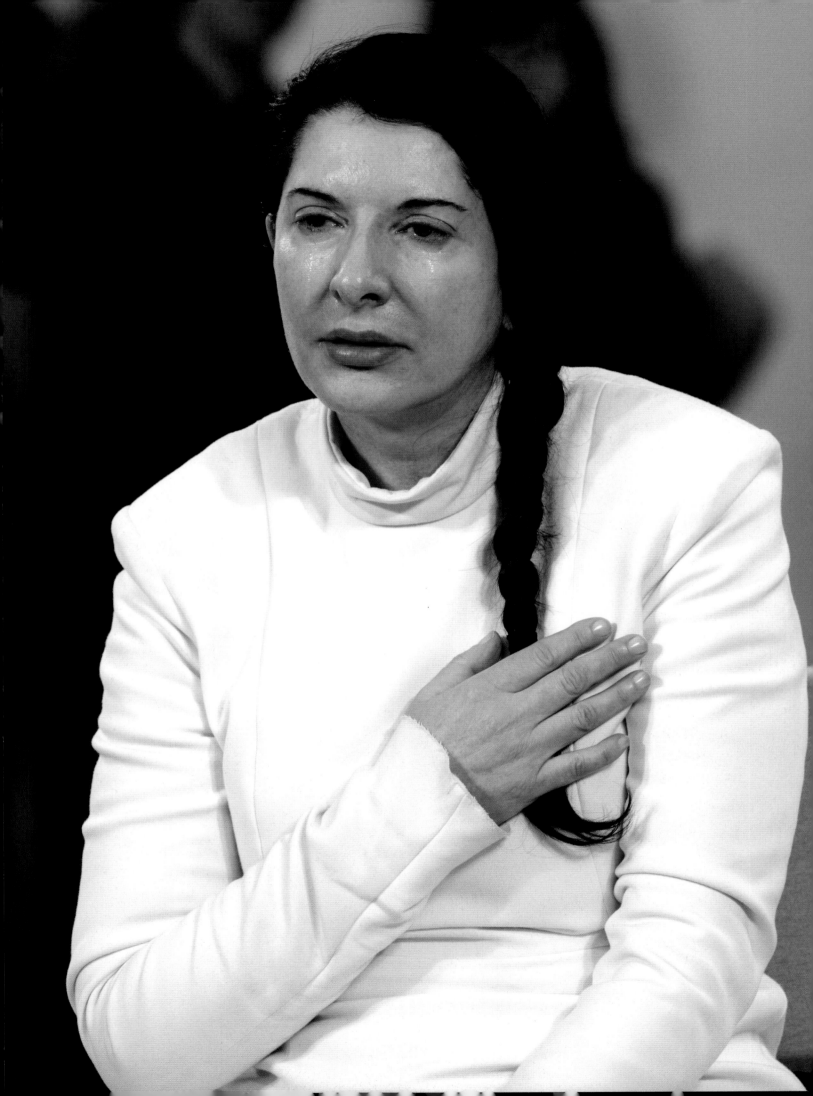

11

TURBULENCE

UNSPECIFIED LOCATIONS
2010–2020

ILLNESS, EXPERIMENTS, CURES

My public life was like nothing I had
experienced before. I saw my face on the
covers of magazines around the world. People
stopped me on the streets. I was invited to
fashion shoots and celebrity parties. And
I caused incredible trouble. After I was
invited to curate the 2011 MOCA Gala, people
said I sold myself.

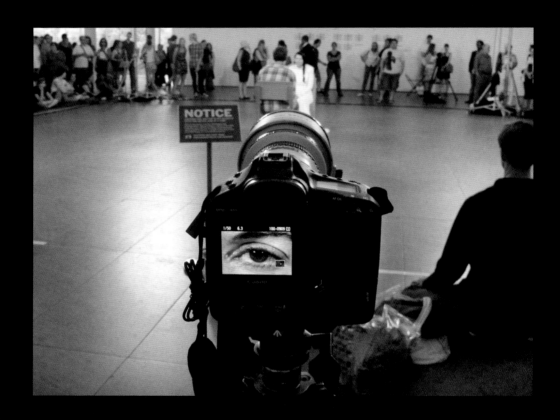

Opposite: *The Life and Death of Marina Abramović*, 2012. Following spread: Fan tattoo.

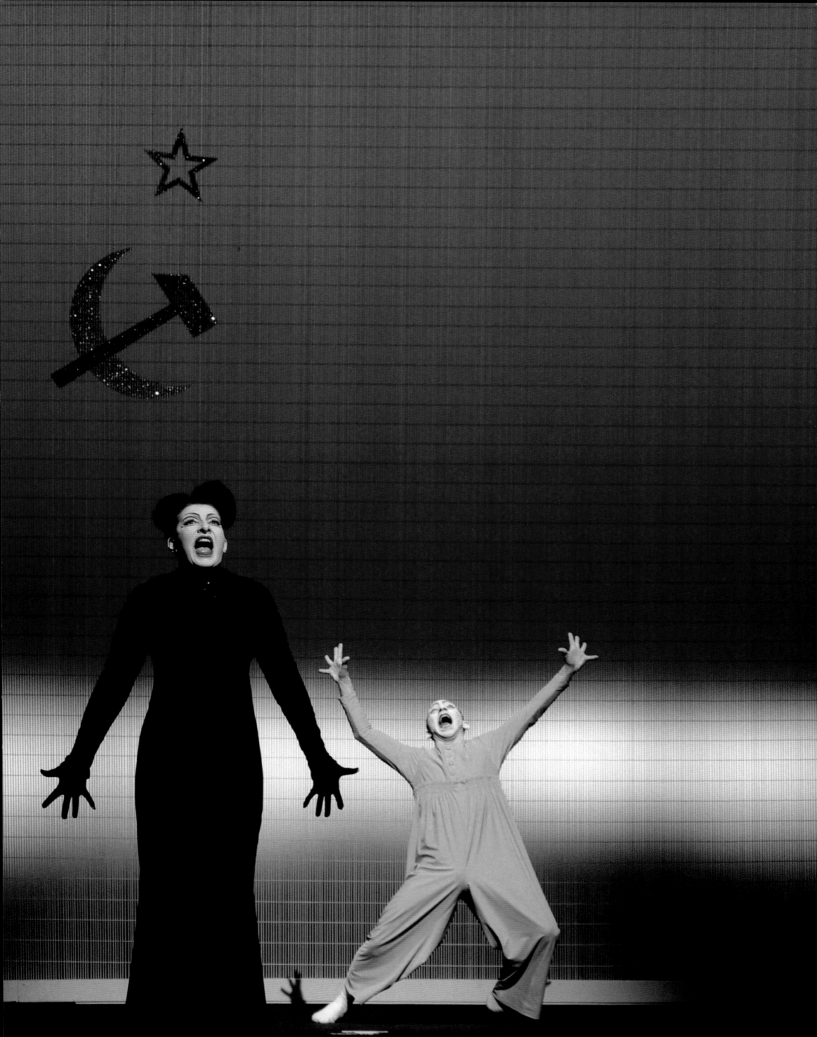

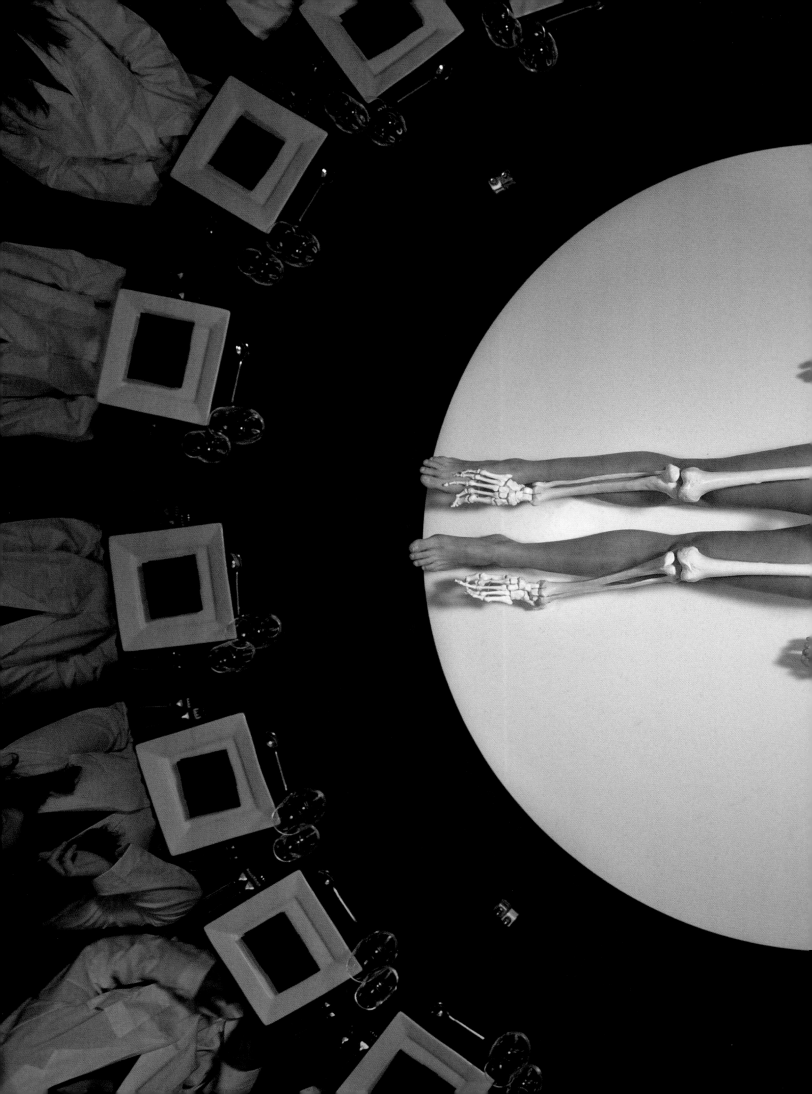

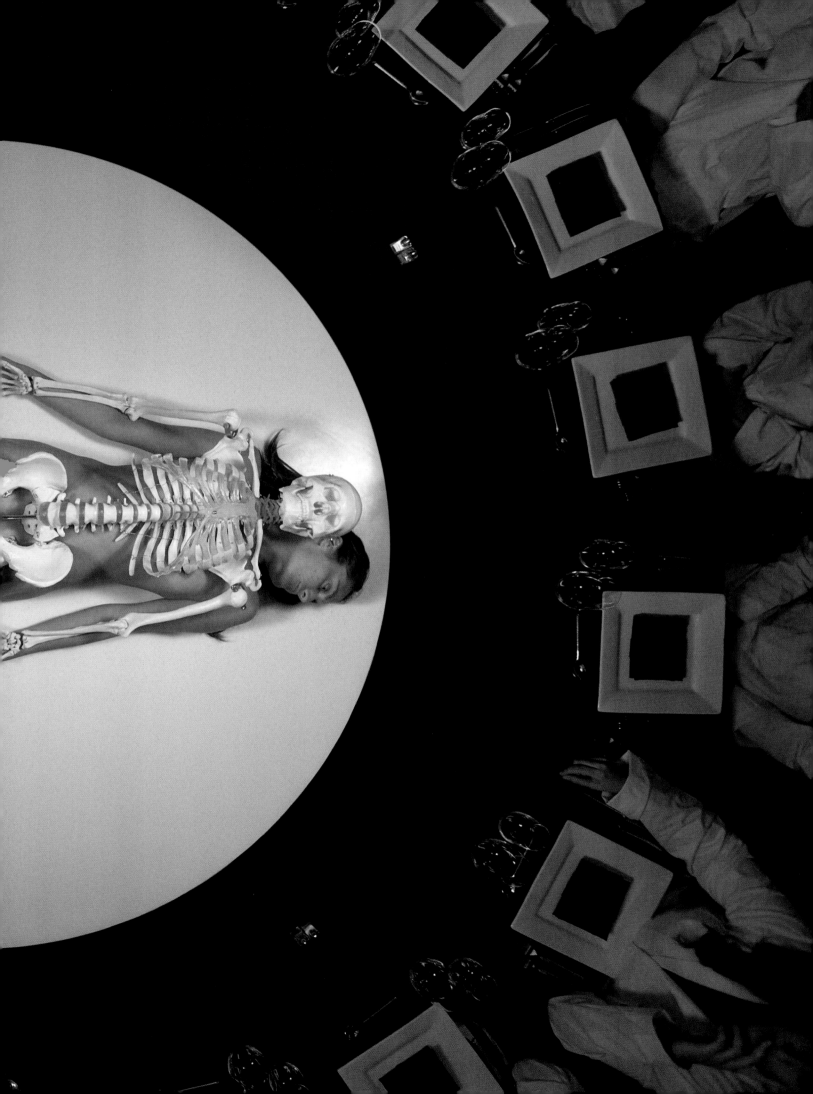

'How could the same person make *The Artist Is Present* and then this?' I heard the same thing when I did *Balkan Erotic Epic* after *The House with the Ocean View*. 'How could this be the same artist?' Of course it's the same artist. I need contrasts. Bad criticism hurts me, but I can live with it. I told you what happened one night after I performed in *The Life and Death of Marina Abramović*?

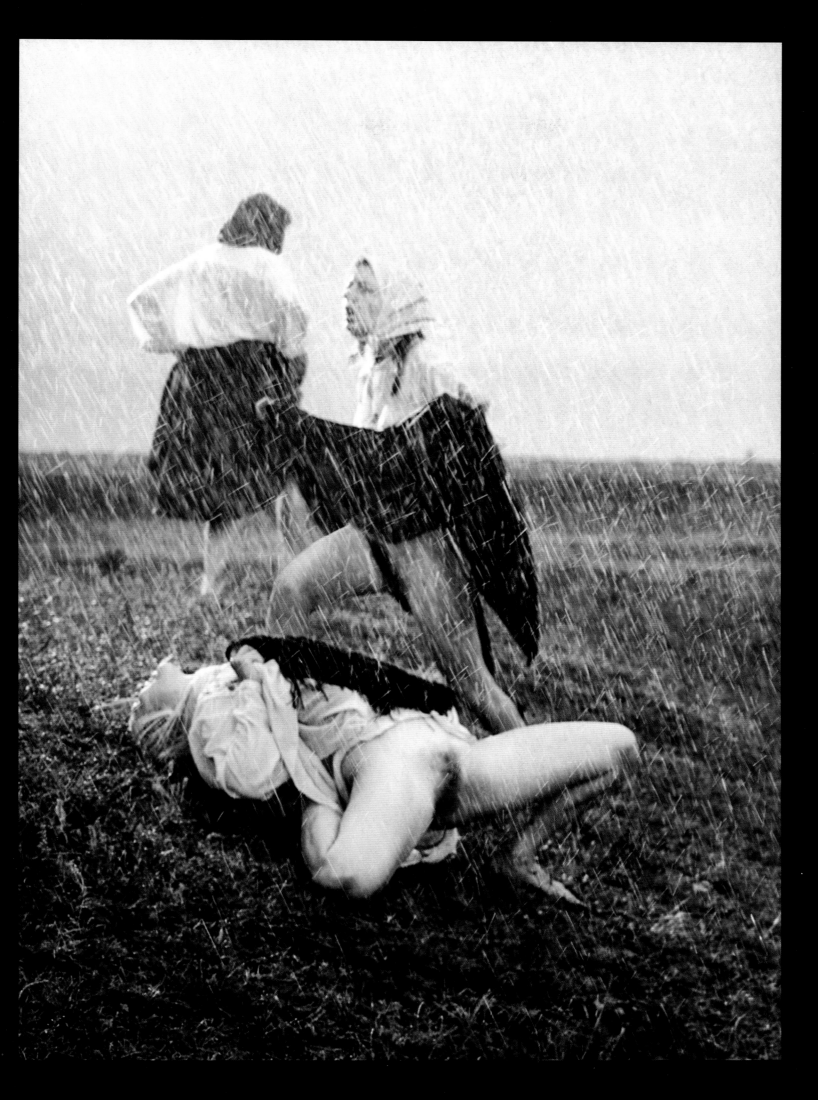

This was in 2012, when [theatre director] Robert Wilson made a biography of my life – one of six different biographies about me so far – and cast me in the role of my mother. After one performance, a woman came to me backstage and said: 'I am a psychotherapist. You just saved yourself 20 years of therapy.' It was so funny.

And true. I put everything into my work. I make my pain and humiliation public, and that's how I get rid of it. It's how I connect with people. There's no way another human being doesn't feel the same things I do. We share these things.

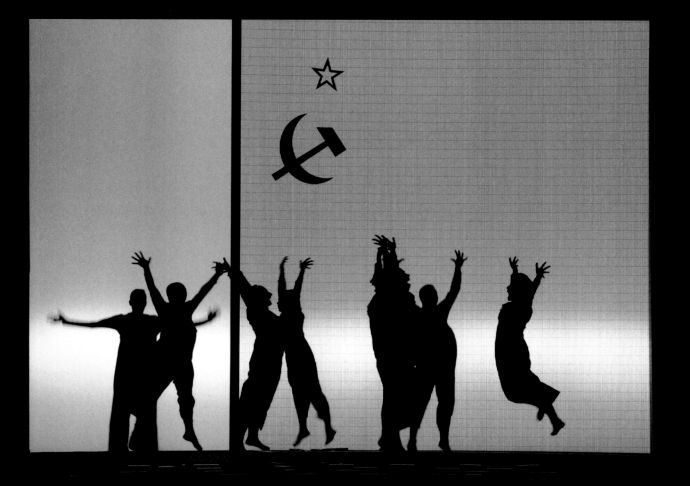

Above and opposite: *The Life and Death of Marina Abramović*, 2012.

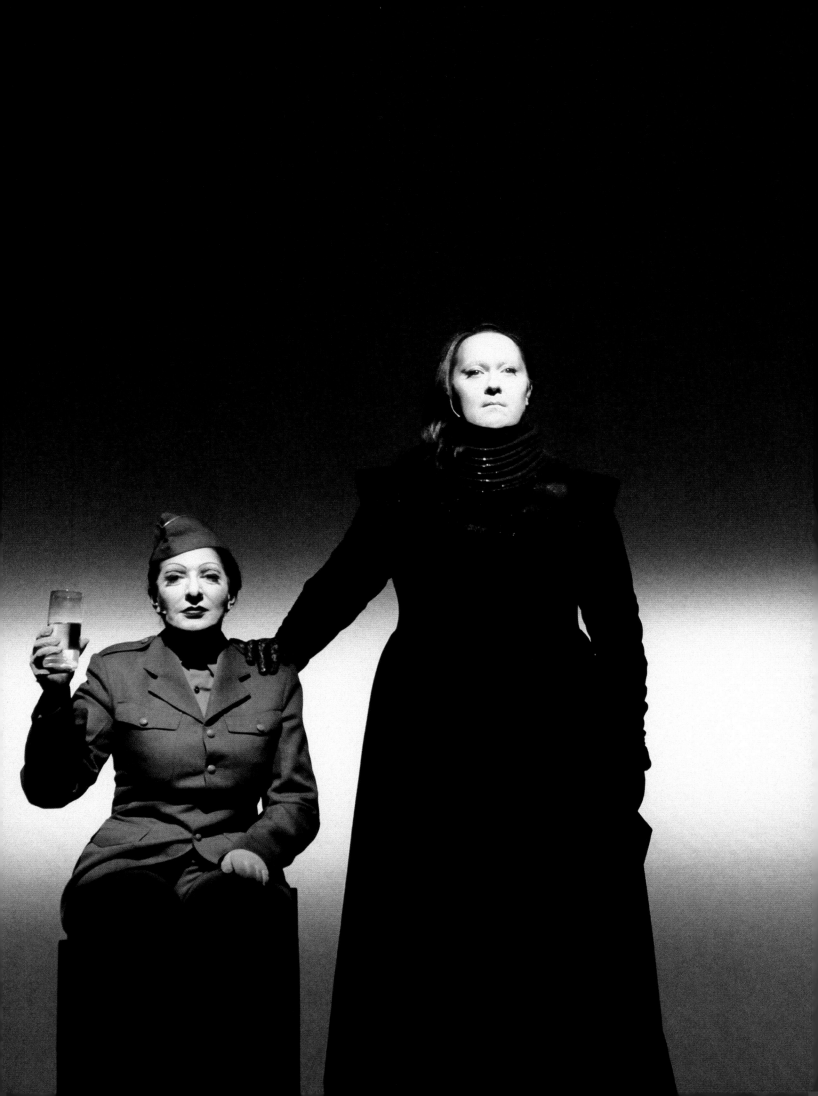

after *The Artist Is
me. I'm sure he thought I was
t our work was getting so
said we'd been incorrectly
e from our joint work, and
ed with him. I had to take
y him. It's a shitty story.

MARINA ABRAMOVIĆ

🌀 Sceptic, heal thyself. 🔋 Discipline is both a noun and verb. 👁 When a stranger stares into your soul, do not press charges. Stare back.

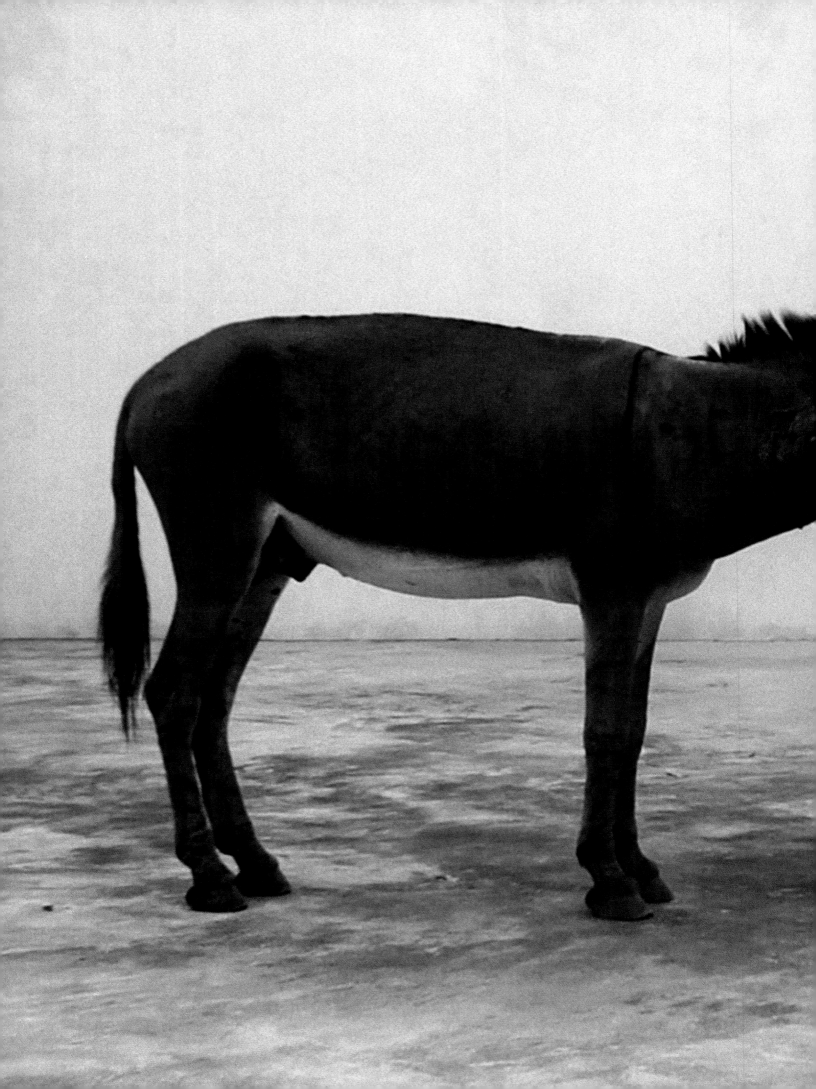

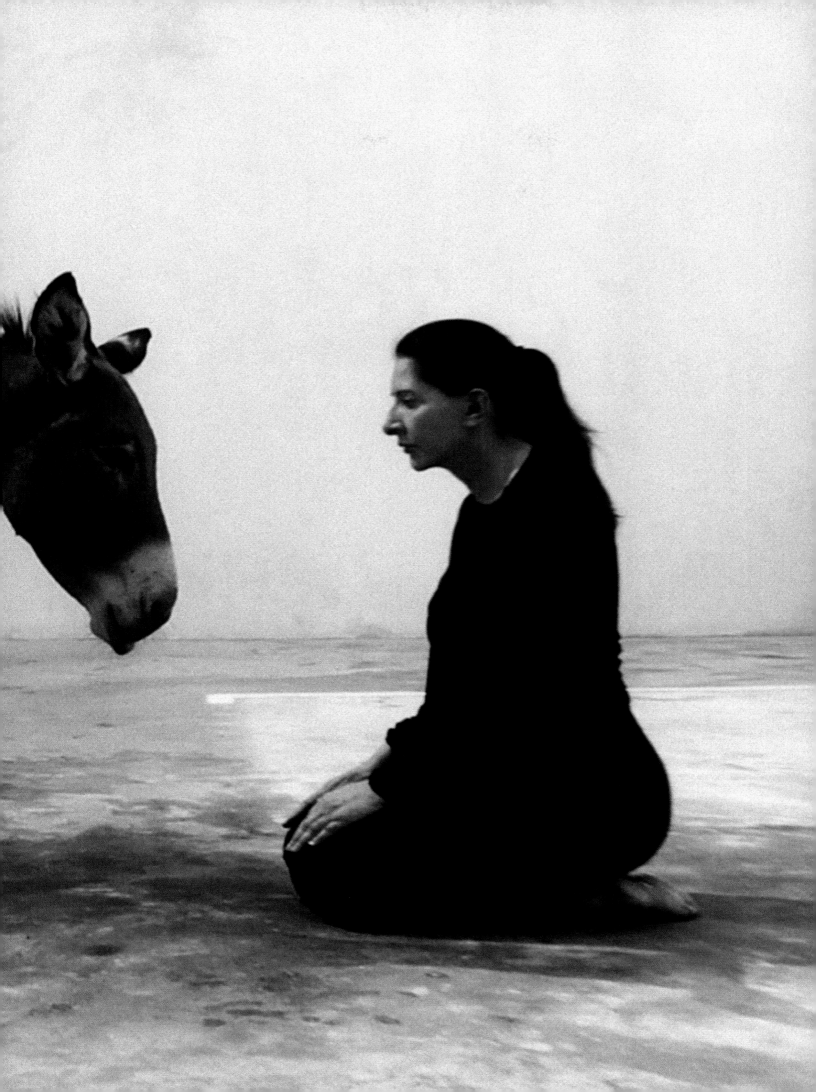

The best part is what happened next. I was so exhausted. I booked a very strict Ayurvedic retreat in India. It took 36 hours to get there. I arrived at 6 a.m. and guess who's just standing there? I almost left. But I believe so much in life's synchronicities and symbols. Destiny put us together. There is no other explanation. By the end of the month in India, Ulay and I forgave each other completely.

It was around that time he found out he had cancer. After that, he called me on every birthday until he died [in 2020]. You remember we have the same birthday…

You and Ulay made peace.
Completely. When I least expected it. The last time we ever talked, he thanked me for what I have done for our work.

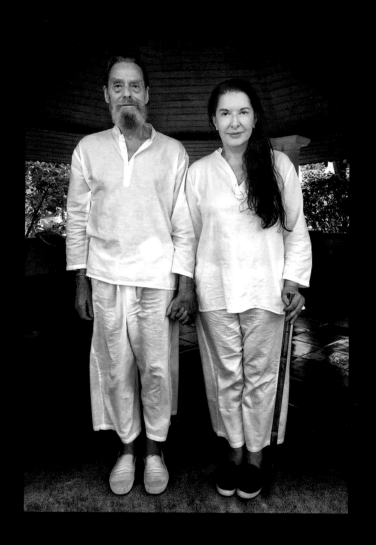

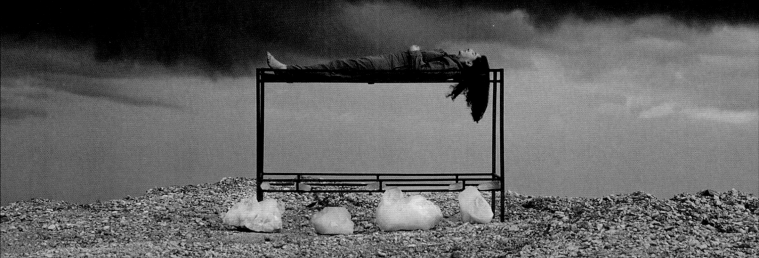

And something else. After *The Artist Is Present*, Paolo came back and then left me again. I was desperate and heartbroken. I went to Brazil looking for a cure.

For what?
I just wanted to feel better. I was approaching 70 and thinking: 'What have I done with my life?'

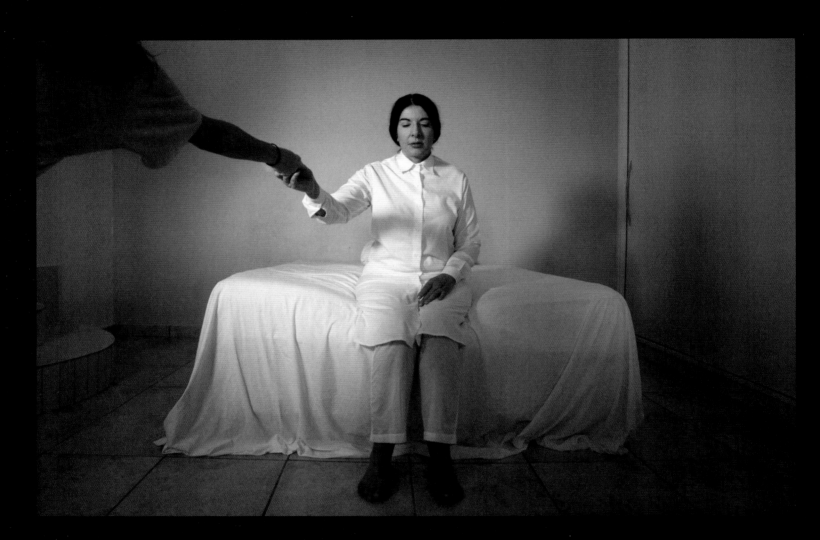

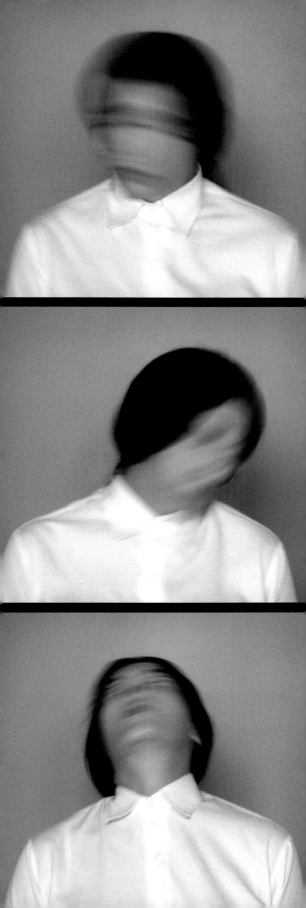

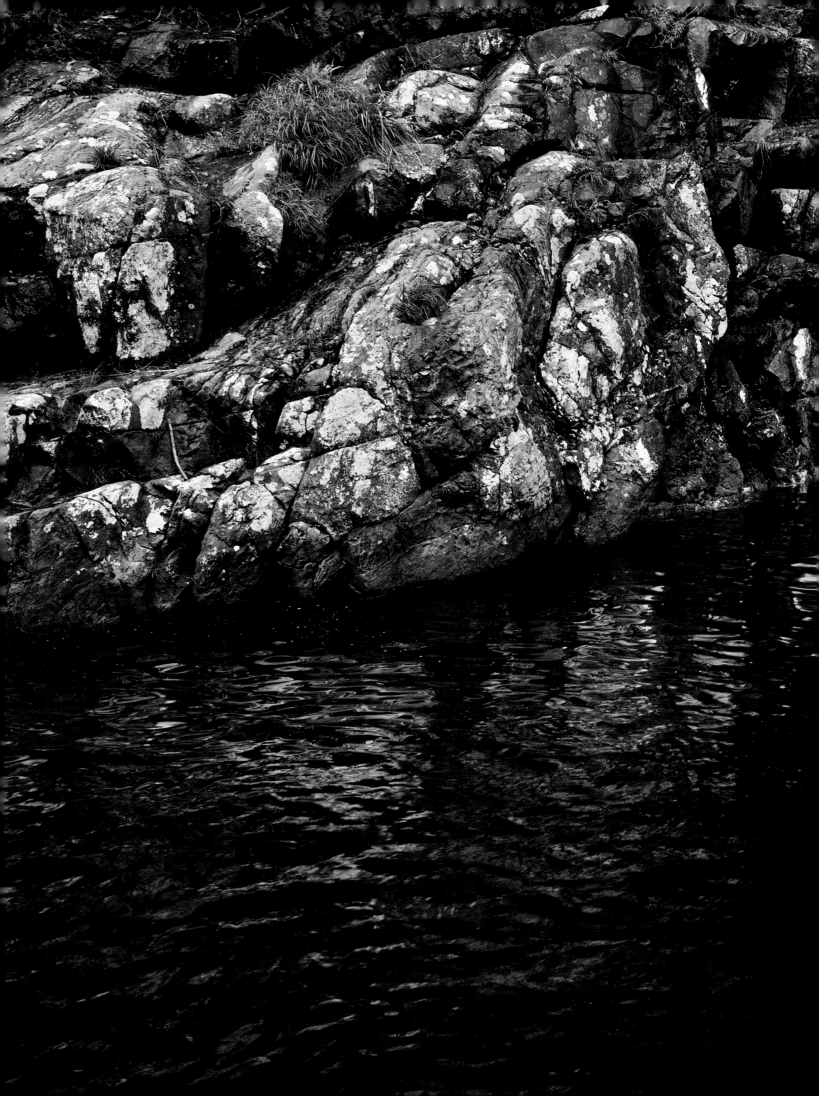

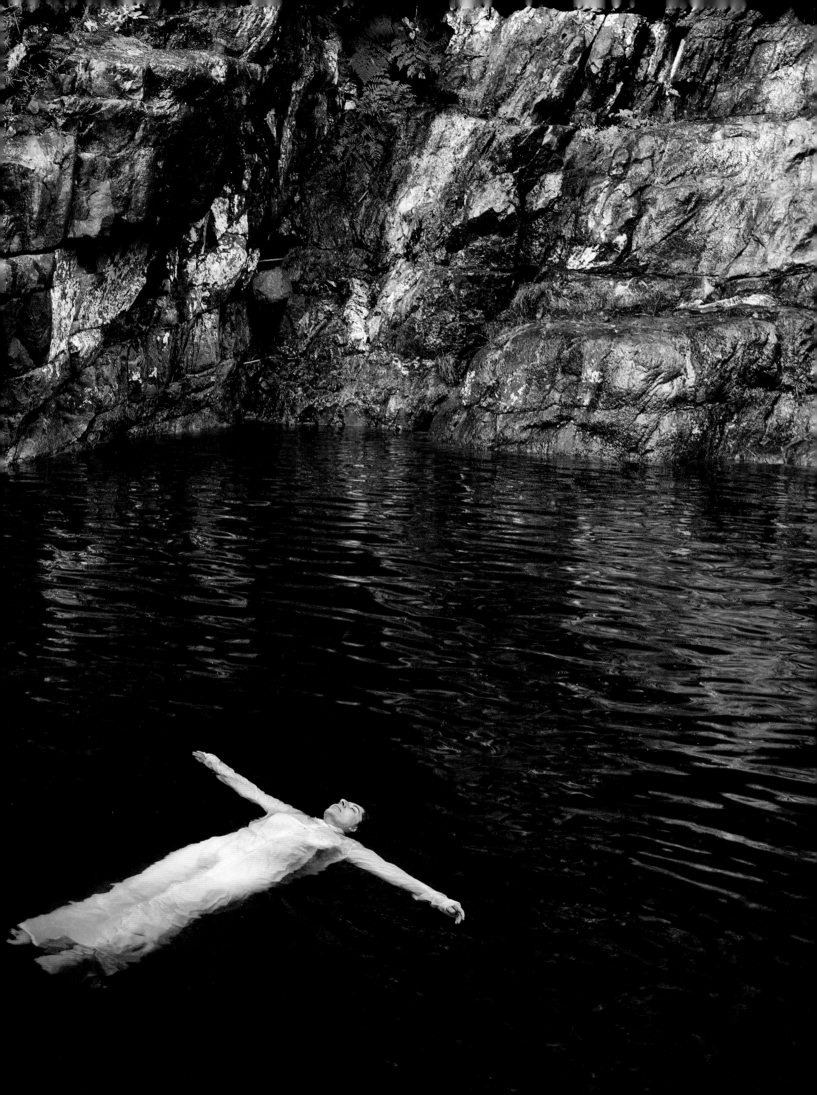

Did you come up with an answer?
I came up with three.

1. I brought performance art into
 the mainstream.
2. I legitimized the idea of reperformance and
 created a blueprint for asking permission,
 crediting and paying the original artist
 or foundation.
3. I made my Method. I've taught so many people
 about long, durational work.

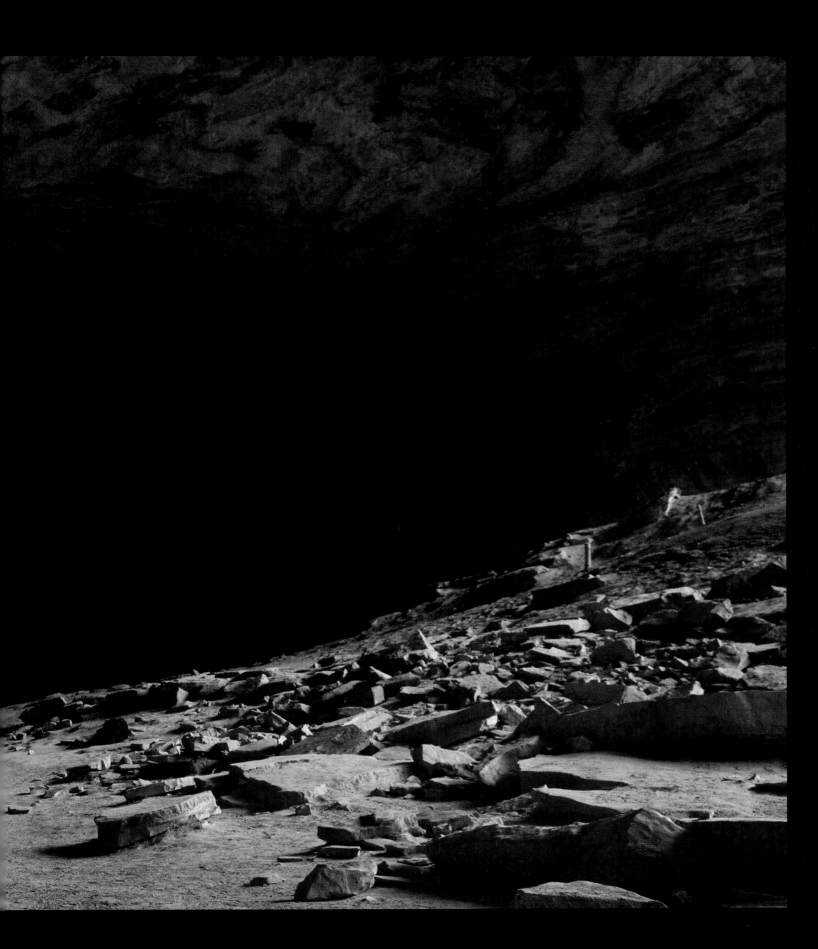

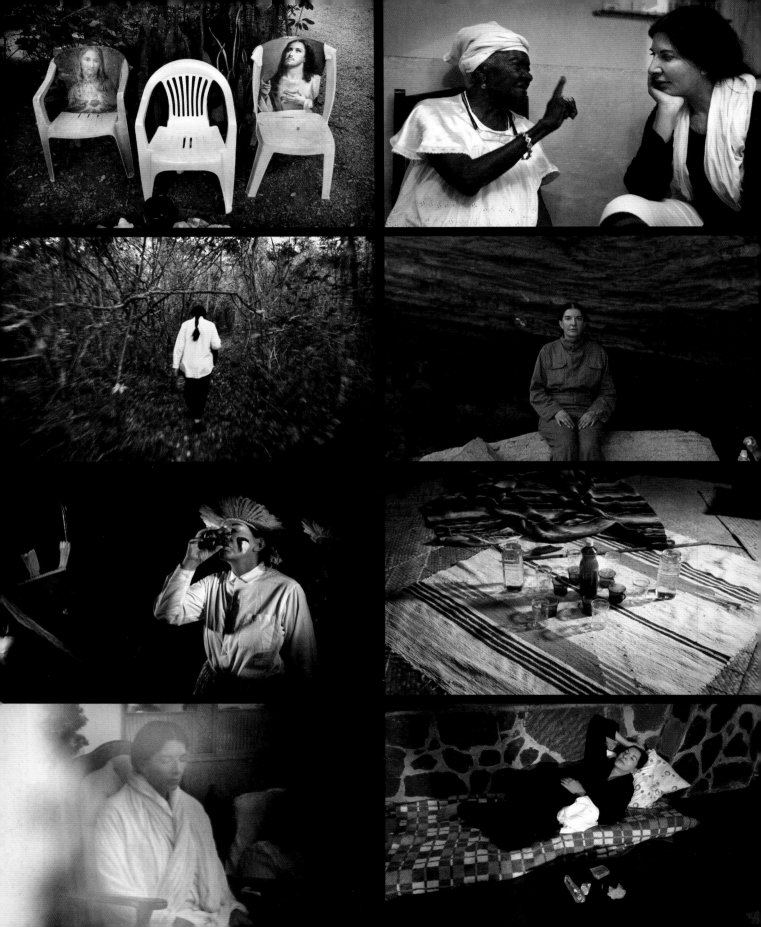

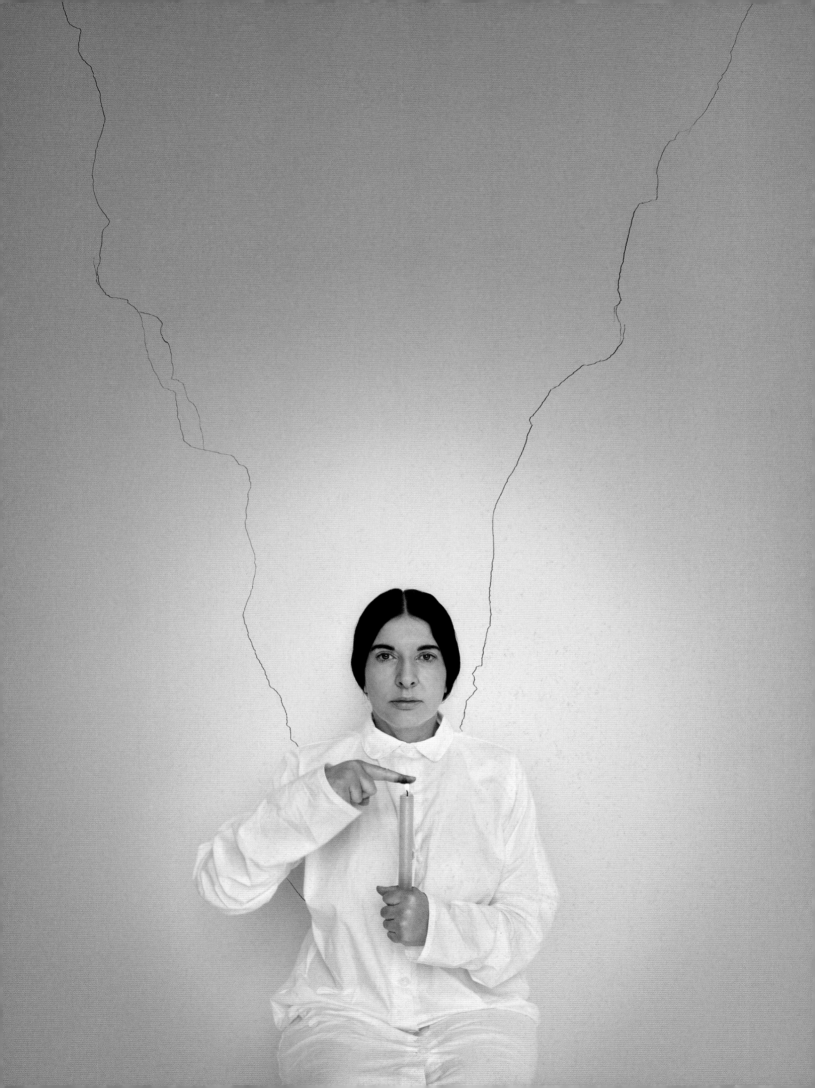

Tell me why long, durational work is important.
Because it can be transformative, both for
the artist and the public. It can change your
life. I was scheduled to have an exhibition
of new work at the Serpentine Gallery in 2014.
After the time I spent healing in Brazil,
I called them and said: 'There isn't going
to be any new work. The public is the work.
The walls are going to be empty.' This became
512 Hours (2014). Every morning, I would let
in the maximum amount of people – 250 – and they
would start doing the work: walk in slow motion,
close your eyes, breathe… It was so personal.
Some people came back every single day. I was
always there until closing so that I could say:
'Goodnight. Thank you for your trust.'

You say the public is the artwork. Do you agree
that many people come just to see you?
Yes, I can become an obstacle to my own work.
That is why, more and more, I remove myself from
the work. I have facilitators guide people
to the experience, not to me.

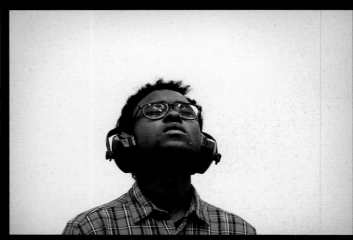
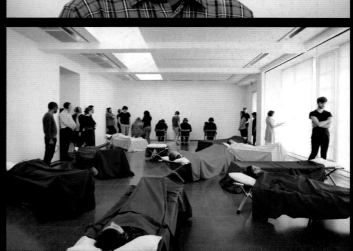

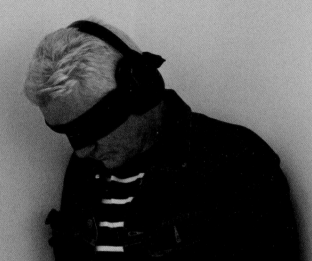

THERE ISN'T GOING TO BE ANY NEW WORK. THE PUBLIC IS THE WORK.

l didn't know what was
felt chronically sick. I was
n. Tired, confused, panic
to ignore it. I kept working,
s and going to events. I made
seventieth birthday, but

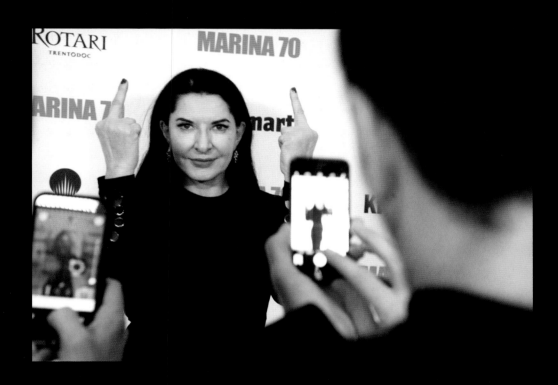

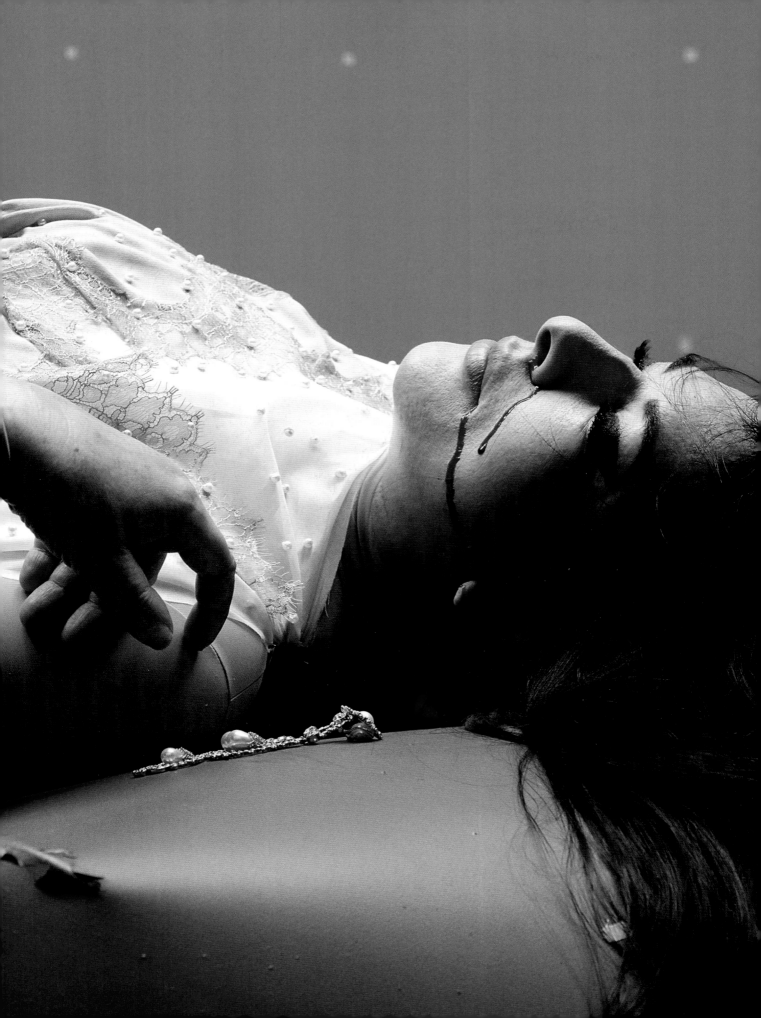

Finally, Sean Kelly's wife, Mary, suggested
I get tested for Lyme disease. She was right.
A tick had transmitted four different diseases
to me. I took four different antibiotics for
three months. You can imagine. Pain, pain,
pain… How to get it out? Only one way for me.
Put the pain into the work.

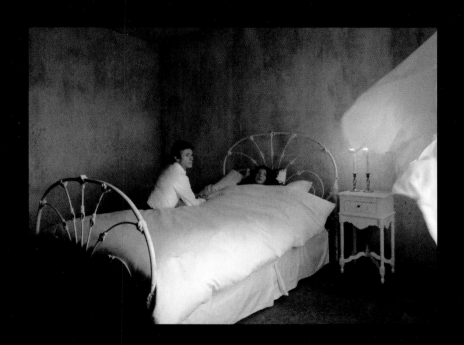

Above and opposite: *7 Deaths of Maria Callas*, 2020.

Katya, I'm in the last act of my life. I don't have time anymore for bullshit! What really hit me is: I need to realize the works I still want to make. When I received an invitation to direct an opera in Munich [at the Bayerische Staatsoper], it took less than 30 seconds to agree I would do *7 Deaths of Maria Callas* (2020) – a project I've been wanting to make for 30 years. I didn't do just one opera, I did seven in one night – each 10 minutes long, and each ending in the death of the heroine, as the result of love. Wow. What's very important to me is that each opera was once performed by Maria Callas and mixes her real life with the fiction. Then Petter Skavlan [the author of the book of the opera] said to me: 'We need an eighth death.' And the eighth death was the one of Callas herself. And this death was played by me.

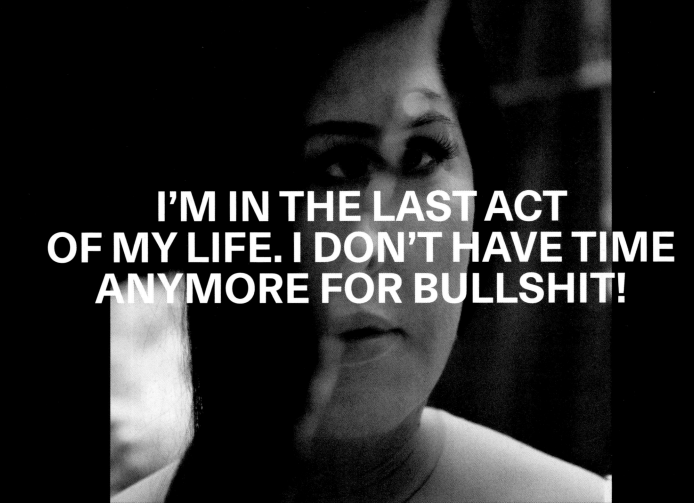

I'M IN THE LAST ACT OF MY LIFE. I DON'T HAVE TIME ANYMORE FOR BULLSHIT!

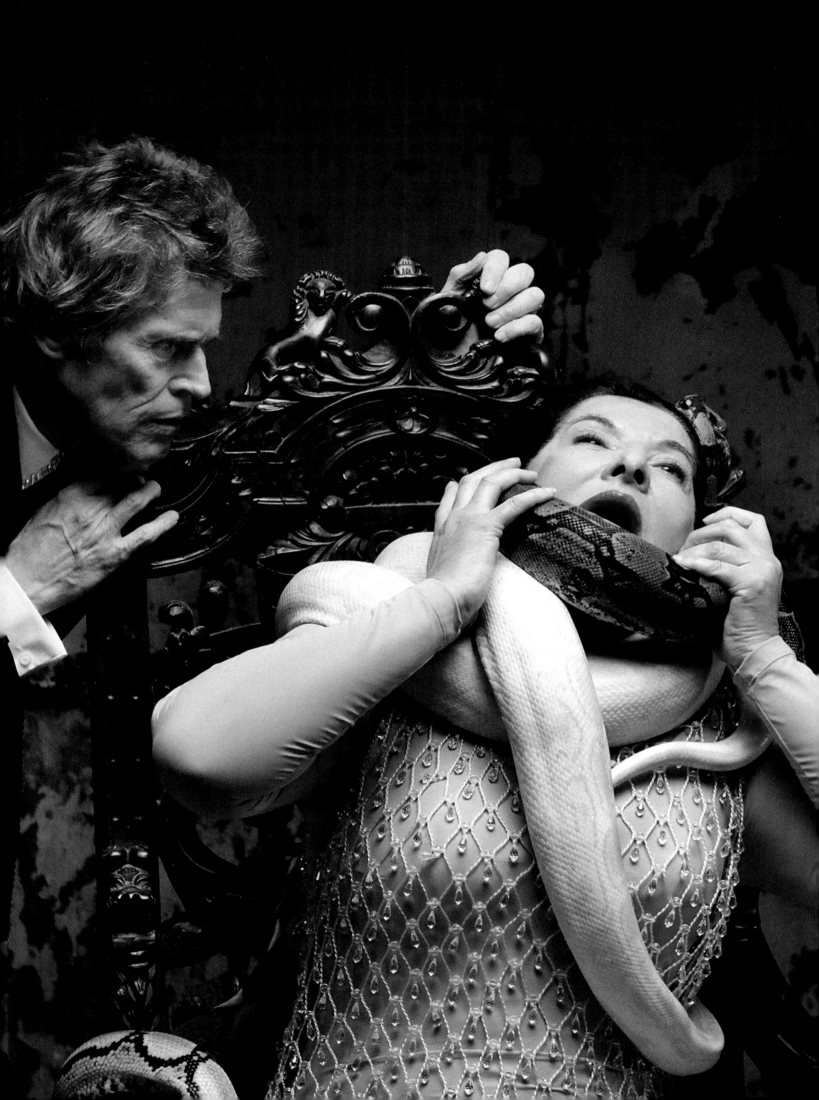

AIDA
(SUFFOCATION)

NORMA
(BURNING)

CARMEN
(KNIFING)

LA TRAVIATA
(CONSUMPTION)

MADAME BUTTERFLY
(HARA-KIRI)

OTHELLO
(STRANGULATION)

TOSCA
(JUMPING)

The artist's titles for the seven operas, including the manner of death.

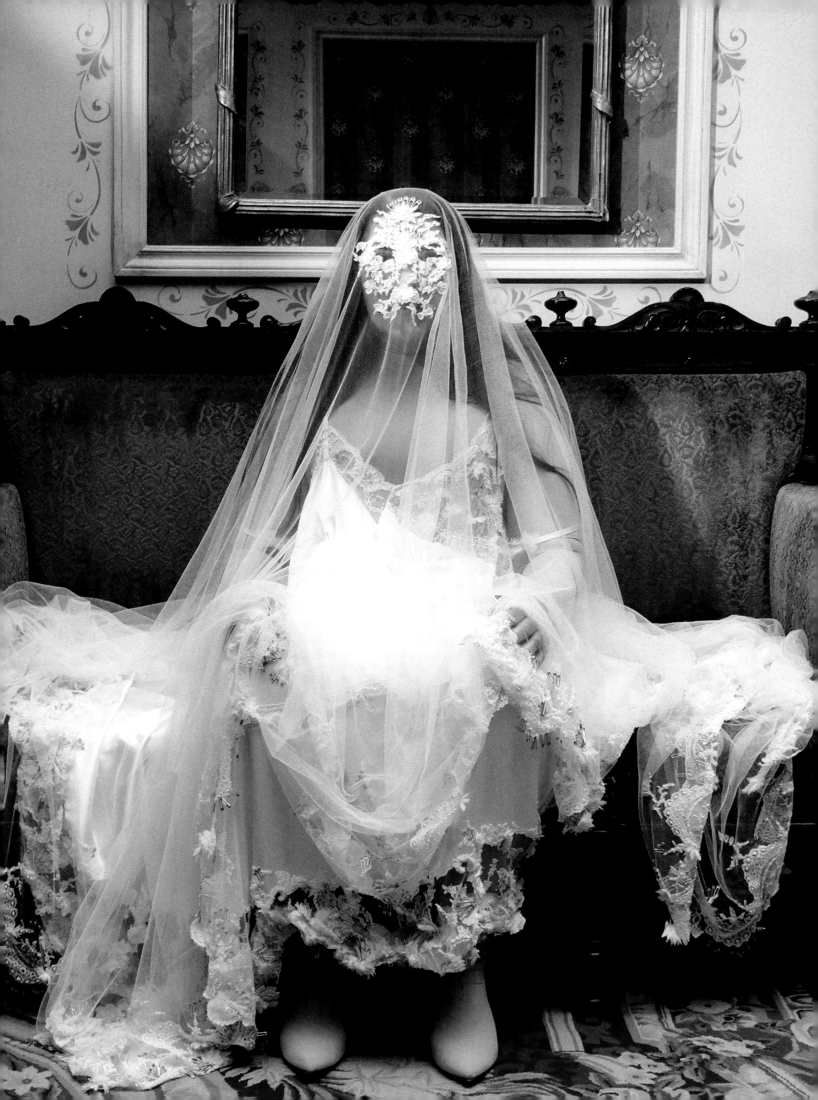

Why Maria Callas?

She fascinates me. We have so much similarity. She had a very difficult relationship with her mother, she was a Sagittarius, big nose, passionate about love, always suffering. And it's incredible to see how she transformed from a fragile person to a dominant force on stage, how much the public's applause changed her. But Callas once said that she would give up everything – her career, her talent and success – for a nice childhood and a traditional life. God, I got so angry when I heard that.

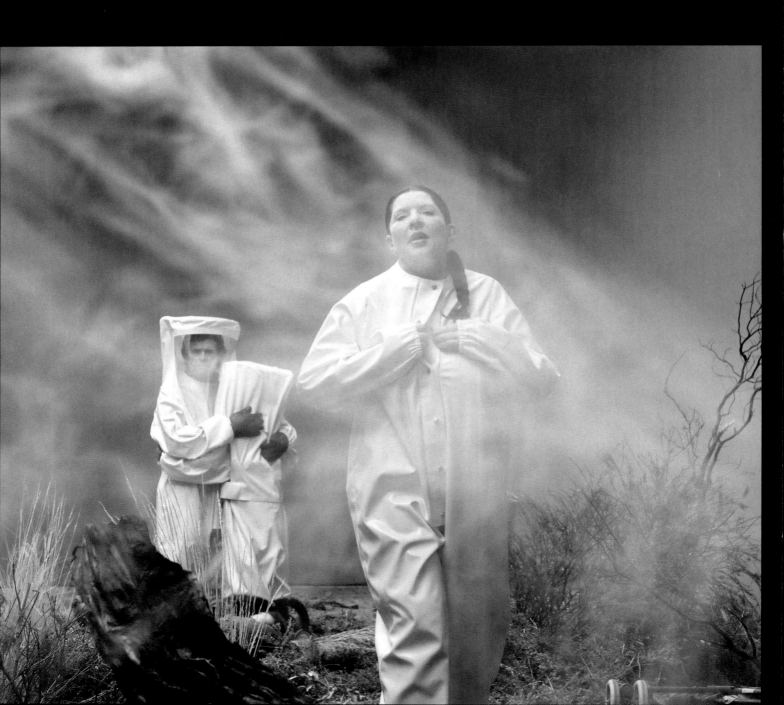

Angry?
Yes! Because when you have such a gift, it
doesn't belong to you! It belongs to everybody,
and you have to live for it! A traditional
life? It's almost like a traditional life
isn't allowed.

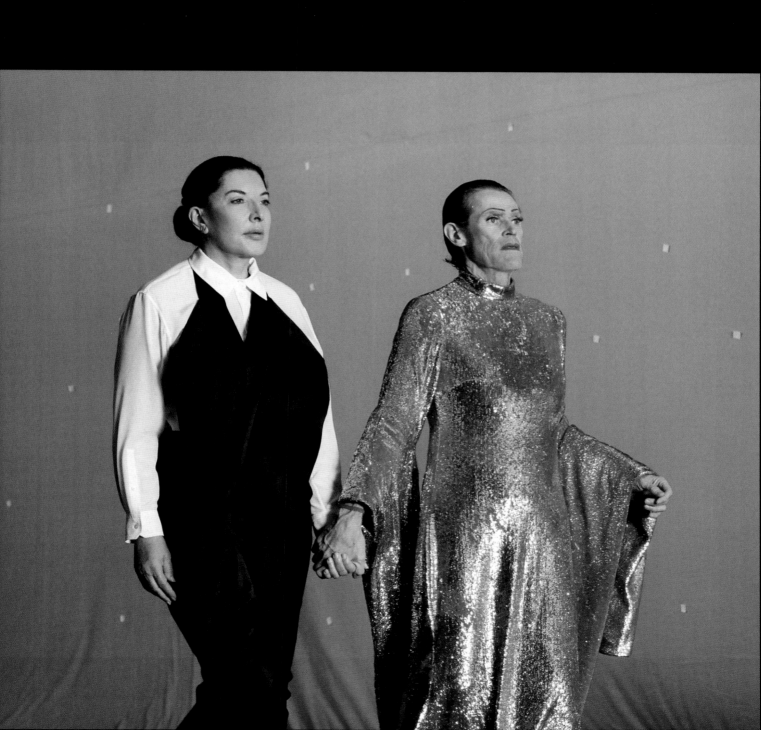

Did you always love Maria Callas?
Oh yes. I remember sitting in my grandmother's
kitchen. How old was I? Fourteen? And from the
old Bakelite radio I heard her voice. I didn't
know who she was or why I was so moved, but
I started to cry.

Did your mother love Maria Callas?
Of course.

Did she ever get as emotional as you,
listening to opera?
Never.

Ah. A soldier. Or, rather, a Partisan.
Both.

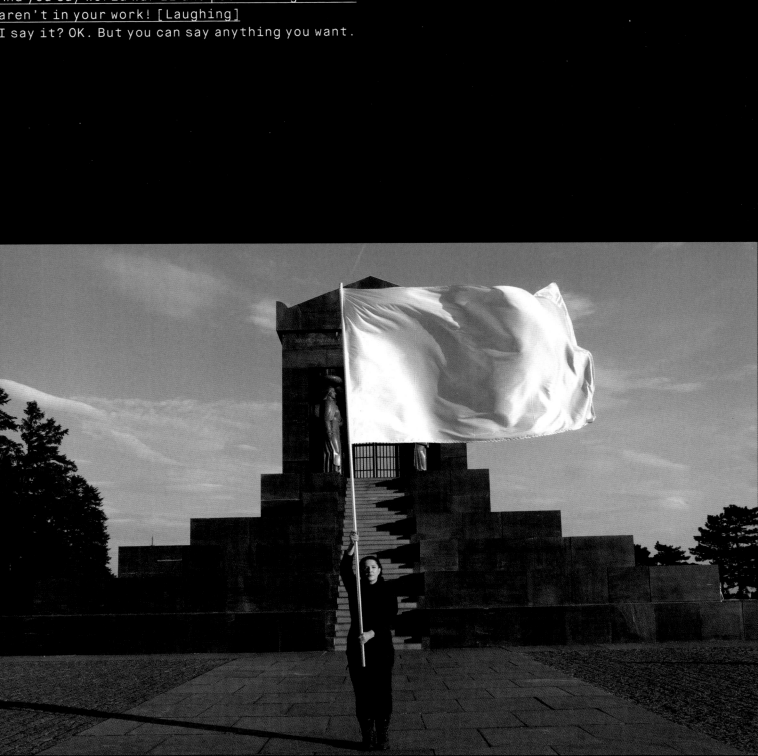

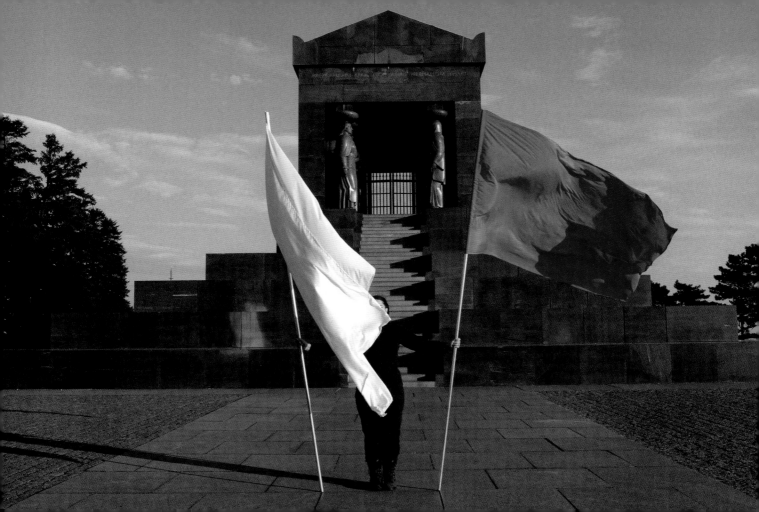

12

I'M NOT DEAD YET

ON EARTH WITH PURPOSE
2020–2023

BRUSH WITH DEATH, CORRECTIONS

Making a book like this is dangerous. I look
through the pages and, even though I see
my life, it looks completely new to me. Most
artists don't get this chance. Books like
this only come out once they die. And how many
times have I joked that 'I'm not dead yet'?
I don't want to die. I want to live a really,
really long life.

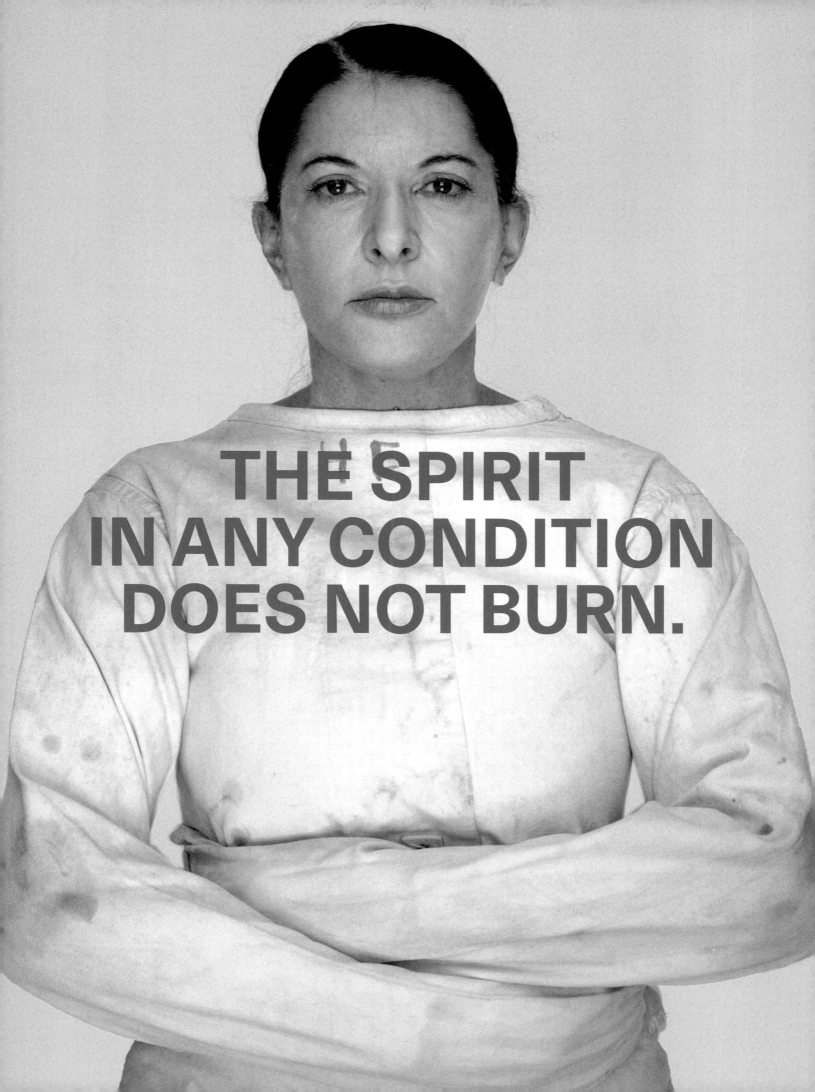

I DIDN'T REALIZE HOW CLOSE I WAS.

[Later.] When I told you that, I didn't realize how close I was. On 22 April [2023], I was preparing for a trip to Copenhagen, to receive the Sonning Prize [Denmark's top artistic honour]. The morning of my flight, I couldn't breathe. I went to the hospital by ambulance. Since then, three different doctors have told me if I'd gotten on that plane, I would not be here now.

What was the diagnosis?
A large pulmonary embolism. A six-inch blood clot in my lungs and part of my heart. I had one life-saving surgery to take out the clot; two life-saving surgeries after that to stop internal bleeding. I was on a ventilator. I still don't know exactly what happened. It has been weeks since I went into the hospital. Katya, I have toyed with death so many times in my work, and it's like an angel said: now would you like to really try it? This is the most difficult experience of my life.

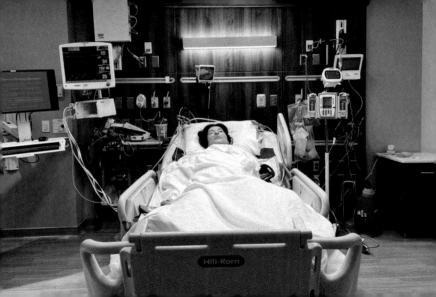

The morning you went to the hospital, I was
going to call you to argue. You had been sending
me hundreds of images you wanted to add to this
book. You were writing me nervous emails.

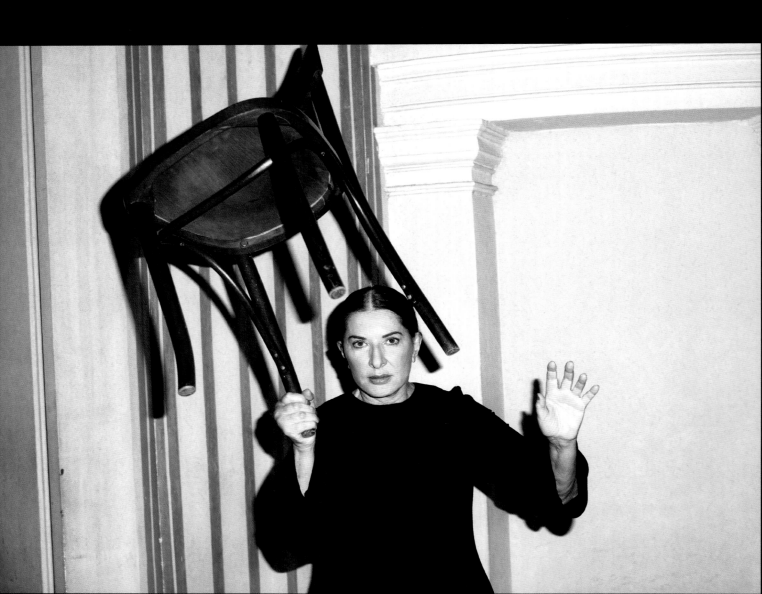

DEAR KATYA,

I CAN'T SLEEP. I'M IN A COMPLETE PANIC ABOUT HOW YOU ARE GOING TO END THIS BOOK... WHAT ABOUT ALL THE MISSING PEOPLE? FORGOTTEN PEOPLE? PEOPLE WHO LOVE ME? PEOPLE WHO HAVE STOPPED LOVING ME? WHAT ABOUT THE ONES WHO WERE FRIENDS AND BECAME ENEMIES? THE ONES WHO WERE ENEMIES AND BECAME FRIENDS? WHAT AM I GOING TO DO WITH ALL THESE PEOPLE IN MY LIFE?! WHAT ABOUT MY PUBLIC?! THEY HAVE SUPPORTED ME ALL THESE YEARS. GALLERISTS, MUSEUM DIRECTORS, WRITERS, GOOD AND BAD CRITICS! I REALIZE YOU DON'T KNOW THESE PEOPLE, BUT SOMEWHERE IN MY MEMORY, I HAVE LOVE FOR THEM.

Email from the artist, sent 3.21 a.m., 11 April 2023, New York.

There is a big problem. I don't see Todd
[Eckert] anywhere. I have been with him for six
years. He's the one who took me to the hospital.
He has been by my side, crying, sleeping in the
hospital while I was near death, and he's not in
the book? We love each other. Where is he?

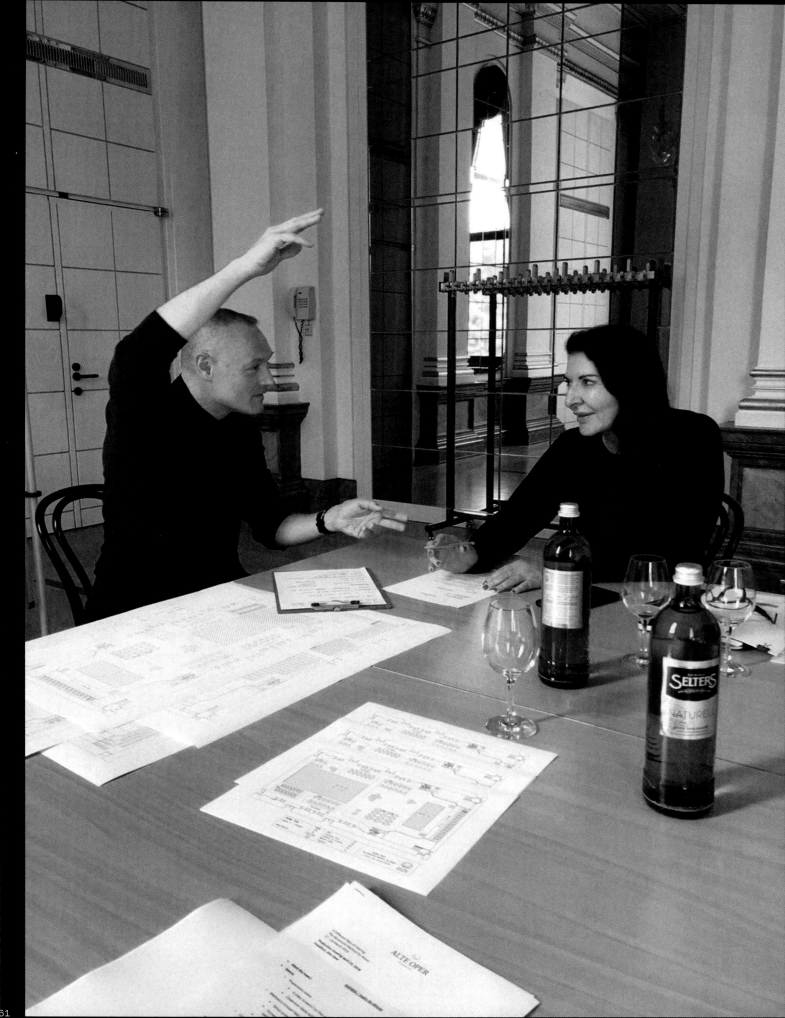

Todd and I used to laugh. I would say: 'When I get very old, I will go to a monastery in India where nobody will ever find me.' He would act horrified and say he'd definitely find me. I don't know if we will make this joke anymore. We are incredibly conscious of how much our time together counts. Every day together is precious. He was missing in my life. After I turned 70, I thought the rest of my years would be spent in a lot of lonely hotel rooms. He changed how I see my life. Even more now. It's so beautiful and fragile. You really understand when you almost lose it.

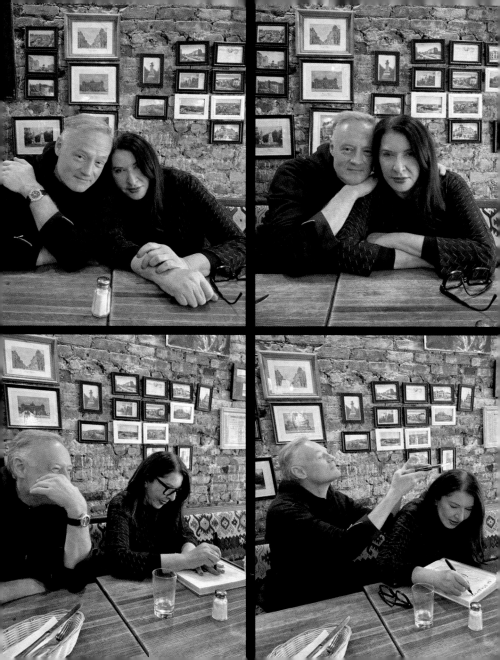

ke him to
as a child while
in the back,
started to cry.
to divorce

That is why I want this photo in the
book [below].

I don't understand.

It is the first photo Todd ever took of me. He says it captures a moment 'utterly without calculation'. That is how it is with us. We don't lie to each other. We say things as they are. We trust each other. I don't like secrets. Everything in my family growing up was a secret. My mother collected all the press about my work, but cut me out of every photo in which I was naked. Even that was a secret. I felt so repressed. I rebel against this. The only way I can survive now is to be completely open. Todd and I are completely open with each other. I remember he tried to do a workshop fast with me for fi days. He came up to me after some time and sa 'I can't do this anymore!' I thought he was breaking up with me. He just meant he wanted something to eat. [Laughing.] I love this. I am glad he ate something.

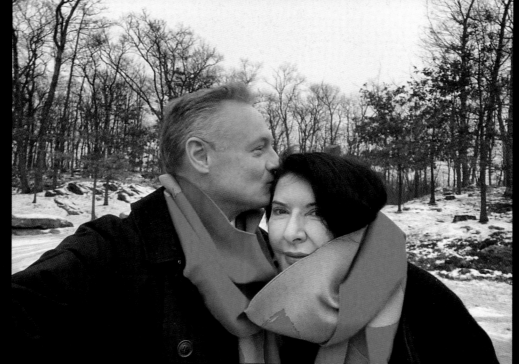

I have many more stories like this.

Marina, I know there is much more we could add, but this book is not a catalogue of every important person and moment. It's a tiny percentage of your massive archives. This book is my subjective version of your life. When you said, early on, that anybody can project their biography onto yours, I did that. I hope other people will, too. Even though your life is unlike any other, I think the emotional experience of it represents a broader human experience – not necessarily yours.

That is similar to how I think about my work. You know, I am not comfortable with my body in my private life, but when I am in public, I don't care. To the public, I am not representing my body. I am representing a body. Any human body. I am a mirror. In my performance, the public witnesses me confronting fear and difficulty, and that means they can confront their own.

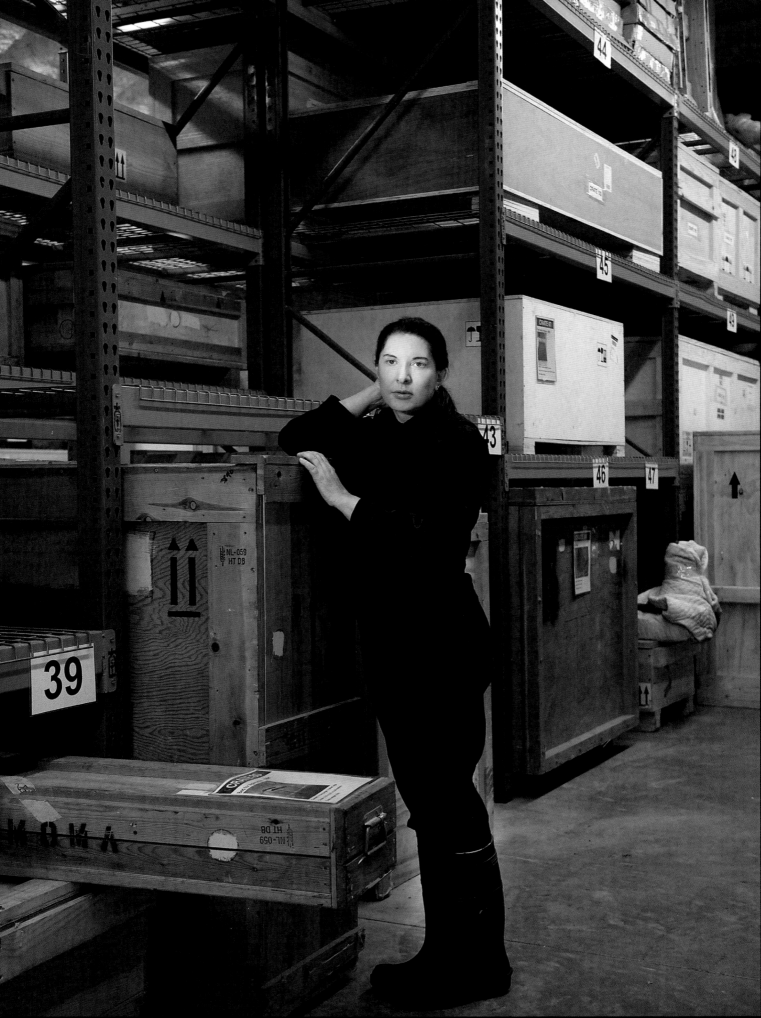

I started writing you a letter on that
subject when you went in for your first surgery.
It felt like I was writing your eulogy, and
I had to stop.
What did your letter say?

DEAR MARINA,

WE COME FROM A SIMILAR SPOT ON THE MAP,
AND I ALSO LOVE TERRIBLE JOKES. BUT WHAT
WE HAVE IN COMMON IS A BELIEF IN THE
TRANSCENDENCE OF ART (SOME ART). I DON'T
THINK YOUR WORK IS *ABOUT* OR *LIKE* SOMETHING.
IT ISN'T COMMENTARY OR METAPHOR. IT IS
A HIGHLY CONCENTRATED SEGMENT OF LIFE ITSELF.
IT SIMPLY IS – A STATE OF EXISTING UNDER
GIVEN CONDITIONS IN A GIVEN TIME, GRAPPLING
WITH CHOICE, AND SUSTAINING THE ACTIONS
AND EMOTIONS OF OTHER PEOPLE.

WHETHER INTENDED OR NOT, THE END IS ALWAYS
UNPREDICTABLE. UNPREDICTABLE END.

PART OF THE EXPERIENCE IS PAIN, OF COURSE.
SO IS HUMOUR AND CONNECTION.
YOUR WORK NOT ONLY TESTS YOUR STRENGTH
AND CONCENTRATION, BUT THAT OF YOUR
AUDIENCE. HOW MUCH IMPULSIVITY RUNS
THROUGH YOUR PUBLIC? WHAT MAKES
YOU TRUST THEY WILL FOLLOW YOUR CONDITIONS?
UNPREDICTABLE EVERYTHING! THE POTENTIAL
FOR CHAOS! MUCH IS SAID ABOUT 'CONTROL'
IN YOUR WORK. I AM EXCITED BY THE LACK OF IT.
FOLLOWING ALL THE RULES OF SUPERSTITION
WON'T ALWAYS KEEP OUR GREATEST
FEARS FROM MATERIALIZING.

I WROTE THIS BOOK IN A STATE OF GRIEF,
HAVING LOST MY FATHER AS YOU AND I WERE
WORKING. YOU WERE ONE OF THE FIRST
TO CALL ME, AND I WILL NEVER FORGET THAT.
MARINA, I WILL BE SO PISSED OFF IF I HAVE
TO FINISH THIS BOOK GRIEVING YOU, TOO.
YOU HAVE TO PULL OUT OF THIS THING. YOU JUST
CALLED ME TO TALK ABOUT THIS BOOK AS
THEY WERE PREPPING YOU FOR SURGERY!
UNBELIEVABLE. I KNOW YOU'RE NOT DONE YET.

Unfinished letter written to the artist, not sent, Los Angeles, 23 April 2023.

Can we end here? I don't want to add over
200 photos of people you want to thank.
If somebody is upset that their photo isn't
in the book, why don't you just blame me?
OK, I will blame you. But just one more
photo. It's very special. It shows my family
together. A rare photograph. From it, only
three people are alive today: my brother, my
niece Ivana [centre]… and me.

The artist in her grandmother's apartment building, 2020

JUST
ONE MORE
PHOTO.

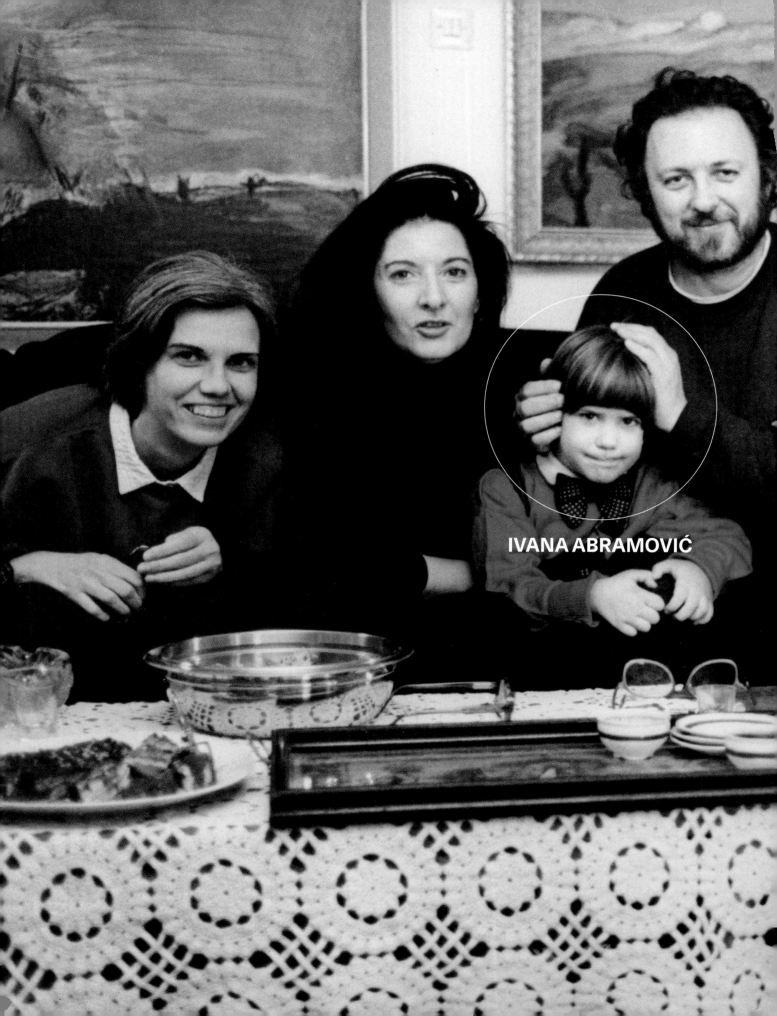

IVANA ABRAMOVIĆ

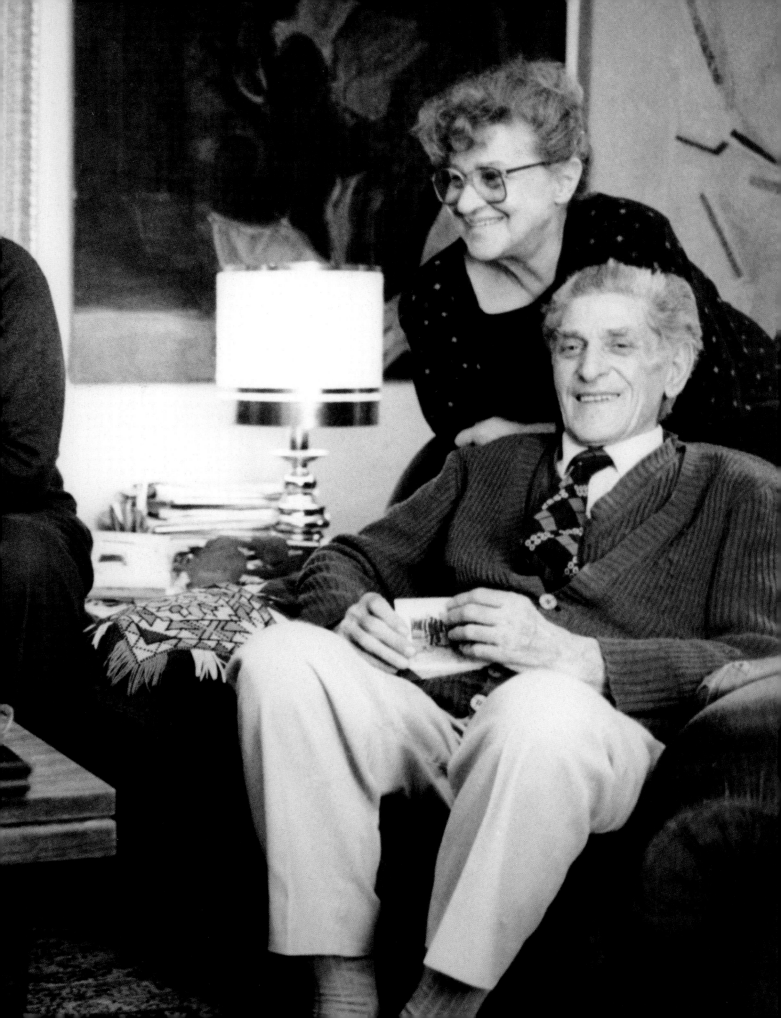

A FRACTION OF THE PEOPLE
MARINA WOULD LIKE TO THANK

01
Marco Anelli – a photographer
I have worked with for years and
years and is a dear friend.

02
Here you see my office babies
– Cathy Koutsavlis and Sydney
Fishman. They are driving
me home.

03
Giuliano Argenziano,
who worked with me for many,
many years. This is us at an
Ayurvedic hospital in India
during the Covid lockdown
when nobody travelled.

04
Me and Billy Zhao in our
matching pyjamas. This has
to go in the book.

05
Here I am with Lynsey
Peisinger during *512 Hours*
in London, 2014.

06
This is a happy time
with Giuliano and Sydney
in Madrid, 2021.

07
And Hugo Huerta Marin!
He is a graphic designer and
art director. We have done
so many projects together!

08
Serge Le Borgne. I can't
believe Serge is not in
the book.

09
This is Natascha Linssen
Jacobson, who saved me many
times. A big friend.

10
Louwrien Wajers, who made all
of the spiritual connections
in my life. She introduced Andy
Warhol, Joseph Beuys and me
to the Dalai Lama.

11
This is Chrissie Iles, who
is a wonderful curator and
historian who can explain my
own work to me.

12
Some of my oldest friends
are like family to me. This
is Michael Laub, who directed
The Biography Remix in 2004,
with stories from my life. We
cast Ulay's son [left] to play
Ulay himself [right] – and Ulay
was in the audience. We didn't
even put that story in.

13
Me with two really great
artists – Rebecca Horn and Pat
Steir. We are so different, but
looking at this photo, I see how
we really loved each other.

14
With Mary Kelly at the Calder
Foundation in France, 2003.

15
Christine Koenigs, my oldest
friend from Amsterdam.

16
Fyodor Pavlov-Andreevich,
Nico Vascellari and me.

17
And, Katya, I need to thank
all of my students, who have
done the Method with me and
learned about durational
work. This image is from
The Drill at the Manchester
International Festival in
2009. (Photo: Marco Anelli)

18
My purpose is to help
my students achieve their
work. That is me with the
artist Miles Greenberg, who
is doing such great things
now. There are so many times
where I have cried from joy
at my students' successes.

19
And my gallerists – they are so
close to me. This is me walking
with Ursula Krinzinger in 1978
– she was my first gallerist
then and still my gallerist and
friend today.

20
Mark Sanders with
Apinan Poshyananda.

21
And this is me with my gallerist
Sean Kelly and his family,
Lauren, Mary and Thomas. They
are all so extremely important
to me.

22
Me with Willem Peppler.

23
Riccardo Tisci, Damien Jalet
and Sidi Larbi Cherkaoui after
working on *Boléro*, Paris, 2013.

24
Riccardo Tisci and me at the
Givenchy event celebrating the
end of *The Artist Is Present*.

25
With Todd and his
daughter Adeline.

26
With Todd's mother.

27
Starhouse with the
Poots family.

28
Alex Poots's kids
picking tomatoes.

29
With Damien Jalet
in Paris, after *7 Deaths
of Maria Callas*.

30
With Hans Ulrich Obrist
in my old office, May 2013.

31
With Petter Skavlan.

32
Willem Dafoe, Marco Brambilla
and Klaus Biesenbach over for
a casual dinner at my house.

33
With Zinaida and Serge, 2017.

34
Alanna Heiss and me.

35
Rossy de Palma and me
in Barcelona, 2023.

36
Josef O'Connor, Damien Jalet,
Hugo Huerta Marin and me.

37
Some of my earliest supporters,
Ingrid and Žika Dacić.

38
Lena Pislak, Yasemin
Kandemiroglu, and Rafi
Gokay Wol.

39
Melati Suryodarmo and me.

40
Sondra Radvanovsky and
Ilias Tzempetonidis.

41
Nonna Brenner and me.

42
Uma Thurman, her children
and me.

43
Me and Alessia Bulgari.

A very special thank you from
Marina and Katya to everyone
at Abramović LLC who has worked
tirelessly on this project:
Cathy Koutsavlis, Sydney
Fishman, Giuliano Argenziano,
Billy Zhao, Matthew Moorman.

Thank you to the entire team at
Laurence King for their support
and trust in this project:
Laura Paton, Elen Jones, Robert
Shore, Liam Relph, Marc Valli,
Donald Dinwiddie, John Parton.

Enormous thank you to
Hingston Studio, with special
thanks to Jūratė Gačionytė.

To Radovan Cukić and
Joes Segal.

To The Blair Foundation
and Adam Reed.

Thank you from our hearts
to Polina & Alexander Tylevich,
Alexei Tylevich, Eric Kelsey
and Oona Tylevich Kelsey.

Above and opposite: Every Christmas my office and MAI (Marina Abramović Institute) make a new holiday card. These are some examples from throughout the last decade.

LYNSEY / / VICTORIA / MARINA / GIULIANO / / LEAH /
/ POLLY / / MARIA / / CHRISTIANA / / SIDNEY

Wishing you a peaceful holiday.

From, Abramovic LLC and MAI

Sydney

Giuliano

Paula

Marina

George

Lynsey

Thanos

Matthew

Cathy

Hugo

Billy

The artist leaving the ho

To the people of Ukraine, I stand with you
in solidarity.

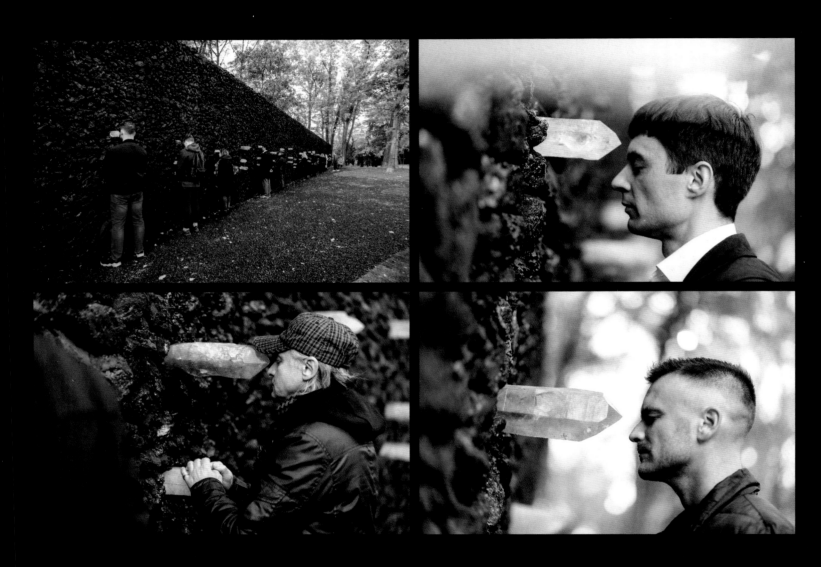

Above and opposite: *Crystal Wall of Crying*, 2021, Babyn Yar Holocaust Memorial
Centre, Kyiv, made in commemoration of 100,000 victims, including almost
the entire Jewish population of Kyiv, massacred and buried at this mass grave
between 1941 and 1943. Near the site of bombing during Russian invasion, 2022.

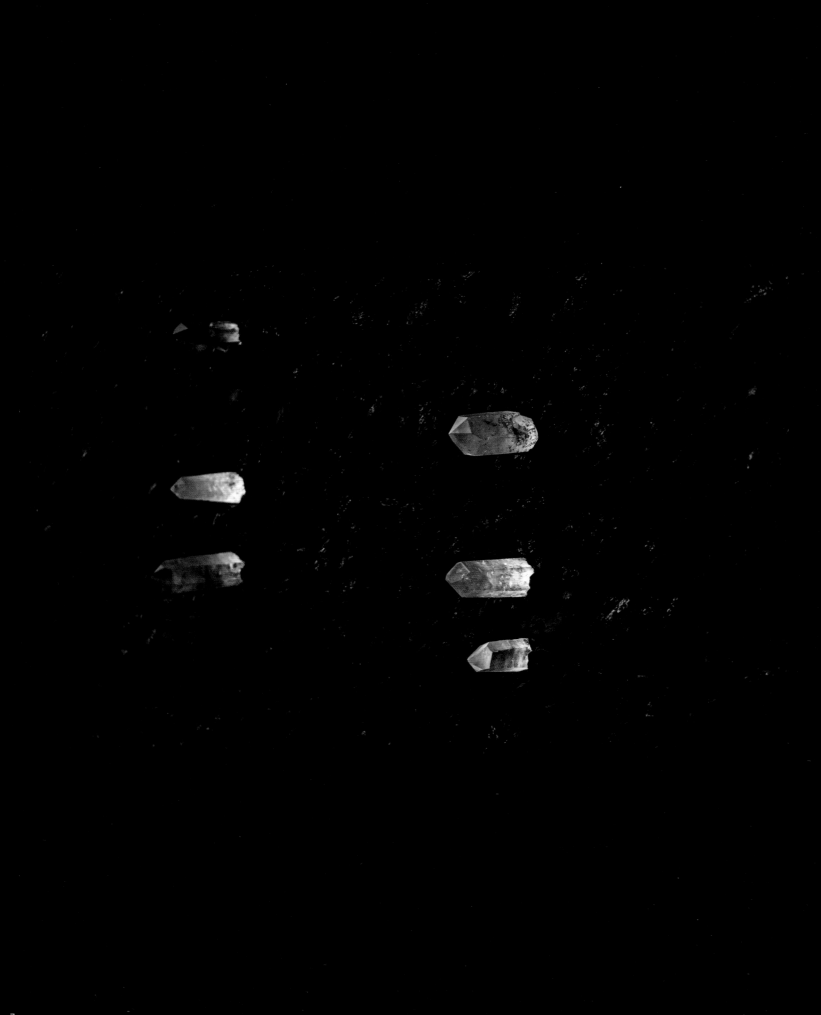

CREDITS AND INDEX

Text Credits

The Marina Tsvetayeva quotation on page 11 is from Boris Pasternak, Marina Tsvetayeva and Rainer Maria Rilke, *Letters: Summer 1926* (New York: New York Review of Books, 2001). The quotations on pages 49 and 126 from the interviews with Micky Piller and Gijs van Tull are taken from *Marina Abramović: Interviews, 1976-2016* (2018). The Velimir Abramović quotation on page 167 is taken from Marina Abramović, *Artist Body: Performances, 1969-1998* (Milan, 1998).

Picture Credits

Unless otherwise stated, all images used are © Marina Abramović, Courtesy of the Marina Abramović Archives.

Photographs on the following pages are by Marco Anelli: pp280–281, 394, 396–397, 398, 400, 402, 403, 404–405, 406, 407, 426, 427, 428–429, 430–431, 432, 434, 435, 438, 439, 440, 441, 443, 444, 445.

Page 16
El Greco, *Disrobing of Christ*, ca. 1580-95

Page 47
Three Secrets, 1965

Page 48
Top: *Truck Accident (II)*, 1963
Bottom: *Truck Accident (I)*, 1963

Page 51
Self-Portrait, 1965

Page 55
Top & Bottom: Celebration of the first of May, Belgrade, 1 May 1949 (Photograph: Dragutin Grbić, Photo service of the Cabinet of the Marshal of Yugoslavia; Collection of Museum of Yugoslavia)

Page 57
The Artist Is Present, 2010 Museum of Modern Art (Photograph: Marco Anelli)

Pages 72–73
Marina Abramović, *Freeing the Horizon*, 29 paintings on Agfacolor prints, 1971

Page 74
Tito Eating the Country, 1967

Page 76
Photograph: Martynas Plepys

Page 77
Photograph: Martynas Plepys

Page 84
Marina Abramović, *Sound Corridor (War)*, Sound installation (amplified sound of machine guns), 1971/2017

Page 89
Marina Abramović, *The Cleaner*, ca. 1958, Washing machine, wheels coated with gold leaf. Installation image from Bundeskunsthalle, Bonn, 2018

Page 93
Marina Abramović, *White Space*, Sound Environment, 1972. Installation image from Lisson Gallery, London, 2014

Pages 94–95
Marina Abramović, *The Forest*, Sound Environment, 1972

Page 96
Marina Abramović, *Rhythm 10*, Performance, 1 hour, Museo d'Arte Contemporanea Villa Borghese, Rome, 1973

Page 97
Marina Abramović, *Freeing the Body*, Performance, 8 hours, Künstlerhaus Bethanien, Berlin, 1975

Page 102
Marina Abramović, *Rhythm 5*, Performance, 90 minutes, Student Cultural Centre, Belgrade, 1974 (Photograph: Nebojša Čanković)

Page 105
Marina Abramović, *Coming and Going*, 1973/2017, 9 silver gelatine prints (Photograph: Neša Paripović)

Page 108
Monument of an Unknown Soldier, Avala, Belgrade, 21 July 1945 (Photograph: Petar Obradović, Tanjug agency; Collection of Museum of Yugoslavia)

Page 111
Marina Abramović, *Rhythm 10*, Performance, 1 hour, Museo d'Arte Contemporanea Villa Borghese, Rome, 1973

Pages 112–113
Marina Abramović, *Art Must Be Beautiful, Artist Must Be Beautiful*, Performance, 1 hour, Charlottenburg Art Festival, Copenhagen, 1975

Page 115
Marina Abramović, *Rhythm 0*, Performance, 6 hours, Studio Morra, Naples, 1974 (Photograph: Donatelli Sbarra)

Page 116
Marina Abramović, *Rhythm 0*, Performance, 6 hours, Studio Morra, Naples, 1974 (Photograph: Donatelli Sbarra)

Page 118
Marina participates in a Hermann Nitsch performance, 1973

Page 119
Marina Abramović, *Rhythm 2*, Performance, 7 hours, Gallery of Contemporary Art, Zagreb, 1974

Page 122
Marina Abramović, *Rhythm 4*, Performance, 45 minutes, Diagramma Gallery, Milan, 1974

Page 123
Marina Abramović, *Rhythm 0*, Performance, 6 hours, Studio Morra, Naples, 1974 (Photograph: Donatelli Sbarra)

Page 125
Marina Abramović, *Lips of Thomas (Star on Stomach)*, 2 hours, Krinzinger Gallery, Innsbruck, 1975

Pages 134–135
Marina Abramović, *Role Exchange*, Performance, 4 hours, De Appel Gallery, Red Light District, Amsterdam, 1976

Page 137
Ulay/Marina Abramović, *Relation in Space*, Performance, 58 minutes, XXXVIII Biennale, Giudecca, Venice, July 1976 © Ulay/Marina Abramović (Photograph: Jaap de Graaf)

Page 138
Ulay/Marina Abramović, *Light/Dark*, Performance, Amsterdam, 1978 © Ulay/Marina Abramović

Pages 144–145
Ulay/Marina Abramović, *Relation in Space*, Performance, 58 minutes, XXXVIII Biennale, Giudecca, Venice, July 1976 © Ulay/Marina Abramović. Photograph: Jaap de Graaf

Page 150
Ulay/Marina Abramović, *Breathing In/Breathing Out*, Performance, 19 minutes, Student Cultural Centre, Belgrade, April 1977

Page 151
Ulay/Marina Abramović, *Balance Proof*, Performance, 30 minutes, Musée d'Art et d'Histoire, Geneva, December 1978

Page 154–155
Ulay/Marina Abramović, *AAA-AAA*, Performed for television, 15 minutes, RTB television studio, Liège, Belgium, February 1978

Page 164
Ulay/Marina Abramović, *Interruption in Space*, Performance, 46 minutes, Kunstakademie 'Rinke Klasse', Düsseldorf, January 1977

Pages 174–175
Ulay/Marina Abramović, *Relation in Time*, Performance, 17 hours, Studio G7, Bologna, 1977

Page 178
Ulay/Marina Abramović, *Incision*, Performance, 30 minutes, Galerie Humanic, Graz, April 1978

Page 179
Ulay/Marina Abramović, *Imponderabilia*, Performance, 90 minutes, Galleria Communale d'Arte Moderna, Bologna, 1977

Page 180
Ulay/Marina Abramović, *Point of Contact*, Performance, 1 hour, De Appel Gallery, Amsterdam, January/August 1980

Page 181
Ulay/Marina Abramović, *Work Relation*, Performance, Palazzo dei Diamanti, Ferrara, October 1978

Page 183
Ulay/Marina Abramović, *Rest Energy*, Performance for video, 4 minutes, ROSC '80, Dublin, 1980

Page 188
Ulay/Marina Abramović, *The Brink*, Performance, 4 hours and 30 minutes, Biennial of Sydney, 1979

Page 204
Nightsea Crossing, Museum voor Hedendaagse Kunst, Ghent, 1984

Pages 206–207
Marina Abramović/Ulay, *Nightsea Crossing: Conjunction*, Performance (with Ngawang Soepa Lucyar and Watuma Tarruru Tjungarrayi), 4 days of 4-hour sessions, Sonesta Koepelzaal, Museum Fodor, Amsterdam, April 1983

Index